*Nature into Art*

# CARL WOODRING

# NATURE

*into*

# ART

*Cultural Transformations in Nineteenth-Century Britain*

HARVARD UNIVERSITY PRESS
CAMBRIDGE, MASSACHUSETTS
LONDON, ENGLAND
1989

*Library of Congress Cataloging-in-Publication Data*

Woodring, Carl, 1919–
    Nature into art : cultural transformations in
nineteenth-century Britain / Carl Woodring.
        p.    cm.
    Bibliography: p.
    Includes index.
    ISBN 0-674-60465-2 (alk. paper)
    1. English literature—19th century—History
and criticism.    2. Art and literature—Great
Britain—History—19th century.    3. Great
Britain—Civilization—19th century.    4. Art,
Modern—19th century—Great Britain.    5. Art
for art's sake (Movement)    6. Nature
(Aesthetics)    7. Art, British.    I. Title.
PR468.A76W6    1989
820'.9'357—dc19                        89-31112
                                              CIP

*To students*
*at Columbia and Wisconsin*
*who taught me*

# PREFACE

Although the sights of this book are pointed toward movements, events, and minds in Great Britain, the transformations here traced, beginning with the "return to nature" and ending with the supersession of nature by art, took related forms throughout the Western world. Remarks and happenings on the Continent or across the Atlantic that are noted in the following chapters either impinged upon or help to clarify what was happening in Britain. It was only after work on the book arbitrarily ceased, and the title was chosen, that I came upon a congenial sentence in Penelope Lively's novel *Next to Nature, Art*: "And all around, on the terrace and along the woodland rides and by the cascade and over the serpentine rill, people are hunched over drawing-boards, turning nature into art, trying to impose order upon chaos." Topics pursued can be summarized in approximately the order in which they arise in the nine chapters:

Toward the end of the eighteenth century an increasing number of active minds began to agree with Rousseau that convenient substitutions for the mother's milk were not the only evidence that a corrupting civilization had driven human nature from Europeans. The impulses of those we call romantic were congruent with a proposal by Schiller: call natural conduct back from exile by return to the uncontaminated source of natural law, the underlying, enduring single principle of growth in what came to be defined as organic life. Mathematics and physics gave ground to chemistry, biology, and the geology of fossils.

Natural theology, which found the Creator's design in every

flower, insect, and chasm, encouraged close study of physical phenomena. Like the burgeoning scientists and engineers who coerced nature into making her coal available for steam and urged her to share the potential of magnetism, electricity, and galvanism, poets implored nature to share her powers of synthesis and infinitude. In a masculine culture, Nature was a female mysterious but ready, in biblical and Byronic usage, to be *known*. Baconian science and industry advanced because nature was there to be *used*. Utility of external nature gave a footing to utilitarian schemes for society. For the romantics, nature had powers that love would entice her to share, or she was a demon, as Nina Auerbach has epitomized the masculine view, to be stalked but never by conquest to be fully known.

The cultural games of the picturesque and the Gothic continued, but the sublime was pursued as intensely as indeterminacy would be a century later. In revolt against rationalistic rule and calculation, and fretting under inescapable Humean skepticism, romantics attempted to redefine human nature as rooted in imagination. Particularly through the empirical process of fiction, they rediscovered human nature in spontaneous reveries, dreams, visions, and the validities of hallucination. Affirming the reality of the supernatural, much of the literature of the fantastic told of punishment for transgression derived from overreaching desire to exploit a forbidden otherness.

Human imagination assumed the burden of creating its own universe. Romantic irony permitted persistent doubts without reducing enthusiastic propulsion. Prevailing beliefs and inclinations conjoined in a narcissistic discovery of self in the reflecting mirrors of nature. Romantic Hellenism, notably in Keats, cultivated the ground from which a cult of beauty would over time be erected.

Several generations at mid-century sought a solution to the perils of imagination in the self-restraint of observing accurately the surfaces of things and of representative ordinary lives. Realism in literature and visual arts proposed to display test-tube samples of swarming life. Such samples were to be found preeminently in cities. If their parents had sought the rural, realists looked largely to the urban. The invention and utilization of photography gave a

firmer support to faith that objectivity could be achieved in art and in the empirical sciences.

Ruskin turned close attention to detail toward renewed reverence for nature and polemic morality in art. A question that had risen early in the century persisted throughout varying emphases in fine and useful arts: How far should skill be applied to evoke the character of the materials employed rather than to create an illusion of different materials or of no physical medium at all? The Great Exhibition of 1851 increased the number of observers troubled by the question.

Influentially at mid-century the London Pre-Raphaelites exhibited a convergence of meticulous observation and "romantic" idealism in revolt against academic convention. For Rossetti and especially Burne-Jones, and for their many followers, observation dissolved into dream. The precepts of realism diverted demonic possession, doubling, and division, basic instruments of the supernatural, into the credibly psychological before they became devices in unconstrained art.

In Britain, civilization and artifice spread a blight of undeniable ugliness outward from such industrial cities as Manchester and Glasgow. Ruskin and after him Morris preached that the health of society required beauty in individual purlieus. Morris climbed to a waiting pedestal in cultural history by emphasizing decorative beauty to be achieved by handicraft in an egalitarian society.

Meanwhile, utilitarian analysis had begun to call into question the ancient precept, First follow nature. Organic nature, wasteful and murderous, could provide no basis for moral conduct. The nearest analogue to the destructive warfare for survival in nature was the cash nexus of industrial capitalism, eloquently challenged by Carlyle, Ruskin, and Marx among others. In 1859 Darwin verified perceptions that nature was amoral by effectively displacing natural law as traditionally conceived with the chance of natural selection. Physicists rejected the concept of chance, Darwin feared it, and most biologists sought ways of evading its implications. Writers unconcerned with the mathematical laws of probability sensed that something drastic had occurred to the previously comfortable trust in natural law. The obvious but perilous response of seeing individ-

ual lives as juggled in a universe of mere chance brought from Hardy and Conrad great fictions of mischance.

If nature was not worth imitating, art could be freed from antiquated restraints. Among those liberated, some began to equate art with the unnatural. To be civilized was to use cosmetics, to wear a mask, to enter—however near exhaustion—the dance. Art was not illusion but deception. Decadence, to recur in the twentieth century under other names, was a phase in the freeing of art from its midcentury union with nature for the promotion of moral health. Art finally, as in the pronunciamentos of Whistler and Wilde, had achieved freedom from reliance on nature and from responsibility to the natural. The creativity touted by the romantics had triumphed beyond their most audacious dreams.

The process here traced has continued throughout our own century. Wendy Steiner in *Pictures of Romance* (1988) quotes from John Canaday's *Mainstreams of Modern Art* (1956) on Turner's fading masterpiece *The Slave Ship*: "The title of the picture still clings to literary associations not inherent in the painting as an independent work of art, and it is with a kind of disappointment that we discover the narrative incident in the foreground right, where a shackled leg disappears into the water, surrounded by devouring fish. This bit of storytelling appears as an afterthought, a concession to popular standards in a picture that was not only complete without it but is reduced from grandeur by its inclusion." In 1956 and 1988 Whistler's victory over Turner is still in process. An axiom in sports, apparently based on misquotation, can bear further adaptation: Submission to an author or artist is not everything, but victory over a work of art is nothing.

I would not discourage a reader from finding other implications for our own time in the history I have tried to write. Like the art critic Étienne-Jean Delécluze (1783–1863), who wrote in 1835 that he had lived clean-shaven through the Etruscan beards of 1799 and the Gothic beards of 1832, I leave to others pertinent discourse on the hermeneutical circle that limits the sort of history attempted.

Some of my debts are of long standing. Ricardo Quintana used to say of his years as a student, "At least they left my mind alone." I cannot say that of Rice Institute. In a rare negative effect, all my

favorite professors at Rice disparaged Wordsworth, perhaps as a father figure; finding in my own father nothing to reject, I rebelled against the surrogates by espousing Wordsworth and Shelley. After World War II screamed in my ear that books are not everything, I could count among powerful teachers at Harvard Hyder Rollins, Douglas Bush, Howard Mumford Jones, and W. Jackson Bate. In 1948, when I began apprenticeship at the University of Wisconsin, the Romantic Group of the Modern Language Association was not yet convalescent; the Victorian Group was ascending. My sense of the Victorians was formed, without substantial later change, by J. H. Buckley's *The Victorian Temper* and G. M. Young's *Victorian England: Portrait of an Age,* with help from the pastiche of Caryl Brahms and S. J. Simon's *Don't, Mr. Disraeli!*

As well as from the students to whom this book is dedicated, I have learned continuously from colleagues—in recent years repeatedly from Carolyn Heilbrun, Karl Kroeber, Steven Marcus, Joseph Mazzeo, Martin Meisel, John Middendorf, James V. Mirollo, E. W. Tayler, Inge Halpert, and Olga Ragusa. W. Theodore deBary and Loretta Nassar have led the Columbia Society of Fellows in the Humanities in relaxing the hold of specialization.

Mary Ellis Woodring made survival possible during years when the work was only an idea kept down by Coleridge's *Table Talk.* The book was expedited by generous aid from the librarians W. Alan Tuttle, Rebecca Vargha, and Jean Houston and other members of the staff guided by Charles Blitzer and Kent Mulliken at the National Humanities Center. It was helped by bracing exchanges there with Robert Patten, Beatrice Farwell, Sima Godfrey, Gail Minault, Henry Petroski, Deborah Shuger, and Helen Ulrich, Fellows at the Center in 1987–1988, and with Beverly Taylor and Joseph Viscomi of the University of North Carolina. Aid through the years from librarians of Columbia University and the New York Public Library was continued by university librarians of North Carolina, Duke, North Carolina State, and, in the final stages, by genial custodians of the Harry Ransom Humanities Research Center and other libraries of the University of Texas at Austin. Of those who helped with the illustrations, Stephen Wildman of the Birmingham Art Gallery was particularly generous in aid.

The omission of recent scholars and critics from the index is not a

declaration of independence. The endnotes make a tourist's declaration of dependence on critics and scholars at home and abroad.

Richard D. Altick kindly made suggestions for improvement. At the Harvard University Press, Maud Wilcox has given salubrious advice, as always, and Camille Smith has reduced in number my errors of omission, obscurity, and ignorance. I have been cheered by their confidence that readers will share my interest in the subject and in the evidence dredged up.

# CONTENTS

# ILLUSTRATIONS

*Following page 40*

*Stowe,* by John Britton, in John Britton and Edward Wedlake Brayley, *The Beauties of England and Wales* (18 vols., London: Vernor, 1801–1816), 1:284. Courtesy of the Harry Ransom Humanities Research Center, University of Texas at Austin.

*Newstead Abbey.* Drawn by C. Fellows, engraved by Edward Finden for the title page of Thomas Moore, *Letters and Journals of Lord Byron, with Notices of His Life,* 1830.

*British Museum,* engraved from a drawing by Thomas H. Shepherd for *London and Its Environs in the Nineteenth Century* (London: Jones and Co., 1829) [1831]. Courtesy of the Harry Ransom Humanities Research Center, University of Texas at Austin.

John Flaxman (1755–1826), *Design for a Monument.* Drawing, pen and wash over pencil, 6⅝″ × 7¾″. Courtesy of the Henry E. Huntington Library and Art Collections.

*Following page 76*

William Marlow (1740–1813), *Capriccio: St. Paul's and a Venetian Canal.* Oil on canvas, 51″ × 41″, ca. 1795. Courtesy of the Tate Gallery, London.

John Russell (1745–1806), *The Face of the Moon,* pastel, 25¼″ × 18½″, ca. 1790–1795, with the calligraphic inscription, "Painted from Nature by John Russell R.A." Courtesy of the Birmingham City Museums and Art Gallery.

William Holman Hunt (1827–1910), *The Awakening Conscience.* Oil on canvas, 29¾″ × 21⅝″, 1853. Courtesy of the Tate Gallery, London.

J. M. W. Turner (1775–1851), *Snowstorm: Hannibal and His Army Crossing the Alps.* Oil on canvas, 57″ × 93″, 1812. Courtesy of the Turner Collection, Tate Gallery, London.

*Following page 156*

Samuel Luke Fildes (1844–1927), *Houseless and Hungry.* Wood-engraving from a drawing by Fildes, a full page in the *Graphic,* 4 December 1869.

George du Maurier (1834–1896), "No Smoking Here, Sir!" Wood-engraving in *Punch,* 6 October 1860.

Dante Gabriel Rossetti (1828–1882), *Found.* Drawing, pen and ink, 9¼″ × 8⅝″, ca. 1855. Courtesy of the Birmingham City Museums and Art Gallery.

*Following page 246*

George du Maurier (1834–1896), "The Rise and Fall of the Jack Sprats: Ye Aesthetic Young Geniuses." Wood-engraving in *Punch,* 21 September 1878.

James Abbott McNeill Whistler (1834–1903), *The Little White Girl: Symphony in White, No. 2,* oil on canvas, 30⅛″ × 20½″, 1864. Courtesy of the Tate Gallery, London.

Cover of *Parables from Nature,* by Margaret Gatty (London: Bell and Daldy, 1861–1865).

Design by Dante Gabriel Rossetti (1828–1882) for the covers of poems by his sister Christina Rossetti, 1862, 1866, and later.

Charles de Sousy Ricketts (1866–1931), proof for endpapers of Oscar Wilde, *Poems* (London: Elkin Mathews and John Lane, 1892).

*Nature into Art*

# NATURE
# AND
# ART

The rivalry of art with nature did not begin in 1801. A student of the subject at that date, taught to seek and to find origins, would ask where a history of the opposition of art and nature should begin. A history of nature and art contrived in 1801 might have commenced with the contrast of city and country on the shield of Achilles in Book 18 of the *Iliad*. Within the heavens and the seas, Hephaistos forged two cities, one at war, one at peace. In the city at peace, there were marriages and festivals; disputes were settled conclusively by judgment of the elders. In a peaceful countryside, people who lived among vineyards, oxen, and sheep cooperated with the land in sowing and reaping; in the country Hephaistos forged a dancing floor for young men, maidens, and happy observers. Whatever Hephaistos makes, whether shield, floor, or spear, is art, but peace is the natural state. Youth at peace moves to a natural rhythm, accepts the conditions of a simple life. This pastoral vision has seldom been more vividly present than in 1801. The city at peace included murder and consequent litigation, which Wordsworth would have taken as evidence of urban civilization.

In the *Iliad* men at battle clatter to earth like felled trees. Homeric similes describe Achaians at war in terms of domestic activities they left behind in following Agamemnon to Troy. The life recalled was neither of luxury nor of piping melancholy. Peaceful human activity included as a matter of course mauling by lions and the hunting and slaughter of various beasts. If, as Wordsworth recommends, you believe that every flower enjoys the air it breathes, the *Iliad* may not seem ecologically ideal. If you share

Byron's antipathy to hunting or Leigh Hunt's to angling, you will look to a later pastoral model. Most educated readers in the eighteenth century lacked these scruples, and could believe that nature and Homer are the same. Joseph Warton provoked no dissent from the romantics when he declared in the *Adventurer* of August 11, 1753, that "the behaviour of *Hecuba,* when she points to the breast that suckled her dear *Hector,* is as finely conceived as the most gallant exploits of *Diomede* and *Ajax*: the *Natural* is as strong an evidence of true genius, as the *Sublime*." The *Odyssey,* with a wider range of customs, laws, and domestic life, "is the greater, more natural poem."

The nineteenth-century historian of nature in art would not ignore Theocritus. Atomists and other unrighteous historians of mere nature might begin with Lucretius. The tension between civilization and nature in the *Aeneid* would make Virgil central to the study of nature and art even if the *Eclogues* and *Georgics* had not survived. That tension is not altogether resolved even when the recurrent imagery of building, building, building points toward the ideal of orderly construction by bees. The stately advance of the *Aeneid* frequently makes the reader aware of the horn of artifice. Of the benignly fertile landscape that begins with Homer, Virgil's *Georgics* is the fructifier for later centuries.[1] But the triumphs of civilization were often, in Western arts after Virgil, depicted as opposed and thwarted by nature or reversed by time. Medieval poets, admired anew in the nineteenth century, sent knights from sophisticated courts into the dark, satanic forests that are often the impenetrable background in painted works before the fifteenth century. The presence of the author as declared manipulative artist in Gottfried von Strasbourg's *Tristan* is not unique as evidence of medieval pride in artifice. Yet the weight of authority remained. In the *Inferno* (11.97–105) Virgil reminds Dante on the authority of Aristotle's *Ethics* (by way of Aquinas) that art should follow nature because nature takes her course directly from that art which is unique to the divine intellect of God.

The self-conscious civilization of the Renaissance made confrontation of art and nature explicit.[2] Hamlet speaks for many Elizabethans by putting it in terms of cosmetics: "God hath given you one face, and you make yourselves another." The choice of a fuller

text might fall on *The Tempest* or on *The Winter's Tale*. E. W. Tayler profitably chose the latter in *Nature and Art in the English Renaissance*. Jean Hagstrum pointed to positive demonstrations of the superiority of nature in *The Winter's Tale,* where a living Hermione succeeds her seeming statue, and to the converse in Spenser's Bower of Bliss in Canto 2 of *The Faerie Queene,* where art tries by deceit to displace nature.[3] In *The Tempest* art is given a fairer chance to compete, but perhaps with no more chance of defying nature than Milton's Satan of defeating God. Gonzalo is laughed at, but given the center of the stage:

> I' th' commonwealth I would by contraries
> Execute all things; for no kind of traffic
> Would I admit; no name of magistrate;
> Letters should not be known; riches, poverty,
> And use of service, none; contract, succession,
> Bourn, bound of land, tilth, vineyard, none;
> No use of metal, corn, or wine, or oil;
> . . . . .
> All things in common Nature should produce
> Without sweat or endeavour: treason, felony,
> Sword, pike, knife, gun, or need of any engine
> Would I not have; but Nature should bring forth,
> Of its own kind, all foison, all abundance,
> To feed my innocent people.   (2.1.143–60)

Montaigne had said, in John Florio's translation of "Of the Caniballes" in 1603, "there is no reason, art should gaine the point of honour of our great and puissant mother Nature." On the island of *The Tempest,* where a range of characters and classes are shipwrecked, Prospero is able by magic to reverse the disorders of European civilization. The island, which holds a mirror up to nature, includes the gross spirit of Caliban as well as the airy, ethereal, but prankish Ariel. Gonzalo's commonwealth might prevent bumpkins from laughing at wisdom, *sophia,* by preventing them from aspiring to sophistication, but Caliban's aspirations to share the corruptions of civilization emerge from nature. The play reveals both rivalry and complementarity between art and nature, but not enmity. It does not force us to decide, when Prospero lays down his implements of

transformation to return to Milan, how far he has drawn upon nature for his art or how far the playwright by imagination has created and exploded an illusion. A mirror has been held up to the sordidness of human life and to transcendence through human imagination. The political and social life of (the audience's) Milan will be transformed by what has occurred in a species of dream contrived by a poet. Impervious to both the fantastic and the dishonest around him, but speaking the language of a society that believes in the rationality of natural law, Gonzalo is close to nature.

None juxtaposed the terms nature and art more frequently than George Chapman, who explained in an address "To the Reader" accompanying his translation of the *Iliad* why all the paraphrasers and commentators on Homer had failed:

> they wanted the fit key
> Of Nature, in their down-right strength of Art;
> With Poesie, to open Poesie.[4]

For the word "Nature" Samuel Johnson's *Dictionary* offers eleven definitions:

1. An imaginary being supposed to preside over the material and animal world.   [*King Lear*]
2. The native state or properties of any thing, by which it is discriminated from others.
3. The constitution of an animated body.
4. Disposition of mind; temper.
5. The regular course of things.
6. The compass of natural existence.
7. Natural affection, or reverence; native sensations.
   [Pope]
8. The state or operation of the material world.   [Pope]
9. Sort; species.
10. Sentiments or images adapted to nature, or conformable to truth and reality.   [Addison]
11. Physics; the science that teaches the qualities of things.

Most of these meanings are present in *King Lear*, both in vocabulary and in symbolic structure; the characters and their environment, neither unquestionably under the influence of an "imaginary be-

ing," undergo the travail of return from abnormality to a state natural to each. Usages were plentiful outside Shakespeare. Johnson's second and fourth definitions, "state or properties" and "temper," were known to ancient languages, but classical Latin writers employed *ingenium* for these meanings more often than *natura*. "Affection," Johnson's seventh usage, common among the Elizabethans, came to the fore in such titles of eighteenth-century drama and fiction as *The Unnatural Mother, The Unnatural Son*: to be unnatural is to be more than kin and less than kind. In Wordsworth's earliest poems, the "world" is bad and hard; to draw more closely the "bond of nature" is to stop striking children and "all unkindness cease." So total had the anthropomorphic view of nature become that Thomas Gisborne, in *Walks in a Forest* (1795), could describe the cuckoo as

> her who, doom'd
> Never the sympathetic joy to know
> That warms the mother cowering o'er her young,
> A stranger robs, and to that stranger's love
> Her egg commits unnatural.[5]

In time, the dogma of "natural selection" would make Gisborne's lines seem more unnatural than the cheating cuckoo. Meanwhile, assumptions of the "unnatural" were common enough to make ironic usage safe. When Dickens's Louisa Bounderby will not increase the amount she takes secretly from her husband to meet her brother Tom's gambling debts, Tom calls her reluctance "unnatural conduct" (*Hard Times*, bk. 2, ch. 7).

Definitions 2, 7, and 10, as directed to "human nature," would be pivotal for the century following Johnson's. No. 4, "disposition," points from Johnson's own preference for the general toward the coming particularity and individualism (no longer the general type, but the peculiar case of some one unnatural son). No. 11, "physics," although it does not predict the rapid growth of scientific specialization, anticipates the title of an important London periodical, *Nature*. Nos. 5, 6, and 8, course, compass, and operation of the physical world—the most pertinent for the usual oppositions of nature versus art—were epitomized by S. T. Coleridge, with an implicit correction to Johnson's no. 1: "Nature is—the

sum total of the laws and powers of the material world, which for the sake of perspicuity we reduce to Unity, and for the convenience of Language we personify."[6] This sense of an ordered cosmos is the *natura* that Sallust evoked in the opening paragraphs of both *Cataline* and *Jugurtha,* to be followed by narratives of unnatural human conduct. Even Wordsworth, known to the Victorians as Nature's Prophet and Nature's Priest, begins with this neutral sense of the word as the collective, underlying laws of existence, whatever they may be, rather than the country, the outdoors, or phenomena available to the senses.

An explanation of the fulcrum from this name for the unity of fundamental laws that make the universe what it is, and a titmouse what *it* is, to the later casual name for the outdoors that a "nature-lover" sees and loves, and with some claim as the fulcrum iself, was provided by Friedrich Schiller in *Naive and Sentimental Poetry,* published serially in 1795–1796 in *Die Horen.* Schiller argued that European civilization had expelled the natural from its population, so that nature could be found only outside urban civilization. The modern, self-conscious, "sentimental" poet had lost the capacity for direct experience that made Homer one with nature. Sentimentalists felt impelled to express their feelings after reflecting upon the impression made individually on them by objects from which they were now collectively alienated. The French, because they had become incapable of direct, simple experience, designated such experience *naïf.* Whether or not one reads "Schiller" for naive and "Goethe" for sentimental, either a poet *is* nature, with the serene spontaneity of Homer and Shakespeare, or the poet seeks nature where it survives—most obviously in the uncontaminated countryside. We go out of the city in the attempt to recover human nature. "It is *because* nature in us has disappeared from humanity [that] we rediscover in her the truth only outside it, in the animate world."[7]

Meeting an intellectual need not filled by Rousseau, Schiller's point was repeated all over Europe. The historian and statesman Adolphe Thiers declared in a review of the 1822 Salon in Paris: "Homer, Ossian, the patriarchs have the same poetic sense, that is, they have none at all. They sing the way a bird flies or a child plays, the way all nature works: by instinct and by need." The principle of recovering human nature is evident enough in many later works, for

example Tolstoy's story "The Cossacks," published in 1863: The wealthy Dmitri Olenin goes as a cadet among the Don Cossacks, where "people live as nature lives." They "mate and give birth— they fight, eat and drink, make merry and die, with no restriction beyond the immutable ones that nature imposes on sun and grass, on animal and tree." Olenin comes to love Nature in the natural beauty of Marianka, whom he contrasts with lisping ladies who wear "pomaded curls padded with false hair." Marianka rejects his proposal of marriage, but Olenin is one of Schiller's self-conscious sentimentalists: once he was so incensed by the drunken conduct of a cossack that "he could not utter a single word in French," and he could not live as cossacks or as Homeric warriors live. Those lonely individuals and couples looking away from us toward the mountains or the sea in the paintings of Caspar Friedrich seem to ask the God of nature to restore wholeness to a diminished self. I find Schiller's principle operative not only in such works as Tolstoy's and Friedrich's, but in Rousseau before Schiller's exposition and in Wordsworth after. The absence of figures from the foreground of many of Constable's pictures does not mean that the "return to nature" was an escape from the human.[8] In "Home at Grasmere" Wordsworth greets a fulfillment of self that had awaited him in this destined place:

> The unappropriated bliss hath found
> An owner, and that owner I am he.[9]

Wordsworth, as an exemplar of the return to nature, made no severe break from views of nature current in his schooldays. Science and religion had collaborated to afford comfort to those who proclaimed themselves communicants in the temple of Nature. Aquinas had found reason in three realms of law: divine, natural, and human. Richard Hooker had found a harmony of divine revelation in scripture, nature, and the human conscience. Euclid and Newton had made available to grammar schools and colleges a rational, stable universe. In 1692, five years after the *Principia*, Richard Bentley explained in the first Boyle Lectures that Newtonian principles demonstrated irrefutably that God designed the universe. So Alexander Pope:

Nature, and Nature's Laws lay hid in Night.
God said, *Let Newton be!* and All was *Light.*

The basis of natural religion is adumbrated in Descartes's sixth meditation: "And plainly it cannot be doubted that whatever I am taught by nature has some truth to it; for by 'nature,' taken generally, I understand only God himself or the coordination, instituted by God, of created things. I understand nothing else by nature in particular than the totality of all the things bestowed on me by God."[10] No miracles are needed, nothing supernatural, in a world of nature perfectly designed at the outset.

Much despairing doubt among Victorian Christians might have been spared if the heavenly city of the eighteenth-century philosophers had not been planted in a garden oblivious of transgression by Eve and Adam. According to Pauline faith, let alone Calvin, no good works by a human creature, miserably fallen and morally diseased, could eliminate the need for justification by acceptance of God's grace. Truant alienation from nature by a believing Christian was alienation from Eden. Hookerian natural law was not heresy if it referred to an ideal state. The natural earth present to the senses, equally with man, was fallen, diseased, and imbued with Satan. From this uncomfortable vision deists and related advocates of natural theology restored the earth to its designed Edenic perfection, so that spiritual peace thereafter required empirical evidence of God's benevolent intent in the mundane phenomena available to the senses. Although the physical shock of the Lisbon earthquake of 1755 had been felt as far north as Scotland, and Kleist in 1810 conveyed the religious ironies of earthquake in *Das Erdbeben in Chile* more subtly than Voltaire in *Candide,* the spiritual shock of Lisbon had subsided in Britain, and Santiago might as well be in Africa, where—who knew? who cared?

The Augustinian and Wesleyan views of fallen earth as imbued with evidences of original sin were preached in the nineteenth century. Edward Irving, a friend of Coleridge and the Carlyles, was emphatic:

> There is no worse sign of the times we live in, no clearer proof
> of the debasement of the soul of man, and demonstration of the
> ignorance of the world to come, than the many poems which

are written, and the many songs which are sung, and the many journeys which are performed, in honour of certain lovely scenes and beautiful objects of nature. They will call me a Goth for saying so . . . But how can any one who is at all interested in the primeval state of paradise which he hath lost, or at all believeth in the millennial and the eternal glory of the world of which he is an heir, take delight and shout forth joyfully in contemplating the present misery of the lower world; when he beholdeth the sandy wastes, the rugged mountains, the hoary forests, the inhospitable climates of heat and cold, the changeful accidents of thunderstorms and thunderbolts, the avalanches of snow and inundations of wasteful waters, the iron frosts, the drenching rains; in one word, the natural barrenness of the earth's bosom, and the evil conditions which she underlieth since the Fall?[11]

Most of the best educated did call Irving a Goth for saying it.

It was no longer good taste, it was now error and ignorance, to believe that the abuse of lambs by lions and of worms by birds was a sign of grievous imperfection that could be mitigated by prayer. Why, before the malfeasance of Adam, should the rose have lacked a thorn, when this and every apparent awkwardness in nature resulted from infallible design in this best of all worlds imaginable by the human mind? Reason placed a snub on plenitude. The prize at Cambridge endowed by the Reverend Thomas Seaton in 1738 and won five times by Christopher Smart was to be in the first year for an essay on "one or other of the perfections or attributes of the Supreme Being, and so the succeeding years, till the subject is exhausted."[12] Natural theology agreed with earlier Christian theologies that we live in a world of meanings, but it replaced typological warnings— the wolf as model of ravage by sin, mountains as reminders of divine wrath—with a naturalism of acceptance. Not passive acceptance of God's inscrutable will, but positive approval by reason of God's plans and specifications as architect.

The deistic belief in design was reconciled with biblical revelation in the works of William Paley, a commonsense utilitarian who argued that the evidence of God's love, and sufficient reason for loving God in return, is the perfect fit of our universe. Paley was not too punctilious to recommend benevolent acts "for the sake of ever-

lasting happiness." His *Evidences of Christianity* (1794) joined his *Principles of Morals and Political Philosophy* (1785) as a textbook at Cambridge. In the spirit of the observation that he wrote his books while pretending to fish, it was noted in his own time that he borrowed from other writers his most telling examples of natural history. He borrowed from one of several near sources the Ciceronian simile of the universe as a watch that implies a watchmaker, but prolonged dissemination of his works has made the figure Paleyan.[13] The value of Paley's accommodation of scriptural revelation is evident—to take an example almost at random—in the way clichés of allegory are raised to the excitement of novelty in James Bland Burges's poem *The Birth and Triumph of Love* (1796). God's "Eternal will presides o'er Nature's laws," and thus over "Nature's laws and Nature's works combined." God is He "Who nature leads His dictates to fulfill."[14] Without the assumptions of natural religion, neither fidelity to nature as observed nor infatuation with the picturesque would have made William Kent plant dead trees in Kensington Gardens. Morse Peckham has called optimistic Paleyan religion "the gardening ideology of the eighteenth century Enlightenment."[15]

An outright enemy of the optimism common among natural theologians, empiricists, and corpuscular scientists could say with Coleridge, "No! Nature is not God; she is the devil in a strait waistcoat."[16] Natural religion could blend into a utilitarian faith in nature with or without God. George Gregory, fellow of the Royal Society and vicar, in three volumes beginning "Of Matter in general" and proceeding through physics, botany, geology, and physiology to custom, taste, and beauty, declared at the outset: "Next to the study of the Scriptures, there is none which seems to lead the human mind so directly to a knowledge of its Creator, as the study of nature."[17] The editor of the inaugural number of the *Zoological Journal of London* in 1824 was diffident enough to call the place of Man as favored by the Creator what the naturalist "feels," but he had no doubts concerning design: "The naturalist . . . sees the beautiful connection that subsists throughout the whole scheme of animated nature . . . nothing is made in vain."[18] In lectures published in 1800 Matthew Young, Bishop of Clonfert and master of hydrostatics, aerostatics, acoustics, optics, and other subserviences

of mechanics, declared as proposition 1: "The business of Natural Philosophy is to describe the phaenomena of the universe; to trace the relations and dependencies of causes; and to make art and nature subservient to the necessities of life."[19] At about the same time the utilitarian A. F. M. Willich, M.D., assured his fellow physicians:

> Nature is our safest guide, and she will be so with greater certainty, as we become better acquainted with her operations, especially with respect to those particulars which more nearly concern our physical existence. . . . She teaches us the rule of just oeconomy;—being a small part of her great system, we must follow her example, and expend neither too much nor too little of her treasures.[20]

Works of art decline, but nature is endlessly renewed: "The pyramids themselves must perish, but the grass that grows between their disjointed stones will be renewed from year to year."[21]

Nature as "she," as in Willich but with reemphasis on her fertility and cyclic continuations, came into greater prominence with the decline of the great masculine mechanic who had invented and wound the watch. Syncretic mythographers such as Jacob Bryant helped to recover the Isis who spoke to Lucius in *The Golden Ass* of Apuleius, enduring from 1566 to the Loeb Classics in the translation by William Adlington: "I am she that is the naturall mother of all things, mistresse and governesse of all the Elements, the initiall progeny of worlds, chiefe of powers divine, Queene of heaven, the principall of the Gods celestiall, the light of the goddesses: at my will the planets of the ayre, the wholesome winds of the Seas, and the silences of hell be disposed" —*rerum naturae parens, elementorum domina, saeculorum progenies initialis, summa numinum.* For most in the early nineteenth century, nature was womb, bosom, lap, mother, and goddess whose temple is the organic world. The endurance of this comprehensive sense of mothering is evident in words spoken in 1903: "The power which fashions us from birth, sustains the vital force of the body, and feeds its growing functions, seems to exceed the blind and mute region of matter."[22] The words were presented as an account of Wordsworth's sense of nature's "moulding influence" and "spiritual presence," but the view was not rejected.

Emotion was the new key. Keats's objection to what he called the

Godwin-Methodism of "consequitive reasoning"[23] is the obverse of Constable's emotional attachment to "natural painture." The change wrought in natural theology by such language of emotion as Wordsworth's elicited in John Keble's lectures on poetry, given in Latin at Oxford from 1832 through 1841, the argument that God's solution whenever His people strayed at a distance from His will was to introduce a flock of nature poets. Keble reminded auditors of his second lecture that he had "ventured to attribute to Poetry, as by peculiar prerogative, the function of providing that mortal men should not be without remedial relief, when either unwilling or unable to declare openly their utmost feelings." He counted even Lucretius, guided by a Providence able to thwart his own intentions, as a poet calling urbanized readers back to nature. The interrogative employed in Keble's thirtieth lecture does not diminish the strength of his assertion: "May it not be by the special guidance of Providence that a love of country and Nature, and of the poetry which deals with them, should be strong, just at the time when the aids which led our forefathers"—holy scripture, solemn liturgies, and sacramental occasions—have become otherwise "far removed from the habit of our daily life?" In his final lecture, the fortieth, he repeats the thesis: "Our conclusion was, that this divine art essentially consisted in a power of healing and restoring overburdened and passionate minds." Keble's survey begins with ancient Greece, but he often, throughout, quotes or cites Wordsworth, "easily the first of modern poets." In concluding, he implies that Sophocles is inferior to Wordsworth in depth of feeling and in communication of curative power.[24]

Emotion added to natural religion by Wordsworth and Coleridge was more than matched by fervor in Germany. The painter Philipp Otto Runge wrote self-consciously to his brother in 1802:

> When the heavens above me swarm with countless stars, the wind whistles through immense space, the wave breaks roaring in the vast night; when the atmosphere reddens over the forest and the sun lights up the world, the valley steams and I throw myself into the grass amidst sparkling dewdrops; when every leaf and every blade of grass abounds with life, the earth lives and stirs beneath me; when all things resound in a single, harmonious chord—then my soul shouts for joy and flies about

in the immeasurable space around me. There is no more below
and above, no time, no beginning and no end; I hear and feel
the living breath of God, who contains and carries the world,
in whom everything lives and acts.[25]

Nature and human history tend alike to ignore the artificial
divisions found convenient in human calendars: a salient character-
istic of the early nineteenth century, the rapid growth of the idea of
development and its spread through almost all fields of research and
endeavor, had begun in the eighteenth.[26] Yet approaches to nature
made something like a new start about 1800. Mathematical as-
tronomy and physics, dominant for two hundred years, surrendered
pride of place to biology and the fossils of temporalized geology.[27]
The ancient distinction of primary and secondary qualities con-
firmed for empiricists by Locke—shape, mass, and weight versus
color, sound, and taste—had led Newton's earliest disciples to
emphasize the permanent in natural law. "And since we are as-
sured," wrote Stephen Hales in the second paragraph of *Vegetable
Staticks,* "that the all wise Creator has observed the most exact
proportions, *of number, weight, and measure,* in the make of all
things; the most likely way therefore, to get any insight into the
nature of those parts of creation, which come within our observa-
tion, must in all reason be to number, weigh, and measure."[28]
More slowly in France than in Germany and Britain, but surely,
"number, weight, and measure" and metaphors and analogies of
mechanism gave way to the organic and dynamic. In Germany the
*Naturphilosophen* attempted to incorporate organic growth within an
idealism of eternal laws.

Mark Akenside (1721–1770), amalgamating neoplatonism,
Newtonian order, and Lockean associationist psychology in *The
Pleasures of the Imagination,* could describe the ascending scale of
nature from random colors through shape, symmetry of parts, fruits
and flowers, the "active motion" of animals, upward—as visualized
on a graph of qualities—to the human mind (1:448–540, in the
revised and expanded version of 1772, summarized in the Argu-
ment as "colour; shape; natural concretes; vegetables; animals; the
mind"), but Akenside wrote without any thought of evolution or
attention to change. The linear progress envisioned by philosophers

of the Enlightenment was temporal largely in the pragmatic thinning of error, a progressive removal of accumulated clouds to allow the eternal sun of reason to purify the mildewed crevices of human society. What followed was a sense of values as relative and therefore of history as relative. In *Kosmos*, begun in the 1840s, Alexander von Humboldt prepared his readers for the intricacies of astronomy with two volumes on the universal history of descriptions of nature, of travel, of scientific study ("physical contemplation of the universe"), and of the poetry and painting of nature—from Genesis to the Herschels.

Akenside describes an ascent in complexity. Wordsworth's "Nature" is found by internal, spiritual descent. The mind traced in *The Prelude* has sensations of the qualities of things, then of their forms, then of "presences" that animate the forms (deeper below full consciousness, such are "under-presences"), with these united in perception or recollection as "the earth." For the individual mind, this unity implies a single animating presence; the human mind collectively has identified a unifying principle, not mechanical but organic and active, rightly called Nature. Nature in *The Prelude* of 1805 is not God, but is neither a usurper of God's place nor a challenger of God's existence; perhaps, though, as has been closely argued, intimate communion with Nature makes God redundant.[29] The god of the romantics had to preside over change, and could not be given much time to become a god developing and growing.

Asked to introduce the first number of the periodical *Nature* in 1869, T. H. Huxley began with "Nature: Aphorisms by Goethe": "Incessant life, development, and movement are in her, but she advances not. She changes for ever and ever, and rests not a moment . . . Her steps are measured, her exceptions rare, her laws unchangeable." Nature here is restless, but not yet dynamic; universal processes are still subordinant to permanent natural law.

Kant's *Universal Natural History and Theory of the Heavens* (1755) represents more than adequately the cosmologies of change. Even the title, specifying the need to modify synchronic theory with natural history, points to the future. According to the law of development, Kant says (in Hastie's translation), "the developed world is bounded in the middle between the ruins of the nature that has been

destroyed and the chaos of the nature that is still unformed." The situation at any moment contains "the seed of future worlds." When creation "has once made a beginning with the production of an infinity of substances and matter, it continues in operation through the whole succession of eternity with ever increasing degrees of fruitfulness." Kant retains in the law of development the doctrine of divine plenitude: "infinite space, co-extensive with the Divine Presence, in which is to be found the provision for all possible natural formations, buried in a silent night, is full of matter which has to serve as material for the worlds that are to be produced in the future, and of the impulses for bringing it into motion, which begin with a weak stirring of those movements with which the immensity of these desert spaces are yet to be animated."[30]

The time was not yet when nature could be seen as destructive of the type; Kant could speak optimistically of a process that blissfully and bountifully destroyed individuals:

> Innumerable animals and plants are daily destroyed and disappear as the victims of time; but not the less does nature by her unexhausted power of reproduction, bring forth others in other places to fill up the void. Considerable portions of the earth which we inhabit are being buried again in the sea . . . but in other places nature repairs the loss . . . In the same way worlds and systems perish and are swallowed up in the abyss of eternity; but at the same time creation is always busy constructing new formations in the heavens, and advantageously making up for the loss . . . But we ought not to lament the perishing of a world as a real loss of Nature. She proves her riches by a sort of prodigality which, while certain parts pay their tribute to mortality, maintains itself unimpaired by numberless new generations in the whole range of its perfection.   (Pp. 149–50)

A sense of nature as evanescent brought a new glory to watercolor in England and, through the English, to freer landscape and history painting in France. The experiments of John Robert Cozens (1752–1797) overcame the linearity of Francis Towne (1752–1799) for the progressively light-splashed spontaneity of Paul Sandby (1725–

1809), Thomas Girtin (1775–1802), Richard Parkes Bonington (1801–1828) in France, John Sell Cotman (1782–1842) of Norwich, and Turner.

The pervasive sense of organic development accounts in part for the resistance to revolution by Burke, Wordsworth, Coleridge, and Southey. Every plant and every people must grow by its own internal laws. Southey, lamenting in *The Poet's Pilgrimage* the destruction at Waterloo of men, horses, and crops, took comfort from the cessation there of abrupt change in Europe:

> All sudden change is ill; slow grows the tree
> Which in its strength through ages shall endure.   (2.3.17–18)

Ancient Egypt and modern Africa, he noted later in the poem, had continued for centuries unchanged: "God's natural law they scorn'd" (4.12). Under the growing historicism, peoples of the past were to be judged only relative to their own peculiar standards, and accounts of customs, beliefs, and manners needed to represent human nature as changing; as Southey illustrates, however, peoples of the nineteenth century could be judged according to the natural law of change.

Civilization and its arts were making change visible to everybody. Rapid enclosure of land, for application of innovative agricultural methods, for landscape gardens, and for hunting, became known in a period of other catastrophic changes as Agricultural Revolution. Enclosure, the rural equivalent of Blake's urban "chartered Thames," seemed abrupt only to the thousands directly affected. Other changes were immediately evident to all. So poor had the roads been for a thousand years that the new canals, which stimulated national commerce, seemed at five miles an hour to speed passengers along. Two vehicles racing toward each other at eight miles an hour enabled De Quincey to communicate a vision of sudden death more vivid than any that children raised on star wars can derive from collisions in space. Steam would make it possible to speed not only from crop to market, from country seat to Parliament, and from city to "unspoiled nature," but also from port to port.

Science had *progressed* toward belief in growth. Natural religion

and empirical science had advanced in tandem from the middle of the seventeenth century. Keith Thomas dates the crucial origins of modern ecology from thoughtful, careful observers like John Ray (ca. 1627–1705), who began to describe the varieties of animal and plant without any man-centered symbolism, assumption of human superiority, or classification by utility as "edible and inedible; wild and tame; useful and useless."[31] Similar study by less disinterested naturalists proceeded at first along lines of utility and natural religion: (*a*) animals, like the stars, were designed for man's benefit; (*b*) we can practice a novel glorification of God by discovering the perfection of detail in the world He designed. In such a faith, even "the most apparently noxious species" *must* have a place in the economy of nature that it therefore behooves human reason to identify and progressively unperplex. Thomas sees the new "humanitarian" sensibility, acknowledging the claim of animals for moral consideration, as spread by increased industrialization and the consequent growth of towns.[32] The rise to dominance of ecological values needed assistance from anti-Christian materialists; the right of animals other than human to liberty and the pursuit of happiness required a questioning of human spirit as essence.

Societies for the exchange of botanical knowledge arose and increased rapidly in the late seventeenth and early eighteenth centuries. Botanical study before John Ray had been mainly medicinal; his successors were concerned primarily with classification. The course of natural history thereafter is as much a story of growth as are the phenomena studied. Administration of the Jardin des Plantes in Paris, laid out in 1626, gradually required a museum of natural history. The British Museum, founded with the library and art collection of Sir Hans Sloane in 1753, acquired specimens and then a department of natural history not transferred to separate quarters until the 1880s.[33] (All such national museums descended from private or royal cabinets of curiosities; their variety is recapitulated in the dusty collections of county museums in the United States.) The growth of botanical societies belongs largely to the history of middle-class professionals and the well-to-do in towns. The study of plants and the collection of shells and then of fossils attracted women as well as men. *A Natural History of English Insects* by the painter Eleazar Albin, of which the first plates were ready in 1720,

was a work for show.[34] The term "natural history," which had referred to systematic study of the objects of nature, as by Pliny, without reference to development or change, began to appear more and more frequently in titles and was on its way to implying popular and relaxed rather than systematic study. Perhaps it was David Hume's ironic use in *The Natural History of Religion* that made the term available for suggestions of wry sociology, as in a review by George Eliot in 1856 in the *Westminster Review,* "The Natural History of German Life." The term "natural philosophy" faded away; "natural history" continued. Probably not incidental to the change in terminology, natural history, particularly in Germany but effectively in Britain, was becoming more philosophical than empirical, a trait it retained until Darwin's revolution.

A word for the study of plants and animals, yoking botany and zoology in a single spectrum, "biology," came first into German and then into other European languages about 1800, along with a turn toward "the functional processes of the organism," no longer a search for general, timeless truths, but continuously increasing specialization in "plant and animal physiology."[35] For most by mid-century, "nature" and "natural history," unless qualified by other specification, referred to plants and animals, including snakes and butterflies.

And what was art? Even if the nineteenth century had not begun in apotheosis of nature, nature would need to be defined first because art, as the antithesis of nature, is whatever nature leaves to be contrived by mankind. Art is human contrivance, the wheel, the ogee arch, steam power, the Sistine Chapel, a topiary garden, a zoo. Emerson defined art as what human will does to nature: "*Nature,* in the common sense, refers to essences unchanged by man; space, air, the river, the leaf. *Art* is applied to the mixture of his will with the same things, as in the house, a canal, a statue, a picture."[36]

Nature is there first, civilization is erected within it. Education, as Helmholtz recognized, is an art of conquest.[37] According to Horace, however, "you may drive out Nature with a pitchfork, yet she will ever hurry back, and, ere you know it, will burst through your foolish contempt in triumph."[38] George Gregory, by way of the associational psychology of John Locke and David Hartley, arrived at a nineteenth-century version: "Deviations from nature

happen chiefly in a state a few removes from barbarism. True refinement brings men round to the primitive simplicity from which they have been diverging."[39]

Natural theology had tended to conceal the opposition of nature and art. Utilitarian science stripped nature of her secrets in order to exploit them, just as civilization had invented weapons to prevent nature from concealing or protecting anything edible or of utility as clothing or shelter. Civilization had sought to defeat nature by driving back the wilderness and diverting destructive waters; most recently, in England, by digging canals to speed transportation. Earlier, in a clearer emblem of revolt, a new era of global commerce had been made possible by the discovery of tacking against the wind. This defiance of wind, contrary to the previous utilization of wind, is emblematic of the exploitation of nature in scientific exploration. In assessing this defiance, the precocious Mary Shelley in *Frankenstein* and her husband in *Prometheus Unbound* were reflecting perceptions widely if only half-consciously felt by the second decade of the nineteenth century. Constable's *Old Sarum,* a watercolor exhibited at the Royal Academy in 1834, is related to a view in his *English Landscape Scenery,* where he describes the once-proud Sarum as now "tracked only by sheep-walks." To the right edge he pasted a strip for the addition of a rainbow, but it is not clear whether this added arc of promise betokens renewal of civilization, renewal of nature despite civilization, or hope from the Reform Bill of 1832. John Sell Cotman's *Bedlam Furnace,* included in the exhibition *Wordsworth and the Age of English Romanticism* (1987), leaves no doubt about the challenge to nature's sublimity from industrial advance; although the aura of the coke-hearths is without the melodramatic excess of a John Martin, it reddens the sky as if with the fires of Pandemonium.

All such fires carried suggestions of revolution. The French Revolution had brought an unprecedented awareness of human energy. If the eruption was natural, suppression of it would be unnatural, but a range of interpreters from religious prophets to political caricaturists read the events as the devil's attempts to hasten apocalypse. For those inclined to charge all defiance with contempt of nature, the Napoleonic wars revealed defiance to be genetically the uncle of devastation. When Scott, Southey, and Byron looked

on the scene of Napoleon's final defeat, each contrasted the power of Nature in a seasonal renewal of vegetation with the fierce interlude of civilized destruction.[40] Human nature, seen in Belgian peasants sowing and reaping, belonged, with both wild and cultivated plants, to the rhythm of seasons disrupted by war. By a word or two each poet disclosed an awareness of fertilization by blood—never so red the rose—but each pressed home instead the folly of interrupting the fertility of nature. All three poets chose nature over art, but each, having looked at paintings in Brussels on the way to Waterloo, drew upon seventeenth-century Flemish representations of ordinary life as the norm of continuity in the cycles of nature.

The *O.E.D.* gives as one definition of "nature": "The material world, or its collective objects or phenomena, the features and products of the earth itself, as contrasted with those of human civilization." A central, insoluble, but permanently debatable question remains: How far is art a natural human activity? How much art can one reject without ceasing to be human?

Wordsworth as a poet of nature will reject the artificialities of pastoral—Marie Antoinette dressing in the palace of Versailles to step outside as a dairy maid—for the economic realities of the shepherd or farmer in a period of agricultural enclosure and industrial change. It has been said that "nature" continued to mean for the romantics "a good order in the universe" but "also meant the rejection of the artificialities of upper-class decorum."[41] For Wordsworth and Coleridge in youth, as for Rousseau, persons of modest means can be natural; to be rich is to be artificial in circumstances reached artificially.

Unexpectedly, Wordsworth gives the clearest of all welcomes to the extension of nature through art in his sonnet of 1833 on "Steamboats, Viaducts, and Railways":

> Motions and Means, on land and sea at war
> With old poetic feeling, not for this,
> Shall ye, by Poets even, be judged amiss!
> Nor shall your presence, howso'er it mar
> The loveliness of Nature, prove a bar
> To the Mind's gaining that prophetic sense
> Of future change, that point of vision, whence
> May be discovered what in soul ye are.

In spite of all that beauty may disown
In your harsh features, Nature doth embrace
Her lawful offspring in Man's art; and Time,
Pleased with your triumphs o'er his brother Space,
Accepts from your bold hands the proffered crown
Of hope, and smiles on you with cheer sublime.[42]

Turner extends respect and apparent welcome to steam in *The Fighting Téméraire Tugged to Her Last Berth to Be Broken Up* (National Gallery, London).

For witty demonstrations that social refinements are made natural by custom, we turn to Austen. In *Emma* Mrs. Elton explains to Mr. Knightley:

> "It is to be a morning scheme, you know, Knightley; quite a simple thing. I shall wear a large bonnet, and bring one of my little baskets hanging on my arm . . . We are to walk about your gardens, and gather the strawberries ourselves, and sit under trees;—and whatever else you may like to provide, it is to be all out of doors—a table spread in the shade, you know. Every thing as natural and simple as possible. Is that not your idea?"
>
> "Not quite. My idea of the simple and the natural will be to have the table spread in the dining-room. The nature and the simplicity of gentlemen and ladies, with their servants and furniture, I think is best observed by meals within doors. When you are tired of eating strawberries in the garden, there shall be cold meat in the house."

For Austen, artificiality is not a characteristic of class, but of individuals.[43]

Custom, durable because acceptable, makes normal conduct natural. This is the meaning of the term "second nature," sanctified by an ancient proverb, *usus est altera natura*. Actions and thoughts repeated by an individual through habit, like procedures that become the norm among civilized people, are almost as if divinely implanted in the first week of creation, "first nature"; products of human art, they have become second nature.[44] One can say that the opposition of nature and art had itself become "second nature," as in Byron's objection to Rubens's use of color: "And I suppose it must

be Art—for—I'll swear—'tis not Nature."[45] From the same human suspension between art and nature, but looking in the other direction from Byron, King Lear had urged that nature be allowed no more than nature needs (2.4.266). Charles Leslie cited the words assigned by Scott to Edie Ochiltree, in *The Antiquary,* to reject dueling: "What are you come here for, young men? Are you come among the most lovely works of God to break His laws? Have you left the works of man, the houses and the cities, that are but clay and dust, like those that built them; and are ye come here among the peaceful hills, and by the quiet waters, that will last whiles aught earthly shall endure, to destroy each other's lives?"[46]

By 1801, "art" had gained a recent meaning significant for all discussions of the arts thereafter. Shoeing a horse and even plowing a furrow had been counted among the arts of civilization. During the eighteenth century an increasingly large portion of the population gained the leisure to travel and to observe paintings, sculpture, and monumental architecture. Concerts of music and the acquisition of paintings, prints, and sculpture ceased to be reserved for royalty and aristocrats. Largely in Germany, but drawing upon Shaftesbury, Addison, and other English writers, philosophers separated beauty from morality and defined a field of aesthetics.[47] It would no longer be necessary to say after Horace *ut pictura poesis,* because such specification of painting and poetry was redundant: pictures, poems, sculptures, fine buildings, and music from trained musicians—*les beaux arts,* as they were to be known thereafter—all had in common aesthetic as distinguished from moral beauty. A sense of sister arts had been replaced by the idea of art as an essence common to all fine arts; not sister arts but modes of expressing art. In 1790 Kant introduced for later generations the proposition that aesthetic experience is disinterested. Previously, music had been composed for sacred or state occasions; a fugue by Bach could now have godless listeners; a concerto could be composed to give aesthetic pleasure. The principle was established that a totem or fetish, removed from the culture for which it was designed, could be cased in a public museum, where it would give pleasure to viewers ignorant of the object's original meaning. Once the idea of a single essence underlying all the "fine arts" was in place, journalists could refer casually to "any branch of art," as in the *Westminster Review* of

March 1844: "Neither university possesses a school in which the theory and practice of any branch of art is taught, and has not even a course of lectures, nor any means by which a young man may either be taught, or can acquire the requisite knowledge on this class of subjects."[48]

The defining of fine arts as distinct from "the imitative arts" was a significant step toward freeing fine arts from the necessity of imitating nature, but the dogma of "first follow nature" was not immediately overthrown. If nature is prior, and if art can mirror nature, as many in the nineteenth century believed, then in any branch of art nature is to be honored. Leslie complained of Richard Westall: "His faults seem to arise chiefly from a wish to improve upon nature, not knowing that what generally goes by the name of improving upon nature, is nothing more than being able to select all that is good from her, and that to obtain this end the artist cannot have too much intercourse with her."[49]

Especially obvious to believers in an organic rather than a mathematical or mechanical cosmos, poets are born, not made; talent may be learned by art, but genius is a gift from nature. On Schiller's principle, an untutored poet would have less to unlearn. When Shakespeare was praised, not, as Coleridge and Lamb would praise him, for joining judgment to genius, but for warbling his native woodnotes wild, a rustic poet would have the advantage of being close to nature. Close to the elemental, enduring forms of meadow, hill, and stream, the poet uneducated in urban deceit seemed more likely to meet the new criterion of sincerity; that is, fidelity to inspiration from within.

Robert Burns, who calls upon nature often to aid his art, claims close kinship with her, and appeals to her as the ground of liberty, fraternity, and equality, is conscious of advantages and dangers in his situation as plowboy petted by the literary elite. He can claim proximity to nature, but he must not offend patrons and purchasers by claiming other than natural art. When he spied in Miss Wilhelmina Alexander of Ballochmyle "one of the fairest pieces of Nature's workmanship that has ever crowned a Poetic landscape or met a poet's eye; those visionary Bards excepted, who hold commerce with aerial beings," he wrote a song in her praise, only to learn that she was "too fine a Lady" to give him *permission* to publish it. Experience

taught him caution, so that he was later able to walk a tightrope in explaining to his patron Frances Dunlop why he had married the unlettered child of nature Jean Armour: those bred as he was among the hay and heather, however superior in intellect and accomplishment, had to settle for the second rank of "female excellence" because they could not aspire to "that highly polished mind, that charming delicacy of soul" to be found in the elevated stations but yet—Mrs. Dunlop is rare in her class—"unstained by some one or other of the many shades of affectation, & unalloyed by some one or other of the many species of caprice."[50] The wooing of Frances Dunlop by a natural genius required that she be declared free of affectation and caprice, but she would detect the malice against her privileged class in the insistence on "many shades" and "many species" of the traits of artificial conduct.

If Burns as a rustic needed especially to conceal his art, an interlocking of nature and art can be shown in almost any lines by Erasmus Darwin, a naturalist thought in his own time to be a highly artificial poet. Darwin's art is sophisticated by his own standards, naive by Coleridge's. In *The Temple of Nature* he pictured synthetically an Eden where unclad Graces and Cupids gamboled until Eve's error brought the disordered world that had been described by Thomas Burnet in *The Theory of the Earth* (1684): "Now rocks on rocks, in savage grandeur roll'd."[51] Within warring winds, as the transformation into asymmetry came about:

> Here, high in air, unconscious of the storm,
> Thy temple, NATURE, rears it's mystic form;
> From earth to heav'n, unwrought by mortal toil,
> Towers the vast fabric on the desert soil . . .
>
> . . . . .
>
> Unnumber'd ailes connect unnumber'd halls,
> And sacred symbols crowd the pictur'd walls;
> With pencil rude forgotten days design,
> And arts, or empires, live in every line.
> While chain'd reluctant on the marble ground,
> Indignant TIME reclines, by Sculpure bound;
> And sternly bending o'er a scroll unroll'd,
> Inscribes the future with his style of gold.  (1.65–68, 75–82)

Darwin's versified botany and geology give a curious impression of the temporal without change. The lines quoted confirm the speculations of William Warburton and Lord Monboddo that hieroglyphic arts preceded language, and confirm equally, as Darwin explains in a note, the "curious account of Ancient Mythology" by Jacob Bryant and other syncretic mythographers that the emblems of one universal myth would have adorned such a temple. The "mystic form" of the temple is emblematic also of Erasmus Darwin's theory of evolution: Nature herself erected, over a period more extended than James Ussher's four thousand years, her own temple, Earth, descending in "ribbed vaults" of fossils "deep in earth" and rising through a palimpsest on the surface reinscribed again and again with differing species by Proteus. Proteus here means Time, and again conveys curiously little sense of fluidity or change. Erasmus Darwin as naturalist and versifier, organic in subject and mechanical in method, can stand very well for the limits of comparative study extracting synchronous examples from differing fields. And yet the wood engravings of Thomas Bewick's *History of British Birds,* with meticulous detail made possible by a combination of observation and keenness of work across the endgrain of boxwood, would have been different, and probably less incisive, without the prose and verse of Erasmus Darwin.

A later paradoxical figure at total remove from Darwin, the French romantic painter Delacroix, is more subtly articulate than either Darwin or any English romantic artist and therefore an apt representative of characteristics directly opposite to Darwin's. As a Christian pessimist, Delacroix recommended submission to nature without, in art, imitation of nature. Art, and civilization generally, must rise by "self-imposed task" into combat against nature. He noted in 1850:

> It clearly matters very little to nature whether man has a mind or not. The proper man is the savage, he is in tune with nature as she really is. No sooner does man sharpen his wits, enlarge his ideas and his manner of expressing them, and develop his needs, than he finds nature frustrating him at every turn. He has to be continually at war with her, and she on her side does not remain inactive. If man ceases for a moment from his self-

imposed task nature reclaims her rights, invading, undermin-
ing, destroying or disfiguring all his work.[52]

Delacroix had great influence, however, in transmitting ideas of
the natural in art. He insisted, for example, in line with Rubens
and Géricault and against Ingres, on the revelation of the artist's
strokes of the brush not only in sketches but in finished paintings.
So rapidly did this view of the natural in method spread that a
patron of Thomas Cole warned him in 1826 against taking the
errant path of Thomas Doughty, who had descended from faithful
reproduction of varied and "unmannered" foliage in sketches to the
false bottom of ideal compositions uniformly mannered.[53]

The insistence on truth to method has wider implications than
one might on first thought expect. Trained talent can get by on
skill, but fidelity to inspiration requires honesty of hand. With
reference particularly to architectural surfaces, and most of all to
plaster facsimiles of stone, Richard Payne Knight in 1805 and
A. N. Welby Pugin from 1836 until about 1850 called for integ-
rity of materials in art. Pugin declared the collapsed tower of Font-
hill Abbey, which James Wyatt built for William Beckford, not only
ruins but "modern ruins, too, of mere brick and plaster."[54] Wil-
liam Morris, in lectures and practice from the 1870s until his death
in 1896, extended the principle vigorously to all "decorative arts."
Earlier than Morris, writers in Henry Cole's reformist *Journal of
Design and Manufactures* had called for flat patterns on wallpapers
and carpets as an aspect of truth in materials.[55]

In 1840 Thackeray deplored the increase in wood and steel en-
graving as "art done by *machinery*": "We confess to a prejudice in
favour of the honest work of *hand,* in matters of art, and prefer the
rough workmanship of the painter to the smooth copies of his
performances, which are produced for the most part on the wood-
block or the steel plate."[56] Pugin, who objected to inessential and
inappropriate ornament, along with eclecticism and such anomalies
as castellations, sally-ports, and donjons on private houses, declared
satirically: "We cannot fortunately import the climate of a country
with its architecture, or else we should have the strangest possible
combination of temperature and weather; and, within the narrow
compass of the Regent's Park, the burning heat of the Hindoostan,

the freezing temperature of a Swiss mountain, the intolerable
warmth of an Italian summer, with occasional spots of our native
temperature."[57] Despite periodic calls for truth to nature in materi-
als, the Victorian age gloried in the falsifications displayed in the
Great Exhibition of 1851: iron to look like wood or stone, wood to
look like marble, and paper to look like leather, marble, wood, or
iron.

Mark Girouard has shown how the hatred of stucco and similar
shams led to polychromatic mixtures of rough stone, flint, and cut
brick in later Victorian buildings.[58] Stronger reactions lay ahead. It
was a lingering defiance of the principle of fidelity to material,
coupled with applied classical or Gothic ornament and quite possi-
bly the suspect Victorian avoidance of the imagery of machines, that
led in the twentieth century to assemblage, the display in galleries
of natural objects found on the beach, and sculpture unadulterated
from metal stove legs, bicycle handlebars, crumpled autos, and
airplane skin. One end of the road was blocked by Claes Olden-
burg's ironic exposures of the vulgarity of popular taste by crude
sculptural falsifications of material, surface, color, and dimension.
The perseverance of the romantic instinct to let nature be is clear
enough when an art historian writing appreciatively of these devel-
opments for a wider public distinguishes between "natural kinet-
ics"—"the operation of invisible, nonmechanical forces which drive
Calder mobiles . . . wind currents, gravity, temperature and hu-
midity changes"—and "artificial kinetics," with "man-made mo-
tive force" made honestly visible to the observer. A valid distinc-
tion can be made between the artificial creation of real light
by human ingenuity, or the movement of wheels on a hub, and
the artificiality of flowers made to look real or the illusion of a
coach on stage that appears to move because the panorama behind it
changes.[59]

From a flying survey of the interweavings of art and nature in the
early nineteenth century, we can turn to some shared assumptions of
the arts in an era of nature's ascendancy.

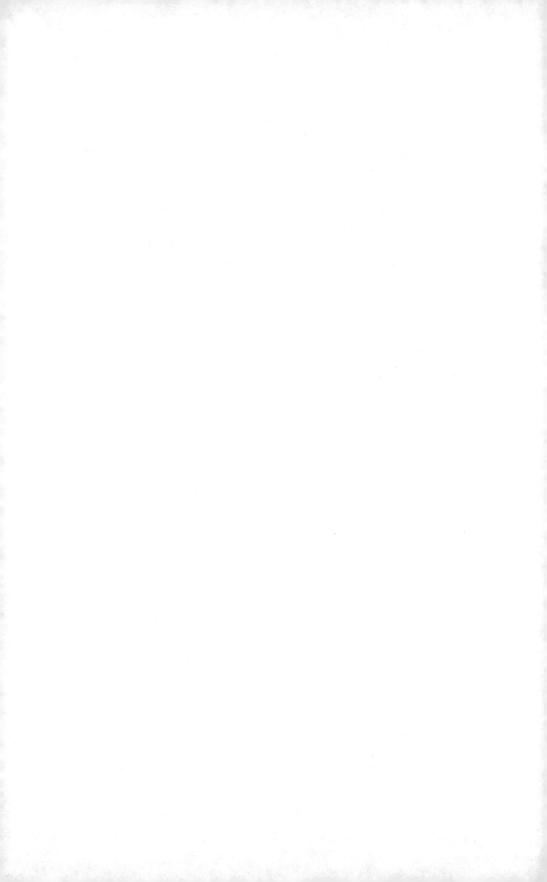

*two*

# SUBLIME
# PICTURESQUE
# BEAUTIFUL

English writers on the arts in the eighteenth century reached their distinctions of sublime, beautiful, and picturesque from a basis of common belief in general nature. Grandeur resided in the general, not in the particular. A sculptor who had learned the visual and verbal lessons of Greece and Rome would not seek the most beautiful body in the world; he would search until he had found several beautiful bodies from which he would select strengths in order to produce in marble an ideal torso more beautiful than any human body he or anyone else had ever seen. No parents could have admitted recognizing their child in a realistic portrait that included blotches and inequalities of left and right cheekbone or ear. A painter sought in the young sitter the general nature of innocent childhood. Railroad magnates later were able to bring to the United States portraits by Reynolds and Romney that could serve as noble, general-nature ancestors of anyone with sufficient wall space. Poets wrote of *the* benevolent man or of *the,* not *a,* schoolmaster, *the* parson. Decorum glorified and preserved the type.[1] "It is enough," declared William Gilpin, "that the province of the picturesque eye is to *survey nature;* not to *anatomize matter.*"

> The oak, the ash, and the elm, which bear a distant resemblance to each other may all be characterized alike. In a sketch, it is enough to mark *a tree* . . . If we have a general idea of the oak, for instance, as a light tree; and of the beech as a heavy one, it is sufficient. [And once again:] In the transient view of a country, all that appears needful, or rather all that can be

done is to mark the *shapes*, & *nature* of objects; & their *relative distances*. By the *nature* of an object, I mean only the rock, or wood, or broken ground, of which it consists.[2]

Gilpin's advice is directed to the amateur who sketches scenery on walking tours, but Sir Joshua Reynolds gave similar advice in his presidential discourses to the Royal Academy. Gainsborough, after an early phase of georgic realism, could paint from a landscape of twigs and broccoli in his studio.[3] Known as the chief popularizer of the picturesque, Gilpin accepts the shelter of the neo-classical tradition in England:

We seldom see a man, or a horse, without some personal blemish: and as seldom a mountain, or tree, in its most beautiful form. The painter of *fictitious* scenes therefore not only takes his forms from the most compleat individuals, but from the most beautiful parts of each individual; as the sculptor gave a purer figure by selecting beautiful parts, than he could have done by taking his model from the most beautiful single form. (P. 161)

Decorum required elevation into the general. The streaks of the tulip were not to be numbered. From the perspective of romantic particularizers and their realist successors, the looser style of Gainsborough's later years signaled a loss of attention.

John Philip Kemble's efforts as an actor to achieve the elevation of general nature were regarded, not long into the nineteenth century, as artful. On an evening in 1814 painters dining with Sir George Beaumont were contrasting, as most theater-goers at the time did, the classical Kemble and the mimetically emotional Edmund Kean—meaning, in 1814, the *natural* Kean. Sir George had no direct experience of Kean, but he knew who would dislike him: "The admirers, or at least the admirers and *friends* of Kemble, would not like Him, he had found this to be the case in several instances." Joseph Farington, reporting the conversation, interpreted Sir George as meaning "that those who felt *nature* strongly approved Kean, while those who were devoted to the art of the Kemble school disapproved Him."[4] Romantic poets and visual artists sought the individual and the particular as if they were heeding

the warning of William Blake that knowledge can only be of the particular: "To generalize is to be an idiot."

Blake and the romantics after him found in the particular what they could not find in the general or the type—the universal: infinity in a grain of sand, the infinite moment that was an unfolding multifoliate rose of timelessness. Every firefly and every flower grew by its own internal laws. A marginal gloss, "Energy of Nature," appears beside a pertinent sentence in a work of 1709 by Shaftesbury, the grandparent of almost all the beliefs held in common by the romantics: "For know that every *particular* NATURE certainly and constantly produces what is good to it self; unless something *foreign* disturbs or hinders it."[5] As Hazard Adams has put it in describing the "recognition of particularity as real" in "the 'secular' symbol," the romantic particular doesn't contain, it generates.[6]

Observation of particular, developing objects gave the romantics a kinship with empirical biologists and experimental chemists.[7] Searches undertaken by English romantic poets and essayists were at once tentative and self-intensive, but a point made in Jacob Bronowski's lectures on the romantics for television is to be taken seriously: the poets resembled the inventors Richard Arkwright and James Watt in attempting to evoke the power hidden in nature. Wordsworth, Shelley, and Keats call out to individual cuckoos, skylarks, and nightingales, momentarily present and enduringly symbolic, to stimulate a revival of the divine force from which human civilization has declined. Byron as skeptic distrusted not only general nature but the ideal in any form[8]—questioning, he says in *Don Juan,* until he doubts if doubt itself be doubting—so that he cannot hope that nature will reveal and share her hidden power. He can, however, point to the power of nature to defeat human endeavor as evidenced equally in fossils and in human artifacts under avalanches and on the ocean floor. Perception of the kinship of romantic poets with geologists has been dimmed by failure to remember or to notice that the word "science" in English romantic poetry refers to exact knowledge of any subject, not specifically "natural philosophy" but any body of demonstrated truths or observed facts systematically classified.

Empirical natural philosophy did share with other systematic

observation and classification distrusted by the poets a detachment from moral concerns. Science for Wordsworth "is simply another force in modern life that, like the city, threatens to retard man's moral progress by divesting the objects of experience of their human associations."[9] No vocation was acceptable to Wordsworth that could "murder to dissect." W. L. Bowles, charged with putting external nature above moral conduct—by elevating the descriptive poetry of Thomson and Cowper above Pope's *Windsor Forest*—cried out in pain: "Have I ever denied that Nature, in the proper sense of the word, means Nature *moral* as well as external!"[10]

Of the turn from idealized nature to particularized, faithful detail, one problem can stand in this chapter for many. Two theorists and painters of landscape in France, prepared to defend pure *paysage champêtre* as distinct from *paysage historique*—Pierre-Henri Valenciennes in *Elémens de la perspective pratique* (Paris, 1800, 2nd edition, 1820) and J. B. Deperthes in *Théorie de paysage* (1818)—noted that studies completed in *plein air* could not include accurate detail, because of the shifting light of the sun, and therefore should be free of detail.[11]

Conceptions of the beautiful, sublime, and picturesque had been well established under the banner of general nature. The vogue of the sublime had separable strands: applications of the work known as "Longinus" on literary style, new explanations of the misshapen contours of the earth, new attitudes toward mountains and other awesome features of landscape, and manifestations of these changes in visual arts.[12] The Greek treatise *Peri Hupsous* (*On the Sublime*), attributed to one or another Longinus, had been translated into English by John Hall in 1652, but its influence spread in Britain as well as on the Continent from the French translation by Boileau in 1674. In a translation of 1680 it was called *A Treatise of the Loftiness or Elegance of Speech*. Longinus analyzed aspects of grand style, accompanying a loftiness of subject and thought, in passages of intensity and exaltation that evoke from the reader emotional transport. A sublime passage is one that so moves the reader that the author is effaced and the reader has the sense of achieving transport—as if creating the passage—unaided. Boileau distinguished between the rhetorical sublime, to move the audience, and the pathetic, with

intrinsic aesthetic value. Gibbon informed his journal on 3 October 1762 that his awareness of two ways of criticizing a beautiful passage, idle exclamation and exact anatomy, had been enlarged by a third, from reading Longinus: "He tells me his own feelings upon reading it; and tells them with such energy, that he communicates them."[13]

A new geological sense of the broken surface of the earth accepted its vast mountainous and cavernous spaces as no longer incomprehensively fearful, but pleasingly awesome and no more disordered, if properly understood, than the planets and constellations of the heavens. The work most often cited as introducing this novel pleasure in stupefaction is Thomas Burnet's *Telluris theoria sacra* (1681–1689), in English as *The Sacred Theory of the Earth* (1684). Prefiguring Kant's analysis of the sublime, Burnet declared of mountains, "There is something august and stately in the Air of these things, that inspires the mind with great thoughts and passions; We do naturally, upon such occasions, think of God and his greatness: and whatsoever hath but the shadow and appearance of INFINITE, as all things have that are too big for our comprehension, they fill and over-bear the mind with their Excess, and cast it into a pleasing kind of stupor and admiration."[14] Connoisseurs in Britain and most of Europe turned their attention to the asymmetrical in Italian landscape paintings, for the sublime particularly to works by Salvator Rosa, the painter of bandits and witches plotting or performing misconduct in the darkness or chiaroscuro of a forest of broken trees; for example (in the Louvre), the disguised Saul, before the battle in which he perished, with the Witch of Endor and the ghost of Samuel; or Prometheus disemboweled, which Turner designated "horrible."[15] In 1766 the landscape near Keswick was said to have "beauty, horror, and immensity, united," such as "would require the united powers of *Claude, Salvator,* and *Poussin*" (probably meaning Drughet) to depict.[16] Humboldt the traveler ascribed to the viewer of sublime scenery the illusion that Longinus attributed to the reader absorbed into a sublime style: "All that the senses can but imperfectly comprehend, all that is most awful in such romantic scenes of nature, may become a source of enjoyment to man, by opening a wide field to the creative powers of his imagina-

tion. Impressions change with the varying movements of the mind, and we are led by a happy illusion to believe that we receive from the external world that with which we have ourselves invested it."[17]

Thomas Gray is rightfully included among those who encouraged greater friendship with mountains, but a cold fog kept him from repeating his first tentative excursion: "Mont Cenis, I confess, carries the permission mountains have of being frightful rather too far; and its horrors were accompanied with too much danger to give one time to reflect upon their beauties."[18]

From change first in theory and practice of gardening, classical, mathematical, ordered, Palladian symmetry gave way in all fields to the asymmetrical. What Addison in the highly influential series of essays in the *Spectator* of 1712 on the pleasures of imagination described as Chinese gardening came to be called the English garden. In Addison's validation of "the sight of what is great or beautiful," the "great" is the uncommon, new, strange: "It is this that bestows charms on a monster, and makes even the imperfections of nature please us." Conceptions of beauty were beginning to be divorced from ideas of moral perfection. By popular etymology, the "sublime" was liminal, at the threshold; discussion in the later twentieth century has often made it superliminal, at the upper edge of what is above all physical sensation.[19]

In 1757 Edmund Burke established the ground for all subsequent discussion in *A Philosophical Inquiry into the Origin of Our Ideas of the Sublime and Beautiful*. Beauty, he argued, is not as previously believed a matter of proportion. Objects that evoke a sense of beauty are small, smooth, delicate, light or fair in color, gradually varying in contour. (Opponents explained that Burke simply admired his wife, and a related suspicion lingers over Hogarth's definition of the perfect line of beauty as a delicate *S*.) Beauty, according to Burke, is a social quality that promotes love; sublimity derives from the need for self-preservation. Objects arousing a sense of sublimity are obscure, dark, rough, massive or vast, perhaps infinite, or having the privations of vacuity, lightlessness, solitude, or silence. "Whatever is in any sort terrible, or is conversant about terrible objects, or operates in a manner analogous to terror, is a source of the sublime." Sublimity in art is "conversant" with the terrible. Sublime objects evoke from the observer a pleasing sense of awe. Minimal

requirements for identification of the sublime are the terrible and pleasure.

Although Burke attributes sublimity to qualities of the object perceived, his exploration begins in the psychology of the percipient. Nobody doubted that the essential source of the sublime was subjective. Assumptions of subjectivity were everywhere evident, as in Lord Kames's explanation that a Greek ruin, resulting from the victory of barbarism over taste, is less picturesque than a Gothic ruin, the result of time's victory over strength. Kames here conflates picturesque and sublime, but the presumption of associative subjectivity is clear. Akenside insisted in the final version of *Pleasures of the Imagination*:

> Mind, Mind alone, bear witness, earth and heav'n,
> The living fountains in itself contains
> Of beauteous and sublime . . .   (481–83)

The Creator must have made it that way. In *Praelectiones de sacra poesi Hebraeorum* (1753), translated into English as *Lectures on Hebrew Poetry* in 1793 with notes by J. D. Michaelis, Robert Lowth asked that the Bible be approved for the sublime in its poetry. Genesis begins in both cosmic and Longinian sublimity. A. W. Schlegel, Coleridge, Wordsworth, and De Quincey were among the many after Lowth who found the sublime in the Jewish and Christian scriptures but not in Homer or other Greek poets.[20] Wordsworth explained that it was the anthropomorphic gods of the Pagan religion that put Greek and Roman poets in bondage to definite form, from which the Hebrew abhorrence of idolatry kept the Bible free. Although the sublime was not an important category for Chateaubriand, in *Génie du Christianisme* he distinguished Homer's lesser sublimity, a harmony of words with thought, from the Biblical in which the thought is always sublimely elevated above the words.[21]

With or without religious bias, writers on the sublime tended to blur distinctions between sublimity in nature and sublimity in art. Titian's landscapes were sublime because the viewpoint was high; in Claude's landscapes of beauty the viewpoint was uniformly low; so also in actual vistas and prospects, although painters could exaggerate the sublimity of a looming cliff or a wind-beaten mast through a

low viewpoint extremely close to the object depicted. An influential writer on gardening, noting that ruins introduce chains of reflection on specific events and ways of life and more generally on "the change, the decay, and the desolation before us," observed that "such effects properly belong to real ruins; but they are produced in a certain degree by those which are fictitious; the impressions are not so strong, but they are exactly similar."[22]

The critique of aesthetic judgment in Kant's *Kritik der Urteilskraft* of 1790 joined Burke's *Inquiry* as law on the sublime. In the introductory analytic of the beautiful, Kant declared that the judgment of taste, not logical, not cognitive, cannot be other than subjective. He granted that some objects might be regarded as beautiful, but insisted that sublimity is discoverable only in the mind. He distinguished between the mathematical sublime, in which the mind confronts an object great beyond all comparison, and the dynamic, in which the mind pictures to itself the possibility of resisting a might that is irresistible beyond imagination. With an instinct of self-preservation, the mind takes a sobering pleasure in thunderstorms, hurricanes, volcanoes, and chaotic waterfalls at a moment when life does not seem to be immediately threatened. Both varieties give pleasure indirectly: a check to the vital forces by fear is followed by an abrupt discharge of emotion when respect for the omnipotence of nature is joined by the soul's respect for the imagined power of its own existence. Thus an imagined resistance to the chaotic violence of nature lifts the soul into a transcendent state of absolute freedom.

Joining Freud and sometimes Derrida to Kant, a number of recent studies have concentrated on the unacknowledged, unrecognized, and unconscious, from which, according to these studies, attempts to represent the sublime often resulted in a writer's or painter's blockage.[23] A sonnet by Hartley Coleridge, defining the sublime as "the Eternal struggling out of Time," follows more closely Kant's exposition:

> Whatso'er creates
> At once abasement, and a sense of glory,
> Whate'er of sight, sound, feeling, fact, or story,
> Exalts the man, and yet the self rebates,

> That is the true sublime, which can confess
> In weakness strength, the great in littleness.[24]

From the aesthetics of the sublime, or from the same social forces that led to meditations on the sublime, came the fiction of terror, including the Gothic novel; the Gothic "horridness" of translations and adaptations of *Sturm und Drang* on the stage; illustrations of these and the independently horrid in visual arts: representations of formidable mountains, avalanches, storms, shipwrecks, looming ruins, dungeons (sometimes of the mind, as by Piranesi), Stonehenge as a place of Druids and human sacrifice, untamable beasts, volcanoes, and bottomless caverns.[25] On canvas, in decor for the stage, and in bombardment of the senses at his Eidophusikon, Philip James de Loutherbourg ranged from the newly conventional storms, shipwrecks, and ruins to the currently fashionable Pandemonium of Milton's *Paradise Lost.* In 1790 a William Beckford—not the author of the "horrid" *Vathek*—tried in *A Descriptive Account of the Island of Jamaica* to describe for his readers the savagery of a hurricane striking Jamaica by appeal to scenery in the Drury Lane Theatre. Byron, describing to Tom Moore an episode in Venice when a mistress had caught her sister-in-law with Byron, grabbed her by the hair, and slapped her sixteen times, assured Moore, "I had seen fits before, and also some small scenery of the same genus."[26] Byron's word "scenery" belongs, not to tragedy and not quite to comedy, but to the dramatic world of the sublime and picturesque.

Turner's paintings have been classified as the picturesque sublime, the architectural sublime, the historical sublime (raising landscape to the ideal grandeur called for in Reynolds's presidential discourses), the sea, mountains, lakes, cities (subsuming the industrial sublime, a domain of Joseph Wright of Derby), darkness, and the terrific (in ascent from Salvator Rosa).[27] From contrasts of scale in landscapes by Turner, John Martin became a master of what S. T. Coleridge and Keats called the "material sublime," measuring the vastness of natural forces—and on subjects such as Belshazzar's feast divine forces—against the little schemes of Byronic heroes.[28] In June 1831, the Dioramic and Cosmoramic Exhibition in Regent Street advertised in the London *Times* its current program of terrors,

including "The Pyramids and Sphinx of Egypt," "Mount St. Gothard," and "Mont Blanc." In contemptuous comparison with the true sublimity of *Paradise Lost,* Coleridge decried Klopstock's "arithmetical sublime": "Klopstock mistakes bigness for greatness."[29] Early paintings of Thomas Cole's, such as *Landscape, Composition, St. John in the Wilderness* (1827; in the Wadsworth Atheneum, Hartford), with a tiny St. John in a vast wilderness, obviously—whatever one is to make of Cole's denial—owe their "composition" to Martin. The panoramas for a paying public would progress from the terrible to a later fad of realistic topography.

The diction of William Blake, as Josephine Miles demonstrated in a series of monographs, follows every convention of the sublime. On the surface, Blake's language resembles no other writing so much as the hysterically biased Lucan's *Pharsalia.* Only Blake's imagination—that is, only almost everything of significance—separates his illuminations of the terrible from the material sublime of Martin and Klopstock.

Like the descent at the end of *Vathek* of the villainous hero and his paramour into the halls of Eblis, Gothic fiction of horrific sensation descended as far as publishers' censorship allowed to achieve the power that Tennyson, in an essay for the Cambridge Apostles, ascribed to the teller of ghost stories:

> he unlocks with a golden key the iron grated gates of the charnel-house; he throws them wide open: & forth issue from the inmost gloom the colossal Presences of the Past . . . some as they lived, seemingly pale with exhaustion & faintly smiling; some as they died in a still agony, like the dumb rage of the glaciers of Chamouny, a fearful convulsion suddenly frozen by the chill of Death & some as they were buried, with dropped eyelids, in their cerements & their winding sheets.[30]

Byron's metaphysical drama *Cain: A Mystery* would have been a different poem had ideas and examples of the sublime not been near at hand. As usual in Byron, a yearning for infinite power is checked by a hunger of human reason for explanations—and by mischievous disbelief. In Act 2, when Lucifer takes Cain on a cosmic journey through "the Abyss of Space" to look down on pre-Adamic giants, it is the misshapen earth of Thomas Burnet, available to Byron in

the cataclysmic Christian geology that Georges Cuvier opposed to the uniformitarian gradualism of James Hutton, that raises questions. As Lucifer has already explained (1.530), a tribal god made Cain's world out of wrecked former worlds. Time, mystery enough, is no more mysterious than Christian belief in Ussher's 4004 years. Cain would willingly kneel with the family to pray if someone would give him a reason; he could live with Jehovah's preference for Abel's bloody sacrifices over his own toil-produced harvest if someone would tell him why. He kills Abel with Abel's own *brand*, partly out of frustration, as Byron told Tom Moore, from "the inadequacy of his state to his conceptions." Even this motive includes intellectual curiosity: they have "known death" from Abel's slaughter of animals, but members of the family who have avoided Lucifer by trusting Jehovah have dropped hints that human death will be less final. The felling of Abel leaves curiosity on this point ironically unanswered. The knowledge of good and evil has answered little. The men have "known" women: in the "same hour" Adam "sowed the seed of evil and mankind" (1.443). Humanity knows nature; divinity does not. In John Scotus Erigena, *On the Division of Nature,* we read that God does not know evil; the gods do not know death; and the Gnostics were right: before the Logos, there was the abyss. Byron was not out to make better poetry than Milton, but to make better sense. Yet in the anticipations east of Eden of New Testament language—Lucifer refrains from saying, "believe in *me*"; the prayer is keep us (deliver us) from *further* evil— as well as in the sublimities of space and time, Byron wished to make a noise.

The sublime traveled also in the opposite direction of quiet. Henry Fuseli sought the psychological terrific and achieved at the very least the horrid, as in his Lapland witch (Metropolitan Museum) and in his various versions of *The Nightmare,* with the mare peering in or leaping out of the room where a simian incubus squats on a female victim whose innocence is problematic. In the opposite vein of sublimity, Fuseli extracted from his design for *The Shepherd's Dream, from Paradise Lost* (in the Tate) a dreaming figure with the butterfly of the soul flutterless nearby and the silent moon above. One version of this extraction is given the title *Solitude, Morning Twilight.* Burke himself had made much of the sublimities

of silence and deprivation. A painting by John Russell (1744–1806) in the City Museum and Art Gallery, Birmingham, isolates against vast space the delicately pitted face of the moon before landings from the earth were other than imagined. The painter's calligraphic inscription on the canvas declares it "Painted from Nature"; that is, in fidelity to detail seen through a telescope; but the suspended moon shares its yearning solitariness in equal exchange with the human viewer. Richard Wilson's painting of Mount Snowdon in the Walker Art Gallery, Liverpool, leads the eye quickly past two small human figures in the foreground to an identification with the mirroring, and with the distant peak mirrored, in the calm water of the middle ground. Other painters employed mirrored calm to similar subjective effect before it became a hallmark of Martin Johnson Heade and other "luminists" in the United States.[31]

Dugald Stewart, illustrating the sublime in "the *sympathetic dread* associated with the perilous fortunes of those who trust themselves" to the inconstant and treacherous ocean, notes the complexity of response to a calm sea: "in its most placid form, its temporary effect in soothing and composing the spirits is blended with feelings somewhat analogous to what are excited by the sleep of a lion; the calmness of its surface pleasing chiefly, from the contrast it exhibits to the terrors which it naturally inspires."[32] Wordsworth carried Stewart's perception further into the quiet of the human mind. Characteristically in the sonnet "It is a beauteous evening, calm and free," Wordsworth looks through the quiet of sea and innocent child, likened to a nun breathless with adoration, toward the power declared fearsome by Stewart but for Wordsworth noumenal in the child. London at dawn, in the sister sonnet "composed upon Westminster Bridge," is a Danaë about to waken to her own workaday Jovian powers. In the "Lines Composed a Few Miles above Tintern Abbey," as in the two final books and the concluding lines of *The Prelude,* the poet points toward an "aspect more sublime" in the "still, sad music of humanity," heard through a landscape not sundered from its natural condition by the households whose hidden chimneys give "uncertain notice" of social continuities.[33] The quiet sublime imbues the sorrow-worn face of Moneta within the temple of Western memory built by Keats in *The Fall of Hyperion.* Destruc-

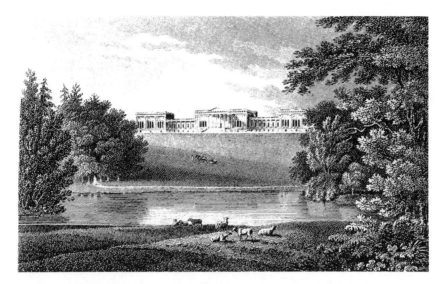

Stowe. *A Palladian house of 1697–1775, given a picturesque framing by John Britton in 1801. A Gothic library designed by Sir John Soane added another modish element in 1805.*

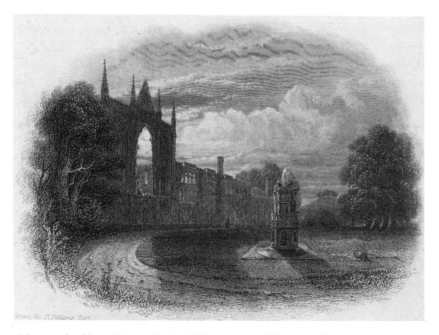

Newstead Abbey. *Drawn by C. Fellows, engraved by Edward Finden, 1830. The sublimity achieved through time and fate is exaggerated in the looming chapel. The chapel had been reduced to ruin by Cromwell's troops.*

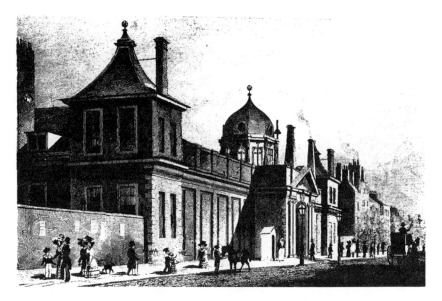

British Museum. *Engraved from a drawing by Thomas H. Shepherd, 1830. The front on Great Russell Street, before the classicizing by Sir Robert Smirke's familiar ionic facade, which was completed in 1847.*

*John Flaxman,* Design for a Monument. *Design based on Greek steles, with Roman fasces and profile of the memorialized contemporary.*

tion of nature and art by time remains sublime, but the fiery furnaces of industry were, for most, occluded from the sublime by the ear-annoying thunder of industrial progress.

Leigh Hunt, reviewing a performance of Mozart's *Don Giovanni* in the *Examiner* of 17 August 1817, praised the solemnity and quiet of the Commendatore's arrival on horseback in the last scene, but complained of Mozart's noise when the ghost dismounted: "The loudness, the crashing, the slamming thumps, are all comparatively vulgar." Without considering the possibility of comic exaggeration in the music, Hunt proposed that Mozart should have consulted Wieland or Schiller concerning true sublimity. The lesson has been learned in Verdi's revised version of *La Forza del Destino* for La Scala in 1869, wherein a noisy suicide at the curtain, in the version of 1862, is replaced by rapid drumbeats followed by a pianissimo close. Thomas Cole, in his "Essay on American Scenery" of 1835, offered precepts on the silent sublime of still water that were put into practice by the "luminists." Hunt and Cole quoted, as Ruskin would do in *Modern Painters* (1, ch. 1, 1843), 1 Kings 19.11–12: "And behold, the Lord passed by, and a great and strong wind rent the mountains, and brake in pieces the rocks before the Lord; but the Lord was not in the wind; and after the wind an earthquake; but the Lord was not in the earthquake; and after the earthquake a fire, but the Lord was not in the fire: and after the fire a still small voice." The sublimity of quiet succeeds and rebuts nightmare and shipwreck as the passage in Kings had succeeded God's descent to a quaking Mount Sinai in fire and smoke, in Exodus 19.16–19, heralded and surrounded by "thunders and lightnings, and a thick cloud." Nature offered the quiet sublime in response to the abrasive noises of the ax in the American wilderness and to the thunder of industry in England. There were also offensive political and social noises to countermand. Coleridge quoted the passage in Kings to his older brother George in March 1798 to demonstrate that he no longer believed in the wind and earthquake of the French Revolution. He may not have convinced his brother, but he was bellwether to the flock.

Even in 1798, the more fervently thereafter, in search of the ultimate unity of multifarious particulars, Coleridge utilized the distinctions of beautiful, picturesque, and sublime in a meditation

on the equivalence of Intellectual Beauty and organic unity. Sails partially reefed make a vessel less beautiful, he observed (on a voyage to Malta in 1804),

> unless it be made more than beautiful by becoming the Language of passion & peril / tho' it is most worthy of Observation, that in such circumstance there is such a wonderful correspondency of the surrounding objects, clouds & billow, & Ships, & their new relations to each other, & to the Stars . . . that the whole Field of Vision becomes sensuously picturesque, & the *parts* acquire as *parts* a charm which they have not as Things per se.—I mean to say, that divested of the passion that makes such a combination of Forms sublime, it would even sensuously *be grand* . . .[34]

For Coleridge, at least in that meditative moment, both the sublime and the picturesque involved the objectively aesthetic, the psychological, and the social.[35]

A writer easier to follow, Anna Jameson, instructed her public in 1849:

> In general, though size be one of the elements of the sublime, the really sublime and ideal work of Art loses but little when reduced in dimension . . . You can have colossal proportions and god-like power within the circumference of a gem for the finger . . . On the other hand, picturesque sculpture will seldom bear to be magnified, nor will any subject which is merely ornamental or conventional in the treatment.[36]

Erasmus Darwin wrote in *The Temple of Nature*: "Objects of taste have been generally divided into the beautiful, the sublime, and the new; and lately to these have been added the picturesque."[37] The picturesque, in migration from Italy, originally meant something visualized suitably for a painting. By the late seventeenth century in England "picturesque" meant like a picture by Claude Lorrain or Gaspard Poussin (Dughet)—or one of the more relaxed and less populated scenes of the great Nicolas Poussin.[38] Asymmetrical trees were more picturesque than symmetrical, and therefore beautiful, flowers. The need for asymmetry produced an adage: two cows cannot group. Charles Leslie gave advice to young painters: "Na-

ture, everywhere, arranges her productions in clusters . . . Grouping is therefore a universal law . . . In the composition of a picture, taking the whole together, a scattered general effect is always a fault."[39]

The popularizer of the picturesque was William Gilpin. He sent tourists looking for the picturesque as Jacques Cousteau was to send vacationers to watch fish in their own habitat. In one small book after another, in letters, and in unpublished notes, Gilpin gave precepts for examining and sketching landscape: "Where Art interferes, picturesque beauty vanishes." "We always wish for so much *sublimity,* to banish every thing low, and trivial; & for so much *amenity,* to soften the sublime." I am pleased by a cottage in nature, he said, "But when I see it in a picture, I always remove my eye."[40]

The picturesque in gardening meant imbalance and surprise; an end to mathematically straight lines as at Knole, Versailles, or Nymphenburg, where every alley hath a brother; Pope's grotto and similar manifestations of the Italianate, largely Palladian, tastes of Lord Burlington;[41] in landscape architecture, juxtapositions of Greek temples, Gothic vaults and traceries, Chinoiserie, Egyptian obelisks, Tivoli cascades; every available opportunity for sudden vistas.[42] Palladio's name, invoked to suggest mathematical symmetry in buildings, meant with reference to villa gardens parterres with fountains and cascades. Ideally, one should have on the estate an actual ruin, of whatever size, showing by the overgrowth of vines that the man-made was returning to nature.[43] Wordsworth asserted the rationale in *A Guide through the District of the Lakes*: "buildings, which in their very form call to mind the processes of nature, do thus, clothed in part with vegetable garb, appear to be received into the bosom of the living principle of things."

All agreed that garden planning, "improvement of the estate," should soften art from regularity near the house, gradually or by jumps through garden, park, and grounds, toward untamed nature in the distance. But how close to the house should the imitation of irregular nature come? How far into nature should each degree of art extend?

Archibald Alison, in *Essays on the Nature and Principles of Taste* (1790 and many editions thereafter), traced the wavering development of gardening from uniformity to variety; from the regular,

through a sprinkling and then a profusion of Italianate objects, to a steadily increasing imitation of nature—encouraged particularly by Thomson's *Seasons*. By 1770, in *Observations on Modern Gardening,* Thomas Whately had struck a note immediately popular: picturesque landscape, as distinct from the sublime, was distinctively English. Sir William Chambers's "Dissertation upon Oriental Gardening" (1772) was implicitly declared insufficiently patriotic by William Mason in *The English Garden* (1772–1782). Informal gardening was English gardening.

By 1801 landscape was what one went out of town to see. If fortunate in pastoral control of perceptions, one found in the countryside picturesque figures of the sort that provided staffage in Claude's paintings and in landscapes descended from Claude. Picturesque gardening reversed Schiller's principle for recovering human nature; as enclosure for improved agriculture cultivated the previously untamed landscape, gardeners like "Capability" Brown brought the appearance of nature into the estate. Honoring the contours of the terrain, he would be seen by his successor Humphry Repton as stripping civilization toward barrenness.

Sir Uvedale Price, piqued by his friend Richard Payne Knight's insistence in *The Landscape* (1794) that the categories of sublime and beautiful required no third, defined the picturesque as that which excites curiosity through the (Hogarthian) characteristics of variety and intricacy; the picturesque is "rough and abrupt, with sudden deviations."[44] The term "picturesque" enabled Price to explain how the choice of ugly subjects by Dutch artists could result in beautiful paintings. A landscape gardener should study Claude and other masters, not to make the garden like a painting—William Kent had done that—but because Claude, like Shakespeare, had observed nature closely, with "the accumulated experience of past ages," to the benefit of common observers who would otherwise miss what a Claude enabled them to see (p. 61). The picturesque in nature was not like a painting, but "a provocative to painting."[45] In *A Dialogue on the Distinct Characters of the Picturesque and the Beautiful* (1801), Price had his layman, Mr. Seymour, learn that great landscape painters can improve the common viewer's ideas of nature.

In *An Analytical Inquiry into the Principles of Taste* (1805), Richard Payne Knight handled his friend Price gently, but insisted that

taste could be explained only by the psychology of association. Price had looked to objects for distinctions "which only exist in the modes and habits of viewing and considering them." Critics had attempted "to direct by rules, and limit by definitions, matters, which depend entirely on feeling and sentiment." The picturesque, which affords pleasure only to those acquainted with painting, is "every thing of every kind, which has been, or may be represented to advantage in painting." Viewing human nature with generosity, Knight rejected in several contexts Burke's founding of the sublime in the desire for self-preservation. He rescued from Burke classical belief in the beauty of virtue. In reacting to tragedy on the stage, we confirm Longinus's "feelings of exultation and expansion of the mind, tending to rapture and enthusiasm." We know that the person acting Othello will not die at the close: "What we do feel, are the sentiments of heroic magnanimity, of warm and generous, but rash and impetuous affection." We do not react from *knowledge* of fear or sublimity; "reason excites no sympathies"; Homer and Sophocles had not read Aristotle. In his final chapter, "Of Novelty," without giving fuel directly to critics who derided picturesque attention to surprise, Knight appealed to associational psychology in declaring life insipid without change: "Change and variety are . . . necessary to the enjoyment of all pleasure."[46]

Attempts to distinguish picturesque and sublime were not confined to specialists like Gilpin, Price, and Knight. Darwin, for one example, set forth a scale or spectrum beginning with the *picturesque,* an arrangement of repetitions with novelty; for *beauty,* add curves and smooth surfaces; add more rocks, deeper dells, and perhaps more novelty than repetition, for the *romantic;* if some of these properties "are much above the usual magnitude," you have the *sublime.*[47]

How essential the categories of picturesque and sublime were to pictorial composition from the middle of the eighteenth century onward can be seen from Balthasar Nebot's *Aysgarth Falls,* in which a painter in the 1740s, dedicated to topographical recording of estates, was driven near the edge of chaos by insistent horizontals in an undomesticated landscape confronting an eye unaided by Claude, Salvator, the Poussins, or English painters to follow.[48] Paley's God had imposed no design on Aysgarth.

Aside from the difficulty of determining when it is sliding into something else, the picturesque was so pervasive in the early nineteenth century that sampling is as odious as comparisons would be. My favorite is a before-and-after-picturesque-landscaping by Humphry Repton: before, the wind blows away milady's hat and the terrier barks the dissatisfaction felt by all; after, the family can picnic at a table shaded by a tree in the foreground, with the now-contented dog nearby. In what might seem an extreme case, but is not (despite his picturesque name), the great engineer Isambard Kingdom Brunel, who began to design the Great Western Railway in 1833, left the mouth of one tunnel unfinished, with ivy trained over it. Lord Holland's Tudor house of 1609, in an engraving for John Britton's *Architectural Antiquities of Great Britain* of 1809, becomes much more picturesque, in the manner of Claude, than a century of Whigs had made it. By lucky chance, it represented something like "that mixed style," recommended by Knight, "which characterizes the buildings of Claude and the Poussins" (p. 219).

A topographical view of Newstead Abbey engraved about 1720 for a series to identify the estates of noblemen, although needed to illustrate Byron's origins in the first full edition of his works, stands in dull frontal nudity that pales in contrast with the engraving borrowed from Finden in 1834 for the title page of Moore's life of Byron. In this engraving by C. Fellows the ruined chapel of Newstead Abbey looms on the left as sublimely as if it had been reduced by time instead of by Cromwell's troops; from the chapel the eye is drawn to a garden ornament in the center of the design, inevitably suggesting first to Byron's and Moore's readers the tomb of the Newfoundland dog erected by Byron where he assumed the high altar of the chapel had been. One sad end of the picturesque can be seen in the *Byron* of a dainty series of Georgian picture-books published by Collins: Byron, Isabella, the dog, and several peacocks help decorate a flower garden attached to Newstead Abbey, the chapel and all other unpleasantness out of sight. In a sad middle of the story, the severe linearity of John Flaxman's illustrations for the *Odyssey* was made incongruous in the edition of 1853 by the addition of picturesque vignettes and a wreath around Homer on the title page. All of these embarrassments belong to the rapid domes-

tication of the picturesque, as in Francis Danby's *Landscape near Clifton,* now in the Mellon Centre at Yale, with its precisely rendered foliage, dark recesses, and spot of light in which citizens sit reading.[49] Leigh Hunt has been much maligned for deleterious influence on Keats, but it probably was Hunt from whom Keats caught the habit of extolling excursions from the city in order to sit under a tree and read. In the general population, sketching caught up with reading. In *The Brigand,* a dramatic entertainment adapted from the French by James Robinson Planché in 1829, two artists captured by a brigand spend their time making picturesque sketches of him.

From the Lord Burlington era onward, attempts were made to account for the picturesque craze and for the Whiggish myths of liberty, aesthetic and otherwise, of which the picturesque is an aspect. Shaftesbury, a fountain of the cultural revolt, had declared:

> I shall no longer resist the passion growing in me for things of a *natural* kind; where neither *art,* nor the *conceit* or *caprice* of man has spoil'd their *genuine order,* by breaking in upon that *primitive state.* Even the rude *rocks,* the mossy *caverns,* the irregular unwrought *grotto's,* and broken *falls* of waters, with all the horrid graces of the *wilderness* it-self, as representing NATURE more, will be the more engaging, and appear with a magnificence beyond the formal mockery of princely gardens.[50]

Darwin (*The Temple of Nature,* p. 105) thought the cause was weariness from cultivation that had brought not only plowed fields, mown meadows, and shrubs in rows—quite enough to create a desire for "undisguised nature"—but also mutilated trees, hedges, and sheep. Pleasure from nature and intimations of the natural came from the novelty of such feeling.[51] Boredom with restrictive culture is evident from the opening lines of the Prologue of *The Orphan of China: A Tragedy* (1759), adapted by Arthur Murphy from Voltaire:

> Enough of Greece and Rome. The exhausted store
> Of either nation now can charm no more.

Willson of Lincoln, who supported the Pugins' war on sham, decried with them misuses of Gothic: "The repetition of Palladian

symmetry had become so tedious, that relief was eagerly sought in the varieties of the Gothic Style."[52] Rejecting the proposal frequently made that the taste for a nature less manicured came from improvements in transportation, Keith Thomas has argued that the progress of agriculture, with two million additional acres brought under cultivation in the eighteenth century, provided an adequate incentive.[53] But travels through Britain in search of vistas, performed by Gilpin and satirized by William Combe and Thomas Rowlandson in *Tour of Dr. Syntax in Search of the Picturesque* (1812), were preceded by the increase in numbers who could tour the Rhine, Switzerland, and Italy.[54] Alexander von Humboldt, who traveled to observe and describe exotic lands, vegetation, and segments of the sky, recognized in Columbus the initial impetus toward landscape painting: "The delineation of natural objects included in the branch of art at present under consideration, could not have gained in diversity and exactness, until the geographical field of view became extended, the means of travelling in foreign countries facilitated, and the appreciation of the beauty and configuration of vegetable forms, and their arrangement in groups of natural families, excited."[55]

Surely wrong in his low estimate of travel as incentive, Thomas is more persuasive in suggesting that it was the urban huddling of the professional middle classes that hastened the new sensibility: a link of gentility with the landed past required access to trees.[56] Or, to paraphrase the line taken by David Allen in *The Naturalist in Britain,* nature, stripped of its outward mysteries by the intellectual assault of science, could assume elusive mysteries that teased simultaneously intellect and senses. Pursuit of the picturesque made it possible to discard the artificial birds that had inhabited artificial gardens.

Sometimes implicitly but often with a militant defensiveness, exponents of the picturesque declared it a distinctively English answer to the sublime of the Alps.[57] Granting that Walpole and Mason had a right to their patriotic pride in English gardening, Price explained his attacks on Capability Brown as conducted for the honor of England; instead of Brown's clumps, belts, smoothings of terrain, and slaughtering of natural stands of trees, "the noble and varied works of the eminent painters of every age and of every

country, and those of their supreme mistress, Nature, should be the great models of imitation."[58] By drawing upon Claude for knowledge of nature, landscapists could make gardens more English. Just as Americans regarded their wilderness as uniquely sublime, with its natural divinity untainted,[59] the English took pride in the modesty of their picturesque vistas, a *via media* between the forbidding grandeur of the Alps and the geometrically authoritarian France and—bearing in mind religion—Rome. Whig aesthetics was English aesthetics, or British when its proponents remembered that its topographical aspects were more obvious in Scotland and Wales. Patriotism is confirmed by such references as Francis Jeffrey's, in a carefully considered review and its revision in the *Encyclopaedia Britannica,* to "a common English landscape—green meadows with grazing and ruminating cattle—canals or navigable rivers—well fenced, well cultivated fields—neat, clean, scattered cottages, humble antique churches."[60] Jeffrey's point is that both the simple rusticity of an English scene and the "lofty mountains, and rocky and untrodden valleys" of Wales and the Scottish Highlands appeal to us by Hartley's and Alison's laws of associational psychology; "it is to the recollection of *man* and the suggestion of human feelings that its beauty is also owing." In making his point, however, Jeffrey appeals to English examples of the picturesque and British examples of the sublime. Not long into the nineteenth century the picturesque discovered in nature by a Lorrain glass or other device for framing the vista was hackneyed, and anything artificially picturesque was suspected of sham. Repton, in *An Enquiry into Changes of Taste in Landscape Gardening* (1806), advised that the gardener "must studiously conceal every interference of art, however expensive, by which the natural scenery is improved." He means this partly as a rebuke to the followers of Kent and Brown, who destroyed ancient associations by whitewashing churches and allowed what Coleridge called trespass on the eye—visual pollution—by painting or whitewashing houses. Thus far the issue is not a falsification of materials but a disruption of the tourist's vistas. An expert yet scarcely grateful inheritor of the picturesque, John C. Loudon, in *The Suburban Gardener and Villa Companion* (1838), distinguished the picturesque, arranged suitably for a painting; the gardenesque, displaying the art of the gardener without conceal-

ing "the individual beauty of trees, shrubs and plants in a state of nature"; and the rustic, "to produce such facsimile imitations of common nature, as to deceive the spectator."[61] In his poem of 1794, Richard Payne Knight had approved the quiet sublime but left the artificiality intact:

> 'Tis not the giant of unwieldy size,
> Piling up hills on hills to scale the skies,
> That gives an image of the true sublime,
> Or the best subject for the lofty rhyme;
> But nature's common works, by genius dress'd,
> With art selected, and with taste express'd;
> Where sympathy with terror is combin'd,
> To move, to melt, and elevate the mind.[62]

Artifice was soon pricked both by ironists and by romantics. If a picturesque garden requires surprise, Thomas Love Peacock quipped, what is it like the second time round? Tom Moore found the parsonage of William Lisle Bowles "beautifully situated, but he has a good deal frittered away its beauty with grottos, hermitages & Shenstonian inscriptions—When company is coming, he cries 'here, John, run with the crucifix & missal to the Hermitage & set the fountain going.' His sheep-bells are tuned in thirds & fifths— but he is an excellent fellow notwithstanding."[63]

Austen, who nudged the Gothic novel off the road in *Northanger Abbey,* was tenderer toward the improvement of estates in Repton's manner. In *Sense and Sensibility* (1811) the irony falls on picturesque taste but is pointed more lethally at books defining the picturesque. She assigns the rational view of the question to Edward Ferrars, who says of Marianne Dashwood: "And books!—Thomson, Cowper, Scott—she would buy up every copy, I believe, to prevent their falling into unworthy hands; and she would have every book that tells her how to admire an old twisted tree." In the next chapter (18), Ferrars addresses the victim of fashionable taste directly:

> You must not inquire too far, Marianne—remember I have no knowledge in the picturesque and I shall offend you by my ignorance and want of particulars. I shall call hills steep,

which ought to be bold; surfaces strange and uncouth, which ought to be irregular and rugged; and distant objects out of sight, which ought only to be indistinct through the soft medium of a hazy atmosphere.

After Marianne confesses that many are merely imitating him who first defined the picturesque, Ferrars reaches toward graphic representations without easing his objections to the theorists:

I like a fine prospect, but not on picturesque principles. I do not like crooked, twisted, blasted trees. I admire them much more if they are tall, straight and flourishing. I do not like ruined, tattered cottages. I am not fond of nettles, or thistles, or heath blossoms. I have more pleasure in a snug farm-house than a watch-tower—and a troop of tidy, happy villagers please me better than the finest banditti in the world.

Wordsworth, as well, objects to the "rules of mimic art," the "rules prescribed by passive taste."[64] He is objecting to such prescriptive writers as Uvedale Price, to instructions such as Gilpin's on where to stand and what to see, in the lines of "The Tables Turned" often taken as an attack on empirical science:

Enough of Science and of Art,
Close up those barren leaves.

Such rules contribute to the perversion of the people into a public, "For to be mistaught," Wordsworth will say in 1815, "is worse than to be untaught." Hazlitt (if we take the poem biographically) is not advised to quit painting, but is warned to stop reading the proponents of exact knowledge, who will thicken his head against impulses from the vernal wood.[65]

The name and vocation of "scientist" was just then coming into its modern meaning, more restricted than the previous reference of "science" to any exact knowledge. If, Wordsworth says in the Preface of 1802, the "Man of science"—Humphry Davy with his successors—can make the language of science familiar to all, then the language of science will join Wordsworth's revolution against artificially restrictive, decorous, "poetic" diction.[66] In a passage that has

vexed critics into high-energy creativeness, Wordsworth declares that when he and his companion first beheld the unveiled summit of Mont Blanc, they grieved

> To have a soulless image on the eye
> That had usurped upon a living thought
> That never more could be.[67]

The "unheard music" of expectation was richer than the actual sight, along the lines of Lamb's and Hazlitt's protests against reductions of an imagined Lear and Hamlet to a physical actor and stage, but I propose that Wordsworth and Robert Jones were also complaining of overfamiliarity from the multiplied engravings of Mont Blanc that dulled the "living thought." Actual sight of Fuji suffers similarly from the strength and plethora of reproductions. Or listen to Baudelaire: "Anyone can easily understand that if those whose business it is to express beauty were to conform to the rules of the pundits, beauty itself would disappear from the earth, since all types, all ideas and all sensations would be fused in a vast, impersonal and monotonous unity, as immense as boredom or total negation."[68]

In such works as his guide to the Lakes, Wordsworth succumbed, not like Blake to the diction of the sublime, but to the technical language of vista-framing. Coleridge could let no subject go without appealing to established and possible distinctions—the sublime was not pretty, picturesque, majestic, or grand—but his early attitudes are revealed in his noting an anecdote of an innocent addressing Fuseli: "What a fine subject for your pencil, Mr Fuseli— Horrors—Terrors—" (*Notebooks,* 1:742). His late appraisals of the picturesque are best understood from reiterated insistence that his own poetry is not pictorial but musical. But perhaps the signal to go home comes not from the antagonists but from the avoidance of the terms "picturesque" and "sublime" (except for a contemptuous reference to Gilpin) in Kenneth Clarke's *Landscape into Art.*

The silent sublime had a strong ally in the waves of Hellenism that broke over the Gothic, Chinese, Egyptian, Hindustani, and Turkish exoticisms accumulating from the 1760s onward. This was not merely a second wind of neoclassicism. The turn from Roman to Greek models, meaning particularly a turn from Cicero and Horace

to Roman copies of Greek statuary, spread over Europe, most cultural historians agree, from J. J. Winckelmann's *Geschichte der Kunst des Altertums* (Dresden, 1764), not his first work on Greek statues, but his first comprehensive work after seeing the Apollo Belvedere. One of the most compelling influences in Britain from antiquarians and archaeologists was the series provided by Nicholas Revett from 1762 to 1816, *The Antiquities of Athens.*[69] The severity of the Doric, as in the vestibule of Sir John Soane's Bank of England, superseded the grandiosity of the Corinthian. Translations of Homer and excitements created among students of Greek literature by Vico and F. A. Wolf—could Homer have been a person?—did not impede the study of artifacts. From about 1817, Goethe was a major influence. Byron accomplished in 1812, in the second canto of *Childe Harold's Pilgrimage,* what had been denied to Winckelmann and Goethe: he captured a wide audience for a work based on an actual visit to Greece. Cantos 3 and 4 had to be richer poetically than the second, because Greece was exotic territory for the reader, but increasing numbers had traveled up the Rhine; Claude, Richard Wilson, and word-picturers had made Italian scenes familiar. Byron and the archaeologists both contributed to two paintings by Turner exhibited in 1816, *View of the Temple of Jupiter Panellenius, in the Island of Ægina, with the Greek National Dance of the Romaika: the Acropolis of Athens in the Distance,* "Painted from a Sketch taken by H. Gally Knight, Esq. in 1810," and *The Temple of Jupiter Panellenius Restored*; first Greece in ruins, subjected to the Turks, and then prospective restoration to independence.

Paradoxically, the rugged landscape of Greece was not well enough known to stand for the sublime rather than for the physical setting of literary and graphic beauty. Instead, a road was built from Winckelmann to Matthew Arnold's "sweetness and light." For grandeur Rome would do.[70] For Byron and Shelley, Greece represented above all the political ideals of the Athenian city-state and the urgency of revolution against despotic powers after the fall of Napoleon. If Shelley's *Hellas* does not make clear the priority he assigns to Grecian clarity and simplicity, however, his advocacy of such aesthetic values is vivid in his "Critical Notices of the Sculpture in the Florence Gallery" and in letters to Peacock on Michelangelo's "revolting" Bacchus and on his Moses as an aesthetic mon-

strosity conveying adequately enough the moral heinousness of the biblical character but ignoring all that the Greeks could teach.[71]

Winckelmann had shifted classical interests to the beauty of Greek forms. He had pointed repeatedly to noble simplicity and silent greatness.[72] In designs for funerary monuments Flaxman copied Greek steles of restrained, domestic dignity.[73] Without Winckelmann and his ally the painter Antonio Mengs, Flaxman would be inexplicable. It was in the penumbra of Winckelmann that Keats declared it nobler to sit like Jove than to fly like Mercury.[74] Keats "stood on tiptoe" partly because he was of short stature, but also because his ideal was energy in stasis. He comes to "richer entanglements," globed peonies, and autumn in alert repose on the granary floor somewhat in kinship with Wordsworth's "wise passiveness" but more by way of the discus-thrower—strength paused before exertion—and the metopes, frieze, and pedimental figures brought to London by Lord Elgin from the Parthenon. Keats's verse does not always achieve the force of his ideals; Praxiteles overcomes the more vigorous Phidias, and Keats shares with Canova, as in their visualization of Cupid and Psyche in embrace, a sweetness that eclipses light.

In the circle of Keats and his mentor Leigh Hunt, the "disinterested" beauty of Hellenism belongs in part to a middle-class revolt against aristocratic hegemony in Roman morals and law. This middle-class aspiration, with the accompanying tensions between it and the energies concurrently promoted by adherents to the picturesque, connects Keats's love of beauty, as Hellenist, with Hunt's environmentalist objections to angling. Linearity in art, by general belief derived from lost murals of ancient Greece, had become partly captive to what can be called the Jacobinical, Roman-moral linearity of the politically minded David. Blake, for whom the bounding line was not of nature but of wholeness achieved through imagination, could divorce the linearity of Flaxman and Barry from association with the Greeks, who had proved their subjection to external nature by thinking the muses were daughters of memory. Though perhaps caught between Jacobinical moralizing and antirational imagination, linearists like Barry, Mortimer, and Flaxman contributed to the victories of Hellenizing simplicity.

This mercantile aesthetic counterbalance to education for leader-

ship at Eton and other public schools was recognized by Josiah Wedgwood, who satisfied it with classical designs embossed in white on jasper ware. Thomas Hope's *Household Furniture and Interior Decoration* (1807) attempted successfully to influence the decoration of merchants' houses with illustrations of Greeklike chairs and rows of Greeklike vases in rooms with Doric entries. Scenes from Greek myths on the vases collected at Naples by Sir William Hamilton, a source for Emma Hamilton's "attic attitudes," were given flowered borders in an edition of the engraved plates inexpensive enough for wide distribution as patterns that merchants could show to craftsmen decorating their new houses. To set against such picturesque villas as those built at Blaise Hamlet by John Nash, Repton designed for the new Hellenic taste severely simple villas at Brentry Hill near Bristol. In Hampstead Keats himself resided in a house of similar undecorated clarity. Simplicity in beautification is the more apparent juxtaposed with the Romanized imperialism of Henry Holland's East India House; with the tottery but surviving Britannia pediment that breaks the horizontal of the Regent's Park houses designed by Nash; or later, with the cosmetic facade applied by Sir Robert Smirke to the British Museum. Largely for picturesque but partly for Hellenizing reasons, J. C. Loudon recommended that suburban houses be placed so that their inhabitants could not see the town.[75] Kroeber has argued persuasively that romantic Hellenism replaced the linear with the interpenetration and uncertainties of color that recognized the reality of "conditions fundamentally plastic, porous, and equivocal."[76]

The early historians of the aesthetic movement in England were not looking in the wrong direction when they began with Keats; even if they had begun with Kant, they could not have bypassed Keats. Among other Grecian aspects of *The Fall of Hyperion*, the opening scene of a garden laid waste represents a fall from the nature of Homeric Greece to the self-conscious struggle of nineteenth-century art. The recasting of the more objective *Hyperion* was a self-conscious assessment of self-consciousness; as Carlyle was to put it, those who linger to consider health are the sick. Keats's *Ode on a Grecian Urn* could illustrate most of the paragraphs in the chapter now coming to an end. Paying tribute to beauty, pillaging and evoking Claude and Nicolas Poussin in its role as sylvan historian,

the ode continues the Theocritan tradition of pastoral Greece latent in every manifestation of the picturesque.[77] It is not general nature or generalized art; it is not a single, particularized artifact, like the engraving of the Sosibos vase traced by Keats; it is a single, particular, romantically imagined urn. The poem weighs the endurance of art against the intensity of human experience and human desire. In the fusion of the represented scene with the absent town that was the source in nature for the persons depicted—and of the artist who imagined and shaped them—the poem reconciles nature and art. To live in that imagined town now is to live a better life. The ode unrolled from the urn by the imagination begins with a valorization of the quiet sublime, so silent indeed that its voice and its music are only imaginable. What is visualized is a purely decorative Augustan copy in bronze of a utilitarian product of Greece that ought to be discoverable in an Etruscan tomb. Also envisioned is a monument with a message, if not a *memento mori* of the kinds pointed to in Wylie Sypher's interpretation of the poem, then a "Stop! Traveller" with something to say. The traveler must ask questions: "What men or gods are these?" The answer of the kind of stele emulated by Flaxman and present by analogy in Keats's ode is not "Be calm" but "I'm calm." The reader is asked to know next that her questions must be disinterested, must be asked to no end—for the urn need give no answer but itself. Beauty is its own truth. Imagined beauty is superior truth.

# IMAGINATION
# AND
# IRONY

Many European thinkers after Newton had foreseen a ceaseless upward progression of human reason harnessing the material universe and all its living creatures for the perpetual improvement of human life. Nature was not a mystery, but a puzzle; in the certainty of progress, proponents of natural philosophy sought to uncover the principles of nature like children seeking Easter eggs hidden by parental design. Not more Alexanders and Attilas were predictable, but more Aristotles, Bacons, Galileos, and Lockes. Unpredictably, David Hume questioned the ability of reason to answer all the questions reason could raise. It is experience, not reason, that makes us expect the sun to rise tomorrow. You cannot, by means of reason, know whether you have actual neighbors out there with a consciousness like yours; for all that reason can determine, you may have imagined them. A sense at this moment that you existed this morning does not by reason prove that this sense was caused by your existence this morning. What binds us to neighbors is not reason but sympathy.

With Hume's shattering of the epistemological and ethical sequence of each individual's seeking and finding pleasurable truth through the utilization of reason by self-interest, the romantics came to value sympathy, intensity, and imagination. As Shelley explained at the beginning of *The Defence of Poetry*, reason is analytic, searching as in science for differences among like objects; imagination is synthetic, finding likenesses among beings previously regarded as unlike. In a world divided, imagination seeks or creates unity. From this meaning of imagination comes the use of

the word "image" to mean simile, or, more in keeping with the sense of imagination as creative fusion, to mean metaphor. Fixities and definites, in Coleridge's formulation of an idea from Germany, are dissipated, dissolved, and fused into a single whole. In a distinction made before Coleridge and Shelley but acceptable to them, one who has seen a man and a horse can leave the fixities of memory unmodified in fancying a centaur, but imagination is required for the creation of a Caliban. William Marlow fancifully contrives a capriccio in which the London cathedral of St. Paul's appears at the end of a Venetian canal; Turner again and again dissolves topographical details and imaginatively fuses historic or mythic episodes that are interrelated on the canvas in ways left to the alert viewer to discover. Coleridge and De Quincey were fascinated by Piranesi's *Prigione* as prisons of the mind, prisons lifted to a higher terror by the perceiver.

Richard Hurd, promoting historical relativity in 1762 by arguing that the Aristotelian rules for an epic should not be applied to a literary embodiment of Gothic chivalry such as Spenser's *Faerie Queene,* elevated imagination above nature: "A poet, they say, must follow *Nature;* and by Nature we are to suppose can only be meant the known and experienced course of affairs in this world. Whereas the poet has a world of his own, where experience has less to do, than consistent imagination."[1] In "a world of his own," the poet is personal, sincerely devoted to inner inspiration, and original. Like the child in Wordsworth's Intimations Ode, the poet lives in a celestial light unknown to commoners trudging through the dullness of common day. Wagner's Tristan, glowing with the same metaphor of inner light, would in the cause of love extinguish (first version, Munich, 1865) *frechen Tage,* impudent day. Imitation, then, whether of nature or of art, will not suffice for a true meistersinger. The presidential discourses of Joshua Reynolds had shifted incrementally from recommending imitation and copying of Raphael to emulation of Michelangelo according to Edward Young's principle that one should work in the spirit of the ancients but not with their materials. When Farington recommended to Constable that he study Claude, Constable thanked him politely.[2]

Coleridge wrote in his manuscript "Logic":

we must evermore bear in mind that we are throughout treating of mental processes wholly abstracted from all outward realities, and consequently that we must learn to consider the sense itself, or the faculty of original and constructive imagination, aloof from all sensation and without reference to any supposed passive impression from objects extrinsic to the percipient; but if so, if the passive be wholly separated, what can remain but acts and the immediate results of the same in the subject or agent himself; for this is the very principle from which we commence, that we confine ourselves to the mind, and that the mind is distinguished from other things as a subject that is its own object, an eye, as it were, that is its own mirror, beholding and self-beheld.³

Coleridge never totally abandons a hold on nature, the sense that his mind is the mirror of God's eternal *natura naturans,* the whole that includes his mind—as distinguished from dead *natura naturata,* the sole nature acknowledged by "the needle point pinshead System of the Atomists." In a moment of recovery from despair, he makes a note:

Saturday Night, April 14, 1805—In looking at objects of Nature while I am thinking, as at yonder moon dim-glimmering thro' the dewy window-pane, I seem rather to be seeking, as it were *asking,* a symbolical language for something within me that already and forever exists, than observing any thing new. Even when that latter is the case, yet still I have always an obscure feeling as if that new phaenomenon were the dim Awaking of a forgotten or hidden Truth of my inner Nature/ It is still interesting as a Word, a Symbol! It is _____ the Creator! and the Evolver!⁴

The comprehensive imagination comprises all the power a human individual possesses. The soul looks out of the eye and sees itself.

These dramatic revaluations of originality and imagination brought an uneasy status to the word "artist," which had been more or less synonymous with "artisan"—one who did work with the hands. Blake, excluded as an engraver from the Royal Academy, protested that invention and execution are inseparable. In England

as in France, the artist was called artist because skilled; an individual with imagination—no mere craftsman—could create as a poet creates.[5] Cyrus Redding called Turner "truly the poet of painting."[6] D. G. Rossetti, painter and poet, measured both poetry and painting by the presence of "fundamental brainwork," but he referred to the emotion and imagination in a painting as the poetry of it. Charles Lamb could profess to be despondent over a manuscript displayed at Cambridge exposing *even Milton's* need to make corrections of a sort suggesting craft rather than the lightning flash of inspiration. Shelley, Coleridge, and other romantics cited Tasso's axiom that only God and the poet deserve to be called creator. Wordsworth addressed Coleridge with the certainty of agreement concerning

> the animating faith
> That Poets, even as Prophets, each with each
> Connected in a mighty scheme of truth,
> Have each his own peculiar faculty,
> Heaven's gift, a sense that fits him to perceive
> Objects unseen before . . .   (1850, 13:300–305)

Defending "Elevated Landscape" as superior to what Fuseli called "map-work," Turner agreed with the poets: "Why," he complained to John Britton, "Why say the Poet and Prophet are not often united?—for if they are not they ought to be."[7] All these meanings are sentimentalized in J. G. Millais's life of his father: "It was the poetry of Nature that appealed to him—the love, hope, sweetness, and purity that he found there—and it was the passionate desire to express what he felt so deeply that spurred him on."[8]

Citing Newton's dispute with Leibniz over priority in the invention of calculus and Charles Darwin's vexation at the thought that "anyone"—that is, Wallace—might publish before him, Robert Merton has pointed out that the ambition to be first was not only earlier in the sciences than in painting but persisted among scientists even as *l'avant-garde* gained prestige in the arts.[9] Nonetheless, though empirical science was practiced by individuals ambitious to be first, every new analysis in science was a discovery shared for others to repeat, whereas the poetic imagination, as described by Wordsworth, Coleridge, and Shelley, claimed uniqueness for its

individual discovery of likeness; none before Wordsworth had said that Newton was voyaging on strange seas of thought alone, and none after him can gain fame by adding "like Columbus." Claims for imagination were as expansive as hydrogen. In the final books of *The Prelude* imagination is love, liberty, the true wealth of nations—

> Is but another name for absolute power
> And clearest insight, amplitude of mind,
> And Reason in her most exalted mood.   (1850, 14:190–92)

Imagination is not for Wordsworth the sole divinity, as it becomes in Blake's *Jerusalem*, but it is, as Blake and Coleridge agree, the wholeness of the individual who has got it all together. What a gestaltist such as Kurt Koffka describes as wholeness imposed on perception by the entire bodily organism, the romantic calls imagination. As belief in soul declined, imagination was made noumenous. [10]

Such claims for imagination are suspect, and grievously have the romantics answered for them. It has been said, in a modest example, that the originality of the romantics in "the art of viewing landscape" is that they "brought to the landscape their own preoccupations: Coleridge's unhappiness, Byron's pride, Shelley's restlessness . . ."[11] More sweeping diagnoses have been made, as in "The Catastrophe of Imaginative Vision" by Bryan Wolf: Cole's sublime landscapes "draw their energy from the drama of the psyche in the struggle of self-definition"; Cole's scenes (and Allston's, Irving's, Hawthorne's, and those of all the other imaginers) are American only as the reinforcement of the artist's psyche needs "a tale of self-origination."[12]

Albert Boime has argued that the rise of landscape painting at the expense of the French Academy's pride in history painting brought a decline in the meaning of originality, from aristocratic distinction to democratic individuality; from "a mere obsession with spontaneity and originality," landscape provided an unlimited subject matter that could be handled with public success after "a minimum of formal instruction."[13] So complete was the victory of mere individuality, notes Boime, that the Academy by 1840 stopped denouncing novelty and began denouncing traditions as

mere conventionality. In the process, topographical painting, "map-work," fell from its place as high art.

Imagination belonged to genius, not to talent. Talent could be made, genius was born. Always sensitive, a genius might seem to have extrasensory perception, was likely to be an outcast, and might be mad. The myth of genius allied to madness gave Tasso special appeal to Goethe, Byron, Shelley, and other romantics. Charles Leslie was one of several for whom Don Quixote remained throughout a full career a favorite subject. The myth of the sensitive, rickety poet infected even George Eliot: the sickly narrator of her tale of poetic prescience, *The Lifted Veil,* not only enters the consciousness of others, but foresees that the slim, fair-haired fiancée of his brother will later be his own wife and will be the Lucrezia Borgia of Giorgione's painting. Genius flowered early, belonged to youth; a genius could be expected to die early—Chatterton, Burns, Keats, Novalis, Mozart, Schubert, Girtin, Bonington. Painters portrayed friends as wispy painters or poets. [14] Self-portraits could be by suggestion a suffering Christ. Samuel Palmer and decadent photographers (later) made the identification explicit.

Imagination allowed, but did not require, such radical departures from the observation of nature. Turner made accurate sketches in pencil knowing that subsequent works in color would efface and transcend the accuracy. Constable, not afraid to record with absolute fidelity a clump of fir trees in Hampstead, transformed what his physical eye told him it saw into John Constable's imagination on paper.

Constable's mastery as draftsman can introduce another meaning of imagination, the making of representations, or images. However high the valuation of imagination and vision, the romantics never abandoned particularity. Coleridge's Ancient Mariner has ingested the Wandering Jew, Jonah the scapegoat, and other archetypal figures, and there is something to Wordsworth's complaint that Coleridge's protagonist lacks the typifying characteristics of a mariner, but demoniac uniqueness does not conflict with particularity. The Polyphemus that Turner's Ulysses derides may be hard to see, but he is not some other giant, he is the Polyphemus of Book 9 of the *Odyssey,* no less—he is that Polyphemus and more. The usual meaning of the word "image" in English romantic literature is not a

trope, but a mental affect seemingly produced by perception of a physical object. Wordsworth writes of "the imagery of nature," but this sort of imagery, as well as metaphor, exists in the mind. The mind can modify either at once or in memory the sensation that agreed-on characteristics of the perceived object might be expected to cause. In the only context justified by the English romantic writers themselves, "imagery" is an assemblage of images. Yet Constable, usually thought of as the most externally visual of romantics, reveals in *Various Subjects of Landscape, Characteristic of English Scenery* a consciousness of meditation on ways of living within external nature while seeking nature within. He, like the poets, called such consciousness imagination.

Peter Thorslev has defined an "organic sublime": "Romantic or organic dialectic thinking is not inductive or empirical, much less experimental: it is basically intuitive, and what is intuited is the process as a whole."[15] What has been said above concerning imagination supports Thorslev's argument, but what must be said about image-making does not. The English romantic poets, eye on the object, are experimental, empirical, and tentative. In the furrow opened by Burns, they write about something turned up by the plow. Their favorite mode is to write of situation, occasion, encounter. Representing himself as wandering, the poet sees a host of daffodils; lying on the grass, he hears the babbling of a cuckoo that evokes memories; his occasion may be seeing the Elgin marbles or sitting down to read *King Lear* again. A counterpart is Thomas Lawrence's conversion of neoclassical portraiture into an impression of Miss Farren catching the viewer's eye in a fleeting moment.[16] The final lines of Keats's *Lamia* go beyond Wordsworth's objection to amoral botanizing upon the mother's grave, but they express a fear of abstraction that would deprive the poet of purples and pipings, of the feel and aroma of hay, of "sensations sweet," of synesthesia. A passage in Addison's essays on imagination anticipates Keats's *La Belle Dame sans Merci*: like a knight who awakes from a world of flowers to scene of desolation, so do we confront a world deprived by Locke of the secondary qualities of sound, smell, taste, and touch. The situations and occasions are very likely to include intuitive wonder: Keats stands on tiptoe to meet the dawn of creation.

Apotheosis of the imagination required attention to varieties of

vision. Most believers in imagination made certain concessions to empiricists: the senses give knowledge at least of external nature. (Always excepting Blake, for whom external nature is an erroneous report of the senses, fractured, factional, and factitious.) It was generally agreed that sight and hearing, in contrast with smell, taste, and touch, are intellectual senses that give the mind access to language from other minds. In notes for a lecture of 1808 Coleridge explained why "in correct Language Beauty has been appropriated to the Objects of the Eye & Ear—for these senses are the only ones that present a Whole to us combined with a consciousness of its parts."[17]

The eye was acknowledged to be not only the most useful but in every way the most powerful of the bodily senses. Blake, who calls for a fourfold vision that begins in seeing through rather than with the eye, has the agreement of the romantics generally on the superiority of internal vision. Wordsworth and Coleridge complain often of the despotism of the eye. A tyrannical eye could imprison mind along with the other organs of sense. Mind could not be altogether arterio-visceral nor merely nerves and brain. The romantics distrusted telescopes and microscopes as extensions of physiological perception. A kaleidoscope, full of suggestion, was preferable to John Dalton's use of a microscope to search for atoms. The physical eye and its extensions by instrument excluded suggestion, feeling, and intuition. A Wordsworth, a Ruskin, an Emerson, a Thoreau insists on empirical observation of particulars, but retains belief in nature as underlying principle—lasting, noumenal, and reachable through the imagination. Where, Coleridge asks, could Shakespeare have observed the language of generals as expressed by Othello? He asks in order to answer, "it was with the inward eye of meditation on his own nature."[18] Speaking of Hamlet's recommendation that the stage hold a mirror up to nature, the Alexander Lecturer of 1982 looks for the answer in audience response: "Did he not mean that which is recognizable and acceptable by an audience, that which speaks not merely to the eye, which can recognize the external form of things, but speaks rather to the spirit of the hearer? . . . 'Nature' surely is what people apprehend as true to life as they know it."[19] Characteristically, the romantics agree on the inade-

quacy of material reality verifiable by physical experiment, but find compensatory amplitude in "the inward eye of meditation."

Many enamored of natural theology took Locke to have said that mind has direct knowledge of objects, but Locke had intermittently asked salient questions: How accurate is the report of the senses? How can the degree of accuracy be tested? How far does the mind alter what the senses would otherwise report? As language is separated from its object by report of the senses and unmeasurable alteration in the mind, how far is our knowledge of ideas in the mind limited by language?[20] In a lecture of 1834 to the Academy of St. Luke in Rome, Tommaso Minardi described the situation without fear: "As everyone knows, visible objects form impressions in the mind of man, which, like images in a mirror, represent a real painting within him. As a result of the operating forces of his intellect, man always tries to put into action and express externally that which he feels most strongly within; thus he spontaneously produces the artifact of the painting according to his temperament."[21] *Ut pictura poesis* was agreed to hold for representational distancing in pigment or in words. Minardi spoke for many in taking physical sight as a challenge to spirituality. Attention to physical appearance, like attention to technique, distracts the spirit of a painter or a poet from its true calling.

Sight needed imagination, intuition, suggestion, feeling. For Wordsworth "thought" involves feeling, inward and contemplative emotion. He calls for the "sensitive eye," the "feeling eye," the inner eye open to the eye of heaven. When the poet remembers the Wye, in London rooms, he sees "not with a blind man's eye," and not, at such times, with an economist's blind eye. Coleridge was an admirer of Kepler, who recognized, and apparently was the first to recognize, that the retina creates a representation distinct from the psychological process of seeing.[22] Coleridge noted "with what cordiality" Kepler thanked Giambattista della Porta "for the invention of the camera obscura, as enlarging his views into the laws of vision."[23] Where the retina receives unmeaning sensations, the whole nervous system, Coleridge's "primary imagination," sees a man hanging from a tree; the mind, Tolstoy was to say in agreement with Coleridge, knows that what is seen thereby is evil. In his

journal for 1 September 1859, Delacroix explained what painters needed to know:

> In the presence of nature herself, it is our imagination that makes the picture: we see neither the blades of grass in a landscape nor the accidents of the skin in a pretty face. Our eye, in its fortunate inability to perceive these infinitesimal details, reports to our mind only the things which it ought to perceive; the latter, again, unknown to ourselves, performs a special task; it does not take into account all that the eye presents to it; it connects the impression it experiences with others which it received earlier, and its enjoyment is dependent on its disposition at the time. That is so true that the same view does not produce the same effect when taken in two different aspects.

Yet a watercolor by Girtin at the Tate shows the kind of reservation that needs to be made. Before he could select and imagine, and no matter to what degree the eye did his selecting for him, Girtin had to observe and consciously notice the precise moment at which the light of a setting sun caught the house and cast a long white shadow on the Thames.

There was the question of language. Wordsworth and Byron agreed—a rarity—that words are powers. Are they also things? Are they representations of things? Of ideas? When Coleridge is reported as saying, "It is not that the German can express external imagery more fully than English; but it can flash more images at once on the mind than the English can," a distinction is made between images flashing on the eye and images flashing on the mind.[24] If the mind refashions its selection from what the eye has selected, what sort of visualization went on in the reader of lines in Wordsworth's early poem *An Evening Walk*?

> Just where a cloud above the mountain rears
> An edge all flame, the broadening sun appears;
> A long blue bar its aegis orb divides,
> And breaks the spreading of its golden tides;
> And now that orb has touched the purple steep
> Whose softened image penetrates the deep.
> 'Cross the calm lake's blue shades the cliffs aspire,

With towers and woods, a "prospect all on fire;"
While coves and secret hollows, through a ray
Of fainter gold, a purple gleam betray.   (Final version, 168–77)

After imagining an "orb," did readers visualize watery "tides" before forming a mental representation of broken rays at sunrise? If "tides" and "the deep" called out of the memory an expectancy of ocean as the locale, was it memory of ocean, of graphic representations of ocean, or of words? That scene could be painted, and had been. Poetic diction made effective illustration of poems much easier than either Victorian detail or nineteenth-century exploitation of ambiguity would make it.

By dramatic monologues and other forms of what Robert Langbaum has convincingly named "the poetry of experience," the romantics raised further questions for themselves and their successors. Were the mental progressions changed more fundamentally, as Wordsworth believed, when he assigned simpler language in "The Thorn" to an imagined unreliable narrator?

"Ah me! what lovely tints are there
Of olive green and scarlet bright,
In spikes, in branches, and in stars,
Green, red, and pearly white!
This heap of earth o'ergrown with moss,
Which close beside the Thorn you see,
So fresh in all its beauteous dyes,
Is like an infant's grave in size,
As like as like can be:
But never, never any where,
An infant's grave was half so fair."

According to Wordsworth much later, he wished to invent for an observed object of nature communicable equivalents for the intense impression it had made on him. (Illustrator of a biography of Wordsworth here visualizes a poet observing a stunted thorn.) The stanza quoted asks the reader to call up an image of an infant's grave from memory of such or from an illustration offering contrast with the graves of adults—but not from language—and then to erase the memory. The stanza is an increment in the narrative process of the poem, evoking an image of a definable "heap of earth" but keeping

uncertain its identity as the grave of a infant. Nietzsche's principle in *The Birth of Tragedy* holds—"For the genuine poet, metaphor is not a rhetorical figure but a vicarious image that he actually beholds in place of a concept"—although the infant imagined by the poet may be, in the poem, buried near the thorn, actual but unburied, fantasied by villagers lacking pity for the mother, fantasied by a superstitious, hallucinating narrator who also fantasied the mother, or actual but not, in the narrative, seen by the easily frightened narrator. What is ultimately more significant than any of these ambiguities is Wordsworth's poetic creation of the thorn, "a mass of knotted joints," a "wretched thing forlorn," as a symbol of the miserable Martha Ray depicted in the narrative.

The romantic symbol is a particular image that admits of a variety of interpretations, extensive in range but ultimately limited by the particularity of the image. A romantic symbol differs from metaphor by incorporating the analogy within the subject or quasi-subject presented. If the assemblage of images or imagery is imitative of reality—Kubla Khan did a dome decree, the skylark soaring ever singeth—then the evidence of symbolism is to be found in the context of the image. If the assemblage of imagery is not imitative—I could build that dome in air, Bird thou never wert—the reader is invited to pursue the symbolic reference before proceeding in the context. Coleridge's definition in an appendix to *The Statesman's Manual* soars from a particular image of the physical eye to the empyrean:

> a symbol is characterized by a translucence of the special in the individual or of the general in the especial or of the universal in the general. Above all by the translucence of the eternal through and in the temporal. It always partakes of the reality which it renders intelligible; and while it enunciates the whole, abides itself as a living part in that unity, of which it is the representative.[25]

The temptation for an exegete is to announce triumphantly an equivalence not announced by any previous critic that proves what a word, a place, an event, or a character stands for, *means*—for example, Robert Penn Warren on sun and moon in *The Rime of the Ancient Mariner* or nearly everybody on Shelley's *Prometheus Un-*

*bound.* The habit lamented (but practiced) by Newman I. White persists: every reader her own allegorist. Linguistic analysis of ambiguities has approached much more closely the practice of symbolic suggestion among those we call romantics. The "sun," throughout the *Ancient Mariner,* means the sun, particularly as an indicator of time, direction, and geographical coordinates, but the moon carries implications of journeying, loneliness, femininity, dreamy illumination, and cycles of return as well as the irrationality that defines human nature and human existence. Much of Blake's work, if it does not eliminate temptation, resists finality; Urizen, like other names more consistent in Blake than what they name, calls for paronomastic etymologies, but horizon, *your* reason, Uranus, or even "your eyes in" or "your eyes end ('the limits of your perception')"[26] fail to account adequately for either the ironies or—in either Blake's special sense or a sense general to romantic symbols— the emanations. Samuel Palmer, in his period as disciple of Blake with visions of God in nature at Shoreham, painted in *Hilly Scene with Church and Moon* and *Coming from Evening Church* interchangeably Gothic forms of church, trees, and hills. "It is as if Palmer were anxiously preparing the Shoreham valley for divine inspection, and somewhat overdoing the tidying up."[27] Nature could not be more benignly fruitful than Palmer makes it. He continues Blakean excess but conveys a fruitfulness in which the actual can be recognized and approved.

The romantic impulse required neither excess nor insistence. Occasionally a word or phrase in Wordsworth's poetry will give a nudge that says, "Admire me, I am a symbol," but in his most distinctive narratives the reader listens for a whisper, "I am translucent." The "pleasure-dome" of willed contrivance in *Kubla Khan* is the "pleasure-house" of thoughtless pride, murderously offensive to nature, in Wordsworth's "Hart-Leap Well." Jonathan Wordsworth has inerrantly shown how the broken bowl and pitcher of Ecclesiastes, called to dinner like Pavlov's dog in Wordsworth's early poems *An Evening Walk* and *Descriptive Sketches,* gains the translucence of reality in the "useless fragment of a wooden bowl" of *The Ruined Cottage.*[28] In "Michael," the overt symbols are so declared by the characters according to rural custom. It is the way of shepherds to name a favored oak "the Clipping Tree" for the vocational act

performed annually beneath its shade. The hours Michael and his
wife spend at their traditional cottage industries are so unfailingly
extended that their cottage is known to neighbors as the Evening
Star. The patriarchal tone leads quietly from these overt symbols to
an identification of Isabel with Sarah, who bears, far beyond the age
of expected fertility, a son of promise. Luke, the son—like the New
Covenant Luke's Jesus—is typologically Isaac, to be sacrificed if the
Lord requires sacrifice. Michael and Isabel debate in the night, with
each other and then each in sleepless anxiety, the chances that a
prodigal will deserve the fatted calf. At the time of telling, a
"straggling heap of unhewn stones" remains as emblem of the
covenant by which Michael attempted to bind his son to the past
and to an envisioned future on this soil. The oak remains—England
has strength left to call upon—and shepherds atuned to the rhythm
of natural life still call that oak the Clipping Tree, but the cottage is
gone. The ruinous sheepfold is a reminder of an ancient way of life
that is failing through Parliamentary neglect; unless "Michael, a
Pastoral Poem" is sensitively read, and soon, a way of life as vener-
able as Abraham will, like the cottage, disappear, and this poem
will be its solitary monument.[29]

After I. A. Richards on Coleridge it was common for critics to
appeal to the principle of organic unity while explaining a subordi-
nation of mechanically articulated parts to the whole, whereas the
organic analogy meant to Coleridge that if you cut a living poem (or
fragment) it bleeds. A geographer drawing upon anthropology and
Konrad Lorenz for the conviction that we carry a primitive urge "to
see without being seen" can find in all landscape paintings the
symbols of prospect and refuge from hazard, but romantic practice
was much subtler, if you like more amorphous, than that.[30]

Although there are profound differences between the English
romantics and later absorptions into English of French symbolism,
as traced for example by Frank Kermode in *The Romantic Image,*
descriptions of symbolist practice that ignore the concretely occult
can be applied without change to the romantics: "they were all
synaesthetists . . . they were all symbolists: concerned with evoking
and exploring a world beyond conscious reality and contemporary
life, behind the naturalistic description and superficial word—a

world where dimensions of space and time spread out towards the infinite and the imagination could be free to roam to other moments in its history, all the way back to its 'earliest picture dreamings.' "[31]

Romantic uses of imagination and symbol congregate in J. M. W. Turner's densely translucent *Snowstorm: Hannibal and His Army Crossing the Alps*, exhibited in 1812. It has been well established in and for our time that this painting marks a departure for Turner from traditional methods as he had learned, practiced, and taught them at the Royal Academy. His finished paintings up to this time, like most American landscapes even after Cole's successors had seen Turners and read Ruskin on Turner, accepted their form from the Arcadian asymmetries of Claude. Turner would continue to set his seaport scenes in open rivalry with Claude's. In the *Hannibal* of 1812 he turned from rational rectangular, pyramidal, or diagonal order to the dynamic gyration of vortex. Rejecting Kenneth Clarke's suggestion that Turner was donning the Mannerist dress of serpentine recession, Jack Lindsay took off instead from Michael Kitson's proposal that Turner created in 1812 an "uncontrolled and dynamic" system that "made possible a much looser and more modern type of pictorial organisation"; in Lindsay's words, "the dynamic form of spiral, an explosive vortex, a field of force." Lindsay wrote specifically of the *Hannibal*: "In a vast cavern of churning elemental fury, foreground and distance are merged and separated by the spiralling tumult. Men emerge distinct in violence and rapine, though driven into patterns obedient to the storm, or are swallowed up in whirls of mist and light."[32] Andrew Wilton, relating the blur of the landscape to Turner's fusion of the hero with "the effect of his actions on the human condition," repeats the emphasis on innovation in method: "The crisp precision of his earlier delineations of the Alps is replaced by a vast blur of involved and battered fragments of the air in which the landscape is disintegrated."[33]

The *Hannibal* had the side-effect of propelling John Martin into his grandiloquent series of sublime settings that dwarf the protagonists—Manfred, Sadak, Nebuchadnezzar, the Last Man. It is also a giant haul in Turner's lifelong importation of the spontaneous

transparency of watercolor into oil on canvas.[34] His innovations of style and method from about 1807 to 1812 were so various that he cannot have been unconscious of a double aim, to be best and first.[35]

Turner's thoughts and feelings about individual works, other than their value in time required and payment due, are in general hard to ascertain, but he has left evidence enough of his sense of accomplishment in the *Hannibal*.[36] He paid exceptional attention to its positioning in the Royal Academy exhibition and to opportunities for having it engraved to demonstrate a new art of English landscape.

Even earlier than the consensus concerning the novelty of method there was general agreement also, on dubious grounds, concerning the subject and its implications. Turner's own title of convenience, as in a letter to J. O. Robinson, was "Hannibal." In exhibiting the picture at the Royal Academy, he included in the catalogue for the first time—the beginning of a habit—lines from the poem he called "The Fallacies of Hope":

> Craft, treachery, and fraud—Salassian force,
> Hung on the fainting rear! then Plunder seiz'd
> The victor and the captive,—Saguntum's spoil,
> Alike, became their prey; still the chief advanc'd,
> Look'd on the sun with hope;—low, broad and wan;
> While the fierce archer of the downward year
> Stains Italy's blanch'd barrier with storms.
> In vain each pass, ensanguin'd deep with dead,
> Or rocky fragments, wide destruction roll'd.
> Still on Campania's fertile plains—he thought,
> But the loud breeze sob'd, "Capua's joys beware!"[37]

Commentators on the painting, with Turner's verses in the catalogue in mind, have usually written as if it were Turner's Hannibal and Hannibal's army that committed violence and plunder "in vain," but Turner's words say that the Celtic mountaineers ("Salassian force") by treachery, plunder of what Hannibal had brought from Saguntum, stones hurled and rolled, and successive acts of destruction, were acting, though aided by storms, "in vain" as Hannibal proceeded according to plan and improvisation. The treacherous and fraudulent failed to dim the hopes of Hannibal,

who would go on to astounding victories in Etruria and Umbria and at Cannae.[38]

Polybius gives a fuller account than Livy of the ferocity and confusion of events during the crossing. In an earlier book, Livy revealed that even in 412 (340 B.C.) Capua was "destructive of military discipline, through allurements of every kind of pleasure."[39] Livy 23.14–18 tells of the "sleep, and wine, and feasting, and harlots, and baths, and idleness" that weakened Hannibal's soldiers in body and spirit (*enervaverunt corpora animosque*) when he wintered in Capua in 216 B.C. Livy notes the paradox and draws the moral of Turner's verses: warriors not broken by any extremity in the Alps were undone by excess of pleasures. This debilitating Capua appears only in the verses, not in the painting.

It is a common error to believe that elephants were among the beasts lost by Hannibal at the crossing. About 1827, in a trial watercolor to illustrate lines by Samuel Rogers on Hannibal passing that great barrier, Turner followed Rogers closely in depicting prominently a fallen elephant and horse, but his revised version and the engraving made from it, for "The Alps" in the 1834 edition of Rogers's *Italy,* include in the foreground a fallen horse and rider but a prominently upright elephant and baldachin.[40] Even Andrew Wilton, a splendid interpreter of Turner, has in the past said of the *Hannibal* of 1812: "The hero himself is nowhere to be seen."[41] In the distance, however, just below the whited yellows of the snow-storm, an orderly procession is dominated by a mounted elephant outlined against the storm.[42] It would not be Turner's way to name Hannibal in the title and exclude him from the painting. The *Hannibal* conforms to Turner's usual practice of giving the protagonist a minute place visually but a major role symbolically. Turner's own lines look with the eyes of "the chief" on the treacherous hostility of the Gauls. His painted Hannibal in the Alps successfully joins courage and imaginative use of power: what he needs to fear is success.

Livy, Polybius, and their redactors agree on the most remarkable of several remarkable feats in Hannibal's passage of the Alps. Baffled by the rocky narrowness of the way, his thought of detour thwarted by a fresh fall of snow, Hannibal set his soldiers to work

building a road over which his thousands of foot soldiers and cavalry, and his thirty-seven elephants, could pass. Wordsworth, in the essay added in 1815 to the Preface to *Lyrical Ballads,* made use of a point Coleridge had made to him not later than 1807:

> every author, as far as he is great and at the same time *original,* has had the task of *creating* the taste by which he is to be enjoyed: so has it been, so will it continue to be. This remark was long since made to me by the philosophical Friend [Coleridge] . . . The predecessors of an original Genius of a high order will have smoothed the way for all that he has in common with them;—and much he will have in common; but, for what is peculiarly his own, he will be called upon to clear and often to shape his own road:—he will be in the condition of Hannibal among the Alps.[43]

When Wordsworth returned to the subject later in the same essay, he made clearer his sense of originality as a meeting of original perspective on a subject and original method: "Genius is the introduction of a new element into the intellectual universe: or, if that be not allowed, it is the application of powers to objects on which they had not before been exercised, or the employment of them in such a manner as to produce effects hitherto unknown."[44] Schoolboys had learned, and Wordsworth had remembered, that Hannibal as roadbuilder in the Alps had performed one of the greatest feats in military history. In accepting the hardships of climbing and cutting a pass, Hannibal, Wordsworth, and Turner have a goal before them. Some of the life-voyages portrayed by Thomas Cole have a less certain goal.

A romantic Hannibal looking from the heights into Italy is the Balboa looking with surmise at the Pacific, Cortez staring at Mexico City, Pizarro seeking El Dorado and seeing with amazement an Inca palace, as fused in Keats's sonnet "On First Looking into Chapman's Homer."[45] The voyages of simultaneous discovery in life and art, for Baudelaire and Rimbaud, even for Browning and on to Robert Motherwell,[46] affect effort and novelty as in themselves a sufficient goal aesthetically to allow other aims to be left indeterminate; such voyages begin in Wordsworth's and Turner's radically arduous climbs. Though more metaphorically than the Hannibal in a poem

by Thomas Gisborne that influenced Turner's painting, Turner hoped to "shake the towers of Rome." Hannibal conquers topography as Turner conquers and destroys topographical landscape painting.

In 1844, enunciating his claim as discoverer of photography, Fox Talbot quoted on the title page of *The Pencil of Nature* Virgil's *Georgics* 3.292–93, translated in Beaumont Newhall's edition of Talbot's work, "Joyous it is to cross mountain ridges where there are no wheel ruts of earlier comers, and to follow the gentle slope to Castalia." The parallel with Turner, Wordsworth, and Coleridge as creative road-finders becomes clearer in the context, as Virgil approaches the grubby subject of fleecy sheep and shaggy goats:

> Here is toil, hence hope for fame, ye sturdy yeomen! And well I know how hard it is to win with words a triumph herein, and thus to crown with glory a lowly theme. But sweet desire hurries me over the lonely steeps of Parnassus; joyous it is to roam o'er the heights, where no forerunner's track turns by a gentle slope down to Castalia. Now, worshipful Pales, now must we sing in lofty strain.[47]

Roadmaking as an emblem of romantic originality is consonant even with Morse Peckham's reopened definition of imagination as mere innovation, any innovation, good or bad, useful or "silly and vicious."[48]

The great contemporary roadbuilder and crosser of the Alps was Napoleon. In 1802 Turner had studied in the Louvre paintings that were part of Napoleon's loot from Italy. He had visited David's studio and seen there *Le Passage du Grand-Saint-Bernard* (*Napoleon Crossing the St. Bernard Pass*), a triumphant image still vivid to Turner when he illustrated in the 1830s Sir Walter Scott's life of Napoleon. On the stones in the foreground, as carved below the name of Napoleon, David made visible the letters ANNIBA, as if partly effaced by Napoleon's accomplishment, and below these great names that of Charles VIII, who in 1494 had been the first to cross the Alps with artillery. Painters and poets crossed the Alps, not with artillery, but with imagination. When Wordsworth reflected on the failure of his physical senses to tell him that he and his companion had crossed the highest point of the Simplon Pass, he

exulted in the conclusion that it is imagination, not the senses, that brings true communion with the underpresence of nature, the "invisible world," in the metaphor of organic growth extended through sublimity to infinitude, what is "evermore about to be."[49]

Byron's Manfred contrasts his own spiritual risktaking with the honest chamois-hunter's humdrum days in the Alps, and one of Coleridge's self-mirrorings as a chamois-hunter, though rejecting scientific fact as worthy game, seems to rest satisfied with Swift's grower of grasses, pursuing "a nobler purpose, that of making a road across the Mountain in which Common Sense may thereafter pass backward and forward."[50] He takes on the role of chamois-hunter as a prose-writer whose immediate aim is truth. The reader, he says, has *chosen* the chamois-hunter as guide:

> Our guide will, indeed, take us the shortest way, will save us many a wearisome and perilous wandering, and warn us of many a mock road that had formerly led himself to the brink of chasms and precipices, or at best in an idle circle to the spot from whence he started. But he cannot carry us on his shoulders: we must strain our own sinews, as he has strained his; and make firm footing on the smooth rock for ourselves, by the blood of toil from our own feet.[51]

Perhaps something should be made of the shifty identification, Coleridgean in every shift, both with the hunter and with the reader; the important point for us at the moment is that the artist (poet or painter with poetry in his brush) has a higher calling in the Alps than pursuit of fact or experimentally derived truth, admirable though those rational activities may be.

Constable, whose quiet sublime is often squintingly contrasted with the lightbursts of Turner's imagination, summarized the case for roadbuilding in his introduction to *Various Subjects of Landscape, Characteristic of English Scenery* (1833). He calls for this higher reach without mentioning imagination, the sublime, or Hannibal—a designation of Turner is not to be expected. He identifies in art as in literature two modes, (1) imitate, or select and combine; (2) seek perfection at art's primitive source, Nature, "thus adding to the Art, qualities of Nature unknown to it before":

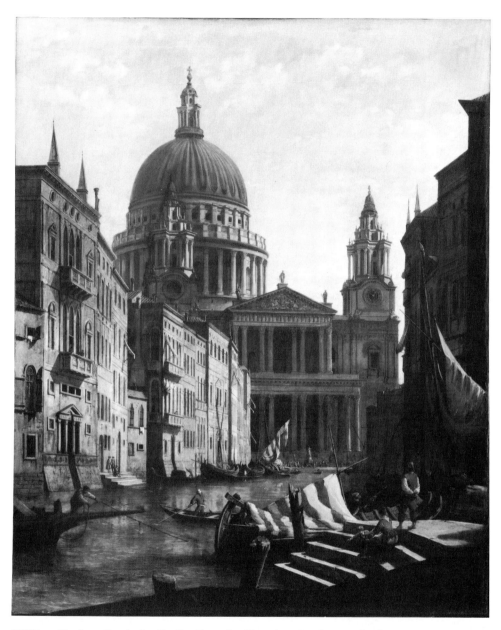

*William Marlow,* Capriccio: St. Paul's and a Venetian Canal. *In Coleridge's terms, the "fixities and definites" of fancy in contrast with imagination, which "dissolves, diffuses, dissipates, in order to re-create."*

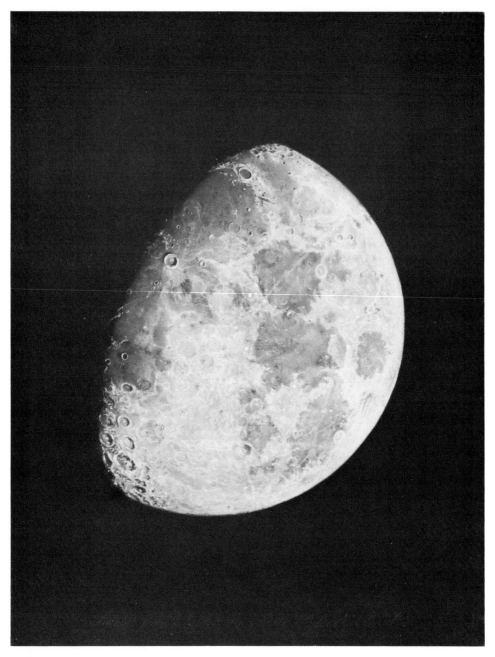

*John Russell,* The Face of the Moon, *ca. 1790–1795, with the calligraphic inscription,
"Painted from Nature by John Russell R.A." Fidelity to nature with the aid of scientific instruments and the pathos of solitude in subjective interchange with natural phenomena.*

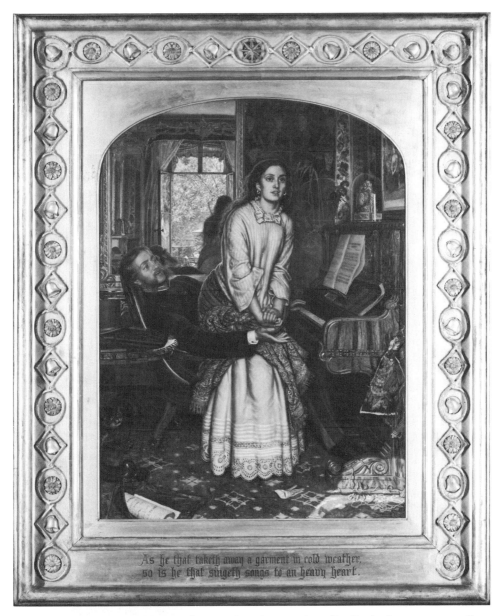

As he that taketh away a garment in cold weather,
so is he that singeth songs to an heavy heart.

*William Holman Hunt*, The Awakening Conscience, *1853. Pre-Raphaelite earnestness, allegory, meticulous detail, and homage to the healing powers of nature.*

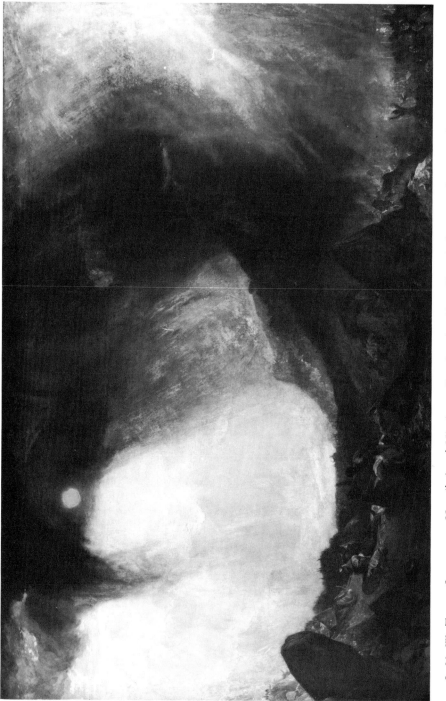

J. M. W. Turner, Snowstorm: Hannibal and His Army Crossing the Alps. *Turner's first major disruption of picturesque conventions.*

The results of the one mode, as they merely repeat what has been done by others, and by having the appearance of that with which the eye is already familiar, can be easily comprehended, soon estimated, and are at once received. Thus the rise of an Artist in a sphere of his own must almost certainly be delayed; it is to time generally that the justness of his claims to a lasting reputation will be left; so few appreciate any deviation from a beaten track, can trace the indications of Talent in immaturity, or are qualified to judge of productions bearing an original cast of mind, of genuine study, and of consequent novelty of style in their mode of execution.[52]

To deviate from the expected beaten path, to be the first English painter to take "slimy posts" seriously, will continue to seem timid in contest with Turner and Hannibal crossing with Alps, but Constable and the quietistic side of Wordsworth share with Turner the assurance that originality arises stubbornly from the unique inspiration of holistic genius.

Turner's complexities were a perpetual defiance of convention. If reservations are to be made about the degree of affirmation in the *Hannibal,* they can be cancelled, or near it, by appeal to romantic irony. Few romantics could have been more ironic than Turner. Often it is said that his *Saltash with the Water Ferry,* exhibited in his private gallery in 1812 and now part of the very lean Turner holdings in the Metropolitan Museum in New York, contains as graffiti on a Gothic buttress in the foreground, right, Nelson's patriotic words "England expects every man to do his duty." All viewers know the words, and Turner knew they would know the words, but they are represented as partly effaced. What England expects may not be occurring. When Charles Eastlake was elevated to R.A. in 1830 Turner congratulated him: "my dear Charles you are now a complete brother labourer in the same Vineyard and England expects every Man to do his duty"—bearing wrily some of the weight of Blake's remark, on exclusion from such ranks, that England expects every artist to be an obedient ass.[53] The original viewers of *Saltash* in that tense time of war could identify among those brought to a pause for the ferry redcoats, workers, and dedicated idlers, and could make out a further word, "Beer."

Contrary to the assumptions of later critics, Turner revived the medieval practice of depicting sequential or disjunct events in different areas of the same canvas.[54] He located Juliet and her nurse in a city where Shakespeare had not thought to send them. *Rome from the Vatican, Raffaelle Accompanied by La Fornarina, Preparing His Pictures for the Decoration of the Loggia* is as complicated as its title in viewpoint, perspective, and historical anachronisms.[55] One reason for such surprises may be, as John Gage suggested in 1987, that such initially enigmatic titles as *Ulysses Deriding Polyphemus* draw the viewer close enough to examine the surface of the painting, as Turner desired. Two later works for which Turner would have kept the *Hannibal* in mind share with it paradoxes of detail. *Valley of Aosta—Snowstorm, Avalanche, and Thunderstorm* (Art Institute, Chicago), with the vortex of storm again central, includes one group of five persons calmly at work and three staring above *us* in apparent consternation, with a dog that seems to bark in alarm at *them*. In a large watercolor, *The Passage of the St. Gothard* (Abbot Hall Art Gallery, Kendal), packhorses trudge along a road almost suspended between the steep mountain wall on the left and the deep chasm that draws the eye infinitely down; further on, toward the pass, a cross emblematic of disaster is tiny in physical perspective but massive in impact. Compositionally it matches the tiny elephant of the *Hannibal*; its signification is a polar opposite. Ronald Paulson has found in the sun and air of Turner's late works "the paradox, or the contradiction or the impossibility—the temerity—of painting directly with human pigments the aerial substance."[56] Awareness of the paradox and the temerity is evident as early as the *Hannibal*; as with Coleridge's attempts to reconcile the empirical and the ideal, awareness that total success is improbable does not stop the effort.

Romantics were not unmindful of the burden assumed in the recreation of nature by imagination and the fusion by imagination, always prospective, of self and not-self. That the protagonists of Turner's historical landscapes are usually minute and often peripheral to the eye does not prevent the mind from discovering their heroism. Turner was more nearly willing to be called vain than to be proved vain. Such defiance of the fallaciousness of hope as his has come to be called romantic irony.

Friedrich Schlegel was the first to define an irony that acknowledges the decay of Newtonian order; a clear awareness of the eternal flux of the infinitely full chaos of the universe we inhabit.[57] Other contemporaries besides Turner located the chaos and flux not merely in the measurably sublime but in effects more evanescent, disturbances more common, storms more frequent than volcanic eruption or earthquake. Schlegel found the distance between reality and the classical ordering of art so great that an aesthetic formlessness is called for; deprived of a sense of polygonal enclosure, the artist might rise above pain and joy by transcendental buffoonery. Schlegel observes that Cervantes, Shakespeare, Sterne, Jean Paul Richter, and even the later Goethe smile down in irony on their characters. Schiller had observed in 1795 (*Briefe über ästhetische Erziehung*) the capacity of irony to make the artist superior to nature through the illusion of art.[58] Although Schlegel did not put special stress on the breaking of illusion, immediate practice and later theory concentrated on authorial intrusion to question form, method, and message. Art as unexamined imitation is countered in Schlegel's *Lucinde,* in Tieck, Hoffmann, Brentano, and Heine.[59] Except for a darker vision of the life that Wordsworth calls "the only Paradise we will ever know," Kafka's "Das Paradies" describes romantic irony precisely. It is possible, says Kafka, that expulsion from Paradise means that we continue to live in Paradise without knowing it, and must destroy ourselves in the attempt to act according to our knowledge of good and evil, an attempt that the human condition requires us to continue despite our lack of adequate strength and our awareness of the lack. Romantic irony is a question of will, not reason; after Kant, God was not Reason but Will.

The younger English romantic poets, Byron, Shelley, and Keats, display in various ways the romantic resolution of Hume's skepticism, the romantic irony of meeting obstacles by proceeding through them. "I go on until I am stopped," says Shelley, "but I am never stopped." Keats fears, right up to the point of knowing, that imagination deceives, but in Keats as poet imagination as divinity will survive all other gods. If human reason can never achieve certain knowledge, Shelley concludes, then it is better to choose the "beautiful idealisms" of love than, say, a frequently chosen alterna-

tive, conflicts of inequality. Besides smashing idols and breaking the illusion of its own narrative, Byron's *Don Juan* presents such ideals as young love, sacrifice for national independence, and admiration for the forces of nature as simultaneously silly and requisite for any human existence worth having.

Keats introduced the verse-epistle portion of his letter to J. H. Reynolds on 25 March 1818 by describing the meteorological chaos of Devon, "a splashy, rainy, misty snowy, foggy, haily floody, muddy, slipshod County." The blank verse begins with incongruities to illustrate a jumbled state of dreaming: the gruff Hazlitt playing with Maria Edgeworth's cats; Junius Brutus Booth, who acted sublime Shakespearean roles at Covent Garden, stumbling drunk in Soho. The middle passage describes the incongruous architecture and indeterminate activity in Claude's "Enchanted Castle," as available in the black and white of the *Liber Veritatis* (which matches Keats's lines as an engraving by William Woollett and the oil painting do not). In vision, the black and white is "touched into real life" with "Titian colours," and heightened further into a confusion of magics—Merlin, Mohammedan, Lapland. Lines acknowledging a lack of reason and knowledge needed to unscramble these elements imply rather that reason is not up to the dream. Looking toward the sea brings the poet "a mysterious tale" beyond telling of "eternal fierce destruction," the view of Wesley and Irving that nature is not nice. Concern for his correspondent's temporary illness, close watch over his brother Tom's rapid decline toward death, and medically trained awareness of his own fatal symptoms have made good cheer difficult, but—here is the romantic irony—all he has written to Reynolds illustrates, not, as Blake would have it, philosophical errors in Paley and natural religion, but the "horrid moods" that rise unbidden to an individual consciousness. Both the post-Napoleonic era and imagination include unmapped regions of residual darkness. If circumstances turn his mood upward, he will begin a "new romance"—which Keats's biographers take to be *Isabella*. The previous day he had lamented to another friend, James Rice, that "Alas!" we cannot settle into permanent contentment within "a sort of mental Cottage" with a pleasant back garden and a cheerful front garden. In truth it would have been "Alas! Alas!"

had such stasis prevailed; imagination and irony needed to go always forward together into dark chambers.

The tension of perseverance was certainly not confined to Byron, Shelley, and Keats. In Blake's *Urizen* parody of rational interpretations of Genesis, Los, in trying to limit Urizen and create a world of imagination in mundane conditions, engages in a parodic repetition of the characteristically limiting acts of Reason; and his name, Los, carries a clearer implication of loss (in fall from the eternal Urthona) than of the generally accepted Sol, the sun. Perhaps George Inness's ambiguous painting *The Lackawanna Valley* (1855, now in the National Gallery in Washington) is a visual example as good as any: commissioned by a railway, the painting seems to renounce and retain a nostalgia for the wilderness of the picturesque; the oncoming train shares the center in the middle distance only with the roundhouse.

Constable's ambivalence toward the staffage added to his finished six-footers in and after 1819 is at least related to romantic irony. Irony may seem crude enough in the collie lifting its leg on the artist's signature in David Wilkie's *Pitlessie Fair,* the painting he brought to London in 1805, and perhaps seems not altogether romantic in *The Blind Fiddler* of 1806 (commissioned by Sir George Beaumont), in which the boy imitating the fiddler with bellows and poker and standing under his own imitative drawing of the Pretender represents a budding artist, "an imitative genius in embryo," and by other inserted indicators, Wilkie himself.[60] With a drier prescience than Wilkie, Turner signed an early architectural watercolor, *St Erasmus and Bishop Islip's Chapels, Westminster Abbey*, on a burial slab in the floor.

The irony of experience without meaning may well be the human condition, as some have of late insisted, but the effort here is to identify something much more limited, not even the general uncertainties that underly all utterances by those we call the romantics; rather an irony arising sporadically in romantic art but characteristically in the younger English romantic poets, of simultaneous awareness of insuperable obstacles and determination to ride through them. Continuation, carrying on, while doubting "that doubt itself be doubting," marks romantic irony off from other

kinds—the Swiftian, to say one thing and expect to be understood by the elect to mean another; the Socratic, repeated in Abe Lincoln and Will Rogers, to have only the wisdom of questioning those who think they know; dramatic, by which the audience can take an actor's words in a sense unavailable to the character represented; the noblest of the several Sophoclean ironies, the cosmic; and the irony of paralysis that intensified from Samuel Butler to Prufrock to Kafka to Beckett. Perhaps Wallace Stevens represents a category between the romantic and the Prufrockian; whereas the romantic urges action without claiming to find rational justification, Stevens stirs out of paralysis but hesitates to seek language that would say whether there is justification for stirring, or if there is justification, whether the jar to contain it would hold reason, sensation, feeling, or aesthetic intuition. The romantic ironist, Jean Paul or Byron or Turner, maintains a self-questioning mobility. Byron counted imaginative poets and idealizing sculptors along with Alexanders and Hannibals, Luthers and St. Pauls along with Muhammads, as madmen who have made men mad. Shelley questions the same range of assertors, from Alexander to Kant to Shelley, in *The Triumph of Life*.

Turner's *Hannibal* does not depict a synchronous universe with the orderly ratios of Newton or Kepler, nor Paley's pantry divinely stocked for the needs of the adult male, nor the sacred atmosphere of spirits controlling the cycles of nature as in Poussin's *Orion*, Giordano Bruno, Thomas Burnet, or the uncompromisingly irrational world of Coleridge's *Ancient Mariner*.[61] From the dark vertex of the swirling cone, night injects remorseless winter. Turner's perspective in *Hannibal* is unillusioned. But the firmly outlined elephant, carrying Hannibal forward, is a romantic emblem of encroachment by the artist on the overfull chaos. Turner, like Wordsworth in *The Prelude*, acknowledges only symbolically, but with little remorse, his own colossal ambition.

# THE
# SUPERNATURAL

The fall of reason brought greater authenticity to dreams, hyp-notic states, unconscious impetus, and spectral vision. Publishers began to reprint, or to print from edited manuscripts, the earliest European literature they could find, and writers searched such works for superstitions to redeem. Charles Lamb scolded Coleridge into removing the word "Reverie" as subtitle for his narrative of travel into tutelary spirits, water snakes, and skeletal bestowers of Death-in-Life, but dream-visions came in various guise to Shelley and to Keats "as naturally as leaves to a tree." Such dreams as that of the Malay who had stood at the door of his house and his conscious-ness in the Lake country, in De Quincey's *Confessions of an English Opium-Eater,* became in the sequel, *Suspiria de Profundis,* fused rather than layered in the palimpsest of the mind.

Goethe, in the axioms quoted by T. H. Huxley, explained: "That which is unnatural is still Nature." Nature retains mysteries. "She wraps man in darkness, and makes him for ever long for light." Huxley was certain that the scientific progress before and after Goethe would continue, but he granted, in 1869, "we have a super-superlative of our own."[1] The epigraph from Thomas Burnet that guides the reader into *The Rime of the Ancient Mariner* declared the faith: mechanical laws of force and inertia account less persua-sively for the experience of mental travelers than belief in tutelary spirits could. "Little we see in Nature that is ours," so little, added Wordsworth in "The world is too much with us," that even poly-theistic pagan animism has something to teach us. Blake would not have proclaimed his belief in the authenticity of poems that Chat-

terton attributed to Rowley had he in fact accepted Chatterton as author of the poems, but Blake felt certain that belief was better than doubt. Romantic valorization of faith must be kept in mind if the earliest reception of early nineteenth-century literature of the supernatural is to be approximated or comprehendingly appraised. Despite such affirmations of irrational nature, given the usual puny sense of the word "nature" as referring to what in the phenomenal world grows or erodes, it is unsurprising that Raimonda Modiano's subtle account of changes in Coleridge's *Weltanschauung* utilizes the generalization of "Coleridge's disenchantment with nature," or that Coleridge himself wrote in 1825 of Nature as "a wary wily long-breathed old Witch, tough-lived as a Turtle and divisible as the Polyp," whose "Winter Blasts" were transformed by the human mind into "Pindaric Odes, Christabels & Ancient Mariners set to music by Beethoven."[2] The nature that disenchants him he describes in preternatural terms.

He complained in 1806 of the Unitarian movement redirected by Joseph Priestley: "God becomes a mere power of darkness, even as Gravitation, and instead of a moral Religion of practical Influence we shall have only a physical Theory to gratify ideal curiosity—no Sun, no Light with vivifying Warmth, but a cold and dull moonshine, or rather star-light, which shews itself but shews nothing else."[3] It would be wrong to attribute such unease solely to religious conviction. After Coleridge, Constable may be called as witness: "He would never admit of a distinction which is sometimes made between poetry and truth. He felt that the *supernatural* need not be the *unnatural*."[4]

The frequently described curve from eighteenth-century Christian belief in a supernatural realm of spirits to a secular realism that gradually reduced all fantasy to abnormal then to normal psychology, whether defended or refuted, needs modification.[5] True, Andrew Baxter argued in a work that enjoyed three editions from 1733 to 1745 that dreams result when "separate, intelligent Beings" excite "our visions in sleep."[6] Equally true, no study of dreams or mind taken seriously by philosophers thereafter asserted such a strong duality of natural and supernatural. Robert Macnish, who followed *The Anatomy of Drunkenness* of 1827 with *The Philosophy of Sleep* in 1830, agreed completely with Coleridge in arguing that

nothing *new* enters the mind in dreams, which, though affected by the physical circumstances of the sleeper, are "old ideas"—meaning all sensations, feelings, and reflections that have passed through the sensorium—such ideas "revived either in an entire state, or heterogeneously mingled together."[7] In a smoky chamber, a person might dream of a city in flames; a man with a blister applied to his head might dream of being scalped by Indians. Whatever the external stimulus, the dread characteristic of nightmare indicates a diseased state of the dreamer. Dreams never occur in complete sleep, which "is a temporary metaphysical death, though not an organic one" (p. 9). In this view, works of fantasy can be contrived by the sane and healthy, but Hobbes is right to call imagination diseased memory. Macnish accepted Coleridge's explanation of *Kubla Khan* as evoked by opium, and agreed with Coleridge on the notable absence, from both sweet and nightmarish dreams, of a sense of surprise. Prophetic accuracy could only be coincidental. Philosophic analysis of dreams had thus freed itself of supernatural elements. Coleridge, who explained biblical and all other apparitions psychologically, thought Mesmeric hypnotism explained at least in part witchcraft, ancient oracles and their priesthood, and other superstitions.[8]

Meanwhile, however, beginning with Horace Walpole's *Castle of Otranto* in 1764, a literature of the fantastic and "horrid" exploited the pleasures of fear without reference to belief. Ann Radcliffe, at the end of the century, was the most successful, but not otherwise alone, in lending respectability to horror by rational explanations at the close. Sensitive, hallucinating maidens who had not died of fright learned at the end of a prose romance or narrative poem that theirs was a false choice: they should have chosen to be reasonable.[9] Writers contemporary with Radcliffe but later designated as "romantic" used the supernatural to express convictions that our world is not a mechanistic contrivance and the human mind is not fundamentally rational. In the amplitude of full reason that is imagination it is not reasonable to be rational.

Intermediate between release of the reader's terror by rational explanation—"Boo! look at the bloody old monk-meted gash beneath these rusty chains" turning to "Don't worry, child, it's only me"—and the supernatural of suspended disbelief practiced by Coleridge come the narratives of drunkenness or imposed anxiety as

sufficient cause for seeing witches but with one unexplained talisman, like the stump of a tail in Burns's *Tam o'Shanter,* or a canny narrative of a canny Scot who can achieve justice by guessing who consorts with the devil, as in "Wandering Willie's Tale" in Scott's *Redgauntlet.* A similar story by Balzac, *La Maison rouge,* begins with characters in wartime who know from reading Scott and Hoffmann what romantic conditions should be, but Balzac's story substitutes for canniness a French condition of honor: can a Frenchman by marrying appropriate the heritage of the daughter of a murdered German? Here gently mocking a fashionable taste for the supernatural, Balzac elsewhere is fantastic enough, but with a dryness not common in Germany and England until later in the century. The supernatural more than most subjects and modes was passed rapidly back and forth among European and English-language literatures; only severe surgery could make the supernatural in Britain available for isolated study.

On balance, despite the displayed skills and obtrusive knowingness of Laurence Sterne, the cult of sentiment that underlay the Gothic seems more moral than aesthetic: tender emotions cleansed the heart. Sentiment and terror, the beautiful and the sublime, are the chiaroscuro of Radcliffe and other "horrid" romancers. The allied ethics of traditional Christian dualism emerge from folk materials into German tales of the not-quite-human, for example Chamisso's *Peter Schlemihls wunderbare Geschichte,* of the shadowless man, and Fouqué's *Undine,* of a water sprite who by less-than-human nature is cold and tearless. Such stories remind the reader how desirable it is to have a soul if one wishes human companionship. Chamisso, like E. T. A. Hoffmann, was a botanist, and Peter's loss of shadow is a contraction into soulless Linnaean classification. Students of nature were beginning to seem, even to themselves, peculiarly unnatural. *Schlemihl* and *Undine* continue eighteenth-century conceptions of unnatural conduct, but one diminishes and the other cancels reprehended villainy.

Longer German and English narratives of terror, taken in the bulk, seem as speciously moral and frivolously entertaining as a critic in 1797 took them to be:

> [Terror] is now so common, that a Novelist blushes to bring about a marriage by ordinary means, but conducts the happy

pair through long and dangerous galleries, where the light
burns blue, the thunder rattles, and the great window at the
end presents the hideous visage of a *murdered* man, *uttering*
piercing groans, and developing shocking mysteries. If a cur-
tain is withdrawn, there is a bleeding body behind it; if a chest
is opened, it contains a skeleton; if a noise is heard, somebody
is receiving a deadly blow; and if a candle goes out, its place is
sure to be supplied by a flash of lightening. Cold hands grasp
us in the dark, statues are seen to move, and suits of armour
walk off their pegs, while the wind whistles louder than one of
Handel's chorusses, and the still air is more melancholy than
the dead march in Saul.[10]

The critic next gives a recipe for producing three volumes of such
stuff, including a ruinous castle, assassins, threescore whispers and
groans, and "an old woman hanging by the neck; with her throat
cut." There was also ghoulery on the stage, continuously between
"Monk" Lewis's *Castle Spectre* (1797) and Maturin's *Bertram: or, The
Castle of St. Aldobrand* (1816), in which Bertram stabs Aldobrand,
whereupon the widow goes mad, kills her son, and is killed by
Bertram, who declares before stabbing himself, "I loved her, yea, I
love, in death I loved her—I killed her—but—I loved her." In
1820 James Robinson Planché, dramatist and stage-planner, pro-
vided a new kind of vanishing point in the vampire trap, to great
applause and unceasing imitation. Theorists of the fantastic agree
that the supernatural can become a separate category only after
general agreement on what is natural.

Those we call English romantics asked both "terrorists" and
rationalists to look again at hard evidence. They took a serious
interest in the survivals of pre-Roman exertion and primitive belief.
Only Austen, who lived near Stonehenge, managed not to share the
awe of the later Hardy, who lived west of it, or of Wordsworth, who
carried gloom through Salisbury Plain on his way to the Wye, or of
the watercolorists, who could not resist the challenge of menhirs
made sublime by speculative association with Druidical rites of
sacrifice, or even of the pragmatists who calculated probabilities of
astronomical, agricultural, or piscatory purpose. Gothic cathedrals,
later to be recognized as analogues in stone of the music of the
spheres, ceased under the pressure of relativizing history to be crazy
models for gleeful folly or emblems in fiction of moldy ruin: by

1801 they were products of the internal laws of national growth. The "Renaissance" was as yet undiscovered; "our ancient authors" extended from the nearly hieroglyphic Anglo-Saxon up to Locke and the word-flattening Royal Society. Wordsworth took the bloodier ballads in Percy's *Reliques of Ancient English Poetry* (1765) as representative of venerable natural superstition that shamed the trumped-up sensationalism of theater pieces imported from Germany or derived from that horrid source. The successes of Cagliostro and Mesmer, or nearer to home, the accomplishments of Thomas Wainewright with pen, pencil, and poison, could be taken as proof of general gullibility or as evidence of nature's fertility in generating the unpredictable and inexplicable. Among concrete survivals, the romantics counted myth, meaning narrative that imbues image with conceptual significance. Hellenic myth would serve, but indigenous myth seemed less resistant to fresh treatment.

In retrospect, the path from the picturesque to the supernatural may look steeper than it was. In literature it went upland through forgeries to enhance an indistinct past (Macpherson's Ossian, Chatterton's Rowley); through literary ballads resurrecting ancient possession by demon lovers;[11] by way of the cultic fragment (as many studies of *Kubla Khan* testify); and by way of the hoax of discovered manuscripts, with the editors of *Blackwood's* practicing a stage intermediate between Ossianic forgery and the authenticating manuscript or cache of letters that frames innumerable fictions of the supernatural. These markers point also, perhaps Ossian most of all, to ways that night thoughts in country churchyards and English transcendence of reason returned enriched from Germany, as in Bürger's *Lenore,* Goethe's *Erl-Koenig,* Schiller's *Der Geisterseher,* and with cascades of magic but less murk, Wieland's *Oberon.*

Longer works of demonic possession trace the arduous climb and vertiginous fall of an archetypal overreacher, the human will in earthly confinement insatiably yearning toward forbidden knowledge. Only a striving for the attenuated atmosphere of the Alps—and sometimes not even achievement of those heights—could divert such restless aspiration from the fate of a sensualist like Shelley's Count Cenci, whose physicality perverts spiritual need into a fatal drive toward stronger and stronger sensation. Escape from nature is escape into trouble.[12] Klingsohr's allegorical tale in Chapter 9 of Novalis's *Heinrich von Ofterdingen* points to a resolution

through the creative imagination—wisdom + peace + love = poetry—but the literature of terror never justifies a protagonist other than a poet or painter for seeking victory through expansion of consciousness. For all others bargaining for transcendence, the Devil will seal the contract in the presence of outraged nature, as at the end of *Ambrosio, or the Monk* (1795) by Matthew Gregory Lewis:

> As [the fiend] said this, darting his talons into the monk's shaven crown, he sprang with him from the rock. The caves and mountains rang with Ambrosio's shrieks . . . The eagles of the rock tore his flesh piecemeal, and dug out his eye-balls with their crooked beaks . . . On the seventh [day] a violent storm arose: the winds in fury rent up rocks and forests: the sky was now black with clouds, now sheeted with fire: the rain fell in torrents; it swelled the stream; the waves overflowed their banks; they reached the spot where Ambrosio lay, and, when they abated, carried with them into the river the corse of the despairing monk.

Rather like the Eve imagined by Ursula Le Guin, who takes away the names given to the animals by Adam, nature exercises revenge for six days, in a progression from insects to eagles, and does not rest on the seventh.

The chief latent content in most of the tales and dramas of titanic overreaching, from 1796 through the 1830s, is Napoleon Bonaparte. No tale had a reader unconscious of his pervasive presence. During Napoleon's ascendancy, the public caricatures placed him in all sorts of mythic, ridiculously sublime roles. He was the Corsican tiger, the supreme eagle among eagles, Hercules, Atlas. A favored caption was "Grasp All, Lose All." In 1814 and 1815, both in France and across the channel, Napoleon became the fallen titan, the "Modern Prometheus" chained to a rock beneath a vulture gnawing his vitals. To one French caricaturist of 1815 the fallen eagle was the *"Titan nouveau"* who had trampled religion, honor, justice, humanity. In angry London he could be a titan only after he had fallen. Every overreaching villain of the nineteenth century has some Napoleon in him—or, as in the graphic case of Becky Sharp in *Vanity Fair,* in her.

In shorter tales, with too little space to develop the theme of

titanic overreaching, a greedy protagonist, defying the northern
ethic of work by trying to get something for nothing, attempts to
escape Pascal's laws of probability. These diminished creatures try
to avoid the natural law of cause and effect by failing to ask the price
when a sudden encounter with a demon or a demonized being
promises success to the wish. Here also, with regard to probability,
the caricaturists had reduced the sense of devastation during the
Napoleonic wars by depicting the antagonists as playing games,
mostly card games of chance, with potential allies the reward of
winning the game. Sometimes the caricaturists had the antagonists
appropriate the games of children, as a way of belittling possible
victory without reducing the sense of risk. Twenty years of such
images lodged them deep within the general reader.

In the folktales retold by Jacob and Wilhelm Grimm the person
who encounters a being from another world may receive poetic
justice in the end, but usually no gamble against conscience deter-
mines in advance that this is the kind of character who will en-
counter an emissary of Satan with an offer too tempting for a moral
pygmy to turn down. Some of the tales do illustrate petty greed,
none better than that of the fisherman living in a pigsty whose wife
urges him to step up his requests (to an enchanted fish) from cottage
to castle to kingship, popedom, and finally rule over moon and
stars, whereupon the fish sends him back to the pigsty. In the first
tale of J. A. Apel and F. A. Schulze's *Gespensterbuch* (1810)—as the
opera *Der Freischütz* known for Weber's music and a happy end-
ing—a huntsman errant of aim desires the daughter of a game-
keeper determined not to let his daughter marry a man of poor aim
and bad luck. The inadequate huntsman consequently acquires
magic bullets from the Black Horseman of Hell, without asking if
the sixty that kill birds might include three untrue and one that
will unerringly find the "beloved." Chamisso's Schlemihl—in a
longer narrative—will not sell his soul, but trades his shadow to a
devil for a purse, and in the process loses substance in the presence
of others. He freezes Chamisso (as a character dreamed by Schlemihl)
into a laboratory of dried plants. Chamisso here laughs again at
himself as botanist. Among the reasons in *Die Neue Melusine* for the
protagonist's return from a diminutive world of wish-fulfillment to
his normal life as a barber, Goethe includes weariness from the

surprises accompanying preternatural riches. Ludwig Tieck's tale of Walter, who ignores a sorcerer's warning in electing to keep his good blonde homemaker, Swannhilde, after resurrecting the dark, passionate, blood-drinking Brunhilde, and then tries futilely for improvement in a third wife, carries a simple, very general lesson: Walter tries to get what none of us can have.

The pettiness of greed is taught also in happy endings. In the short but involuted pre-Napoleonic narrative by J. K. A. Musäus translated as *The Bottle-Imp,* total renunciation brings release from pursued and pursuing magic; in the tale by Fouqué translated as *The Field of Terror,* demonic contract motivated by love of spouse and offspring enables release unattainable by protagonists with villainously small hungers. If the shorter tales form, as they seem to, a literature by and for the bourgeoisie, dramas and longer fictions of titanic overreaching, in resurgence at the same time, can be taken as satisfying, with less calculated intent, the dreams and familial morality of a middle-class audience.

Narratives ranged by Todorov from the supernaturally marvelous to the naturally uncanny found room for themes more readily expected in realistic fiction—growth, degeneration, decay, responsibility, freedom, destiny, biological heritage, individual versus society—with subjects and devices soon passed on from fantasy to realism: boredom, doubling, self-division, masking, mood, emotional cannibalism, survivals in civilized society of talisman and taboo. Themes of social significance thus accompanied the central purpose of scaring hell out of the reader. Few tales of the genre are as complex as most of E. T. A. Hoffmann's in characterization, psychology of possession and divisive doubling, plot and enfolded structure, thematic particularity (for example, of optics or botany), symbolic method, intricacies of organic magic, or moral ambiguity. Yet all romantic tales of the supernatural, including Hoffmann's—and not merely his thematically simple *Gambler's Luck*—challenge irrational wagers, whether petty-minded, life-staking, or eternity-risking, to expose their relation to passive acceptance of fate. Hoffmann, with comedy, satire, irony, the grotesque, and a touch of pedantry, encourages the reader to relate such gambles with the unknown to the gambles taken by writer and composer: magic spectacles, binoculars, and magic plants give powers to transform

the dreariness of everyday life but also the dangerous power of imagination to unhinge the mind or desiccate the body. In suspiciously unnatural powers, Napoleon was succeeded by Paganini, but Hoffmann had enough to contemplate in his own creativity.

In France, where overreaching had been left largely to Napoleon, the generation of Stendhal was overcome with lassitude from realizing that the chance of becoming a Napoleon had passed. For Russians the themes of ennui, gambling, and fate were even more tightly bound than in France. It is the gamble against conscience, producing the *unnatural man,* that links Napoleon, "the Man of Destiny," to both the protagonists of tales of terror and works by Pushkin and Lermontov that display a more open concern for society in distinguishing among chance, necessity through natural law, and character completely unpredictable except through divine foreknowledge. Pushkin's *Pique Dame,* its questioning of magic left intact at the close, is so skillfully narrated that the callous destruction of an innocent (Tchaikovsky was to give this Liza a more active role) turns a groveling, stingy desire for material gain into cosmic overreaching. Whether or not Hermann was already mad when he accepted the damning advice on three cards from the pale ghost of the Countess, he had been shown even earlier to act as if he thought the universe amoral. Lermontov's Pechorin, "hero of our time," is heir to Diderot's Jacques the fatalist, Byron's outlaws, and Pushkin's Onegin. Cruelty, smoldering in Jacques, Byron, and Onegin, blazes in Pechorin. He tests his own ability to feel and gambles with the feelings of others, to the point of thrusting their lives and his own into the murderous hands of fate. From betraying maiden innocence to murdering a duellist who would have murdered him, he befogs indifference and misdeed with a fiction of fatedness. Tossing dice with demonic forces implies the existence of a noumenal that might be Judeo-Christian; aggressive embrace of fatedness proclaims death to the Christian ethic. Every reader got the point: surrender to fate is defiance of the lawful and orderly in nature. The major tales of Kleist demonstrate elegantly what readers who hated Napoleon and other disruptive forces did not wish to know, that society and the universe join in the ironically perfect timing of collusive destruction.

English poets attempted to naturalize the overheated prose of the

Gothic supernatural. What Wordsworth in *The Prelude* called the "hemisphere of magic fiction" denied to his own pen was mastered by Coleridge as the magically psychological. Coleridge encapsulated the materialism he was trying to combat in a notebook entry of 1804: "Holcroft after Mrs Wolstonecroft's Death took chaise & came with incredible speed to have Mrs W *opened*—for an extraordinary woman."[13] Self-observation renders psychological results throughout his work. In *The Wanderings of Cain,* confronting "in silence and darkness of soul" an evil Shape proclaiming that "the dead have another God," the Coleridgean Cain "stood like one who struggles in his sleep because of the terribleness of a dream."

Guilt is encountered and soon shared by the reader equally in the bald sensations and primary colors of *The Ancient Mariner* and in the pastel tints and nuances of *Christabel.* Gripping the reader with mesmeric eye and skinny hand, the mariner goes beyond one end of the earth's seas and back without ever leaving a world of normal consciousness shown to be neither mechanistic nor rational. *Christabel* leaves it to the reader to find the doubtfully innocent Christabel as Coleridge's double and Geraldine as Christabel's double.[14] In Part 1 of the unfinished poem Coleridge points the way for Keats to embed folk materials in self-conscious art (Schiller's sentimentality) in *The Eve of St. Agnes* and *La Belle Dame sans Merci.* For Part 2 Coleridge steals authenticity and magic simultaneously by embedding folk names for actual places (Windermere and Langdale Pike give credence to "Witch's Lair" and "Dungeon-ghyll") within folk accounting for atmospheric phenomena—as previously embedded, not in ballad or romance, but in "history and antiquities." As the sacristan carries out the decree of Sir Leoline that his wife's death be tolled each dawn,

> With ropes of rock and bells of air
> Three sinful sexton's ghosts are pent,
> And often, by the knell offended,
> Just as their one! two! three! is ended,
> The devil mocks the doleful tale
> With a merry peal from Borodale.[15]

Compare the antiquarian, topographical description of an echo on Windermere "exactly similar to the first explosion by lightning,

then after an intermission of about three seconds a sudden rattling of thunder to the left. And after another intermission, when one imagines all to be over, a sudden rumbling to the right, which passes along the rock and dies away not distinguishable from distant thunder." In *The History and Antiquities of the Counties of Westmorland and Cumberland,* by Joseph Nicolson and Richard Burn, this description of echoing thunder follows immediately, with a suggestion of linkage, an account of desperate revenge by one Robert Philipson ("Robin the Devil").[16]

This explicitly natural supernaturalism, which suggests why Coleridge and Wordsworth thought they could collaborate on *The Ancient Mariner* and *The Wanderings of Cain,* was explained in 1889 with unwonted clarity by Walter Pater:

> Religious sentiment, consecrating the natural affections and rights of the human heart, above all that pitiful care and awe for the perishing human clay on which relic-worship is but the corruption, has always had much to do with localities, with the thoughts which attach themselves to definite scenes and places. And what is true of it everywhere is truest in those secluded valleys, where one generation after another maintains the same abiding-place; and it was on this side that Wordsworth apprehended religion most strongly. Having so much to do with the recognition of local sanctities, the habit of connecting the very trees and stones of a particular spot of earth with the great events of life, till the low walls, the green mounds, the half-obliterated epitaphs, seemed full of oracular voices, even the religion of those people of the dales appeared but as another link between them and the solemn imageries of the natural world.[17]

It is the surviving culture of attachment to nature's soil that enables the urban Keats to make what he does of *Isabella; or, The Pot of Basil;* he takes from Boccaccio the "wormy circumstance" of a woman's planting of her lover's head and watering it with her tears into a natural, nutritious circumstance set against the murder of her lover because of the unnatural greed and unnatural industrialism of her unnatural brothers.[18]

Stanley Cavell has explained what it is that makes Coleridge more interesting to him than Blake. Blake despised skepticism for its

attempts to banish the supernatural. For Cavell skepticism is "an issue of the human denial of the conditions of humanity"; he worries, not about the supernatural, but about the efforts of skepticism to deprive us of the ordinary world. He sees *The Ancient Mariner* (the chronology of Coleridge's reading set aside) as an example of the romantic bargain with Kant, "buying back the thing in itself by taking on animism." If the thing in itself cannot be known, it can be lived with. Cavell has said the wisest thing about the *Mariner,* or the wise thing in the best way: the Mariner has it wrong; it is not best in life to love, but "to let yourself *be loved* by all things both great and small." [19] If Coleridge, who thought himself constituted of pure love, had comprehended all that poetry was able to say through him, his relations with Wordsworth would have been a lot less bumpy.

The strongest bridge between tales of terror and the exalted individualism of the English romantics is the poetry of Byron. Although Keats was taken with Coleridge's medievalism and Percy Shelley was bewitched by evanescence and easily identified part of himself with the punished Wandering Jew (freed of the guilt that burdens Coleridge's Ahasuerian Mariner), Byron's demonic restlessness drove him closer than the other English romantic poets, far closer than Shelley, to the shoals of spurious terror. From these shoals Byron soared to overreaching heights that made him a living Orphic legend. Even the polymorphously perverse Byron of later biography retains legendary excess. His readers and critics, like Shelley's, are drawn irresistibly—Byron's justly and by his own design—to a fusion of poet and protagonists.

In interrupted sentences making sly allusion to Manfred's blood relation to Astarte—"one who—but of her anon"—*Manfred* exploits the reader's awareness of rumors concerning Byron and his half-sister and diverts attention from the general fatedness implied in the words, "my embrace was fatal." Despite Byron's protests, the work is profoundly Manichean. Manfred admits guilt—meaning, as in *The Ancient Mariner,* the sensation of guilt. He does not acknowledge responsibility in a universe of equal forces, a world where darkness eclipses all aspiration toward light. The spirits that Manfred has "sought in darkness and in light"—evenhandedly—include, along with the traditional four elements, night, the energy

of storm, and a seventh, the star of Manfred's destiny that is disorder beyond the Keplerian system.

Manfred's sublimity does not depend upon his isolation in the Alps; gambling against any God that Pascal can deduce or imagine, Byron's Manfred trumps the ace of every Faust that had preceded him. "I kneel not," Byron makes him proclaim, "I will not swear," I make no contract with any god or devil, never have, and never will. My thunderous curse, like Childe Harold's, is forgiveness of enemies and forgiveness of fate.

The strength of Manfred's independence can be seen more clearly by contrast with the narrating hero of a story by Robert Macnish. Having unintentionally exchanged bodies with a fellow student, Macnish's hero refuses to sell his soul to a Mephistophelean devil as the price for getting his body back.[20] As a reader would expect, but unlike Byron's protagonists, he refuses out of righteous allegiance to a just God. Manfred, like Byron's Cain, finds it unreasonable to choose between equal forces each demanding a bended knee. Seeking in vain Paley's perpetual timepiece, Manfred asks for reasons that the universe declines to give. Such Promethean defiance is impressive. Yet the inclination to regard Manfred and related Byronic heroes as noble, either in the text or in the author's intent, should be resisted. However defiant, this Manfred is ineffectual beyond other Fausts; he complains that he was fated to destroy others, but he is also fated to destroy himself; refusal of compact gives him a titanic sense of adventure, but the self-enclosure deprives him of adventure in any actual world. William Godwin, in *Lives of the Necromancers* (1834) lists the motives of human ambition in ascending order of overreaching: to improve one's comforts and living conditions, to gain power over others, and to defy the human condition. Manfred ignores the first, denies the second, and fails at the third.

The magnetic pole of the supernatural in Britain was *Blackwood's Edinburgh Magazine.* Along with romantic poetry and the insistence of Wordsworth, Coleridge, and Lamb that predigested ethical and economic parables offered less nourishment to children than fairy tales and the *Arabian Nights,* tales in *Blackwood's* helped make it possible for Jane Eyre to hear Rochester call from a preternatural

distance. Of the many forays into Germanic spookiness by William
Blackwood's writers, Gide's choice of one of them for voluptuous
torment has made a clear winner for the twentieth century of James
Hogg's novelette, *The Private Memoirs and Confessions of a Justified
Sinner* (1824).[21] For most of the original readers, incitement be-
gan with a letter in *Blackwood's* for August 1823, signed "James
Hogg." The signature itself is a red flag, for Hogg usually appeared
to readers of the magazine, even when in language clearly invented
by John Wilson and fictionally attributed to the Hogg-persona, as
"The Ettrick Shepherd." The letter, headed "A Scots Mummy,"
gives a circumstantial account of the opening of a grave, with
details of a life that ended in suicide a little more than a century
earlier. Two named young men who *partly* opened the gravesite
found there, all "still as fresh as that day they were laid in the
grave," the half of the body thus exposed, the sword-grass rope that
the youth caught in theft had hanged himself by, and the bright
clothing of which Hogg says he is sending a sample to satisfy
curiosity. He calls attention to two preternatural aspects: the perfect
preservation of the body and its accompanying objects, and the
apparent impossibility that such a frail rope could have suspended a
body. Hogg regrets to report that the grave has since been opened
again, so that the body will undoubtedly now fall to dust.[22] In sum,
the evidence for confirming or refuting his account will have been
destroyed. Opening paragraphs, not later reprinted, explain that
"North" (John Wilson) told him to look at "the grand phenomena
of nature," and a sentence also omitted later, following the account
of the suicide's life, promises that "the grand *phenomena of Nature's* a'
to come to yet." The specification of a rope that could not have done
the job it did is an interjection of the supernatural utilized only as a
second alert to the reader.

As the first part of the published book, which followed in due
time upon Hogg's letter, an enlightened editor, tolerant of all but
the intolerant, assembles from documents of 1687–1712 an account
of George Colwan, a jaunty young blade who consorts with tennis-
playing, Episcopal Cavaliers, and Robert Wringhim (Colwan), a
dirty sniveling sanctified brat, born as a second son to George's
pious mother, but disowned by the elder Colwan as certainly the

son in spirit, and perhaps in flesh, of the predestinarian Rev. Mr. Robert Wringhim, Lady Colwan's sanctimonious adviser. Colwan replaces his wife with Arabella Logan as intimate housekeeper.

After attempts, not altogether unsuccessful, to provoke George's circle of fortunate friends to violence, young Wringhim appears to George, first as a gigantic spectral illusion in the halo of vapors above Arthur's Seat, and then, as George flees from the apparition, in the jolt of a physical body that George instinctively strikes down. (Hogg, like Coleridge, was fascinated by the phenomenon of the Brocken spectre in the Harz mountains,[23] and a friend of George's assures him that "there could be nothing supernatural in the circumstances; and that the vision he had seen on the rock . . . was the shadow of his brother approaching behind him.") When the cringing Wringhim confesses that a friend out of sight nearby told him George would be there, George, uncorrected by the editor, says that only the Devil could be that friend. In consequence of Wringhim's lying report of the episode, George is jailed, but eventually, to the satisfaction of the now thoroughly biased reader, exonerated. Not long after, George is found murdered, and Wringhim assumes his estate and title as Laird of Dalcastle. Perplexing circumstances of the murder include a sort of evidence that Drummond, an acquaintance accused of the murder, may have been successfully impersonated by an associate of Wringhim's.

Bell Calvert, a fallen woman so completely outcast and downtrodden that testimony she gives in gratitude to Miss Logan cannot be doubted, enables the editor to convince us in subsequent scenes that young Wringhim killed his brother accompanied by a male figure (a) able to look like Drummond, (b) of a temperament to make Wringhim confess his crimes and listen to a suggestion that he kill his mother, and to do both in the hearing of witnesses (Calvert and Logan) that the mysterious stranger knows to be present, and (c) able at will to wear the exact appearance of the murdered George. As justice closes in, neither Wringhim nor Lady Colwan can be found.

Next comes the main body of the work, the confessions of Wringhim as justified sinner. He confesses to early sins, but he knows that they have been blotted out because he was welcomed by his mother and the elder Wringhim "into the society of *the just made*

*perfect,"* the elect made free of damnation by grace, so that no "future act of my own, or of other men, could be instrumental in altering the decree." That he despised his mother he believed to be "a judgment of heaven inflicted on her for some sin of former days." It soon becomes important that the doctrine of predestined election (dominant in Hogg's Scotland) include acts "of other men," because Wringhim soon meets one who "was the same being as myself," offering for convenience the name Gil-Martin, able by assuming the appearance of another to assume also the same inner thoughts, and powerful enough in influence to enable Wringhim's mother and "guardian" to perceive at once that their darling is transformed. Although convinced by freakish reasoning that his new friend is Czar of Russia, Wringhim shoots to death reluctantly a divine who is objectionable to Gil-Martin because he preaches morality. In keeping with the pattern throughout, it is implied that Gil-Martin during the collaborative murder has taken the form of a second divine soon arrested for the act. Despite a tendency to slide back into "sinful doubtings" that further executions indeed carry out the will of God, recollection of "the infallibility of the elect" makes Wringhim see the logic of killing his brother and father, not *really,* he thinks, to get the estate, but because they are the Lord's enemies as well as his.

He concludes that he is bewitched by his father's concubine, because for a month he suffers the distemper of thinking himself "to be two people," with the second alternately his brother and that "other." In language exquisitely chosen by Hogg, Wringhim reveals to the reader, but does not himself quite catch, "a certain derisive exultation" of the Mephistophelean Gil-Martin at his conquest through Wringhim's hypocrisy.

Despite misgivings partly pragmatic but extending to a vision wherein he hears "as it were a still small voice," Wringhim leaps Romeo-like between swordsmen in a duel that leaves a drunken George dead, from—Gil-Martin assures Wringhim later—our autobiographer's sword. In possession of Dalcastle, he begins to be accused of murders (of his mother, for example), of seducing and destroying a beautiful young lady (he is sure he could never have done *that*), and of other crimes, all of which his now burdensome companion assures him—and others—he has committed. On one

occasion he is approached by George, who turns out to be Gil-Martin; later, he is warned by Gil-Martin to escape from a crowd closing in with two corpses and convinced that Wringhim not only is a murderer but is Satan incarnate. Thrust onto back roads among simple rustics—"I never was apt to be taken with the simplicity of nature; in general I despised it"—he encounters the dialect of superstitious belief in the cloven hoof of the Devil and is caught in the net of a simple but suspicious weaver like Agamemnon entangled in the net of Clytemnestra. The confessions come to a pause with a plan to print them immediately as a pamphlet, their author disappointed to have the printer one who laid "stress upon morals, leaving grace out of the question."

Wringhim continues in an anxious journal of late summer, 1712, beginning with word to the Christian reader that the printer was told by his journeymen how the Devil had come to assist them (a pun on "printer's devil," an apprentice), whereupon the printer "ordered the whole to be consigned to the flames." (The reader will come to know that the confession, without the continuing journal, was successfully printed and a copy rescued by its author.) In confirmation of the printers' belief that the Devil was present, "horses broke loose, and, snorting and neighing for terror, raged through the house"—and, what goes beyond Shakespeare, trampled Wringhim almost as effectively as soon after, in dream or reality, he was "surrounded by a number of hideous fiends, who gnashed on me with their teeth, and clenched their crimson paws in my face." From the fiends he is rescued by his contracted incubus, "persecutor and defender," who has made himself additionally unwelcome by offering the diabolical temptation of suicide, albeit a double suicide. The rest of the journal, like *Frankenstein,* follows the Godwinian pattern of lateral flight with the claustrophobic anxiety of pursuer pursued. Unlike Godwin and Shelley, however, Hogg tempers the "growing sense of immediacy and oppression" in these pages with phrases of ghoulish humor representative of the Blackwood group.[24] In criminal despair, Wringhim writes in the last entry of his journal, "I pledged myself to my devoted friend that on this day we should die together."

The editor now provides a postscript to authenticate a work that might otherwise seem hard to believe. After reading Hogg's letter

in *Blackwood's,* but unable to get that taciturn shepherd to serve as guide to the grave, the editor discovered a reliable neighbor able to correct Hogg's errors with regard to location, found the part of the body previously aired now in a shocking mess, and recovered from the other, freshly preserved half of the grave the printed pamphlet, with the final entries in manuscript, both already made known to the reader. The enlightened editor, sure "in this day . . . it will not go down that a man should be daily tempted by the Devil, in the semblance of a fellow-creature," suggests that the body belonged to a "religious maniac" who wrote about a deluded creature until he believed himself to be that wretched Wringhim and therefore killed himself. The quotation from Hogg's letter in the postscript includes the advice that the body, if the grave has been reopened, will have fallen to dust, so that confirmation or disconfirmation by the reader is now impossible.

There is little room for doubt that Gil-Martin, within the narrative, is a Mephistophelean devil. The confession and journal are made subject to explanation as psychological delusion. That Wringhim is schizophrenic is a possibility created by Hogg. Wringhim as presented can regard himself as George's double, but that Wringhim can be the underside of George's psyche is not a proposition that can be derived in sanity from Hogg's text. The brothers are foils, not doubles. The suggestion in the editor's postscript that a suicidal fanatic invented Wringhim might explain the document attributed to Wringhim, but the postscript makes no effort to explain ambiguities in the initial narrative that include sightings of Drummond's double and of George's double by characters presented as reliable. Hogg might answer that the whole Presbyterian populace lives in illusion and self-delusion; the work includes satiric exposure of self-righteousness that gives it kinship with Burns's deadpan *Holy Willie's Prayer.*[25] Wringhim's friend assures him that he prizes most the allegiance of one of the Elect, "because, every deed that he performs, he does it with perfect safety to himself and honour to me." Considered as interior double, Wringhim's friend would die in Wringhim's act of self-annihilation; within the allegorical satire, the double suicide removes the diabolical motivating force for belief in Election.

The ambiguities and contradictions can be explained by the

genre, which has as a principal purpose the satisfaction of irrational desires in the normal reader. Ingenious in separating the lives of Wringhim and the suicide whose body is uncovered, Hogg makes no effort to resolve the discrepancy between the editor's final theory that the confessions were the progressively deluded work of the suicide and his own opening pages of historical confirmation. If it were not, says this editor, for "hundreds of living witnesses"—witnesses to something or other unspecified, perhaps bits of cloth and such said to have been rescued from the grave—"I would not bid any rational being believe it." Hogg and his contemporaries had no expectation of meeting narratologists or other fanatics of consistency among their readers. It is customary to call the satiric vein serious and to call the satisfaction of irrational desires entertainment. Hogg's letter removes the author from both satire and entertainment by confessing that, unlike the editor, he never saw the grave.

Even aside from genre, little is gained by pitting psychological explanations against acceptance of the supernatural, as if belief in the Devil had previously excluded belief in self-division from internal impulses toward evil. When had Satan not been a symbol of the desire for death or entropy? The fiends that assail Wringhim near the end of his confession are progeny of the fiends that God had permitted Satan to release within the guilty: what great change is it that sins against God, self, and humanity were becoming sins only against self and humanity? The Gothic arose, as far as this issue is concerned, not because the change was great, but because published authors expecting further publication could not openly deny significance to the fading away of God.

From 1824 on, Hogg began to defend tales of the supernatural for *Blackwood's* internally within the tales. In the series "The Shepherds Calendar"—meaning the Ettrick Shepherd's—with subsections on "dreams and apparitions" and "fairies, brownies, and witches," Hogg began "George Dobson's Expedition to Hell" with a declaration that philosophy doesn't even know what sleep is, much less what dreams are.[26] In "The Mysterious Bride" he expanded the scope of his complaint:

> A great number of people now-a-days are beginning broadly to
> insinuate that there are no such things as ghosts, or spiritual

beings visible to moral sight. Even Sir Walter Scott is turned renegade, and, with his stories made up of half-and-half, like Nathaniel Gow's toddy, is trying to throw cold water on the most certain, though most impalpable, phenomena of human nature. The bodies are daft. Heaven mend their wits! Before they had ventured to assert such things, I wish they had been where I have often been; or, in particular, where the Laird of Birkendelly was on St. Lawrence's Eve, in the year 1777, and sundry times subsequent to that.

The Laird was at Birky Brow, where he saw a lovely apparition he had dreamed of; where he returned for assignations; where, after he rode off to marry her, he was found a blackened corpse; where were later found the remains of his father and grandfather, and ultimately "part of the slender bones and skull" of the lovely Jane Ogilvie, murdered there by the grandfather. One old woman remembers each episode in this story of Jane and the three lairds named Allan Sandison. "She gave the parishioners a history of the Mysterious Bride, so plausibly correct, but withal so romantic, that everybody said of it (as is often said of my narratives, with the same narrow-minded prejudice and injustice), that it was *a made story*. There were, however, some strong testimonies of its veracity." The narrator says many have seen the bones.[27] Internal claims of authenticity serve almost simultaneously suspension of disbelief and pleasure from palpable deceit, but cannot match the threefold pleasure of discovering that a published letter from James Hogg authenticated by anticipation a multifoliate tall tale published under a pseudonym known to be Hogg's.

The doubling, division, ambiguities, and contradictions of the *Justified Sinner* are also active in Mary Shelley's *Frankenstein, or The Modern Prometheus* (1818), but playfulness is greatly diminished— ultimately a gain for monstrous, bare-bones terror on stage and film. Creation of the monster illustrates, if not playfulness, one of the forms of the grotesque new in the nineteenth century. Goya, and Byron in the shipwreck scene of *Don Juan,* had converted the grotesque from the chancred misshapenness of those others to deformities and madnesses that include us. Lucretius had rejected the possibility that Scylla or centaurs had ever existed, for life could not emerge from an assembly of heterogeneous parts.[28] Horace had complained of similar incongruities, such as ladies with fish tails or

wings, in paintings censurable because unnaturally incongruous.[29] Frankenstein's frantic vivisection of animals and his toil "among the unhallowed damps of the grave," with the intermediate aim of disturbing "with profane fingers, the tremendous secrets of the human frame"; these, as well as the resultant monster, represent, like the locomotive monster of Turner's *Rain, Steam, and Speed,* predatory violence against nature. In the broad anthropological sense, Frankenstein's monster is a work of art. From an aesthetic perspective, he is a product of science. Frankenstein fails in his romantic attempt to transcend the limits of human art decreed by nature.[30]

The iconographic structure of the work is polar—unnatural versus natural, solitariness versus family bonds, a scientist's assembly of ill-fitting parts versus nourishment of life in a mother's womb, hit-or-miss suddenness versus natural growth, creator versus creature, ice versus fire. The sequential structure, like that of Hogg's *Sinner,* encloses a first-person narrative by a "monster." That brief narrative, as spoken to Frankenstein, the monster's creator, is central to Frankenstein's own more assured autobiographical narrative, which is littered with sequential fact: this happened, and then this happened. The authenticating frame is also first-person, in the explorer Walton's letters to his sister, begun for the reader before Walton encounters Frankenstein and resumed at the end as a report on Frankenstein's death and the monster's departure across Arctic ice, "lost in darkness and distance," toward a promised demise. Walton's letters put a twinned thesis before the reader early: by his own admission, he, like everybody, needs a friend, a secret sharer; by the author's revelation, Walton, like everybody except the monster, has a dear sister or dear virtual sister. Walton transcribes day by day Frankenstein's spoken narrative. The reader is not encouraged at any point to doubt information given in the letters or in the enfolded narratives.

Walton and Frankenstein authenticate each other's motivation. He who has violated the sacred but rotting precincts of the dead in order to give electric life to an assembled body, in contravention of divine and human law, is praised by Walton as a "divine wanderer," one, near his end, "noble and godlike in ruin." When Walton is faced with mutiny, his ship "surrounded by mountains of ice,"

Frankenstein makes for him, in what Walton calls "lofty design and heroism," the speech that Columbus was forced to make for himself: sail on, face danger, share the courage of your noble captain. Frankenstein, like the alchemists, has sought the elixir of life; Walton, sailing toward the magnetic pole, seeks the cold light back of the North Wind. Both engage in quest and journey without growth. In the historical context, experimental chemists and physicists as well as the *Naturphilosophen* were pursuing the ultimate secret of Nature, the single power that not only would account for the electric ray, Mesmeric magnetism, and the twitch of a dead frog, but would account universally for electricity (Frankenstein), galvanism (the monster), and magnetism (Walton). It is not clear in the author's introduction to the third edition of 1831 whether she remembered the initiating violation as one against natural childbirth or against Paley's perfect timepiece: "Frightful must it be; for supremely frightful would be the effect of any human endeavour to mock the stupendous mechanism of the Creator of the world."[31]

In the monster, ontogeny recapitulates phylogeny. By nature loving and wishing to be loved, he is cast out by his creator as unlovely and therefore unlovable. On a glacial slope in sight of Mont Blanc (emblem in Percy Shelley's "Mont Blanc" of inaccessible power), Frankenstein listens to the autobiographical complaint of his "odious" creation. Cast out, the creature learned from experience of the warmth of the sun, of a woodfire, of a cottage hearth and the activities of a family gathered around it for meals, conversation, and music. By intense application, he learned words for physical objects, then terms for personal relationships, such as *sister,* and on to more abstract conceptions, such as *good* and *dearest* (recapitulating the origin of language in accounts by Rousseau, Monboddo, and others). Once possessed of language, he learned at once of injustice; with the chance acquisition of books he read of sorrow and of love (from *Werther*), of noble actions (Plutarch), and from *Paradise Lost* of a God who loved what He created. The yearning monster attempted friendships, but only a blind man could bear his presence. When he tried to rescue a young girl from drowning, the reward for his benevolence was to be shot. Expecting a beautiful boy to be unprejudiced, and thus on Rousseauistic principles educable as a companion, he found instead the fiercely struggling youngest sibling of

Victor Frankenstein, little William, whom he therefore promptly strangled.

Frankenstein resumes the narration, to tell how he promised to make a bride for his lone creature, but then destroyed her, with the monster looking on, lest a physically stronger race endanger humanity. He tells how the monster pursued and killed those whose lives, the monster thought, were dearer to Frankenstein than his own—his friend Henry Clerval and Elizabeth, his cousin, foster-sister, and intended bride. Frankenstein's motives in creating and rejecting the monster cannot, except mistakenly, be divorced from other acts that reveal his character. When Justine Moritz, cousin and virtual sister of William as Elizabeth has been to the older brother, is arrested, tried, and executed for the murder of the boy, Frankenstein by his silence lets her die. Urged by his father to marry Elizabeth at once, he prevaricates and postpones the marriage for two years in order to keep that other bridal promise—the one to the monster—which will remain equally unfulfilled. When he is accused of murdering Clerval but reprieved by the energies of family and friends, is it characteristic of him that he notices the contrast with Justine's fate, or is the author nudging the reader? Despite the awareness of danger that Frankenstein kept from Clerval, his portion of responsibility for that death is slight. When he ceases work on the bride, however, the monster warns, "I go; but remember, I shall be with you on your wedding-night." It measures Frankenstein's self-centeredness that he takes the warning as a threat against his own life, without any thought ever of the meaning that all previous European narratives made inevitable. It does not even occur to him, as it does to the monster, that annihilation offers a less apt revenge than assuring the enemy's life of continuing misery. As impercipient as Coleridge's Mariner, Frankenstein ignored the laws of hospitality, of community, of family, and of natural process. He ceased to construct a bride on the utilitarian principle that the claims of humanity "included a greater proportion of happiness or misery"; he ignored the awareness dawning among biologists that assessment of other animals to accord with human needs and desires may be a flawed habit. (The monster, like Percy Shelley, was a vegetarian.) Victor Frankenstein forbore divulgence of his ghoulish secret, but he continued to believe that where he had failed, another

might succeed. At the close the monster renounced revenge; in keeping with traditional closure, Frankenstein's lust for vengeance also, if we can trust Walton, subsided.

Frankenstein as individualist who persistently ignores, equally with the resurrectional alchemist who titanically overreaches, lends credence to feminist views that this novel by a woman assaults male pride, defends the alliance of woman and nature, renders grotesque the rational male certitude of her father and her husband. To the arguments derived from Ellen Moers, agreeing that the monster is constructed in male violation of natural childbirth, Gillian Beer adds that what Shelley rejects is the romantic analogy between organic form and the creativity of poetic imagination; "a repudiation of men's claim to an equivalence between creative writing and physical production."[32] The feminist interpretations accumulate on the way to Anne Mellor's argument that the monster is an emblem of the French Revolution, brought on by the literally un-Promethean, unforeseeing, male enlightenment.[33] Utilitarians murder to dissect; unfeeling reason begets violence. *Frankenstein* can be, and has been, treated as the nightmare of a society under strain, or as exemplary of Faustian science fiction, of transformation, of doubles (secret sharers, or the monster as the scabrous underside of Frankenstein's aspirations), of a failed Pygmalion, of Ariel requiring Caliban, of pursuer pursued, of sexual fantasy (the dream of wormy embrace upon first sight of the creature, where the original manuscript began), of the monster as Cain, in one aspect a Cain trying to make his amoral creator experience the misery of the Wandering Jew.[34] I have not encountered in feminist readings the suggestion that rejection of the monster because of physical ugliness may reflect Mary Wollstonecraft's protest against the poverty of female education based on pretty face rather than on "intellectual beauty." Much, after all, remains to be said.

William Gilpin's tolerance for the sublime and the beautiful alternately within the picturesque is refined in Emily Brontë's *Wuthering Heights*. The craggy, weathering old house high on the moors, its "corners defended with large jutting stones" and its evident contents including fierce dogs and "villainous old guns," is sublime. House, situation, and occupants are sublime. Thrushcross Grange, with clean windows, helpless kittens, and pale overdressed

children, is beautiful. Beauty in *Wuthering Heights* is effete. If it is picturesque it is so only in the sense that it is framed. Throughout the novel, jaggedness, sublimity, and violence are accompanied by suggestions of the supernatural.

In the narrator Nelly's metaphor, Heathcliff is laid by a cukoo in a nest from which the legitimate chick is ousted. The ousted Hindley, taking the offensive, reduces Heathcliff to such a bestial state that his soul mate Cathy, half-drawn to Thrushcross beauty and ease, rejects him at the most inopportune moments and marries Edgar Linton of the house beautiful. Heathcliff's story, then, Gothic and sublime, is not of the biter bitten, but of the once bitten biting. By ruthless utilization of the law of entail, he acquires both of the estates with power over all inhabitants. After Cathy's death, he attempts to reduce Hindley's son Hareton and the second Catherine to the subnatural state he had himself endured under Hindley. Finally this monster, like Frankenstein's, relents, and allows the unheroic, ordinary Hareton and Catherine to live happily—but to live out their time where only heroic spirits are thought to live ever after.

*Wuthering Heights* can be regarded as a realistic novel with an atmosphere of the supernatural. In chronology, genealogy, law, and pattern of symbols, the book is keenly rational. The opening chapters explain credibly why the narrator Lockwood, self-exiled from urbanity, dreamed that the ghost of Cathy beat at the window as he slept in her coffin-like bed. By coincidence, it might be, Heathcliff fiercely awake assumes that the ghost came in fact and not in dream. The mudlark Heathcliff, rescued by Mr. Earnshaw (Hindley's and Cathy's father) from the streets of Liverpool, goes off and earns the wealth needed for revenge. He could be, as Arnold Kettle argued, the vengeance of the working class, appropriating the methods of capitalism, against the effete.[35] He could be Earnshaw's bastard; if so, he is half brother to his soul mate.[36] The atmosphere of incest, without the fact, is intensified by the economy of the intermarriages, claustrophobic to some critics, Euclidean to others. Earnshaw told his wife when he arrived with the dirty, struggling waif, "you must e'en take it as a gift of God, though it's as dark almost as if it came from the devil." One way or the other, bastard or devil, Earnshaw's words are not sweet nothings.

Heathcliff outdoes most Gothic villains in passion when, for example, he beats his head against a tree. Cathy says, "Nelly, I *am* Heathcliff." Nelly declares Heathcliff a devil; Lockwood reports no reason to doubt it. The demonic certainly rises in Heathcliff when he separates Cathy's coffin from Edgar's so that his own body will merge with hers in their decay. Superstitious natives believe— Nelly cannot—that the souls of the two over-intense lovers roam the moors at night. The possibilities of diabolism extend much further. Why was Heathcliff found in Liverpool rather than in Manchester? Nothing in the novel prevents a belief that Heathcliff is a water spirit, with a tainted soul rather than one like Kingsley's water babies or with Undine's need for soul. Where and how did he acquire the funds for his revenge? He returned, it may be, to his mother, a mermaid who provided pearls, for her no longer enchanted son, from her palace under the sea. Is Cathy, as Nelly insists, a fickle adolescent who loves Heathcliff but from vanity chooses dull comfort, or does she have unluckily normal desires despite being reared with a demon lover? At the very least, Cathy and Heathcliff long for the supernatural: haunt me, let me see death.[37]

In keeping with the oversized passions of these Platonic-demonic lovers throughout, Heathcliff contrives to die by repeating all the constituents of Cathy's fatal decline. But what killed her? Despair over the mistake of her marriage? An unhealable breach of soul? Female decline? The specified constituent, deliberately repeated by Heathcliff, of starvation? Childbirth? The precise timing, added to the context of Victorian statistics, strongly suggests that the answer to be supplied is death in the act of giving birth. The sexual is never overtly expressed in *Wuthering Heights*—its lovers are not far from Victorian children enacting imagined passion—but then again Cathy's death may have been hastened in the scene of Heathcliff's violence on her pregnant body. When Cathy, delirious and determined to starve, looks into the mirror and shrieks that the room is haunted, is she frightened at emaciation or does she see her doppelgänger (meaning death, as in Rossetti's painting, *How They Met Themselves*)? The episode can be subjected to more specific examination:

> Catherine is shocked when she sees her own reflection because she seems to understand what Yorkshire folklore dictates: that sick people should never look at themselves in the mirror. If they do, their souls may take flight from their weak bodies by being projected into the mirror, and this can cause their imminent death. In accordance with this belief, immediately after she sees her reflection in the mirror, Catherine is convinced that she really will die . . . Her utter horror here stems from Catherine's superstitious belief that suicides, and she now assumes herself to be a suicide, become ghosts. This is why custom, and then law, would have them buried with stakes through their hearts—to prevent their walking.[38]

In this view, bringing to bear data on the ignominy and criminality of suicide in the early nineteenth century, the scene belongs to the series of suicides and concealments of suicide in the novel: first Hindley, then Catherine, two suicides concealed by Heathcliff, and finally the suicide of Heathcliff himself.

If we can judge by the many students required to report their reactions, each reader of this meticulously built novel of passion tends to follow the action and the narrators' proposals for explanation with a consistent view that it is realistic, or a consistent view that it is heightened romance (ending in domestic resolution), or a consistent view that it is a Gothic tale of the supernatural. Q. D. Leavis, associating belief in the supernatural with childhood and social truths with adulthood, discovered a transformation in buried strata of the novel: the romantic Emily who began the narrative believed in fairies; the Victorian Brontë who finished it engaged in social (local) and psychological (timeless and universal) analysis.[39]

When Charlotte Brontë allows the repeated apparition of a nun to intrude in *Villette,* the reader is given two explanations: there was a conspiracy to frighten Lucy, and it worked because the apparitions were "the outgrowth of an already distempered condition of mind." In *Jane Eyre* the supernatural permeates the mind of the eponymous narrator. *Wuthering Heights* makes explanations merely possible. If the novel has a moral, it is that Cathy and Heathcliff have a better religion than does the crabbed apocalyptic servant, Joseph, who tattles on them for mishandling *The Helmet of Salvation* and *The*

*Broad Way to Destruction.* At the end of the book Lockwood turns from the graves of Edgar, Cathy, and Heathcliff for a paragraph on imperturbable nature, what Thorslev calls with reference to Wordsworth's close of *The Ruined Cottage* "the organic sublime": "I lingered round them, under that benign sky; watched the moths fluttering among the heath and hare-bells; listened to the soft wind breathing through the grass; and wondered how any one could ever imagine unquiet slumbers for the sleepers in that quiet earth." To neglect final resolution in the marriage of the placid cousins, heirs of Hindley, Cathy, and Edgar—after the blood of the two polar outsiders, Heathcliff and Isabella, has been wiped clean—is to condemn the second half of a marvelously ingenious book as wasteland.[40]

If *Confessions of a Justified Sinner, Frankenstein,* and *Wuthering Heights* are fantasy, and if all fantasy leaves the reader in indecision with regard to the supernatural, then the three works illustrate the wide variety of forms that indeterminacy can take. Wringhim's narrative may be interpreted as the disintegration of a fanatic, with the rest of the book illustrating the editor's will to believe. Or the work may be taken as explaining human conduct by interference from diabolical forces. One of the pleasures afforded is the answer the work so far shares with the universe, "You will never know." *Frankenstein* gives pleasure by asking the reader not to believe or disbelieve, but to think. It is allegorical in mode, but allegorical of what? *Wuthering Heights* has been well read by those who take every suggestion of the preternatural in it as metaphor. Instead of an unexplained stump of a tail, there is the romantic encouragement to believe that human life, at least life far from the city, feels much less like La Mettrie's engineered matter than like Thomas Burnet's agitation by spirits in a catastrophically wrenched landscape with benign possibilities. The book would be poorly read indeed if taken as committed realism. The moors where Heathcliff and Cathy meet are imagined art in the novel as well as in illustrations to the novel. Even in the world brought from outside the novel, the moors, no less than the word "moor," belong to human perception, nearer to dream than to topography.

# REALISM

Many in the early nineteenth century agreed with Byron's friend Hobhouse that it was a "most unromantic" age. In the view of writers we call romantic the utilitarians and the economists we call classical were soberly at work to make the age as unromantic as possible. Bentham and Ricardo, in fact, agreed; they did wish to make the age unromantic. Why perpetuate superstition and dream? As leaders of the pack, they were following the scent of applied reason. Malthusian tracts were almost as popular as Byron, sermons were more popular, and verse satires sold enough to satisfy publishers, booksellers, and binders. Charles Lamb lamented the reduction from extravagant dress to flat city black as "one instance of the Decay of Symbols among us."[1] Despite rebellious desires to number the streaks of the tulip in celebration of the particular, those who succeeded William Gilpin agreed with him that exact copying of a face, as Quentin Massys and other lowland painters did, was "a sort of plagiarism below the dignity of painting."[2] The popularity of Johann Kaspar Lavater's *Essays on Physiognomy* (1789), cannot have been more than partly responsible for attention to surface. The moment for discovering the interior from external details had arrived; revelations from attention to skin and skull could not account for Blake's interst in Lavater. With distaste similar to Gilpin's, Coleridge called exactly detailed descriptions by Robert Southey and Erasmus Darwin plagiary from nature.[3] Despite such evidence of distaste for surface, romantic particularity extended to caricature, and observed detail invaded both landscape painting and "nature poetry."

Kant's aesthetics of disinterest and Lessing's *Laokoon* could in logic have separated art from imitation of nature and poetry from visualization and description, but these separations are seldom discoverable in the nineteenth century. The major romantic poets, without ever practicing pure description, taught minor Victorians, Edwardians, and Georgians how to describe appreciatively birds, flowers, and morning mists. John Clare won a brief popularity, not for the fierce imaginative eruptions for which he is now read, but for descriptions of rural activity— along with descriptions of the rising of the sun that "wakes all life to noise and toil again," perhaps as unfamiliar to some of his urban readers as the yoking of oxen and whopping of straw. George Crabbe, who had become a poet to oppose Goldsmith's sentimentalizing of rural life, returned to oppose even more extreme flights of fancy in the first decades of the nineteenth century. His message, in a phrase of *Peter Grimes,* was "keep fast your hatchway." After a pause, paintings of agricultural scenes rose in number during the Napoleonic wars and continued through the unrest that followed, perhaps signaling an increased need for national self-sufficiency in addition to patriotic pride and the concern of artists' patrons and purchasers for scenes of efficiency and contentment.[4] Although less unreal than the earlier porcelain-like fieldworkers of George Stubbs, rustics in most of these scenes wore clothing and faces unsoiled and wrinkle-free.

Thanks in good part to Hogarth, the status of realism in the graphic arts in 1801 and after was similar to its status in poetry: not dominant, deplored by connoisseurs as ugly and trivial, but popular with the public. Paintings of cottages, cottagers, and their surroundings by George Morland, influenced by Flemish and Dutch verisimilitude, are now taken as a branch of the picturesque, but in Morland's time were thought to be disturbingly faithful to a loutishness with which his own habits made him familiar.[5] George Dawe, in one of the early biographies, described Morland's typical matter as "the vulgar and coarse manners of the lowest part of society."[6] In any event, the picturesque of "patched plaster," "the fence of bungling workmanship—the wild unrestrained vine," and "the intrusion of pigs"[7] was an intermediate stage on the way from grandeur to ash-can realism. Although extremely popular with the classes able to understand imitation of externals in the engravings

they could afford to buy, Morland's works were not designed to let cottagers see themselves as they really were. Morland's spirit more than Hogarth's, with the truth mitigated first by the artist and further cleansed by the engravers, propelled the satin- and sometimes leather-covered annual giftbooks into the 1830s. The realistic marine and landscape paintings of Clarkson Stanfield maintained over several decades what his memorialist Dickens attributed to the man, "frankness, generosity, and simplicity." Benjamin Robert Haydon, who gives us Keats and Wordsworth convincingly as they were in *Christ's Entry into Jerusalem,* could step down from history painting and megalomania for *The Mock Election* (1827) and *Punch, or May Day* (1829).

There was at least one painter true to genre as lowland painters had limned it, the Scotsman David Wilkie. Often with a sense of irony noted in an earlier chapter, Wilkie painted narratives to be read through details that would be categorized as symbolic if they were not so resolutely the expected objects of cottage or village scenes in the painter's and viewers' own day. Each detail furthers an over-the-back-fence narrative. Even for history paintings, Wilkie sought anecdotal episodes entailing humble interiors and humble dress, as in *Alfred Reprimanded by the Neatherd's Wife*—King Alfred regarded as a vagrant because he was disguised as one. Enjoying aristocratic and royal patronage almost from his first arrival in London, Wilkie tried early to shake off a reputation for low comedy. With *Distraining for Rent,* exhibited at the Royal Academy in 1816, he added to the offenses of Morland the implication that landlords were responsible for misfortune common throughout the rural population. His *Rent Day* of 1807 was put to work along with his *Distraining for Rent* in Douglas Jerrold's reform-minded drama *The Rent Day* (1832). Landlords saw more offense in *Distraining* than Wilkie can have intended; simple *Rent Day* was more typical of Wilkie's subjects—homely but not provocative, satirical, or Netherlandish comic. *The Peep-o-Day Boys' Cabin in the West of Ireland* (1835–1836) was first named for an outlawed society organized against landlords rather than for the less unsettling secret band of Irish Protestants (diminished by 1795) of the final title. In sum, Wilkie found his greatest joy in descriptive, telling detail. He preferred pure line engraving to the more fashionable mezzotints,

aquatints, and stippling because line engraving reproduced the detail of physiognomy, playing cards, and saucepans by which the narratives of his genre scenes could be read.[8]

Wilkie's accuracy prophesied the direction art would take. His popular contemporary Thomas Stothard, admired by Turner, was described by the Redgraves as so tender and gentle that he delineated "the affections rather than the passions—beauty and grace rather than the higher emotions," and was dismissed by Ruskin, implacable enemy of realism either drab or "foul," as so incapable of conceiving "wickedness, coarseness, or baseness" that he "lived in a universe of soft grass and stainless fountains, tender trees, and stones at which no foot could stumble."[9]

Even in departure from topographical accuracy, watercolorists had been true to landscape in outline, as Francis Towne was, or in color, as Girtin and Turner sought to be. The point to be refined by Impressionists was made early in the century by colorists who could attend not merely to season but to time of day and moment of weather. John Gage held an exhibition in 1969 to demonstrate that the principal English landscapists of 1810–1820 sought to paint under the open sky with an innocent eye.[10] Cornelius Varley devised the "graphic telescope" to capture accurate views of landscape.

In woodcuts to illustrate blunt messages, there had been no fidelity to externals and no need for any. Thomas Bewick, even more original than Wilkie, introduced into book publishing the modest, detailed, frameless vignette. In resuscitating wood-engraving, Bewick changed its future course by graving across the grain of boxwood, with results sharply different from the cruder prints, cut by a knife along the grain of softer woods, that continued to illustrate children's books and broadsides. By working in white line, cutting away rather than making incisions, he produced a wider gradation of tints than previously known (his *Memoir* refers to "colour being produced by plain engraving")[11] and made available to his successors creative freedom from the drawing used as source. *A General History of Quadrupeds* (1790) and *History of British Birds* (Land Birds, 1797; Water Birds, 1804), important for the course of natural history, included tailpieces that joined his scenes of rural activity in vignettes for other volumes in anticipation and guidance of the realism to follow at mid-century.[12] These country

scenes clarify Bewick's conviction that "it is the intention of the Deity that mankind should live in a state of civilised society."[13] Realism of Bewick's sort accepts the life that surrounds the artist.

From 1832, in books and periodicals, Charles Knight sent wood engravings among the ordinary and the poor, not only to inform, as the *Illustrated London News,* the *Pictorial Times,* and the *Graphic* would do, but "to improve mankind" from the lower extremities up. Romantics had rashly delved for power; Victorians would settle for truth.

Realism, as slippery a term as the next, can be applied to many changes that occurred in the arts in the middle third of the century. When Uvedale Price recommended to landscape architects that they study pictures as *"copies* of nature" that could make available "the accumulated experience of past ages," he envisioned an increase of the natural; Claude, like Shakespeare, had observed closely what the average landscapist would miss. Wordsworth, on the other hand, although an admirer of Bewick and of Wilkie, made in 1815 an epistemological distinction only, without intending to promote surface realism, when he declared that the appropriate business of poetry "is to treat of things not as they *are,* but as they *appear;* not as they exist in themselves, but as they *seem* to exist to the *senses,* and to the *passions.*"[14] Constable, who believed that nature needed always the addition of art, regarded the realistic direction that panoramic painting had taken as the essence of deficiency, because it tended to depict nature "minutely and *cunningly,* but with no greatness or breadth." He declared painting to be for him—what no panoramist could rise to and no realist could admit—"but another word for feeling." He described the London "Diorama" of 1823: "It is without the pale of the art, because its object is deception. The art pleases by *reminding,* not by *deceiving.*"[15]

The words "copy," "imitation," and "mirror" are not always accurate clues to intention or perception. What one notices is that "first follow nature" came increasingly to signify a fracturing of form and disarranging of proportion. From 1820 William Charles Macready sought for the stage "touches of nature," such as the actual feelings of a father; a *Spectator* critic in 1838 praised Macready's "naturalness (an ugly but useful word)": "To seize on an emotion, to make it perfectly comprehensible to every capacity, to

familiarize the creations of the dramatist to the spectator, rather than to hold them in a state of august elevation."[16] In 1823 researches by Planché brought to costuming in the London theater historical fidelity. The "reign of nature" predicted by Diderot in *Le neveu de Rameau* had come to pass: "We shall become inured to the imitation of the accents of passion and of the phenomena of nature by melody or voice or instrument, for that is the whole extent and object of music." Belief that music could and did imitate human feelings led to that tonal loosening of form so passionately lamented by classicists.[17] Opera particularly moved from mathematically arranged distortions and enhancements of human movement and human voice toward dramatic illusion. The contrived symmetry of arias still determining structure in *Il Trovatore* disappears from Verdi well before *Otello* and *Falstaff*. The gliding of ballerinas above the stage depended less and less on wires and more on the "realism" of toe shoes and superior technique.[18] The corollary of this movement was defined at its end by Yeats, who sought to achieve distance from naturalism "by schemes of colour and simplicity of form, for every sign of deliberate order gives remoteness and ideality."[19]

Loosening of form can create a sense of realism not only relative to tradition but even within a single work. In George Eliot's *Romola,* in its early chapters full of such devices as Italian phrases and bits of ritual that require information from a reader who expected them to convey information, any relaxation of formality comes like a friendly clap on the back. With word that the army of Charles VIII approaches Naples, Goro asks, "Why shouldn't he have sent the French another way to Naples?" The reader pauses to guess who "he" is. But then Goro continues: "Why, they might have gone to Naples by Bologna, eh, Ser Cioni? or if they'd gone to Arezzo—we wouldn't have minded their going to Arezzo." The broken syntax, which would seem literary in Faulkner, in *Romola* gives a sudden sense of actual life. In this novel as in others, Eliot turns realistic devices into impressive ethical structures. In Chapter 30, after astute delay, Eliot describes old Baldassarre by the device of having him examine his own face in a barber's mirror before removal of his beard: "No, he was not so changed as that. He himself had known the wrinkles as they had been three years ago; they were only deeper now: there was the same rough, clumsy skin, making little super-

ficial bosses on the brow, like so many cipher-marks; the skin was only yellower, only looked more like a lifeless rind." Mirroring is soon renewed as beardless Baldassarre looks into a calm pool by the roadside, "to contemplate himself slowly, as he had not dared to do in the presence of the barber." The initial description advanced the plot: if he could recognize the features, then Tito, who had rejected him, must have recognized them. Eyes that had seen his loving face for sixteen years "ought to have searched for him with the expectation of finding him changed, as men search for the beloved among bodies cast up by the waters." In this moment of Baldassarre's strengthened resolve for revenge, the language contributes to plot and to what is as basic to *Romola* as plot, the metaphorical structure. In Chapter 9, when Tito considered the idea of ransoming Baldassarre, in the visualized chance that he had survived when Turks took survivors of his galley into slavery, Tito rejected the act in selfish reflection: "Had not he, Tito, suffered shipwreck, and narrowly escaped drowning?" If Tito had looked into the mirror, in Narcissism unperceived by the viewer, or reluctantly and only half perceived, a critic could still have found missing the further step of the pier-glass of *Middlemarch,* in which confused lines are ordered into a pattern of causal relations. When the old man looks into mirror and pool, plot and the overriding metaphor of shipwreck in individuals, noble causes, and a society are equally served, but the readers' expectation in 1862 of a realistic description of persons, places, and things is also served.[20]

*Romola* can illustrate another aspect of realism. Coincidence in fiction, as in drama, was granted by all to be unrealistic, but accepted for economy if no major conversion of character or turn of plot depended on it. Baldassarre, brought to Florence by an accident assigned to history, could arrive by coincidence at Naldo's, where Tito would visit his child-mistress Tessa. Later, in Chapter 34, Baldassarre's dagger will break against Tito's chain mail, an event that Eliot has made fictionally probable by many references to Tito's fearful precautions. Shakespeare had taught a lesson defined by Coleridge: by every means, increase expectation and diminish surprise. Historical fiction would be reviewed as unrealistic to the degree that it ignored this lesson.

Even in the ethical parable *Silas Marner,* the kinship of Eliot's

doctrine of consequences with Taine's dogma of heredity and environment is notable. At the end of Chapter 9, the author analyzes Godfrey, the Tito of *Marner*:

> Favourable Chance, I fancy, is the god of all men who follow their own devices instead of obeying a law they believe in. Let even a polished man of these days get into a position he is ashamed to avow, and his mind will be bent on all the possible issues that may deliver him from the calculable results of that position. . . . Let him betray his friend's confidence, and he will adore that same cunning complexity called Chance, which gives him the hope that his friend will never know; let him forsake a decent craft that he may pursue the gentilities of a profession to which nature never called him, and his religion will infallibly be the worship of blessed Chance, which he will believe in as the mighty creator of success. The evil principle deprecated in that religion, is the orderly sequence by which the seed brings forth a crop after its kind.

The two springs of the plot are the trial by lots that falsely condemned Silas and—in significant contrast with *Pride and Prejudice* and *Wuthering Heights*—the unentailed estate of Cass, a loosening motivation for sons otherwise unlike. We all cheat: "the force of destiny to certain human lives that we know of," at the beginning of Chapter 14, refers to the guiding hand of the plotting novelist. Before Eliot, Victorian realism could make allowances for coincidence because the providence that had a care for persons in life could be evoked or implied in tracing the fate of characters in fiction.[21] Eliot's sense of the real demanded departures from Dickens.

*Silas Marner* was conceived as pastoral. Realism had become largely fidelity to urban life, not as contemplated by an eighteenth-century Londoner such as Johnson but as observed through urban eyes. There were debts to Hobbes as well as to Hogarth in the recognition of increasing distance from social coherence. Even when the bankruptcy of a character solved a problem of fictional plot, financial insecurity was as real as gutters. The efforts of George Scharf the elder to represent London accurately, from his arrival in 1816 until his death in 1860, reached an emblematic goal in a

pencil sketch, "Building a Sewer, Holborn, 1845."[22] The navvies central to Ford Madox Brown's great *Work* are digging in the cause of sanitation. Thornbury, the art journalist, observed: "I have heard many voices of nature . . . but never a sound so multitudinous, so terrible, as the voice of London at night, the murmur of two millions of people, as they flow and billow to and fro, as if roused by the tempest of irrestrainable rebellion," and, "Look at those faces that pass you, and imagine yourself in an avenue of purgatory. What hollow eyes, pinched lips, full brows, and sunken foreheads!"[23]

The descriptive term for the nonurban was no longer landscape, but countryside, perhaps signaling a return at a lower economic level from the romantic to a principle of the earlier topographical: attention to property that is privately owned. As early as 1814–1815, William Henry Pyne issued *Etchings of Rustic Figures for the Embellishment of Landscape,* for the avowed purpose of teaching the children of the well-to-do a realism they could not learn from the landscapists. The garden moved to town. J. C. Loudon declared near the outset of *The Suburban Gardener and Villa Companion* (1838) that "a suburban residence, with a very small portion of the land attached, will contain all that is essential to happiness" (p. 8). Dickens, preeminently, relocated nature on the hearth.[24] As the century wore on, the garden in the city enclosing the family became a garden of the mind where the individual could cultivate feelings. The subjectifying is almost enough to justify the statement that "Wordsworth created the notion of the personality as a ruin."[25]

Realism as a general infection in Britain and across the Continent included fidelity to physical impression, attention to the contemporary as opposed to an idealized past, the ordinary as a displacement of the aristocratic, the urban as successor to the pastoral, and the casual in succession to idealization. The declared aim of realism, in Britain as well as in France, where declarations originated, "was to give a truthful, objective and impartial representation of the real world, based on meticulous observation of contemporary life."[26] As for realism of manner, no naked woman ever looked more contemporary than those given classical names by William Etty between 1821 and 1849. If the realistic novel in fact spared its society the

pain of facing grief and discord directly by bringing chaos into "the order of significant form," as argued by Leo Bersani and others, that function may not have been unintentional.[27]

Realism as a broad movement in the arts, more than a shared desire to mirror the external, represented a commitment to the world. The naturalism yet to come would show that world with a grimness implying that it ought to be changed; some realists, if not most, were content to show what it was like. A focus on poverty, whether urban or rural, did not necessarily imply protest. "A suspicion came about that perhaps the source of the spiritual experience lay in the detail."[28] Yet realism in English fiction was seldom an end in itself, as Turgenev might make it seem or as Flaubert declared it to be, but nearer to the heavy physical detail of Balzac's *Eugenie Grandet,* as a means to some other end.

Combating Humean skepticism had put a great burden on the creative imagination. Transcendental idealism had given the poet not only the opportunity to create a universe, but with that opportunity the responsibility to do it. Consciousness depended upon imagination to be. The description attributed by Hazlitt to a connoisseur, of Turner's paintings as pictures "of nothing, and very like," no less than Constable's term "tinted steam" in a context complimentary to Turner, acknowledged the burden of creating both likened and likeness. Swift's exemplum of the narcissistic spider rang in English ears: while the bee gathered nutritive honey, the spider spun nastiness out of its own guts. English common sense, always impatient with metaphysics and now weary of epistemology, could be comfortable with the much wider audience for the arts that had no difficulty believing in a material world out there available for perception and imitation.

Paradoxically, the fear of revolution that heightened English distaste for French volatility in politics and sexual morality made the simplicity of French mechanistic materialism a bearable alternative to Hegel. For one excuse, French believers in Laplace's *Méchanique céleste* and La Mettrie's *L'Homme machine* opposed the arbitrary Roman Catholic church, a less disturbing posture than opposition to the reasonable Anglican *via media.* For a long time the English-speaking world has looked to France for extremes of theory: Voltaire's skepticism, La Mettrie's materialism, Laplace's mechanism,

socialism from Saint-Simon and Fourier, Comte's positivism, Bergson's reality as intuitive process, Sartre's existentialism (rather than Heidegger's), Derrida's deconstruction, Foucault's history free of fact. Fourier, though less compelling than Comte, was a more confortable influence. As a "realist," Fourier accepted human passion, sensuality, and the natural ordering of classes, in opposition to civilization, meaning constant change, and to the plans of Robert Owen and other utopian socialists for transforming human nature.

The clear, distinct, and extreme French theorists helped move the English in the direction they had begun to take. Except for mechanistic materialism, all significant factors for realism were under way in England. Before 1837 the middle classes had secured social and political power commensurate with their numbers: an audience able to buy was ready to consume imitative art. Utilitarianism mated with Malthusian fear of overpopulation in books of moral pragmatism, whether to promote emigration or to provide women with methods of birth control.[29] H. T. Buckle's *History of Civilization in England* (1857–1861) is a parody, if parody is possible, of Taine's naturalism: "If we inquire what those physical agents are by which the human race is most powerfully influenced," Chapter 2 teaches, "we shall find that they may be classed under four heads: namely, Climate, Food, Soil, and the General Aspect of Nature." This "Aspect" Buckle defines as "appearances" that affect the association of ideas. With a complacency soon to be called social Darwinism, he explains that Europe has gained superiority over other parts of the world because in Europe the mind of man has encroached upon the organic and inorganic forces of nature. The faith of nineteenth-century realists in objective disinterest reaches its apex in the comfort Buckle takes from statistical averages: "In a given state of society, a certain number of persons must put an end to their own life. This is the general law; and the special question as to who shall commit the crime depends of course upon special laws; which, however, in their total action, must obey the large social law to which they are all subordinate."

Saint-Simon had pointed out in 1803 that English workers lived well because the educated classes in England had more respect for scientists than for kings.[30] Applications of science put England in the van of industry and industrial capitalism. Industry crowded the

cities and despoiled the countryside. Alexis de Tocqueville visited Manchester:

> The soil has been taken away, scratched and torn up in a thousand places . . . Heaps of dung, rubble from buildings, putrid, stagnant pools are found here and there among the houses and over the bumpy, pitted surfaces of the public places . . . fetid, muddy waters, stained a thousand colours by the factories they pass . . . From this foul drain the greatest stream of human industry flows out to fertilize the whole world. From this filthy sewer pure gold flows.[31]

An earth thus soiled repelled romantic affection. In transition, represented preeminently by Turner, the sublimity of steam remained subordinate to the majestic power of nature. Realists looked at steam and factory, and reported what they saw. What had been roadbuilding as imagination became in paintings by John Brett and Henry Wallis in 1858 the poverty and overwork of stonebreakers.[32]

But of course the rampant progress of industry had some of the same attractions as a rampant lion. Iron and coal could mimic the sublimity of Vesuvius viewed by moonlight. However cruel to the laborer, factories and mines were progressively a necessity and a success. Owen, in *A New View of Society,* asked fellow industrialists, "If then due care as to the state of your inanimate machines can produce such beneficial results, what may not be expected if you devote equal attention to your vital machines, which are far more wonderfully constructed?" Ebenezer Elliott, made penniless in the iron trade, wrote with sympathy of the "manufacturers"—meaning those who laid hands on the materials or the machine—as well as their employers, for both suffered from the agriculturists' "bread tax" of the corn laws. The workers rural and urban who now attracted the attention of realists had their own sense of what was fitting, "the old mixture of allegory and engineering detail to express their deep and genuine emotions in a true folk art."[33] Industrialization and popular taste came triumphantly together in the Great Exhibition of the Works of Industry of All Nations that occupied in 1851 the original version of Joseph Paxton's great greenhouse of glass and iron, the Crystal Palace.[34] With Owen Jones in charge of interior decoration and design, such applied arts

as tapestries, carpets, and bookbinding were well represented. A wigmaker assigned to Animal Products protested that he belonged with the "fine arts," officially designated Sculpture, Models, and Plastic Art, which were mostly examples of realism gone mad.

In a self-consciously American vernacular, Walt Whitman expressed the logic that had been building in London shopkeepers, novelists, and illustrators:

> Whatever may have been the case in years gone by, the true use for the imaginative faculty of modern times is to give ultimate vivification to facts, to science, and to common lives, endowing them with the glows and glories and final illustriousness which belong to every real thing, and to real things only. Without that ultimate vivification—which the poet or other artist alone can give—reality would seem incomplete, and science, democracy, and life itself, finally in vain. Does not the best thought of our day . . . conform with and build on the concrete realities and theories of the universe furnish'd by science, and henceforth the only irrefragable basis for anything, verse included . . . ? Without stopping to qualify the averment, the Old World has had the poems of myths, fictions, feudalism, conquest, caste, dynastic wars, and splendid exceptional characters and affairs, which have been great; but the New World needs the poems of realities and science and of the democratic average and basic equality, which shall be greater.[35]

In London the "new world" was temporal rather than spatial, and Whitman's insistence on democracy and glorification of the human would be suspect within the penumbra of Carlyle, who won a wide audience by declaring humanity mostly fools who believed in the Devil, if not in a god. The arts were seriously considering as subject matter Carlyle's description of marriage: mostly drizzle and dry weather. The situation after romantic extravagance had been tamed by self-acclaimed "sentiment and taste"—called by Peter Conrad the cluttered "Victorian treasure house"—has been disparaged still more sardonically:

> Not by chance, *In Memoriam* was written during the heyday of collectibles and souvenirs, when rooms, like selves, became

little more than accumulations of highly discrete particulars and upholstery muffled the "ideal" forms of furniture beneath highly particularized fabrics. The Victorians clung to individualized things. Confronted by a new level of urban anonymity and by the accelerated tempo of "progress," one resisted by personalized accretions.[36]

Birdshot of this sort hits the mark and much else besides.

Difficulties begin with any attempt to describe any school or artist, even Blake, as looking exclusively either through or with the eye. Within the same essay, Emerson could call for transcendence of art, a transparent eyeball, and a plain eye. "Art should exhilarate, and throw down the walls of circumstance on every side, awakening in the beholder the same sense of universal relation and power which the work evinced in the artist, and its highest effect is to make new artists." Two paragraphs earlier: "I now require this of all pictures, that they domesticate me, not that they dazzle me. Pictures must not be too picturesque. Nothing astonishes men so much as common-sense and plain dealing."[37] George William Curtis could illustrate his intimacy with the Transcendentalists by declaring that the best critic of art was "the man whose life has been hid with God in nature," and then finish the sentence by appealing to the legend of perfect verisimilitude—"and therefore the triumph of art is complete when birds peck at the grapes."[38]

No major Victorian writer or artist proceeded through life with a simple belief that language or pigment or graver could translate infallibly from the eye to the medium. It is much easier, however, to extract declarations of fidelity as aim than to describe the fluid devices of departure from fidelity. Dickens moves his readers with the symbolic spontaneous combustion of Krook in *Bleak House,* but insists repeatedly that what he has conveyed is empirical fact. The most perceptive writers on the qualifications that need to be made have been driven to terms that require lengthy definition and general application, "symbolic realism," "lucid veil," "exploratory investigation"—after the trusting realism of the romantics—because "reality became problematic" and contingent, "a particular structure of relationships" (so Hegel), with naturalism as "the melodramatic realism of typogogical destinies."[39]

If for a realistic method in the presentation of character one needs to turn from Dickens to Trollope, who thought all of Dickens's characters grotesque, any of Dickens's novels can provide passages, however exuberant, of descriptive realism. Even in his final summaries, the reminiscent objects carry adjectives that describe two stages of perception, as in Chapter 51 of *Oliver Twist*:

> There was Sowerberry's the undertaker's just as it used to be, only smaller and less imposing in appearance than he remembered it—there were all the well-known shops and houses, with almost every one of which he had some slight incident connected—there was Gamfield's cart, the very cart he used to have, standing at the old public-house door—there was the workhouse, the dreary prison of his youthful days, with its dismal windows frowning on the street—there was the same lean porter standing at the gate, at sight of whom Oliver involuntarily shrunk back, and then laughed at himself for being so foolish, then cried, then laughed again.

Dickens invites his reader sometimes to share pleasure in accurate rendition of the ordinary, sometimes to acknowledge the glorious heights, depths, and absurdities of the ordinary, and sometimes to share an animus against meanness of spirit in whatever physical form. Dickens had too much joy in metaphor to let description have its way. Coketown in *Hard Times* could not remain for more than a sentence Tocqueville's Manchester:

> It was a town of red brick, or of brick that would have been red if the smoke and ashes had allowed it; but as matters stood it was a town of unnatural red and black like the painted face of a savage. It was a town of machinery and tall chimneys, out of which interminable serpents of smoke trailed themselves forever and ever, and never got uncoiled. It had . . . vast piles of building full of windows where there was a rattling and a trembling all day long, and where the piston of a steam-engine worked monotonously up and down like the head of an elephant in a state of melancholy madness.

Red brick that is also the face of a savage, a piston that in shape is the head of an elephant and in expression a melancholy person—

these sequential visualizations may have near parallels in Granville or other caricaturists who compact two images into one, but they are oceans away from Scharf's renditions of London. In the opening pages and from time to time afterward, *Hard Times* rains metaphors to counter the hail of facts in Gradgrind's schoolroom. Dickens stuffs the reader with metaphor to overwhelm "the Facts." In scenes with Stephen and Rachel there is none of the wild metaphor typical of Dickens at his best, although there is sentimental fantasy: "He kissed the border of her shawl again, and let her go." It must be granted, though, that "facts" such as Bounderby's turn out not to be facts,[40] and that none of the supposedly ranked social classes are what they seem. The dismissed Blackpool is noble; Bounderby, pretending to humble origins, turns out not to honor Mrs. Sparsit's family connections enough to marry her.

Visualized metaphor such as that in most of Dickens's greatest flights points toward the difficulty in speaking of realisms in fiction and in painting as if they could share a single style. Perhaps only Trollope among the leading novelists even tried for uniformity of style. Trollope's effort to be realistic in manner as well as matter convinced most of his readers and judges—a far smaller number than Dickens has needed to convince, but enough to be representatively Victorian, either of that era or in nostalgic retrospect. In the notice of Trollope in the *DNB,* influenced in part by the materialistic accounting in Trollope's *Autobiography* and probably in part by contrast with the metaphorical George Meredith, Richard Garnett accepted Trollopian realism's claims of disinterest: "he never creates—he only depicts"; his work is accordingly "mechanical and devoid of all poetical and spiritual qualities"; but "his absolute fidelity to fact is miraculous."

The effort to describe current social reality is perhaps most apparent in the industrial novels of mid-century, the effort that links the much-studied *Mary Barton* (1848) of Elizabeth Gaskell and Charles Kingsley's *Alton Locke* (1850), along with *Hard Times* and Disraeli's two novels on the "two nations" of rich and poor, to Frances Trollope's pioneering *History and Adventures of Michael Armstrong, The Factory Boy* (1840) and shoals of novels whose earnestness included the conveyance of fact, stopping well short of Zola's measurements of the props in mine shafts but more direct in purpose

than Zane Grey's classifications of cactus or (at an identical spot in the next novel) wild ponies. Higher truth, assessment and prophecy concerning the Condition of England, never completely erased fact.[41] Victorians would have been moral without Hogarth, Swift, and Fielding to point the way through verisimilitude.

Most of the aims arrived by way of Flemish and Dutch paintings. The grotesque low life of Adriaen Brouwer was too coarse for open approval by Victorians, but there was the agreeably pungent humor of Jan Steen, who could capture the low cunning in a face without exaggerating it into satire. The English were entranced by the ability of Gerard Terboch and David Teniers the Younger to take pleasure in the ordinary without any of the idealizing or meaningful allusions that the twentieth century has found in Vermeer. Not a reclining nude Venus or a breast-bare Magdalen, but a young woman modestly dressed paring her nails by the light from a window. It has been argued that the purebred Realists of France, Flaubert and Courbet, accentuated the distance between the mundane reality depicted and the overt style of depicting it, as "proof that what was represented had been left untouched, uncontaminated by art."[42] The Victorians recognized that meticulous finish of detail went with deflation of subject as an avant-garde revolt against established conventions in art: broad visible strokes would not have demonstrated the extraordinarily serious attention to the ordinary that the ordinary was now declared to deserve.

The much-quoted passage from the opening of Book 2 of *Adam Bede* speaks not only for George Eliot but for most in her generation:

> It is for this rare, precious quality of truthfulness that I delight in many Dutch paintings, which lofty-minded people despise. I find a source of delicious sympathy in these faithful pictures of a monotonous homely existence, which has been the fate of so many more among my fellow-mortals than a life of pomp or of absolute indigence, of tragic suffering or of world-stirring actions. I turn, without shrinking, from cloud-borne angels, from prophets, sibyls, and heroic warriors, to an old woman bending over her flower-pot, or eating her solitary dinner, while the noonday light, softened perhaps by a screen of leaves, falls on her mob-cap, and just touches the rim of her spinning-wheel, and her stone jug, and all those cheap com-

mon things which are the precious necessaries of life to her . . .
I believe there have been plenty of young heroes, of middle
stature and feeble beards, who have felt quite sure they could
never love anything more insignificant than a Diana, and yet
have found themselves in middle life happily settled with a
wife who waddles.

To satisfy a large mid-Victorian audience, writers and artists built a
kennel and attached the picturesque to it by a leash.

A way of defending the ordinary different from Eliot's apology
was employed by Thackeray at the beginning of Chapter 6 in the
initial version of *Vanity Fair.* He asked the reader to "fancy" or
"suppose" that the chapter had sported the characteristics of violent
adventure with criminal argot after the manner of Newgate novel-
ists; or the "genteel rose-water style" equipped with rakish mar-
quises with long curls, French phrases dripping from the tongue,
and *billets-doux* to be delivered by *femmes de chambre* as in the silver-
fork novels of Mrs. Gore; or the multiple unrealities of the most
frequent victim of Thackeray's lampoons, Bulwer-Lytton. Scott had
introduced the method in the "Introductory" chapter of *Waverley*:

Had I, for example, announced in my frontispiece, "Waverley,
a Tale of other Days," must not every novel-reader have antici-
pated a castle scarce less than that of Udolpho, of which the
eastern wing had long been uninhabited . . . ? Would not the
owl have shrieked and the cricket cried in my very title-page?
. . . Again, had my title borne "Waverley, a Romance from
the German," what head so obtuse as not to image forth . . . a
secret and mysterious association of Rosycrucians and Il-
luminati, with all their properties of black cowls, caverns,
daggers, electrical machines, trap-doors, and dark-lanterns?
Or if I had rather chosen to call my work a "Sentimental Tale,"
would it not have been a sufficient presage of a heroine with a
profusion of auburn hair, and a harp, the soft solace of her
solitary hours, which she fortunately finds always the means of
transporting from castle to cottage, although she herself be
sometimes obliged to jump out of a two-pair-of-stairs window
. . . ? Or again, if my Waverley had been entitled "A Tale of
the Times," wouldst thou not, gentle reader, have demanded
from me a dashing sketch of the fashionable world, a few

anecdotes of private scandal thinly veiled, and if lusciously painted, so much the better?

The device continues to serve for satire and parody as W. H. Mallock uses it against Ouida in the first version of *The New Republic,* but Thackeray and Trollope, who also exercised it, imply more specifically that the narrative taken in hand by the reader will pursue a reality avoided by all the conventions and modes of fiction in vogue. *This* novel will follow nature wherever observation of character and manners may lead. "Mine," says Scott, "is an humble English post-chaise, drawn upon four wheels, and keeping his Majesty's highway." Although Scott would say in a preface of 1829 that he felt a challenge to do for the actuality of the Scots what Maria Edgeworth had done for the Irish, he specifies the king's highway with intent to leave lower byways to the disaffected. Anthony Trollope gives assurances of realism in beginning *The Three Clerks,* "All the English world knows, or knows of, that branch of the Civil Service which is popularly called the Weights and Measures." After Zola's proclamation of naturalism, the protagonist of George Gissing's *New Grub Street* will plan a novel to be called "Mr. Bailey, Grocer," about the "decently ignoble—or, the ignobly decent," a mere person whose life was never jolted by any thought or episode of interest.

That the claim of fidelity to the ordinary is asserted, not absolutely, but relative to failures of credibility in rival claimants, could not be made clearer than by Thackeray's *Vanity Fair: A Novel without a Hero.* The author issues repeated challenges to the reader: deny, if you can, that these characters differ in motivation or manners, in any way, from your neighbors, your friends, or you. Are they not *like?* Thackeray invents not merely a bachelorhood and its appurtenances for the narrator, but also *race, milieu, et moment* for him to hear of Becky's career. Lord Steyne and his cronies were identifiable as perfected versions of known originals partly because the Marquess of Hertford and his hangers-on had appeared in similar guise in earlier novels. Becky herself was identifiable as Sydney Owenson, Lady Morgan. The "little Tom Eaves" who knows all this is an actual source, a fictional character, and eavesdropping rumor. Thackeray asks the reader to believe in generic truths based on

particular fact. Yet the author in a tone not the narrator's declares that the characters are puppets created by him for entertainment and illusion. The final sentence and the final vignette collude: "Come children, let us shut up the box and the puppets, for our play is played out."

In the vignettes and decorated initials the young adults of the novel are represented as children on rocking horses or playing with wooden swords. On the title page of each part, as originally issued, the "moralist, who is holding forth on the cover (an accurate portrait of your humble servant)" is a mountebank talking down to other clowns at the fair. On the title page of the first edition as a book, in 1848, a clown with wooden sword looks at himself in a broken mirror. In the next chapter after he has identified himself as mountebank moralist amidst "all sorts of humbugs and falsenesses and pretensions," the cul-de-lampe depicts an infant jester with the hair, spectacles, and bewildered round face of Thackeray himself.

In the decorative initials and vignettes, even Waterloo is a matter of boyish games. On the title page of the parts, subtitled "Pen and Pencil Sketches of English Society," one of the two military monuments behind the mountebank is the Duke of York's column, then under construction; in Thackeray's version, the incompetent duke is upside down. The ball in Brussels, the night before Waterloo, enters for satiric contrast, as it had in most accounts from 1815 on. More seriously thematic are the graphic allusions to Becky as a Napoleon subverting social and moral foundations. The version of Napoleonic conduct open to her as a woman (and an orphan) is the role of Clytemnestra. " 'Mrs. Rawden Crawley was quite killing in the part,' said Lord Steyne." The ironic contrast between interior scenes in the full plates and pictures on the walls reaches its height in the return of the prodigal son in "Becky's second appearance in the character of Clytemnestra." Thackeray deprived that incriminating plate of a second appearance, but Becky's solicitors, as Gordon Ray pointed out, bear the patronymics of murderers whose names had become identified with three particularly gruesome ways of disposing of one's fellow creatures. According to a fiction maintained throughout, the reader, not the author, is to answer the question, "Was she guilty?" In the final full plate, "Virtue rewarded; A booth in Vanity Fair," the socially accepted Mrs. Crawley—accepted be-

cause rich and because acceptance began at the top of the social scale—gracious Rebecca Crawley is selling kisses for a reputable charity. You and I are implicated; our moral standards dissolve in Vanity Fair. Are we not buying or selling with a false conscience? Trollope will say it in *The Way We Live Now* as Thackeray says it of Steyne's mansion, Gaunt House, in Chapter 47: "In a word everybody went to wait upon this great man—everybody who was asked: as you the reader (do not say nay) or I the writer hereof would go if we had an invitation."

Schlegel's initiating example of romantic irony was Sterne's *Tristram Shandy*; he would have been served equally well by *Vanity Fair*. Harriet Beecher Stowe speaks in *Uncle Tom's Cabin* of a character "introduced into our *corps de ballet*" and acknowledges throughout that hers is a constructed narrative in which situations and types from life are presented to make an argument.[43] The difference lies in the emphasis upon argument. Thackeray and Trollope interrupt illusion otherwise pure. Henry James was appalled by Thackeray's and Trollope's many ways of breaking descriptive illusion— appalled precisely because their books were grounded in successful illusion. They met a specification of James's for realistic fiction: they represented convincingly the manners, not of stonebreakers or miners or hired hands on the farm, but of the classes that read these novels.

Truth to nature in painting and graphic arts had a simpler match between subject and method but took several paths. Of the forms taken by "social realism" the evident forebears were history painting, genre, and line drawings to be reproduced in scientific books, journals, and encyclopedias. The chief source even yet for representations in social histories of textile and mine workers—for example, children harnessed to carts of coal—are the illustrations to reports of parliamentary commissions. Icons of the abuse of factory or rural workers, drawing frequently upon Henry Mayhew's *London Labour and the London Poor* (four volumes, 1861–1862), usually commenced life in the *Graphic* or the *Illustrated London News*. Luke Fildes's *Houseless and Hungry* in the *Graphic* for 1869, with twenty-one figures of all ages huddled along the wall, a policeman looking on, became a more elaborate painting, *Applicants for Admission to a Casual Ward,* so popular when exhibited at the Royal Academy in

1874 that a barricade was erected to control the crowds.[44] Even if he had repeated exactly the same design, some of the grimness possible in black and white would have been lost.[45]

There was genre, with various intensities of sentiment; there was protest or exposure, whether of the plight of the governess, the exhaustion of a stonebreaker, or physical abuse of a farmhand; and there was narrative. By rule of history painting, ignoring Hogarth, the event celebrated "should never be placed in the present" except "with some exotically foreign country, or with some idealised social world, preferably rural or aristocratic."[46] In descent from the heroic or aristocratic, pointing to a moment in history or in literature, came narratives of the actual and the ordinary.[47] As an intermediate step for academic debate, Benjamin West gave the reality of facts precedence over the rules of art—in West's words, choosing "the facts to the transaction" over "classical fiction," by clothing *The Death of General Wolfe* (1771) in dress contemporary with the action. Put into the terms of landscape, as Valenciennes and Deperthes needed to put it, *paysage historique* was the representation of nature as it ought to be, *paysage champêtre* was the mirror of nature as it is.[48]

To interpret a history painting by Tiepolo or David, one could go from the title to a written historical record. Because any written text for the current and ordinary was likely to be itself ephemeral, Victorian narrative paintings had to ask more insistently than works by Hogarth or Wilkie that the viewer find answers within the painting to such questions as, Who are these people? Who is doing what to whom? What in their whole lives and what recent development got them into this moment of tension or equipoise?

William Collins's painting *The Sale of the Pet Lamb,* exhibited in 1813, was engraved at once in two sizes, the smaller in 15,000 impressions, and was still being reproduced and "read" in the 1830s. The first, essential question that the viewer was expected to ask was answered in the details: Why is the lamb being sold? Standing before *The Widower* of 1876 by Fildes, the viewer should ask whether the weeping girl older than the four slurping children is a daughter or a servant, but could go away satisfied without asking. Of Fildes's most famous painting, *The Doctor* (1891), the title tells the viewer that the prominent figure observing the death of a child suffers more, and his expression provides the reason that

he knows and thinks more, than the parents in the shadows. W. P. Frith's exercises in verisimilitude offer a subdued, Victorian version of Robert Greene's cony-catching pamphlets of 1592: they reveal the various ways that an innocent in a crowd can be skinned. As centrally as Frith places fraud in *Derby Day,* however, the initial question for the viewer should be, Do I expect to find in this large picture anything other than a crowded, panoramic scene? The gallery-goer accustomed to narrative would have the answer ready, Yes, I must seek and find a story in order to discover, if not the *sine qua non* then the *ne plus ultra,* of exhibiting the picture. Of course the story could be obvious without reducing public interest. Readers of novels in parts were kept in suspense each month; Abraham Solomon made his public wait two years: *Waiting for the Verdict,* 1857; *"Not Guilty",* also known as *The Verdict,* 1859.

The three sequential paintings of Augustus Egg's *Past and Present* narrate a sad domestic tale; each separately challenges the viewer to ask the appropriate questions, but the three in succession assure the right answers. To the fallen woman of melodrama and opera, from before *La Traviata* on to *verismo,* with the rigorous social result of *abbandonata,* Egg continues in the third frame to the additional domestic sentiment of daughters rendered motherless by the ruinous indiscretion. The children for whom Anna Karinina is concerned never compete for the reader's interest, but for Egg's mid-Victorian viewers, every triangle encloses a family. Yet fidelity to the actual could avoid an insistent finality in didactic moral: Egg's sequence from sexual misconduct to the ruin of four lives probably indicates divine law, but the cause might be the harshness of social rules or meddling by the writer of the accusatory letter that has just been read in the first scene of the narrative. Such realism, without entailing neutrality, had the effect of subordinating lesson to factual detail. Apparently even irony was conceivable. *The Mitherless Bairn* (1855), by Thomas Faed, was popularly viewed through tears of sentimental gratitude to the artist, but after two reproductions by mezzotint in 1860 and a reduced replica in 1880, *Good Words,* of all places, explained the source in Faed's experience of a child who waxed and grew insolent under tender care by Faed's parents, who thought the child an orphan rather than what he proved to be, the son of terrorizing tramps.[49]

Richard Redgrave is an education in the crisscrossing paths of realism. Declining a knighthood but accepting a C.B., he looked back with pride on his series of straightforwardly ("photographically") realistic "social teachings," including—to choose those self-evident from their titles—*The Reduced Gentleman's Daughter* (1840), *The Poor Teacher* (1843), *The Sempstress* (1845), and *The Governess* (1846), with increased rhetoric in his diploma painting of 1851, *The Outcast*. In a letter to Lord John Russell in 1846 he defined the regimen required to educate "ornamental designers" for the proper adornment of manufactured products. They should be trained *technically* in "the power of *imitating* the form and colour of objects" as observed and copied both from Nature and from masterworks in which Nature is submitted to art. Students should then be advanced to the *principles* of ornament, "the knowledge required to form *original* combinations *from Nature*." The curriculum should include "knowledge of manufacturing processes" so that they could practice appropriate modes of imitating nature in forms, colors, and styles fitted variously to stone, metal, wood, and differentiated textiles. Under the new method of instruction that he would—and did—institute as head of the government school of design in Somerset House, "*Nature,* as the true source of ornamental design, would be more fully insisted upon."[50] In *Manual of Design,* prepared posthumously from Redgrave's reports and addresses of the 1850s, what he identified as "*naturalistic* treatments of ornament" in the Great Exhibition of 1851 are set against proper consideration of materials prior to decoration and close attention to "nature's laws of growth." He rejects "the merely imitative treatment now so largely adopted," as in "metal *imitations* of plants and flowers." Instead of subordinating idea to detail, "the endeavour ought to be to seize the simplest expression of the thing rather than to imitate the thing itself."[51] Redgrave's repudiation of mere imitation prepared the way for William Morris.

Consonant with the letter of 1846, a lecture of 1868 at the Associated Arts Institute, on "The Treatment of Subject in Painting," began by the call to first follow Nature, and ended similarly; his auditors were "earnestly to study Nature, not only in its general aspect, but also closely in its minute details, by the separate and careful imitation of parts." But the painter, like the poet, should be

always free of *"the accident of facts"*; the painter of a battle must bring order out of confusion; one can learn from Renaissance painters how to involve the viewer by introducing spectators to the action, or having the principals look at the viewer; recent landscapists had spoken of fidelity "without selection of form, or omission of details," but this was theory rather than practice; the greatest imitation of all was not of veined leaves and blades of grass, but "fleeting glories" as in the landscapes of Turner.[52] Redgrave assessed both his audiences and recent directions in design and in painting: inclinations toward abstract design should be bent toward natural forms; excessive realism in representation, where abstraction had not been a recent vice, should be snubbed; painters of isolated detail should be encouraged toward ideality and artifice. More emphatically for "fine" art than for ornamental, he declared that "mere imitation is an error and an impertinence."[53]

How far did meticulous realism derive from photography and how far did photography serve the aims of a realism already studied from the Flemish and Dutch and socially oriented in the wake of the French Revolution?[54] The camera obscura of the sixteenth century, which had come into being to serve painters concerned with perspective, had been utilized, usually surreptitiously, by Reynolds and other academicians; optical instruments and mirroring devices such as the Claude glass and Wollaston's camera lucida of 1807 (a prism through which an object was projected on a surface beneath the prism) were used by artists for framing, silhouetting, and copying before the explosion in 1839 of ways to fix the images of photography.[55] Daguerre had found a way to preserve images previously evanescent, and W. H. Fox Talbot had invented a method of reproducing the image on paper as if the negative were a rabbit.

The claims for photography in the 1840s were unequivocal. The word itself, like "heliography" and other early alternatives, referred to the power of sunlight to draw pictures. The phrasing of Fox Talbot's introductory remarks in *The Pencil of Nature* (1844) was representative and ominous. His language points to the new advances over all optical and other mechanical aids previously utilized by artists: the images to follow (in six installments) were "impressed by Nature's hand" through "the new art of Photogenic Drawing, without any aid whatever from the artist's pencil"; they were

created by "optical and chemical means alone, without the aid of any one acquainted with the art of drawing."[56] What value remained in imitating nature if nature herself could do the job quicker, cheaper, and better? Miniature portrait painters were dead, and they knew it. Other artists and artisans worried. In Turner's time, it was painters who would "take a view" or "take a sketch"; with the appropriation of accuracy by the camera, a sketch became something that a painter makes. Nearly twenty years after the announcements of 1839, it was possible to say, "The world is believed to have grown sober and matter-of-fact, but the light of photography has revealed an unsuspected source of enthusiasm."[57]

Lady Eastlake, the author of that wry sentence, was able in 1857 to disparage excessive reactions and "to decide how far the sun may be considered an artist, and to what branch of imitation his powers are best adapted." After a critical history of recent discoveries—for example, Niepce made the sun "a drudge in a twelve-hours' factory"—the reviewer assessed the powers and limitations of the sun's mate, photography:

> She is made for the present age, in which the desire for art resides in a small minority, but the craving, or rather necessity, for cheap, prompt, and correct facts in the public at large. Photography is the purveyor of such knowledge to the world. She is the sworn witness of everything presented to her view . . . As what she does best is beneath the doing of the real artist at all, so even in what she does worst she is a better machine than the man who is nothing but a machine.

The miniaturist who used to demonstrate that he couldn't draw can now be employed in coloring photographs. The artist who had wandered into "literal, unreasoning imitation" need no longer be "ignobly employed in closely imitating the texture of stone, or in servilely following the intricacies of the zigzag ornament." In sum, photography had done no harm to art.

In general, artists most committed to imitation in detail were the most vehement, or failing vehemence, the most guarded in their remarks on competition from photography. Charles Landseer, the animal-painter's brother, detected a "foe-to-graphic art"; Paul Delaroche predicted the imminent death of art. Frith denied that he

derived "the slightest assistance" from a photograph of Dickens, and his account of procedures in painting *Derby Day* studiously avoids mention of the wide-lens photograph basic to his procedure.[58] Delacroix found no reason to be embarrassed by either his own use or his praise of the potential in photography, but thinking of verisimilitude he could say in his journal for 21 May 1853 that "to the present, this machine-made art has done us nothing but harm [*qu'un détestable service*]." On 12 October he explained why:

> Take a subject of this kind: the scene round the bedside of a dying woman, for example; seize and render the entire scene in a photograph, if such a thing be possible—it will be spoiled in a thousand ways. The reason is that according to the liveliness of your imagination you will find the subject more or less beautiful; you will be more or less the poet in that scene where you are also an actor; you see only what is interesting, whereas the camera records everything.

Delacroix saw the value of the camera as a tool. His friend Baudelaire, equally a believer in imagination, consigned to longer than a season in hell the mere ugliness of nature and "art's most mortal enemy," photography.[59] When Burne-Jones called photography "the bane of art" he meant that it encouraged unimaginative painters to abandon dreams as the proper source for art.[60]

Painters used photography variously to discover detail not available to the eye; to prolong transitory views (especially valuable for portraits and for the use of oneself as model); as a general aid to memory, sometimes superseding the traditional sketch; to increase accuracy in anatomical representation (Delacroix arranged nude and other models to be photographed for later use); to derive continuing pleasure from arrangements that imitated by photographic processes traditional or masterful compositions; to exploit new effects, whether they were photographic fidelity or photographic distortion; as a source for wood-engravings, for example in news magazines; to make a record of art-works (usually with a distortion of tonal values); to produce representations of masterpieces for students or for the public; to copy, and sometimes to trace as an image on the canvas, as earlier painters were known to use the camera obscura and as some currently used the cliché-verre; to correct previous miscon-

ceptions, after the successes of Eadweard Muybridge (not fully revealed until 1887), concerning creatures in rapid motion; and no doubt, perhaps with self-deception, for pornography. Debate will not finally end the larger question of whether photography encouraged more exact mirroring by painters or whether it enabled them "to shift their focus from 'correct' reproduction to consciously subjective interpretation of their subjects."[61] Painters used photographs as the whole society did, for documentation.[62]

Photographic realism coincided with the general fall of idealism. Thomas Love Peacock has Mr. Falconer say in *Gryll Grange* (1860):

> I wish to believe in the presence of some local spiritual influence; genius or nymph; linking us by a medium of something like human feeling, but more pure and more exalted, to the all-pervading, creative, and preservative spirit of the universe; but I cannot realize it from things as they are. Everything is too deeply tinged with sordid vulgarity. There can be no intellectual power resident in a wood, where the only inscription is not "Genio loci," but "Trespassers will be prosecuted"; no Naiad in a stream that turns a cotton-mill; no Oread in a mountain dell, where a railway train deposits a cargo of Vandals; no Nereids or Oceantides along the seashore, where a coastguard is watching for smugglers.

Ruskin lavished praise on Kate Greenaway: "And more wonderful still,—there are no gasworks! no waterworks, no mowing machines, no sewing machines, no telegraph poles, no vestige, in fact, of science, civilization, economical arrangements, or commercial enterprise!!!"[63] On the Continent, the times provided a greater menace: realism was becoming Realpolitik.[64]

In one identifiable area there seems little doubt that the general descent from idealism and the impact of photography came together decisively. The camera as witness to the immediate physical effects of the Crimean War brought a rapid deflation to traditional heroism in scenes of battle.[65] The process was soon repeated in representations of the war of the Confederacy against the Union.

Photography easily proved its value for documentation. As most of the earliest photographers were artists, cameras were designed to make images not peripherally blurred but as if they were to be seen

framed; thus made, they were pointed at persons, objects, and scenes that frequenters of art galleries had learned to expect. Resemblance to paintings or engravings was not in every case contrived or deliberate: "Nadar, in short, was not imitating paintings but making portraits."[66] But the resemblance was often deliberate. From the beginning, some photographers created arrangements to imitate successful paintings. Julia Margaret Cameron costumed and arranged subjects, including Tennyson, as ideal or fictional; she not only gained picturesque effects by blurring the focus, she had lenses made with blurred focus. She asked her neighbors, their children, and the sun to conspire in Pre-Raphaelitish allegories.[67]

Attempts to elevate photography into an art of imagination took several directions. Henry Peach Robinson insisted on true focus; his favorite way of making photography an art in its own right was to arrange images taken separately into composite scenes. To the objection that the photographer's mind was slave to accidents discovered by a machine, he answered in *Pictorial Effect in Photography, Being Hints on Composition and Chiaroscuro for Photographers* (1869), that "it is only the educated eye of one familiar with the laws upon which pictorial effect depends who can discover in nature these accidental beauties, and ascertain in what they consist" (p. 12). By 1896, disillusioned by "mirror-like imitation of nature," he called for realism only in knowledge, as of botany and geology, but never at the expense of idealization and suggestive truth. "Nature never cares whether she has a sky or a foreground." Avoid defiance of nature; accept her aid: "But Nature knows nothing of art." Fact is "solid and self-satisfied"; the best truth is suggestive. It was not imitation that made Millais's *Ophelia* and other Pre-Raphaelite works delightful. Robinson seems not only to have absorbed the teachings of Ruskin, but to have listened to Whistler: "Nature is raw material which in our alchemycal cameras we convert, when successful, into pictures." Realism in fiction, which had begun as a revolt against convention, was now the enemy of "beauty, nobility, and grandeur of style," and therefore no model for the photographer.[68] Between Robinson's two books, Peter Henry Emerson had attacked his composites and tried to put photography on a scientific basis in *Naturalistic Photography* (1889). Robinson's *Pictorial Effect*, he said, was "the quintessence of literary fallacies and art anachro-

nisms." Photography could best become an art of actuality, truth, and beauty by using only photographic means.[69] With the Linked Ring of 1891, the Photo-Secessionists of 1902, Alvin Langdon Coburn, Alfred Stieglitz, Edward Steichen, and many after, photography came into its own as an art distinct from its powers of accurate documentation.

Meanwhile, it influenced most one of the bands it most threatened, the artists in black and white. Not only could it perform their copying chores faster, cheaper, and with less error. Not only did it prove to be a more accurate historian.[70] Its technical refinements came to be accepted so completely as aesthetic that Theodore Wratislaw could praise in 1893 the virtues a photograph exhibited by Frederick Hollyer without mentioning that it was an imitation of Whistler: "he has conquered, it would seem, almost insuperable technical difficulties. In *The White Frock* he has placed a girl at an open door with the sunlight full on her face, and yet he has preserved the whiteness of the face and the relative tones of light in the sky and on the face and dress."[71] However defective Wratislaw's words as history, his generalization—"The value of photography as a medium for artistic expression is now established forever; it was a battle won without fighting"—is valid on its central point: photography had survived the need to be judged as "realistic."

# Pre-
# Raphaelites

As supreme physician to "the condition of England" in mid-century, Carlyle dispensed invigorating dosages of duty and work, but even he could not eradicate completely what he called dilettantism and others called art. The major Victorian poets all anticipate in various ways the stances and characteristics of the Pre-Raphaelites.

Browning's dramatic characters and monologuists gave concrete form to definitions of art in *Pictor Ignotus, Old Pictures in Florence, Fra Lippo Lippi* ("zooks, sir, flesh and blood," minding legs and arms without fear of missing soul), *Andrea del Sarto* (whose reach never exceeded his faultless grasp), *How It Strikes a Contemporary* ("scenting the world, looking it full in face"), impromptu in *Abt Vogler* ("Nature in turn conceived, obeying an impulse as I"), *Transcendentalism* (like Swinburne, Browning put it in a nutshell), the gulf between creator and audience, and between audiences, in *A Toccata of Galuppi's.* Honoring imperfection, as Ruskin and Hawthorne did, Browning dramatized more intensely escape from imperfection into the infinite moment.[1] He set energy and passion against social constraint in *The Statue and the Bust,* in *In a Gondola,* in *Love among the Ruins,* in *The Last Ride Together,* and in *A Grammarian's Funeral* ("Back to his book then . . . Dead from the waist down"). Renunciation is strangled in *In a Balcony.* No early Victorian poem exposes more graphically than *Pippa Passes* the innocence of believing "All's right with the world." Whether the words of *My Last Duchess* come to us through a witless Duke or with the *sprezzatura* of a Cellini, the lines force into silence a woman who smiled her last smile on canvas

and they ignore Carlyle's warnings by casting a sea horse in bronze. Art in Browning is almost always on the side of energy against restraint, and the advice to live is communicated with all the energies his art can accumulate. Even his exposures of the hedonistic calculus convey richer pleasures than ever could have entered Bentham's liveliest dreams. As Keats's *Ode on Melancholy* indulges the melancholy it rejects, so *The Bishop Orders His Tomb* shares with the reader peach-blossom marble rare as "fresh-poured red wine of a mighty pulse" and lapis lazuli blue "as a vein o'er the Madonna's breast"—as freely, if not quite as openly,[2] as Hopkins shares with his readers "rose-moles all in stipple upon trout that swim." Few Victorian paintings were based on poems by Browning, perhaps because he seemed to be referring to actual works of art rather than because his popularity was of slow growth or because his descriptions preempted illustration; Rossetti, a devoted admirer, based drawings on several different works by Browning, and may himself be an influence on Browning's *Men and Women* of 1855.[3] Frank R. DiFederico and Julia Markus were able to show in the 1970s, in the *Browning Institute Studies* and elsewhere, particularly with regard to William Wetmore Story, American sculptor and author working in Rome, that Browning's men and women of the Renaissance were equally meaningful as individuals and types among his own friends and acquaintances. This perception that Browning looked first to his own day ought to have been common among critics, and should be made so by other scholars.

The "alien vision," a romantic freedom to follow inner inspiration in conflict with a social sense of responsibility to increase the spiritual health of the public, is less obvious, because deeper, in Tennyson's poetry than in Browning's.[4] A private, aesthetic Keats fights a public Byron and Shelley in early Tennyson. A juvenile poem, *A Character,* rejects the inactive virtue of a classmate who

> smooth'd his chin and sleek'd his hair
> And said the earth was beautiful.

*The Poet* dreams of an ideal voice that will transform and perfect the world without one violent word. Amidst poems of vacillation, self-division, and despair, *Mechanophilus* envisions from the first railways a future of spiritual flight. *The Lotus-Eaters* purportedly rejects the

languorous seclusion that it nonetheless makes—and leaves—seductive. *The Hesperides* speaks to post-Victorian audiences, through symbolic suggestion, of genius and daimonic inspiration, to be guarded against intrusion by envoys from society. The lady of Shalott yearns to escape mirrors and shadows for social interaction that will mean the loosening and loss of her inmost being, that which binds the poet, the lover, and the mad; in the view of a critic in *Howitt's Journal* (January 1848) committed to romantic inspiration, she suffers, as the poet's soul, the curse of desire for fame and popularity. Tennyson, more affirmatively, saw the risk and curse as accompanying a new-born love for something in the wide world that "takes her out of the region of shadows into that of realities."[5]

Some of Tennyson's earliest poems are like illustrations of Pre-Raphaelite paintings. The swan dies amidst branches, mosses, weeds, flowers, and things shot over "with purple, and green, and yellow." *The Sea-Fairies* begins like middle-period Rossetti:

> Slow sail'd the weary mariners and saw,
> Betwixt the green brink and the running foam,
> Sweet faces, rounded arms, and bosoms prest
> To little harps of gold . . .

*The Palace of Art,* usually taken as the confession of a poet who withdrew his soul amorally to the sensations and unshared knowledge of many arts, describes more explicitly, unconsciously it may be, the mansion of one of those magnates who would accumulate Rossettis and Holman Hunts among their treasures. Poems cast by Browning and Tennyson in the form of dramatic monologues protect the poet from the risks taken by the "omniscient," "realistic" novelists; distance from a speaker put in a specified situation, as defined for our century by Robert Langbaum in *The Poetry of Experience,* utilizes protectively the fading of objective certainty under the skepticism of the Enlightenment. Society as well as philosophy was turning away from poets; "the lonely self, like the 'soul' of the old religion, had to seek the vital reasons of the heart which scientific reason could not know."[6] Fears that inspiration was a siren calling the poet from society dissolved in metaphors of the garden, the one symbol of art that Tennyson could wholly approve: "Come down, O maid, from yonder mountain height."[7] Ultimately, as in the *Par-*

*nassus* of 1889, nothing in nature, not even the garden, could survive the terrible vision of insignificance enforced by "Astronomy and Geology, terrible Muses!" Beyond the physical present, where one might "Sing like a bird and be happy, nor hope for a deathless hearing," faith required transcendence even of the higher pantheism.

Matthew Arnold, dedicated almost from boyhood to the high seriousness of classical culture—more Roman than Greek, despite his choice of Sophocles as a model for seeing life steadily and seeing it whole—very nearly solved the alien vision by denouncing the lack of proper teaching in his own *Empedocles on Etna* and turning from poetry to a prose of critical admonishment from the 1860s until his death in 1888.

George Meredith, close enough to the Pre-Raphaelite circle to share rent for a time with Rossetti and Swinburne, stands apart from other post-Darwinians by insisting, in novels as well as poems, that man must obey, accept, and love the unbending laws of nature. He challenges his reader in *The Woods of Westermain*:

> Enter these enchanted woods
>   You who dare.
> You must love the light so well
> That no darkness will seem fell.

You will encounter in these woods "the scaly Dragon-fowl" of egoism, because you will bring it with you. In Comte's view of progress, bloody mindedness and the superstition of believing in spirit are to be shed in the better world of brain; in Meredith's version, nothing is left behind, so that humanity must make the best of blood, brain, and spirit conferred by evolution.

The sources of Gerard Manley Hopkins's approval of benign nature, if only partly pre-Protestant, are certainly more traditional than Meredith's. Much like Meredith and Browning, somewhat like Holman Hunt or Seurat, altogether unlike Tennyson, Hopkins broke language into particles. Hopkins's way of fracturing, more extreme than Meredith's, has been much more acceptable to the twentieth century. Where Tennyson aspired to the music of the spheres, Hopkins sought the thisness of particulars, whatever is dappled, brinded, fickle, freckled, adazzle, dim. The similarity of

his speckling to that of the Pre-Raphaelites derives from the general influence of particularizing that was "in the air."[8] An early essay by Hopkins, dated May 1865, "On the Origin of Beauty: A Platonic Dialogue," gives preference to leaping ("diatonic") comparison and contrast over sliding ("chromatic") intensity and emphasis.[9] *That Nature Is a Heraclitean Fire* begins with "Cloud-puffball, torn tufts, tossed pillows," and then hovers like these clouds over "dough, crust, dust" before proceeding to the comfort of the Resurrection for "Jack, joke, poor potsherd, patch." With Watt, Stephenson, the Montgolfier brothers, Wordsworth, and Shelley, Hopkins seeks to extract energy from nature. He has praise for both the extracted and the extracters. Yet the extraction and display of energy are for Hopkins only initiating steps. He can agree with Milton that God does not need the accomplishments of human assertion. *The Windhover,* in my view, as much as *Heaven-Haven* or *The Habit of Perfection* celebrates renunciation and sacrifice. Talent is beautiful; submission is sublime. Ultimate energy must be dedicated to submission.

If the earlier romantics replaced God with nature, Hopkins's poems defy the displacement, but love nature and God will be added unto you. In *God's Grandeur* Victorians are chided for staying in town; God lives in the country. *The Starlight Night* proposes that the reader purchase by prayer a farm in the sky; the Holy Family comes with the purchase. *Felix Randal* and *Hurrahing in Harvest* pay adoring tribute to the marriage of autumn "barbarous in beauty" and the divinely blessed human labor of domesticating animals and soil.

Although Victorian Catholicism was next door to early Pre-Raphaelitism, and a personalized Dante presided over the Rossetti family, a small red-headed, bird-voiced eccentric of aristocratic lineage, A. C. Swinburne, was biographically and aesthetically closer than Hopkins to the Pre-Raphaelite circle. Swinburne's algolagnia—pleasure in receiving as well as in giving pain—probably accounts in part for both of his diametrically opposite approaches to nature. Of natural conduct he was an undeviating enemy. Mid-Victorian Britain asked for a wholesome mind in a healthy body. The first word to be learned and the last to be forgotten was "family." The male, in society, in the family, in the

matrimonial bed, was on top. The man assured progress through national aggression, restrained by proximity to the woman's realm of domestic coordination, peace, innocence, and tender emotions. At the thought of changing all this, Swinburne squealed with delight. The Victorians in his "Dolores" acknowledge the barrenness of lives in which time turns their loves "into corpses or wives." If Conrad's Marlow continued to honor Victorian values, it was certainly without any help from Swinburne. Ruskin had made prevail the goal of filling each prospective work of art with the greatest possible number of the most moral ideas. Swinburne countered in 1866 with *William Blake,* containing the first exposition in England of the doctrine of art for the sake of art. He did not hesitate, although in the cadences of Arnold, to say of all art:

> Handmaid of religion, exponent of duty, servant of fact, pioneer of morality, she cannot in any way become; she would be none of these things though you were to bray her in a mortar . . . Her business is not to do good on other grounds, but to be good on her own: all is well with her while she sticks fast to that . . . Art for art's sake first of all, and afterwards we may suppose all the rest shall be added to her (or if not she need hardly be overmuch concerned . . .).[10]

He was to compare Rossetti's *Lilith,* exhibited in 1868, with the work that first proclaimed *l'art pour l'art,* "the most perfect and exquisite book of modern times," Théophile Gautier's *Mademoiselle de Maupin* (1835).[11] Belief in disinterested art enabled him to admire Andrea del Sarto with a clearer conscience than Browning could manage.[12]

His poems of tainted beauty, Our Lady of Pain, tributes to Faustina and Libitina and Lucrezia Borgia, love as desire for death or equivalent to death, gardens where "flowers are put to shame," kisses that draw blood in blessed memory of flagellation at school— none of these require full rehearsal here. In *Laus Veneris* Christ has lamentably unfitted Tannhauser for a Keatsian death on the breast of Venus. The dramatic poem *Atalanta in Calydon* has been called "a myth of the fall of man and of nature."[13] Swinburne supersedes the Althea of that poem, the old order of natural law, with constant but directionless change.[14] Swinburne waters Baudelaire's "lovely leaf-

buds poisonous"[15] without Baudelaire's expressions of remorse. Baudelaire wrote of sin, Swinburne of vice. The poems search for new sin, but find barren pain in unheard-of tortures.

*The Triumph of Time,* renouncing all in accepting rejection by healthy love ("I shall never be friends again with roses"), offers a bridge to Swinburne's other and opposite road toward nature. In *Thalassius,* and in other poems as well, he does not choose like Byron to compete with the turbulence of ocean, or to draw power from it; he wishes to swim in it. Acceptance of physical nature is most succinctly expressed in *Hertha,* which Swinburne called in a letter to W. M. Rossetti early in 1870 "the poem I think which were I to die tonight I should choose to be represented and judged by."[16] This may be the first pantheistic poem in English showing no fear of the amoral. It has been argued that whereas Tennyson looked to the past for benign nature, Swinburne finds nature liberating in the present: "Now is more than then."[17] The myth demystified is of Yggdrasil, emblem of holistic nature adopted by the Ruskin Society, Yeats's "great rooted blossomer." The pantheism is as naturalistic as Swinburne can make it, a-theistic, anti-theistic, humanistic: "Man, equal and one with me, man that is made of me, man that is I." Unlike Meredith's Nature, Swinburne's has no laws to obey; the one labor is to be free. Even in celebration, Swinburne is immersed in ideas of nature, more than in experience of it; Morris was not merely obtuse in complaining that Swinburne's poetry was "founded on literature, not on nature," that it was not rooted in reality, not "quite at first hand."[18]

Industrial despoilment ought to have led to revulsion, not merely among those who called themselves naturalists, but among nearly all who turned to nature for guidance. For the Pre-Raphaelites, with intensity equal to Keats's, "the romantic love affair with earth" continued.[19] If only their realism is noted, their activity seems a culmination rather than a rebellion.[20] When William Holman Hunt, John Everett Millais, and Dante Gabriel Rossetti found each other in the 1840s, they agreed in one solemnity, the "office of the artist should be looked upon as a priest's service in the temple of Nature."[21] Their common aim was "to swim against the stream."[22] Truth to nature meant, first and most, opposition to the rules of academic training and the conventions obeyed in current exhibi-

tions. No more avoidance of purple and green in submission to
tobacco brown; no chiaroscuro by rule. No more slavery to serpen-
tine curves, pyramids, and coulisses of composition. The leg of the
brother in Millais's *Lorenzo and Isabella* may be too stiff for kicking
the dog, but it kicked the Academy. The periodical of the Pre-
Raphaelite Brotherhood, in January and February 1850, was en-
titled *The Germ: Thoughts towards Nature in Poetry, Literature, and
Art*; in March and April, *Art and Poetry, being Thoughts towards
Nature*, "conducted principally by Artists."

They differed from most earlier adherents to nature in seeking
complete accuracy for every detail. Wordsworth had said in 1815,
"In nature every thing is distinct, yet nothing defined into absolute
independent singleness."[23] In Pre-Raphaelite works, every pebble,
flower, and leaf is defined into singleness. Nothing is aerial. They
opposed "slosh," referring to Sir Sloshua Reynolds, with his
smoothed settings, brown trees, and "approval of togas." Robin
Ironside has said they painted as if without eyelids; others have
described the effect as hallucination.[24] That Millais, Rossetti, and
Hunt made use of photographs had no influence on the surface
details and little on design.[25] Some of their earliest critics, writing
as if they were children of Courbet, found an absence of health in
the mean realism of their works: "Their ambition is an unhealthy
thirst, which seeks *notoriety* by means of mere conceit," demonstra-
ble because in actual paintings earlier than Raphael "disgusting
incidents of unwashed bodies were not presented in loathsome real-
ity; and flesh with its accidents of putridity was not made the
affected medium of religious sentiment in tasteless revelation."[26]
E. S. Dallas, denouncing Charles Kean's "strong tendency to REAL-
ISM" as an actor, with "specification of little traits and details" in
"that style which has been called Pre-Raphaelite," to wit, antiquar-
ianism realized in "inane realism."[27]

Stephens, in the *Germ*, appealed for parallel to the meticulousness
of the new geology and chemistry, more specifically to the exacting
particularity of illustrations available in scientific books and jour-
nals.[28] The illustrated books by the naturalist Philip Gosse were
more pertinent than most in combining meticulousness with en-
thusiasm, as in his choice of quotation from A. R. Wallace: "When
I took it out of my net, and opened its gorgeous wings, I was nearer

fainting with delight and excitement than I have ever been in my life; my breast beat violently, and the blood rushed to my head, leaving a headache for the rest of the day."[29] If the engravings of Gosse join Ruskin in encouraging minuteness, the enthusiasm, religious in its source, is the naturalist's equivalent of Pre-Raphaelite "hallucination."

The Pre-Raphaelites were at once Victorian, exclusive, and various. On a date in 1855 Browning could invite Rossetti, his brother William, and another in their circle to hear Tennyson read *Maud*.[30] Both in subject and in method, the "Brothers" utilized precedent in common and each for his own gradually changing purposes. Millais's *Autumn Leaves* was thought by some to startle through absence of subject, but its solemn girls resemble Margaret, sensing the cycle of decay, in Hopkins's *Spring and Fall*. Before the Brotherhood, William Mulready among others had emulated the Dutch in painting with thin glazes over a wet white ground, but it was the brilliancy of Pre-Raphaelite work that converted William Dyce and drew to their methods other artists less settled than Dyce had been within academic formulas. From the linearity of figures, as if each was a cut-out to be shuffled into other positions, some of Rossetti's drawings must be excepted. If the term "Pre-Raphaelite" suggested the Pugins' Catholicism, and some of the Pre-Raphaelites' subjects aroused suspicions of Tractarian rigidities, the wild color was as foreign as Rossetti's name: "Take the bourgeois, the Saxon has a ponderous coat with stiff collar, heavy waistcoat with huge pockets, and all of a solemn, wearisome, serious, determined, miserable, respectable air about them. The Frenchman is addicted to plum-colour, tea-green, and blue. His umbrella, too, is tea-green, or fawn-colour, just as the Italian farmer's is often scarlet, with a gilt border."[31]

Morris defined the movement as "in one word, Naturalism," but each Pre-Raphaelite had a personal way of trying to bring nature into London. It needs to be remembered as a paradox that this movement, with its emphasis on sharp outline and vivid color, began in a city where, as Rossetti noted in *The Burden of Nineveh*, the sun could barely cast a shadow. Constable, as a student in the Academy schools, had complained in 1799: "I paint by all the daylight we have, and that is little enough. I sometimes see the sky,

but imagine to yourself how a pearl must look through a burnt glass."[32]

In choosing historical subjects with contemporary implications, as Charles Kingsley did in historical fiction, the P.R.B. further insisted on "newly culled facts" from the visible world around them.[33] In order to avoid error in the muscles of the arm, Millais sought a carpenter to model Joseph in *Christ in the House of His Parents (The Carpenter's Shop)*. For *Ophelia* he kept Elizabeth Siddal in the water just short of pneumonia. The search for "more exact truth" in sacred subjects took Hunt to Syria. To paint *The Scapegoat* he parched in the crust beside the Dead Sea. For accuracy in *The Light of the World* he painted at night. To paint *en plein air* was one of the Brothers' more ordinary ways of attempting fidelity.

Especially as expounded by Ruskin, fidelity had two aspects, accuracy of detail and loyalty to the moral wholesomeness of nature. Redgrave, said Ruskin, was "in all detail industriously wrong."[34] Ruskin subscribed to the first requirement of Victorian allegory, moral wholesomeness. Hunt and Millais contributed illustrations to Margaret Gatty's *Parables from Nature,* "with Notes on the Natural History, and Illustrations" (1861–1865), a work issued serially and then combined into upholstered, overdressed volumes. With overt purpose, like the paintings of Hunt, this popular work joins accuracy of biological detail with moral uplift. In "Knowledge Not the Limit of Belief," a bookworm that has eaten through the back of Bacon's *Advancement of Learning* explains to zoophyte and seaweed that "you should not dispute the superiority and powers of another creature merely because you do not understand them." In "The Law of Authority and Obedience," a worker-bee inclined to complain of the idleness of drones and the queen learns "there must be a head to lead and hands to follow." In "Whereunto?" Mrs. Gatty is harsh with "a creature" who believes (like Blake's Thel) that seaweed, starfish, and even rational beings are useless; the illustration by John Tenniel caricatures this human error in one naturalist examining a starfish with a magnifying glass (Wordsworth's physician botanizing upon his mother's grave) and another poking the starfish with a stick. Tenniel's message is Wordsworth's and Hunt's: scientific knowledge must not be freed from moral value.

An additional requirement of Victorian allegory, according to

several recent studies, was biblical typology, figuration.[35] Typology was "closely linked to natural theology."[36] A poem by James Collinson in the *Germ,* "The Child Jesus," foretold every interpretive aspect of the Crucifixion, only not in a carpenter's shop, for "Joseph had one ewe-sheep" and Mary could dream of "many cruel thorns" that would tear its head. But realism, if true to itself, was supposed to be clinical. What if Carlyle and Emerson were right? What if fidelity to external nature obscured God's own spiritual truth?[37]

The clash of realism with morality, apparent in critical reactions to sculpture in the Great Exhibition of 1851, troubled critics of the Pre-Raphaelites because they found contradictions of meticulousness, morality, and vivid color within individual works, made worse because each aspect in contradiction was independently insistent. William Etty had surrounded his nudes with color but without drama. Besides interactive drama, identified by Martin Meisel as an advance in "situation," the Brotherhood aimed at high seriousness as consistently as the Nazarenes of Vienna, who influenced Ford Madox Brown (and William Dyce) if not the similarly sober simplifications of the Brotherhood. What Tommaso Minardi taught the Nazarenes, to practice simplification in order to avoid distracting the spirit by attention to physical appearance and technique, ran counter to Pre-Raphaelite realism except perhaps in Rossetti's earliest oils. Rossetti's first P.R.B. painting, *The Girlhood of Mary Virgin,* was as resolutely allegorical as *The Hireling Shepherd* by Hunt, but there are spaces and light in the *Girlhood* rather than a crowding of detail.

Clarence Cook and other American disciples of Ruskin who produced in 1863–1865 the two volumes of *The New Path* recommended Pre-Raphaelite high seriousness: "A painter of pictures should be a thinker on canvas . . . and a picture should be thought on canvas . . . The true and noble ideal comes of that penetrating perception which, by love and long discipline, sees at once the most essential qualities of things and records these with emphasis."[38] Cook's example of the ideal was a painting by Millais, *A Huguenot, on St. Bartholomew's Day, Refusing to Shield Himself from Danger by Wearing the Roman Catholic Badge* (1852), in which, whatever one's response to the torn lovers, the brick wall, flowers, and vines are very real and very close.

Those not in sympathy pointed to failures and contradictions. Leslie must have had in mind Rossetti's two linear and allegorical paintings of the Virgin when he accused "the Giottos of the present day" of attempting to resurrect the past as if one's writing resembled Chaucer's simply because it was printed in black letter.[39] Although Pre-Raphaelite paintings differ greatly in appearance from Courbet's, their realism, like his, disturbed critics because the idealism, latent in Courbet, explicit in Pre-Raphaelite allegory, could not be ignored. Some would advise Millais to tell the story of Jesus without the shavings on the carpenter's floor; others would have the boy in the shop without the prefigurings of the wound from a nail in the hand, John ready to baptize, and a congregation of lost sheep outside. The distinction fixed by Coleridge for the nineteenth century between allegory and symbol viably distinguishes between the $A = 1$, $B = 2$, $C = 3$ assignable meanings in early Pre-Raphaelite painting and the translucent but illimitable suggestiveness of luscious fruits in Christina Rossetti's *Goblin Market*. Nature includes the lure of goblins; a sister, only possibly with Christ as antetype, can assume and dissolve burdens. The poetic vehicle, apart from the issue of temptation, probably owes something to Rossetti's collecting of beasties: raccoon, raven, owl, wombat, kangaroos, and a "mole for Nolly Brown."[40] Christina's verbal picturing calls up St. Augustine and St. Anthony rather than Paley, but it left her brother Gabriel, Laurence Housman, and a number of later illustrators of the poem free to convey a wide spectrum of jolly evil in their respective goblins. Honest explicators of Hunt's paintings lack that freedom. Rossetti's reportorial poem *My Sister's Sleep* can be read as naturalistic, even after the typological is granted: to the narrator as shocked observer, the sister is "dead" (line 55); to the narrator as poet, she "slept" (line 57); for members of the Christian family, she is "newly born" (line 60); for them, the shuffling of chairs is not on the floor above, but in heaven.

Ruskin admired typological wholesomeness in Pre-Raphaelite work, but he admired more the truth to nature—"all art is praise." In allegorical allusion they were not to forget "material veracity, compelling the spectator's belief . . . in the thing's having verily happened; and not being a mere poetical fancy."[41] Nor was Ruskin

the inventor, though the most ornate preacher, of the morality of art. Constable had referred to both subject and manner of his *Boat Passing a Lock* (1825) as "silvery, windy, and delicious; all health, and the absence of everything stagnant"; S. W. Reynolds, who engraved the work, confirmed the assessment: "masterly without rudeness, and complete without littleness; the colouring is sweet, fresh, and healthy; bright not gaudy, but deep and clear."[42] That Ruskin's emphasis was not inevitable in fine arts is clear from a remark of Leslie's: "I remember a poet, or rather a writer of verse, now remembered by nobody, who placed himself higher than Lord Byron, because as he said (and truly), he never wrote an immoral line, and filled his pages with recommendations of everything virtuous."[43]

We call "Victorian" not Leslie's view, but Holman Hunt's. Granting that his friend Millais lapsed from the highest worship of nature, Hunt in retrospect insisted that Millais "disdained polluted nature, and never, in order to win favour with the fevered sentimentalist, allowed his art to deal with the morbid."[44] Rossetti offended as a "fleshly poet," but there were other ways of being unwholesome. As noted above, critics discovered an absence of health in the mean realism of works from the Brotherhood. Dickens, opposed more to medievalism than to Pre-Raphaelite realism, contrasted the "post-Raphael ideas" of religious aspiration and all "ennobling, sacred, graceful, or beautiful associations" with—"pre-Raphaelly considered"—the "lowest depths of what is mean, odious, repulsive, and revolting."[45] Walter Thornbury asked the Brotherhood to give up medieval myth, but the realism he asked for would be immaculately sentimental: "The large world want the old heart-ache painted; mothers parting from children, death-beds, lovers joining hands . . ."[46]

Holman Hunt's conviction that *The Awakening Conscience* was morally wholesome was not shared by critics until Ruskin came to his rescue. The young woman who rises from her seducer's lap has opened her eyes to hot, indoor, modern life. *Oft in the Stilly Night,* on the music-rest of the very new piano, tells "of other days around me." Objects in disarray on the floor include a soiled glove, a disheveled portfolio, and a cat tormenting a maimed bird. The

seducer's foot presses against tangled yarn—needlework aban-
doned, in contrast with needlework begun in Rossetti's *Girlhood*,
completed in his *Annunciation*[47]—and

> Oh, what a tangled web we weave
> When first we practice to deceive.

In the background we see the glory of blossoming trees, but a larger
frame and the shadowed reflection of the woman's back tell us that
this glorious nature, reflected for us in a mirror, is the external sign
of her sudden internal vision. Carlyle, visiting the studio, failed to
perceive that green nature, seeking the conscience through window
and miror, is reflected still again on the table.[48] The woman has
risen abruptly, and leans forward as if to leap at the viewer with her
evangel. Redemption has been called only "superficially possible"
for this woman, but the face described by Ruskin as "sudden horror;
the lips half open, . . . the teeth set hard; the eyes filled with fearful
light of futurity," was repainted by Hunt into its present ecstasy,
and Meisel has pointed out that Hunt's declared regret at the re-
painting is belied by his consistent reference to the work as *The
Awakened Conscience*.[49] Ruskin's suggestion that the surrealistic de-
tail was appropriate to the fevered state of the woman requires for
validity a similar explanation of fevered detail in other paintings by
Hunt, Millais, Charles Collins, and Hughes.

Hunt could be revolting by calculation, as in *The Scapegoat,* where
the viewer perplexed by this wretched emblem of the sacrificial
Christ is to be surprised by sin.[50] A professional critic approaches
*The Awakening Conscience* or *The Hireling Shepherd,* by instinct and
training, to judge. Both paintings expose errors of contemporary
life, but neither makes a statement significantly concerned with
gender. These and other works by Hunt ask the viewer, not to
judge, but to choose: behold the need for choosing the Light of the
World. In *Strayed Sheep (Our English Coasts),* the nearest ram sets a
pattern for the flock in looking up at the viewer as to a leader, and is
not fed. The scene is near Hastings, where, the viewer could re-
member with unease, William the Conqueror was the last to in-
vade. The context is provided by patriotic "pastoral celebration" in
John Sell Cotman, *The Marl Pit* (ca. 1809) and John Crome,

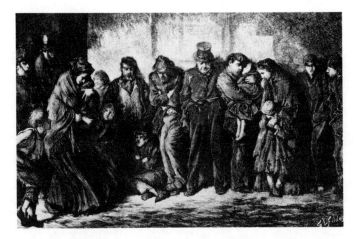

*Samuel Luke Fildes,* Houseless and Hungry, 1869. *Realistic depiction of the unnatural circumstances of life in the city, shading into the protest of "naturalism" against prevalent conditions of poverty.*

PHOTOGRAPHER. *"No Smoking here, Sir!"*

*George du Maurier, "No Smoking Here, Sir!" 1860. Photographer: "No Smoking here, Sir!" Dick Tinto: "Oh! A thousand pardons! I was not aware that—" Photographer (interrupting, with dignified severity): "Please to remember, Gentlemen, that this is not a Common Hartist's Studio!"*

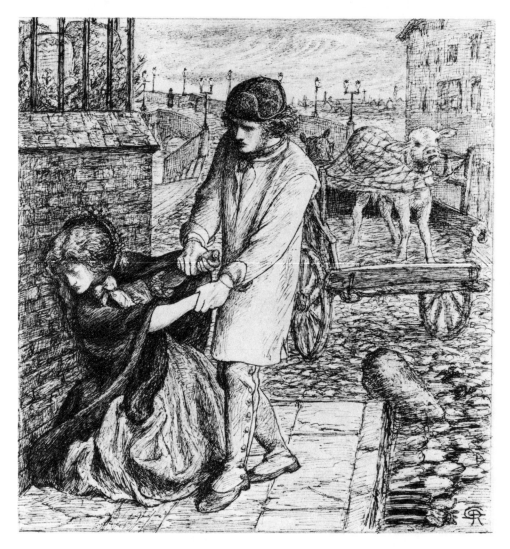

*Dante Gabriel Rossetti,* Found. *One of several preliminary sketches for the unfinished painting. Such realism was rare for Rossetti, although the fallen woman was a common subject in Victorian art.*

*Mousehold Heath* (ca. 1812–1813).[51] Hunt is not celebrating. These hungry sheep bear the ruddleman's mark: a responsibility claimed is not being met. (Hunt's pun here resembles W. S. Gilbert's—I can like your ruddy countenance without approving your bloody cheek.) As is the way with depicted sheep, Hunt's strays idle thoughtlessly near the cliff-edge above the conclusive sea.

Of some seventeen occurrences of "astray" in the N. Testament (with "straying" in 1 Peter 2.25), seven explicitly, and all by implication, say take heed lest you be led to perdition. *Strayed Sheep,* like *The Hireling Shepherd* (John 10.12-13), carries religious, political, and artistic freight. Hunt left to such lesser disciples as Brett and Wallis the simpler tasks of social implication without allegorical puzzles.[52]

The versions of Hunt's realizations and illustrations and translative representations of *The Lady of Shalott* provide a précis of his development as an artist. After preliminary sketches of the final stage of Tennyson's poem, the lady lying in her boat as it floated down to Camelot, where Lancelot could muse upon her lovely face, and intermediate drawings of her kneeling and sitting at her loom, Hunt achieved his basic interpretive icon in the drawing to be engraved by J. Allen Thompson for the Moxon edition of Tennyson's *Poems* (1857).[53] The artist at her "magic web" has chosen the real world of Lancelot, the mirror has cracked, she has woven a spider's web (in Hunt's icon) that has exploded and entangled her, and the fierce wind of change blows her hair in waves across the top of the picture. From his response to Tennyson's objections in 1867 on through his exegesis of 1905, Hunt displaced the aesthetic theme of danger in emergence from embowerment with the religious theme of a curse descending because of inadequate use of powers granted to the artist as individual by God: The servant who brings no increase of talents, in accord with Matthew 25, will be cast into darkness. In the finished painting of 1886–1905, now in the Wadsworth Atheneum of Hartford, the space around the spinner of dreams is enlarged to allow greater intricacy of repetitive patterns and a much more intense elaboration of allegorical detail. The final work, not illusionistic in the overall manner of early Hunt and Millais, is decorative in method and effect if not in aim. Drawing upon *The Palace of Art* and upon design and iconography in

major Italian and Flemish paintings he had traveled to study, Hunt carried the Christian typology of his 1857 design a further step into classical myth as Christian message; he replaced Christ as pantocrator, for example, with Hercules as the type of Christ. These departures from illusion and the literal in metonymy drive from the decorative aestheticism that he probably intended *The Lady of Shalott* to combat.[54]

Rossetti's paintings of the Virgin Mary, alerting critics to Tractarian archaisms, pointed toward little in the work to come either from him or from others. His *Hand and Soul,* however, a prose tale published in the *Germ,* proved to be a touchstone for late Victorian England. The woman who is the painter Chiaro's own soul reprimands him for distinguishing between painting beauty to achieve fame and painting high morality to preserve faith; instead, God's will is done by following what God has set it in the painter's heart to do. Rossetti's fellow Pre-Raphaelite Frederic Stephens wrote perceptively of the self-revelations: "In 'Hand and Soul' it is easy for his intimates to recognise the outpourings, protests, and introspective lamentations, the doubts, self-fears, and partial despair of his future of the author, then struggling with himself to attain means and powers sufficient for his devotion, his hopes, and his ambition."[55] Others were inclined to regard it as the portrait of every artist as a young man in that time of change; each recognized in it his own aspirations and his own discontent. Near the turn of the century it was printed by nearly every newly founded private press. What Rossetti's *How They Met Themselves* was to the fear of death, *Hand and Soul* was to the fear of life. Both the tale and the *Doppelgänger* subject, in ink (ca. 1851) and two watercolors (1864), were set fictionally in a distant time. Historicism becomes in Rossetti a dread of the present.

Pre-Raphaelite paintings tend to be as shallow in perspective as David's neoclassicism, with figures pressed against a wall almost as determinative as in Fildes's *Houseless and Hungry*.[56] If Flaxman is an influence, Hellenic calm has evaporated. Rossetti's shallow interiors may be in part an introduction of novel complexities to avoid the difficulties of academic perspective, but his low ceilings oppress and confine.[57] In a typical Rossetti watercolor, Arthurian figures, or Dante with companions, bend over as if in a cubicle built to confine

slaves. These rectilinear stooping places have been called protective bowers and maternal wombs; whether they are wombs or compacting machines out of Poe, Rossetti precedes the viewer in claustrophobic discomfort. For Rossetti, retreats into a timeless medieval past do not bring freedom. His desire for change included neither a yearning for the distant past nor approbation of "improvement," which Asa Briggs has shown to have been the shibboleth of the age.[58] Yet Rossetti's alienation from his own time never brought him indifference to common opinion. He often performed acts as if he did not care what Mrs. Grundy would say, but peace with his conscience did not include peace with his consciousness of others.

His one painting of a contemporary social subject was *Found*, fretted over for a quarter-century and never finished. A drover has left his cart to grasp both wrists of a cringing woman who turns her face toward the wall of an urban cemetery. Stephens described the pair, she "deserted, expelled, and, whether self-wrecked or not, a wanderer in the streets of London, while we may suppose the grim Nemesis of her sex was leading her toward a veritable Bridge of Sighs"; he, "the young countryman, who, driving townwards to market, no sooner saw the still fair face set in pale golden hair than he recognized the once pure maiden, formerly his betrothed, who, years before, had left his village and was lost in London."[59] Rossetti seems to foreclose the possibility that they were married by altering the chosen epigraph, Jeremiah 2.2: "I remember thee, the kindness of thy youth, the love of thine espousals, when thou wentest after me [that is, followed me] in the wilderness, in a land that was not sown." Rossetti changed "thine espousals" to "thy betrothal" for an undetermined reason presumably deliberate. As often for his pictures, Rossetti wrote a sonnet; not untypically of such companion poems, it forestalls hope that their "mutual pledge" in the past can come to a better end:

> But o'er the deadly blight
> Of love deflowered and sorrow of none avail
>     Which makes this man gasp and this woman quail,
> Can day from darkness ever again take flight?
> . . . . .
>         And O God! to-day
> He only knows he holds her;—but what part

> Can life now take? She cries in her locked heart,
> "Leave me—I do not know you—go away!"

The realistic cadence of her words joins their context to indicate that she is not to be taken as meaning what she says. Does she turn away her face and say these words only from private shame?

Stephens says "the calf trammelled in the net, and helpless, carried in the cart to its death, points to the past and present life of the girl."[60] For Stephens and others after him, the cart and net betoken "the gilded cage" of the fallen woman. According to Rossetti, "in the cart, stands baa-ing a calf tied on its way to market."[61] The bridge he initially sketched was the Blackfrairs, a near way to the Smithfield cattle-market. In one detailed study of *Found* that relates it perceptively to Rossetti's focus in the poem *Jenny* on the poet's consciousness rather than on the whore—and draws on Rossetti's explicit equation vocationally of painter and prostitute—the cart and net are ignored.[62] As for the calf in a gilded cage, the farmer claims ownership of the cart, the net, the calf, and, for all one can tell from the unfinished painting or the early drawing of *Found,* ownership of the woman—"He only knows he holds her." The farmer is on his way to be paid for sending the calf to its death. Supposing the reluctant woman to relent, who would save her from being netted in the cart? If Rossetti sought to make the netted calf an emblem favorable to the farmer, no wonder the work frustrated him. The hard work of establishing context has been done by A. I. Grieve, who interprets the work as a rejection of urban conditions.[63] Supported by Grieve's evidence, we can declare the fallen woman to be London turning her head in shame from the innocence of rural life, the polar contrast of Henry Mayhew's studies of the London poor, utilized by Dickens, Gaskell, and reports with sanitation in mind, over against William and Mary Howitt's books on the seasonal, natural rhythm of country life. Though charismatic and stubbornly anticonventional, the emotionally devious Rossetti makes an unsatisfactory hero in any cause, but he contrasts vividly with the times in the encouragement he gave to serious aspirations of young women as painters, including his wife and Barbara Leigh Smith, who was a founder of Girton College, initiator of the Married Woman's Property Act, model for the stronger aspects of Eliot's

Romola, advocate and principal in independence for all sorts and conditions of women.[64] Hunt *taught* her, as Ruskin taught various young women, but neither could have granted equality or independence.

Only the word "wife" is clearly wrong in a proposal that the drover, like Rossetti, struggles with his own sexuality: "If on one level *Found* is about a drover's futile attempt to save his fallen wife, it is, on another, concerned with the Victorian male's consternation when confronted by that aspect of his psyche which he so little understood and all too often feared: his own sexuality."[65]

Pre-Raphaelite studies have got well beyond describing Rossetti's attenuated wife, Elizabeth Siddal, and William Morris's hair-embowered spouse, Jane Burden, as equally "the Pre-Raphaelite ideal of languorous aesthetic-erotic beauty." There is enough of the erotic in Rossetti's use of "The Sid" to distinguish her as Beatrice from Christina as Virgin, but nothing like the smoldering of Rossetti's Burden, who is woman as beauty, mystery, and tease. If the first two were painted into irreproachableness, the third was put before the viewer as unapproachable. She is also, to the distress and confusion of critics from Rossetti's day until now, what enables him to depict in painting and poetry lovers unable to tell self from other or themselves from God. Opposite to Beata Beatrix was Lilith, for whom the readily erotic model was Fanny Cornforth, the wild cornflower of the aesthetic garden of lilies and green carnations. When the three live models were replaced by others, sometimes as a changed model for the same painting, the three types remained: withdrawn into spirit, withdrawn into self-approval, and poised for amorous enticement—never, in Rossetti, for hurlyburly.

The fundamental brain-work that Rossetti demanded for poetry shows itself in the intellectualized arrangement of episodes in *A Last Confession*; in the wit of *A Match with the Moon*; in the metaphysical conceit of *The Card-Dealer,* the Willowwood sonnets of *The House of Life,* and *The Sea-Limits* (a *Dover Beach* with cosmology); in design; above all in patterns, whether of metaphor, allusions to esoteric or shared reading, or references to color. His dreamy vagueness of suggestion, which seemed to his contemporaries a distinguishing characteristic of his later painting, could coexist in a single poem with intensity of sensuous impression.

The changes in Rossetti's poetry and painting in general are epitomized in his modifications to the poem *The Blessed Damozel*. A monologue in form, as exemplified by Browning's *Porphyria's Lover* or Tennyson's *Ulysses,* the earliest known version is a comparatively objective vision of a late departed saint. She is envisioned by an uncharacterized lover who has heard what the reader, presumably Christian, has heard about the rewards of eternal bliss. The final version, made introspective by an increase in parenthetical asides, leaves even the damozel's achievement of heaven to the fallible judgment of the disconsolate lover. The revisions make uncertain her concern for the unworthy lover left behind, and make it very nearly certain that he will never reach her side again.[66] The doubt and hesitation of Tennyson are multiplied in early Rossetti; anxiety in the early Rossetti is magnified in the later. Although there are details of nature in *The House of Life*—woodflowers peek through the lady's hair when it is spread by the lover—there is more of art: in "Old and New Art" we are not as the great Italians were, but neither are we like Sir Sloshua Reynolds and those guys; we are on the way to renewed improvement in the arts. With the increase of subtext—here or there is Jane Burden, and Morris still exists—beauty and mystery are queried with increased intensity; as the work progressed, love darkened toward death.

All was not dream and drowsiness in the Pre-Raphaelite circles. The Hogarth Club (1858–1861), named, as Hunt said, to honor "the founder of Modern English art," was inaugurated by peripheral and later members of the circle to preserve the foundering sense of brotherhood; among other accomplishments, such as demonstrating how wide Pre-Raphaelite influence had spread, the Hogarth reclaimed Rossetti for the public exhibition of oils. Rossetti's unconsummated rebellion was not as directionless, and not so far from Morris's socialism, as appearances might suggest. For Rossetti, the artist should remain outside quarrels over social issues that should never have been raised or ever needed raising. Morris chose to raise old questions in a form that could achieve conclusion. An ally of the Pre-Raphaelites, John Lucas Tupper, who had failed of public success as a sculptor, could express the more vividly the premises involved. In a letter of 1870 to Holman Hunt, an epitome of

Ruskin's *Unto This Last* leaning toward Rossetti, Tupper's plaint begins with the impious intrusion of a train into hill and sky:

> an unruly outrageous Railway shrieking shamed and discoun-
> tenanced the solemnity, and made nature show like a god
> disgraced in his own world . . . That . . . whistle, poor
> squeamish dotard, makes it all right and safe for a cargo of
> smart Ragsmen bound for Birmingham who sell in the dearest
> markets, blush for Genesis, worship "an enlightened self-
> interest," and know all about the "destinies of America" . . .
> and I asked, if man's future destinies are to be wrought out by
> an age or so of mechanical, brain-busy, soul-sleepy, heart-
> freezing, money-multiplying, honour-ignoring, self-interest-
> substituting, organization-exalting, emotion-suppressing hu-
> manity; of whom are to be born (when Millenium arrives) the
> men and women with faculties to enjoy and thank heaven for
> the possession of such a millenium? . . . I did not know that
> poverty was an evil, but I did know that starved, thwarted,
> and impoverished emotions once receptive to love and beauty
> was a sore evil. Still under the cloud, I saw the mad multitude
> haled hither and thither by devils who whispered them (in the
> Train) that they should undersell their neighbours by means of
> locomotion . . . I am sure that we were never . . . so low and
> grovelling as now when money is set before honour, when
> Trade is a systematic recognized lie, and when human activi-
> ties are so intent on respectability that a boy's education is
> becoming an apprenticeship to Mammon, and there is no time
> for the heart to beat to friendship nor for the intellect and
> emotions to contemplate, and respond to, the wisdom and
> beauty of the world.[67]

As a poet William Morris seemed determined to follow the advice of his Introduction in *The Early Paradise*:

> Forget six counties overhung with smoke,
> Forget the snorting steam and piston stroke,
> Forget the spreading of the hideous town.

In fleeing, however, to the Arthurian world of the other Victorians and on to the grittier world of Froissart, he did not, as others did,

abandon history. His Middle Ages are not Carlyle's timeless realm of true service to heroic masters; not, at least not at first and not altogether, Ruskin's peaceable commonwealth of free, imaginative craftsmen; not Tennyson's model for Prince Albert with Albert reciprocally the model for Arthur; and not Dickens's inhuman time of ignorance, dirt, the thumbscrew, and the rack; but with a little from each of these, a world of heroism in violence, blood, and mud—"a good corrective," in Morris's words, "to the maundering side of mediaevalism."[68] Of Rossetti's poem *Jenny*, Chesterton said, "One has a disturbed suspicion that Morris would have called her 'Jehanne' ";[69] but the Jehane in *The Haystack in the Floods* sees her paramour's head beaten to pieces and she herself will get a fair trial by water: sink, she is innocent; float, she will be executed as guilty. Not all of the violence in *Sir Peter Harpdon's End* is bloody, but it is all cruel: in the ethics Morris found in Froissart, enemies had to grovel before being put to death. In *The Chapel in Lyoness* Sir Ozana dies of spiritual failure. Morris agrees with earlier Victorians and with Conrad that women should be kept free of unnatural war if cohesion, coherence, family, and peace are to survive, but a central point in *Concerning Geffray Teste Noir,* as in *The Haystack in the Floods,* is that women are in reality not kept out of men's unnatural horrors.

Until such irony-filled poems as *The Message of the March Wind* in *The Pilgrims of Hope* volume of 1885 it is perhaps not clear that Morris has in mind the war between poor lovers, in a life "so haggard and grim," and the rich, "How they have, and they hanker, and grip far and wide." He does not, like Rossetti and Pater, probe the experience of beauty; he seeks a life of beauty for all. With Ruskin, he adds to Carlyle's doctrine of work an insistence on joyous work. Ruskin and Rossetti were wrong to think art divine; it is human. Art is the expression of joy in work. In defining Pre-Raphaelite art as naturalistic, Morris awards his highest praise. As leisure is necessary for a life of dignity, some labor-saving machinery might be temporarily beneficial, but when workers unite to become the sole society and all means of production are brought under government control, by violent revolution if necessary, then the need for machinery may wither away. As early as 1858 Morris had joined with others for the beautification of the environment:

Have nothing in your house except what you know to be useful or believe to be beautiful. Morris, Marshall, Faulkner and Co., of which Morris was the sole owner by 1870, included among its products of design painted tiles, wallpapers, furniture, stained glass, and tapestries.[70] For Morris environment is above all architecture; the Brotherhood had been inspired by *Modern Painters,* Morris by Ruskin's graduation from nature to architecture in *The Stones of Venice.*[71] His descriptions of countryside nearly always include evaluations of the inhabitants and the buildings; he notes the paradox that the finest views are sometimes from a train—because you do not see the train.[72] Morris had thoroughly absorbed Ruskin's anti-industrial economics: there is no wealth but life; money measures nothing of importance. In a petty sense it is true that Morris's socialism is a nostalgia for the future, a "realized romance" attaching a failed marriage to satisfying roots in Ruskin.[73]

As early as Mary Wollstonecraft's argument for the introduction of intellectual beauty among women, in 1792, and the revival of Plato's insistence on education by the state rather than by the parents, in Condorcet's *Esquisse* of 1795, the growth of socialism in opposition to Victorian apotheosis of the family could have been predicted. By the 1880s it was no longer a sufficient argument to say that the family was ordained by nature. Shaw declared in Fabian Tract number 2 that "the state should compete with private individuals—especially parents—in providing happy homes for children, so that every child may have a refuge from the tyranny of its natural custodians." Laissez-faire, the cash nexus, and industrial smudge had created further enemies to oppose.

Morris graduated rapidly from Henry George's single tax on land to the sterner analyses of Marx.[74] At the end of 1884 he left Henry Hyndman's Social Democratic Federation and joined with Marx's daughter Eleanor and her lover Edward Aveling to form the Hammersmith Branch of the Socialist League and its public organ, *Commonweal.* He marched with other socialists, but his emphasis on handwork set him apart. His unique blend of nature and art made possible disciples who were distinctly socialist or distinctly aesthetic as well as disciples who were both. His simple language by its very paleness makes a vivid contrast with the diction of other utopians of his time. Edward Bellamy, in *Looking Backward 2000—1887,* had

imagined industrial perfection under socialism: music by telephone, controlled in volume to condition work and (aided by uppers and downers) sleep. *The Dream of John Ball,* by Morris, was meanwhile (in *Commonweal,* 1886–1887) inverting the medieval vision of Carlyle and Ruskin: Ball, in an age of serfdom, could foresee an International twentieth century. Ruskin's *Unto This Last* had given Morris a way of reading Marx; John Ball could dream of a time when relations among all persons would be personal, with exchange of services according to natural equality rather than under the artificial class antagonisms of capitalistic competition.

Morris's *News from Nowhere, or, An Epoch of Rest* (1890) is a fiercely placid attack on European civilization, which is to be replaced after the revolution of 1952 (all in a dream) by a beautiful rural world of half-timber houses along the Thames, where there is no machinery, no pollution in the river, no prisons, no banks, no wages, no Parliament, no required education, no art galleries, no realism in the abundant murals, no fictional romances except as a joke on Dickens, no upholstery on the women, no statutory marriage, no wars because no nationalism, no misery, a minimum of passion, and very little sex. Darwin has not reached this stationary world; the eugenics of Samuel Butler's *Erewhon* (1872) and Shaw's *Man and Superman* (1903) are therefore unneeded. Morris has realized the dream expressed by Thomas Jefferson to John Adams in 1812: "if science produces no better fruits than tyranny, murder, rapine and destitution of national morality, I would rather wish our country to be ignorant, honest and estimable as our neighboring savages are."[75] Morris was stirred and shaken by Richard Jefferies's *After London,* in which after catastrophe there is a "relapse into barbarism"; in Jefferies's grim fantasy, slaves as warriors "stripped man of his dignity, and nature of her refinement."[76] For Morris the destruction of London and its corrupt civilization would afford a fresh start. As in a lecture on the prospects of architecture delivered in March 1881, Morris in *News from Nowhere* co-opted the belief in "struggling, hopeful, progressive civilisation," which he was subverting, much as the romantic believers in imagination had co-opted reason.

In *The Time Machine* (1895) H. G. Wells withered the visions of both Bellamy and Morris. Capitalism, obeying the law of entropy,

would bring to the division of effete owners and deprived workers a world in which the enforced darkness of factories would devolve into a victory of brute, blind strength. Wells was to explain later his animus against Morris's aesthetic socialism:

> The socialist movement in England was under the aesthetic influence of Ruskin; it was being run by poets and decorators like William Morris, Walter Crane, Emery Walker and Cobden Sanderson, brilliant intellectual adventurers like Bernard Shaw and Mrs. Annie Besant, . . . and a small group of civil servants like Sidney Webb and Sydney Olivier. [They were] generally ignorant of scientific philosophy . . . we went on Sunday evenings to Kelmscott House on the Mall, Hammersmith, where William Morris held meetings in a sort of conservatory beside his house.[77]

Only the Fabians were more futile. Accused of having wives in common, "the Fabian Socialists did not even have their ideas in common."[78]

Morris kept his neuroses so deeply hidden that he seemed on the surface hardly aware of the paradox that the products of his company provided a beautiful environment only for the rich. But it may be that his influence on design has lasted more than a century in part because his deepest, instinctive, communicated loyalty was to design. He saw art as arising naturally out of the struggle with nature. The artist's relation to nature was that of Jacob's wrestling with the angel. The artist must both follow and conquer nature. "Men urged by their necessities and desires have laboured for many thousands of years at the task of subjugating the forces of Nature and making the natural material useful to them." Capitalists then stole from society "the fruits of our victory over Nature." In his first public lecture, "The Lesser Arts," in 1877, Morris recommended, or as he put it, discovered, in decoration, "those wonders of intricate patterns interwoven, those strange forms invented, which men have so long delighted in: forms and intricacies that do not necessarily imitate nature, but in which the hand of the craftsman is guided to work the way that she does, till the web, the cup, or the knife, look as natural, nay as lovely, as the green field, the river bank, or the mountain flint."[79] His disciplines refined the decorative but com-

mended fidelity to nature, as in Walter Crane's account of Morris's work: "His patterns are decorative poems in terms of form and colour. His poems and romances are decorative patterns in forms of speech and rhyme . . . But . . . he took his inspiration straight from nature and life."[80]

Morris's relation to the immediate past was paradoxical. He must have owed more than he realized to Owen Jones and Sir Henry Cole. Cole, one of the begetters of the gigantic international exhibitions of industry, had focused education of the poor on "the applied sciences—chemistry, physics, natural history, mechanics, navigation, and the fine arts."[81] Jones, an architect and ornamental designer, heavily involved as Cole was in the Great Exhibition of 1851, had issued his great folio, *Grammar of Ornament,* in 1856, and provided further models in illuminated books. The finest arts, to Cole, Jones, and Morris, were ornamental; Morris saw more clearly than his predecessors that the practice of ornamental art was therapeutic.

The Pugins had turned architecture and interior decoration toward Roman Catholicism; Ruskin had urged a return of the movement to the Protestant fold, had indeed been distressed at its diffusion over the entire range of building in English-speaking countries; Morris accepted the diffusion by changing the course of design.[82] He shaped the future largely by repeating over and over in lectures and books: Be simple, even as your blissful ancestors were simple. His answer to industrialism is his answer to Dickensian fiction, both blatant in *News from Nowhere*: Do without. For inner peace, for what monastic forebears called the good of your soul, Do without. Forbear. Simplification led to Vienna Werkstät, Bauhaus, and the frugal, puritanical lines of Alpers, Lichtenstein, Warhol's cans without soul.

The best of Morris's poems are patterned speech restored to nature and life. In almost every word of *The Defence of Guenevere* the Queen's guilt with Lancelot is evident, but Morris is able to convey sympathy with the grounds of her defense: she cannot have done wrong, because she is queen, she is too much a lady to explain blood on her bed as resulting from rape by Mellyagraunce,[83] and she is beautiful. Her guilt is even more evident in *King Arthur's Tomb,* in which the ironies that Morris weaves through the dialogue of Lan-

celot and Guenevere overlay his source, Rossetti's watercolor *Arthur's Tomb 1854* (of 1855). If nature and life are significant sources for the Guenevere poems, decoration is foremost in two watercolors of 1857 commissioned from Rossetti by Morris, *The Blue Closet* and *The Tune of the Seven Towers,* and Morris retains the decorative aspect in his two poems of 1858 with the same titles. Stephens called Rossetti's *Blue Closet* "an exercise intended to symbolize the association of colour with music."[84] The same could be said of the other picture, and they are almost interchangeably "Blue" and "Tune." Like a palindrome or Morris's earliest wallpapers, the *Blue Closet* is symmetrically paired: singer—bells—keyboard—keyboard—strings—singer. The heavy diagonal of the spear in *Seven Towers,* weakly supported by the diagonal of the bell-rope over the lady's shoulder, gives the work a courageous, peculiar design. Morris translates the details of the pictures into narrative situations rather than narratives. Locked in, as by Bluebeard, Alice explains the supernatural of the refrain and of the lily, shot up (by Rossetti) through the floor. The lover who came to Louise long ago, as from a mermaid, will return from death and lead them to freedom. As if avenging the oppression of women in the *Closet,* Yoland in the other poem is a belle dame without mercy, like the lady in *The Glove and the Lions* by Leigh Hunt asking cruelly for needless chivalric sacrifice. To herself and to the reader, she speaks a refrain—"The graves stand in a row"—as horrendous for the decorative as Rossetti made Sister Helen's for incremental narrative. Yet both the pictures and the poems are "exercises" to explore the limits of art—in the Victorian context, exercises to explore minimal parameters.

To explore the aesthetic was not to declare it. "Art is not a subject for art," Morris repeated after Ruskin in 1881, when he recognized in Oscar Wilde a clever ass.[85] Every exploration by Morris carried the tough-mindedness that pervades his letters and the common sense of his "anti-scrape" campaign for architectural preservation: not only the ancient, but every artifact up to the moment of threatened removal, under the untenable claim of restoration, he considered to be part of the history of every monument and structure. It was falsely elitist not to see that the Georgian heritage deserved preservation along with the Plantagenet. History did not stop short with Carlyle's Abbot Sampson or the reign of

Anne or the time of Josephine. Landscape to Morris, in every literal and metaphorical way, is a "field full of folk."[86]

The vague idealism in Rossetti's rehandling of the *dolce stil nuova* and courtly love, exasperating to Holman Hunt, was heaven-sent to Edward Jones, later Burne-Jones, from 1894 Sir Edward. Jones and William Morris, identified when Rossetti met them as "projectors" of the *Oxford and Cambridge Magazine* (to which Rossetti contributed two of his finest poems), were converted by him to art and asked to join in the creation of distemper frescoes in the Oxford Union, "predestined to ruin by fate and climate." Rossetti's radical simplification of book design was to bear fruit in the 1890s, not only in further simplification but equally in Morris's extremely unsimplified books from the Kelmscott Press.[87] Rossetti was a leader by force of personality. Wherever he went, the term Pre-Raphaelite followed, so that the dreamy myth-painting of the next generation, of Burne-Jones and the American muralist Edwin Austin Abbey, became the Pre-Raphaelitism for the next reactors to reject. The angels of Rossetti's earliest paintings, shorn of linear isolation from surrounding space, are transplanted to classical myth and fairy tale.

Burne-Jones practiced an even-handed avoidance of Hunt's moral commitment and Rossetti's intensity. The apparent placidity of his allusions to myth and the slow gestation of each of his paintings, encouraging a stability of style, made his work a way station in decorative art. The attenuated figures in early drawings by Rossetti became, through their less angular use by Burne-Jones, the common property of aestheticism. It is not clear how far the recent revival of interest in Burne-Jones can be divorced from revived interest in the movements with which he was associated. With unstinted praise for *The Mirror of Venus,* recent critics have set him apart as unique in the combination of "Pre-Raphaelite, aesthetic, Italianate, classical"—characteristics seen otherwise only in competing schools.[88] As a draftsman he achieved remarkable articulation of hands, feet, and mournful faces.

Burne-Jones would have meant Ruskin and the first flowering of the Pre-Raphaelites, along with "the 'photographic artist,' " in declaring that "the realism they talk about isn't art at all but science; interesting, no doubt, as a scientific achievement but nothing more."[89] The predominately decorative myths in his figurative

paintings may deserve only barely Kestner's charge of mysogyny.[90] True, the sleeping knights in the Briar Rose series are gray corpses—"Pale warriors—death-pale were they all." Burne-Jones's best biographer begins a list of his most frequently repeated themes with "the willing victim" of feminine beauty and wile: "The enchantment of the willing victim, sleep, waiting, imprisonment, loneliness, guiding, rescue, the quest, losing and finding, tending the helpless, flying, sea-crossing, clinging together, the ritual procession and dance, love dominant and without pity, the haunting angel, the entry into life."[91] The open eyes of his portrait of Frances Graham look with accusing innocence.

With small reminiscences of Pre-Raphaelite detail, such as the birds in *Love Leading the Pilgrim* and the heavy fruit in *The Baleful Head* (in the Perseus cycle), his paintings fuse uniquely decoration, dreamy myth, and personal introspection, the last an intriguing mystery to viewers not in the inner circle. *Fin de siècle* seems to commence in the 1860s in the melancholy faces of Burne-Jones's women. They seem sick from their own beauty. Of the painter's Four Seasons of 1869, only winter, warmly dressed, seems almost content with inaction. Dugald MacColl may have been right in saying that Burne-Jones "responded to all of the melancholy mixed with beauty and sleep that had been accumulating in English poetry," but the yearning without hope suggests an ending, "the gracious and lingering twilight of an ephemeral heyday."[92] Such melancholy arises not from his temperament, but from his experience. In *The Mill,* commissioned by Constantine Ionides, the three graces who touch fingers were three members of the Ionides family whom Burne-Jones had separately and delectably touched. They dance to the music of love in an Edenic, Ruskinian setting. The sorrowful private myth beneath is more nearly a linked dance of propelled desire, from Maria Zambaco to Ned Jones to Georgiana his wife to Morris to Janie Morris to Rossetti, and onward in a circle. Later, of *The Beguiling of Merlin,* the painter wrote to George Howard, "every year when the hawthorn buds it is the soul of Merlin trying to live again in the world and speak—for he left so much unsaid."[93] Natural conduct is fidelity to wife and to children made legitimate by civil, artful law. For a Maria Zambaco to soak a Burne-Jones through with self-temptation is unnatural. But if the

unnatural occurs, the artist should speak it in art. The guilty artist is an Ancient Mariner who must in the involutions of art confess his dreams until full expression gets self-purgation right.

Burne-Jones was successfully pressed by Morris again and again to remain the chief designer for the firm and the chief illustrator for the Kelmscott Press. His finest contribution may in the long run prove to be his designs for stained glass. His "Viking Ship," for a window at Vinland, the home of Catherine Lorillard Wolfe in Newport, with its revolving curves of sail, ship, and sea threatened by emblematic boars but contained by equation of the Vikings with Jesus and the fishermen (fishers of men) in a storm on Galilee—this design is a masterpiece immune to the recurring doubts concerning his Perseus-Andromeda and other series. His cartoon for *The Pelican,* of about 1880,[94] is a guide to Walter Crane and art nouveau.

The earlier romantics had wished to revive the healthful union of thought and emotion disrupted by Locke. Rossetti and his friends advanced a theory of return to that medieval Eden of the Victorians, to the murals of the Campo Santo at Pisa, representing a coherence prior to the perspective-ridden and the mannered after Raphael. They rebelled against the academic hardening of false methodologies, but their cry, "back to nature," lacked the fervor of the coming revolution into stasis, "escape into art."

*seven*

# DARWIN

By the end of the eighteenth century one needed to be no more scientifically minded than Robert Burns to know that "Nature's mighty law is change." The implications of the invasion of natural law by change advanced by a dialectic of empirical discoveries, conflicting hypotheses, and the inertial check of belief in equilibrium divinely or naturally established. Travelers, who contributed to the flowering of the sublime and picturesque, contributed also to the sense of biological variety over time as well as space. The Great Chain of Being, as Arthur O. Lovejoy made famously clear, was temporalized, but it remained more certain that the chain was single than that time had contributed significantly to its linkages. In 1801 the chain of being was more easily visualized as a ladder, each rung a fixed unit in ascent from the most elementary form of life visible under a microscope to a reasoning male adult human being at the top. An acceptable explanation of the visible universe had to include the Deluge, just as any accounting for racial diversity had to begin with the sons of Noah.

Adherents to exact knowledge in England tended to follow the inductive rule of Newton: derive from accurate experimental evidence only those general laws sufficient for practical need: "This rule we must follow," Newton warned, "that the argument of induction may not be invaded by hypotheses."[1] William Whewell's *History of the Inductive Sciences* (1837) implies at the outset and throughout that induction must precede idea and generalization: "clear Ideas applied to distinct Facts will be discernible in the History of Science, whenever any marked advance takes place."

That Whewell's faith in induction constituted a threat to reason, both divine and human, is highlighted by Herschel's contrasting declaration: "Abstract science is independent of a system of nature,—of a creation,—of every thing, in short, except memory, thought, and reason." Experience taught Herschel that natural laws never change.[2] Besides experience, he and most of the scientists of his day had inherited the axiom of Hugo Grotius and Richard Hooker that God is the fountain of all law.

The argument from design kept induction in order; as Bacon's essay "Of Atheism" had explained, "God never wrought miracle to convince atheism, because his ordinary works convince it." The custodians of natural history continued to renew the argument against Epicurus, Lucretius, Hobbes, and all atomists to come in Sir William Blackmore's *Creation: A Philosophic Poem* (1712):

> If Chance alone could manage, sort, divide,
> And, Beings to produce, your Atomes guide;
> If casual Concourse did the World compose,
> And Things from Hits Fortuitous arose,
> Then any Thing might come from any Thing.
> For how from Chance can constant order spring?

*Nature: A Weekly Illustrated Journal of Science,* founded in 1869, under the dateline of every number until war ended complacency in 1942, carried a motto from Wordsworth, repeated on the title page of each annual volume:

> To the solid ground
> Of Nature trusts the mind which builds for aye.

The deduced order of Nature was much in Goethe and Hegel and everything in the *Naturphilosophie* of Friedrich J. W. Schelling and Lorenz Oken. From the transcendental idealism of Fichte, Schelling erected a dogma of undifferentiated being, both nature and spirit, conceived at the objective pole as matter (an equilibrium of forces), light (electric, magnetic, chemical), and finally organism, containing "all in every part." The architectural analogue of such a structure would be the stupendous tower of Wyatt's Fonthill Abbey, which collapsed. Oken carried Schelling's deductive order and Goethe's analogy of parts within a being as far as ingenuity could

take them. He defined an organism as all the world's activities in one body. During the development of each individual, the animal passes through all the stages of the progression of species. In Oken's vertebral theory of the skull, the head is a repetition of the trunk. Geology was historical in method; science otherwise was to Oken a constistent system of mathematical ideas, often displaying Sir Thomas Browne's principle of the quincunx; "nature is the spirit analyzed and at rest."[3] Assuming without opposition from other professors of natural philosophy that the most complex creature is the finest, Oken reasoned out an ascending scale, with organs in a uniform pattern but with more and more organs from the amoeba to Man. Each additional organ makes the animal less incompletely human. Belief in a ladder up to Man was as common as belief in design; Oken went further; his rage for order was undeterred by the anomalies that troubled naturalists in England.[4] Oken was recapitulating Book 10 of the *Laws,* in which Plato put down Archelaus for ascribing to art, and calling it nature, what is in fact law dispensed by the supreme deity, Reason. Oken exerted a strong influence on Richard Owen, the foremost homologist in Britain, so well known that on title pages—and in *Hard Times,* where Dickens has him seeing a constellation, the Great Bear, as something to dissect—he needed to be called only "Professor Owen."[5] For Owen's *Paleontology* (1860) Oken provided a rational structure for laws derived from the Creator but not obviously or explicably divine.

A time bomb was set in the field of design by divine reason when close study of cliffs and caves led to the discovery of fossils pointing irrefutably to the presence in a distant past of species no longer extant. Astronomers, by proposing that the universe was much more than 4004 years older than Jesus, had created a slight unease. In an explanation of the visible universe generally unacceptable, James Hutton proposed in 1788, in an article expanded to two volumes in 1795, that the earth had changed gradually over a long expanse of time. Changes such as erosion and sedimentation that could be observed in the present could account for everything generally attributed to the Deluge. In gradual, uniformitarian change Hutton could find no evidence of a beginning and no indication of an end. Georges Cuvier was by far the best informed of those who attempted to respect the Mosaic account by positing a series of ca-

tastrophes, of which the Flood could have been the one in that part of the world known to Moses.[6] Napoleon had made catastrophism seem more credibly natural than it would seem when Metternich and Palmerston coexisted.[7] Cuvier's morphological division into four classes, molluscoid, radiated, articulate, and vertebrate, laid an inductive foundation for replacing the ladder with what would eventuate as Ernst Haeckel's branching tree of life. Karl Ernst von Baer confirmed Cuvier's division: the ovum developed differently in each of the four classes. Concepts distinct from one another began to suggest a need for the temporalization of biology: improvement (of knowledge, character, estates), linear progress (as against the cyclic), linear history, development, progression (from simple to complex), revolution, and evolution.

Whewell was still determined in the third edition of 1857 not to let time beat its vulture-like wings against his head without resistance appropriate to the reasoning animal placed by God at the peak of all creation. Whewell defined botany and zoology as sciences of classification. The term "natural philosophy" had been gradually fading and the term "natural history" had come into use for botany and zoology, but Whewell insisted that Natural History had "nothing to do with time": "Natural History, when systematically treated, rigorously excludes all that is *historical*; for it classes objects by their permanent and universal properties, and has nothing to do with the narration of particular and casual facts."[8] Granting that most sciences followed Bacon in excluding final cause as a consideration, Whewell insisted that final cause, called by Cuvier "conditions of existence," was necessary in physiology: every organ in a living creature has its purpose in service to the whole.[9]

In 1826 George Poulett Scrope argued that volcanoes had required vast extents of time to reach their present state.[10] The highly respected Charles Lyell announced a renewed adherence to slow, uniform Huttonian change on the title page of his *Principles of Geology, Being an Attempt to Explain the Former Changes of the Earth's Surface, by Reference to Causes now in Operation* (1830–1833). In short, no miracles and no question-settling catastrophes.[11] Whewell was respectful, but not converted. Later generations were to object to Lamarck's argument that changes in the environment created a need for changes in the organism by calling it belief in the inheritance of

acquired characteristics; Lyell objected to Lamarck's belief in the transmutation of species. In Lyell's world of slow change, species were fixed. Catastrophists had come to believe in a succession of species over time; Lyell objected, but he welcomed their agreement that no human remains were to be found in early strata: mankind could still be considered a late and separate creation.

The word "vestige," referring to an organ thought to be degenerated from a more developed and useful state in the past, was about to have a meaning more sinister for those who held sacred the Authorized Version of the book of Genesis. Whewell and his colleagues, in defense both of design and of scientific accuracy, tried to erect a wall around Robert Chambers's *Vestiges of the Natural History of Creation* (1844). Chambers acknowledged no creator except time. He raised once again, but more stridently than any before him, the likelihood that Europeans had distant cousins swinging from their tails in Africa. Adam Sedgwick, professor of geology at Cambridge, past president of the Geological Society and of the British Association for the Advancement of Science, published an attack of eighty-five anonymous pages in the *Edinburgh Review*. Many of those pages were needed to demonstrate the errors and ignorance of a publisher of popular encyclopedias who had blundered out of his depth; but worse, in a work selling out four editions in seven months, Chambers had "annulled all distinction between physical and moral." Chambers was recklessly endangering the foundations of society:

> If our glorious maidens and matrons may not soil their fingers with the dirty knife of the anatomist, neither may they poison the springs of joyous thought and modest feeling, by listening to the seductions of this author; . . . [he approaches] with the serpent coils of a false philosophy, and asks them again to stretch out their hands and pluck forbidden fruit . . . [He tells them] that their Bible is a fable when it teaches them that they were made in the image of God—that they are the children of apes and the breeders of monsters. [12]

You will have noticed that word "again"; Chambers was reenacting for Victorian maidenhood the scene in *Paradise Lost* wherein Eve, acting for all women to come, brought upon Adam and his male

descendants all that woe. Charles Darwin, who had been collecting ideas as well as information about species during the voyage of the *Beagle,* did well to exercise caution in public expression. Among many hazards, Charles Kingsley, who recommended conchology and other exercises of natural history in *Glaucus, or the Wonders of the Shore* (1855) and less directly in *Water-Babies: A Fairy Tale for a Land-Fairy* (1863), kept active watch against scientists who said "Nature" when they should have named God and particularly against those who rejected imagination for the false imagining that species had evolved other than in the eternal mind of the Creator. Chambers's *Vestiges* belongs to the history of anxiety. God had been in retreat ever since He created Adam, with accelerated pace each time He warned the Jews to stop breaking His commandments and their contracted service to His glory or He would destroy them; by the middle of the nineteenth century He was running even from a half-informed Chambers, uncertain of the best direction for withdrawal from the excessively educated. Nature also was on the verge of retreat.

The instability of Paleyan and Wordsworthian nature-worship was apparent well before the publication in 1859 of *On the Origin of Species by Means of Natural Selection; or, The Preservation of Favored Races in the Struggle for Life.* Nature stumbled before Darwin sent it sprawling. Keats could have been Christian, though he was not, in reporting his vision of "an eternal fierce destruction" in which the "greater on the less feeds evermore." In the 1820s Mary Shelley, Thomas Hood, and others followed Byron's *Darkness,* itself anticipated in *The Last Man* by Thomas Campbell, in foreseeing a bleak end of the world. With only a comic shadow of Byron's interest in geological entropy, Hood makes his last man despair because there is no one left to hang him. No major English romantic depicted a Noble Savage; Wordsworth, for one, knew that vales of Grasmere were rare on distant continents. The inhospitality of the arctic zone was a sufficient disturbance to reach the opening of *Jane Eyre.*[13] It was the ever more frequent discovery of fossils of extinct species, and various theories of evolution before 1859, that made Tennyson write of "Nature, red in tooth and claw." Matthew Arnold had published in 1849 a poem ridiculing sermons that recommended

harmony with nature: "Nature is cruel, man is sick of blood; . . . Man must begin, know this, where Nature ends; Nature and man can never be fast friends." Nature is stubborn, fickle, cruel, and unforgiving. John Stuart Mill's posthumously published essay entitled "Nature" made Arnold's point at greater length. Attention to "nature," Mill charged, has become "one of the most copious sources of false taste, false philosophy, false morality, and even bad law." What strikes one about cosmic forces "is their perfect and absolute recklessness. They go straight to their end, without regarding what or whom they crush on the road." Nature teaches competition to the point of murder as a habit. "Killing, the most criminal act recognized by human laws, Nature does once to every being that lives; and in a large proportion of cases, after protracted tortures such as only the greatest monsters whom we read of ever purposely inflicted on their living fellow-creatures."[14] Two stories by Hawthorne in *Mosses from an Old Manse* (1846), "The Birthmark" and "Rappaccini's Daughter," may be regarded as attempts to counteract these perceptions: scientists erroneously regarded with disfavor flaws "which Nature, in one shape or another, stamps ineffaceably on all her productions, either to imply that they are temporary and finite, or that their perfection must be wrought by toil and pain."[15]

*The Origin of Species* did not shock from mere novelty. Considered as units rather than as synthesis, the segments of Darwin's thought had each been anticipated. His grandfather had tentatively questioned the permanence both of design and of species: "But it may appear too bold in the present state of our knowledge on this subject, to suppose that all vegetables and animals now existing were originally derived from the smallest microscopic ones, formed by spontaneous vitality? and that they have by innumerable reproductions, during innumerable centuries of time, gradually acquired the size, strength, and excellence of form and faculties, which they now possess?"[16] Others, particularly Lamarck, had read the evidence of fossils and of modification by breeders as indicating the transmutation of species. It was from Lamarck that Chambers got the idea of vestiges no longer functional. As Darwin came to realize, a wealthy but obscure botanical writer, Patrick Matthew,

had anticipated him by enunciating the principle of change in organisms from change in circumstances.[17]

Charles Darwin's work was abhorrent to Christian geologists for a reason that it was abhorrent to Evangelicals: if his theory were true, the book of Genesis in the King James Version could not be true word for word, and *The Origin of Species* contained a lot more verifiable detail than one could find in Genesis or in works earlier than Darwin's that challenged Bishop Ussher's chronology. Samuel Wilberforce and Edmund Gosse's father did not like to think of their ancestors as apes: Could Adam have seen a simian face when he looked at Eve or into a still pool? But Darwin did not invent that threat to "the human form divine." Edward Tyson's "Orang-Outang, sive Homo Sylvestris" of 1699 had been reprinted in 1751, between Bernard de Mandeville's paradoxical display of evidence in *The Fable of the Bees; or, Private Vices, Public Benefits* and Lord Monboddo's more serious, if more extravagant, argument in *The Origin and Progress of Language* (1774–1792)—the chief source for the simian elected to Parliament in Thomas Love Peacock's *Melincourt; or, Sir Oran Haut-ton*.[18] Believers in political and social equality were distressed by instantaneous applications of the doctrine of survival of the fittest to capitalist enterprise and imperial expansion. And yet Darwin, drawing on Malthus, could have seemed a new threat to Genesis, charity, and pastoral landscape only in the amassing of empirical detail. In Ernst Mayr's terms, there were "Origins without Evolution" and "Evolution before Darwin," and, in Patrick Matthew, natural selection.[19] Owen graveled Darwin by a review in which the anonymous Owen kept quoting rejections by "Professor Owen" of similarly irreligious conclusions in Chambers's *Vestiges*.[20]

Darwin had from the beginning the power of reporting detail that would reach full flower in *The Expression of Emotions in Man and Animals*; his description there of an infant beginning to cry would arouse envy in any realist: "Lastly, the pyramidal muscles of the nose contract; and these draw the eyebrows and the skin of the forehead still lower down, producing short transverse wrinkles across the base of the nose." In his *Journal of the Beagle* (1839) he described nature's murderous ways in Patagonia:

Several species of mice are externally characterized by large thin ears and a very fine fur. These little animals swarm among the thickets in the valleys, where they cannot for months together taste a drop of water excepting the dew. They all seem to be cannibals; for no sooner was a mouse caught in one of my traps than it was devoured by others. A small and delicately-shaped fox, which is likewise very abundant, probably derives its entire support from these small animals.[21]

For the *Origin* Darwin had examined more pages of the book of nature than anyone studied by Curtius in *European Literature and the Latin Middle Ages* had dreamed of doing. Darwin, like Victorian realists, makes one conscious, not only of moment passing into moment, but also of diversity, of difference from inch to inch over space. With praise for Darwin's detail but otherwise with unease over mere observation, Humboldt denounced "vicious empiricism" that denied unity and harmony to nature.[22]

Darwin threatened not only Genesis but a half-century of hermeneutic study of Genesis and nature as possessing nonelective affinity. Even with a questioning of Genesis, nature had been sufficiently harmonious. Erasmus Darwin had perceived the universal struggle for existence and had found in Malthus an illustration of the principle, but *Zoonomia* and *The Temple of Nature* had unfolded a teleological optimism: organisms that feed on decaying bodies may be individually short-lived, but they "add to the sum total of terrestrial happiness." In the grandson's scheme, no individual organism ever profits directly; natural selection gives the offspring a better chance of survival. By *chance,* selection gives another *chance* to an individual in the next generation.

Science distinguished itself from invention and engineering by the search for explanation and constant laws. Darwin had announced the origin of species to be absence of law. Victor F. Weisskopf, in an address to the American Academy of Arts and Sciences in 1981, listed ten major discoveries in the development of the scientific worldview. The fifth of his ten steps was "evolution of living species," a discovery, he said, that "explains how purposeful and goal-directed events enter into a world governed by laws that are devoid of it." Probably Weisskopf's English teachers in high

school and college are only partly to blame for the failure of his word *it* to refer to any antecedent: "purposeful and goal-directed events enter into a world governed by laws that are devoid of it." The meaning hidden under that failure of the pronoun *it* to refer to anything would seem to be that Darwin exposed a situation in which the human mind can usefully ascribe purpose and goals to a world that lacks either single or multiple aims. Natural selection is the name given by reason to the series of chance events by which life reached the condition we find it in.[23] No purpose or desire of any living creature is ever furthered through natural selection. In this account, nothing in or behind evolution ever intended to, nor can it ever, do good for any extant creature. The mere chance of adaptation allows offspring to survive.

How far did Darwin realize that he was replacing natural law with chance? His writings and jottings from 1838 on follow a general direction of change from belief in a Creator's design, through belief not in design but in the harmony of nature, next to the assumption of perfect adaptation of organism to environment (Lyell's environmental determinism), on to relative adjustment to conditions, and more and more to a conviction that survival would probably be awarded in nature to accidental variations.[24] He was inconsistent, tentative, responsive to objections, and inclined to believe that every object, every action, and every change had a determinable cause.

In the five editions subsequent to the first Darwin yielded ground to objectors that he would not have needed to yield had he known that hereditary genes were shielded from somatic cells and that, as only Gregor Mendel then knew, heritage does not result from a blending of the chromosomes of the parents. He bent toward saltatory mutations and toward Lamarckian inheritance of acquired characteristics, the more waveringly because he was pursued by the authoritative (though erroneous) insistence of Sir William Thomson, later Lord Kelvin, that the calculable age of the sun did not allow nearly enough time on a cooling earth for natural selection to bring the changes Darwin and the geologists claimed to find. If Darwin had mustered a greater interest in what could be known about coordination within each organism, he would have been regarded less often in his own time and after as an untheoretical

collector of facts, one who mindlessly promoted the doctrine of survival of the fittest in human society.

Two preliminary points may clarify the subsequent discussion of chance in natural selection. First, Darwin began like other modern naturalists by studying the results of the artificial selection of those characteristics desired by the breeders of animals and plants. He was well fitted to a utilitarian age.[25] The results of such selection by man were indubitable; Darwin concluded that nature proceeded in the same way. Artificial selection had unwittingly copied natural selection. Just as photographers claimed nature as the artist of photography, so Darwin claimed nature as the artificer in the selection of characteristics preferred for survival whenever the circumstances for survival changed. Second, Darwin avoided clarity concerning acquired characteristics in concluding that "individuals having any advantage, however slight, over others, would have the best chance of surviving and of procreating their kind," restated a century later: "in a natural interbreeding population any variation that increased the organism's ability to leave fertile offspring would most likely be preserved, while the variations that decreased that ability would most likely be eliminated."[26] Darwin saw personally, and said often, that he could discover only what was probable, never what could be regarded as certain, and that evolution of species might never be inductively observed. David Hull, exemplary in exposition of induction, teleology, and essences as they were dimly understood by Victorian scientists and philosophers, argues that Darwin meant by the word chance "governed by laws not as yet known," but the passages he quotes from Darwin's letters reveal rather a "simple muddle" of reluctance to believe what his evidence told him.[27]

Even if Darwin had been clear and consistent concerning the cosmic implications of accidental variation, he was not the sort of writer to force that clarity upon his readers. Without animus, from the study of accumulated data, he felt sure that visible nature did not reach its condition in 1859 from predetermined design. Although willing to admit uncertainty, he was not an innocent reporter. At the end of *The Origin of Species* he pointed to the "grandeur in this view of life . . . having been originally breathed into a few forms or into one"—clarified after the first edition into

"breathed by the Creator"—two paragraphs after observing drily that in later researches "light [in 1872, "much light"] will be thrown on the origin of man and his history."[28] Such an author cannot be regarded as completely open with his readers, or with himself, when he declares in the last chapter of *The Descent of Man,* in a paragraph explaining that the belief in God is itself a product of evolution, that "the birth both of the species and of the individual are equally parts of that grand sequence of events, which our minds refuse to accept as the result of blind chance." Francis Darwin quoted from the autobiography drafted by his father in 1876: "There seems to be no more design in the variability of organic beings, and in the action of natural selection, than in the course which the wind blows."[29] Darwin signaled the final victory of the theory of natural selection by dropping the word "On" from the title in 1872: he was not speculating; he had discovered and describing *the* origin. Species arose in accident, not design.

In another view, Darwin looked at the evidence too closely to arrive at any simple or stable conclusion. He was, in his own field, highly teleological. Some neo-Darwinians have been uncomfortable with the degree to which he described each change through natural selection as accomplishing a purpose that could be defined. Darwin may have had a sort of instinctive access to the explanation that two-stage natural selection is neither chance nor necessity, but something different from either, in that genetic variability occurs completely by accident but external conditions function by strict cause and effect in selecting the chance variable that fits the organism to survive.[30]

T. H. Huxley, known as "Darwin's bulldog," found in Darwin's researches strong support for "the universality of the law of causation; that nothing happens without a cause (that is, a necessary precedent condition)," and he found in Darwin support equally for the undeviating rules of nature, rules true for all time. Huxley tended to put quotation marks around the term "laws of Nature," in order to distinguish his own and Darwin's attitude toward undeviating rules from theological belief in natural law divinely established. But he looked beyond the works of Darwin to find in Herbert Spencer the comforting belief

that there is a wider Teleology, which is not touched by the doctrine of Evolution . . . That proposition is, that the whole world, living and not living, is the result of the mutual interaction, according the definite laws, of the forces possessed by the molecules of which the primitive nebulosity of the universe was composed. If this be true, it is no less certain that the existing world lay, potentially, in the cosmic vapour; and that a sufficient intelligence could, from a knowledge of the properties of the molecules of that vapour, have predicted, say, the state of the Fauna of Britain in 1869.[31]

By 1887 Huxley was granting that the verifiable hypotheses of science did not deal directly with a physical world, but were "a symbolical language, by the aid of which Nature could be interpreted in terms apprehensible by our intellects."[32] His belief in a wider teleology in 1869, which was very close to Milton's distinction between predestination and God's all-encompassing foreknowledge, is reduced in 1887 to the predictability of scientific hypotheses verifiable under experimental conditions.

Huxley's friend John Tyndall, starting from physics rather than biology, took very similar positions. He found the term "order of Nature" so contaminated with religious superstition that he quarantined it within quotation marks. Until the advent of modern science, he wrote, "the human mind lay barren in the presence of Nature."[33] The scientific "positivists" in England, W. K. Clifford no less than Tyndall, used positivistic language as defense against, on the one hand, claims that natural law proved prior design by a Creator, and on the other hand, fear that Darwin had threatened the stability of natural law in the material world of scientific experiment. In his Presidential Address of 1874 to the British Association for the Advancement of Science, Tyndall refers to "Darwin's theory" primarily as an example of the need for science to pursue truth in its own way without inteference or hindrance from religion. "Another" generalization, he uses his authority to say, "of still wider grasp and more radical significance, is the doctrine of the Conservation of Energy, . . . that doctrine which 'binds nature fast in fate' to an extent not hitherto recognised, exacting from every consequent its equivalent antecedent, and bringing vital as well as

physical phenomena under the dominion of that law of causal connection which, as far as the human understanding had yet pierced, asserts itself everywhere in nature."[34] Entropy also, as a measure of the second law of thermodynamics, was easier to face than chance selection because it was a law. Kelvin's assertions, based in mathematics, were be trusted above Darwin's.

As Herbert Spencer had a theory of evolution in place before 1850, his insistence on symmetrical order cannot be attributed in any large part to reaction against Darwinian disorder, but his prolonged eminence was owing surely in part to his capacity for assurance: "Each further advance of knowledge confirms the belief in the unity of Nature; and the discovery that Evolution has gone on, or is going on, in religion, philosophy, science, and the arts, becomes a reason for believing that there is no department of Nature in which it does not go on."[35]

Samuel Butler, one of Darwin's earliest admirers and later one of his most insistent opponents, a notorious lover of paradox, argued in *Life and Habit* (1877) that heredity is a mode of unconscious memory; information is passed down genetically from generation to generation. E. S. Russell suggested something like the information theory of DNA in noting how many professional biologists shared with Butler, by 1916, a near identification of heredity and something like unconscious memory.[36] In Butler's *Luck or Cunning as the Main Means of Organic Modification?* (1887), Darwin stands for luck, Lamarck and Butler for cunning. Butler and George Bernard Shaw, who accepted his arguments, were thorns regarded as gnats by the Darwinians of their respective years. But Tyndall's Presidential Address, appealing to the authority of Herbert Spencer, proposes the questions, the answers, and the examples that later Darwinians have treated as distinctive to Butler and the vitalists: "A chick, after coming out of the egg, balances itself correctly, runs about, picks up food, thus showing that it possesses a power of directing its movements to definite ends. How did the chick learn this very complex co-ordination of eye, muscles, and beak? It has not been individually taught; its personal experience is *nil*; but it has the benefit of ancestral experience."[37] In this refutation of J. S. Mill's insistence on experience solely in, of, and from the individual, Tyndall goes next to the beehive.

Nor was Ernst Haeckel, in Germany, able to exclude Lamarck's reliance on intentional adaptation to environment as a factor in evolution. Evolutionists in the United States, from Louis Agassiz through Henry Fairfield Osborn, varied in their ways of insisting, but not in their insistence, that life controls its own destiny. Among astronomers and other physical scientists, a belief in the "creative wisdom" of design, in this regard not far from Paley's natural religion, was held by John Herschel, Michael Faraday, James Prescott Joule, James Clerk Maxwell, and Kelvin. Herschel retained an early conviction: "It is only when we are wandering and lost in the mazes of particulars, or entangled in fruitless attempts to work our way downwards in the thorny paths of applications, to which our reasoning powers are incompetent, that nature appears complicated."[38]

Surprising and telling evidence of the reluctance of scientists to absorb the implications of Darwin's work appears in *A History of European Thought in the Nineteenth Century,* completed by John Theodore Merz in 1903, which purports to survey seriatim the astronomical, the atomic, the mechanical, the physical, the morphological, the genetic, the vitalistic, the psycho-physical, and the statistical views of nature. After showing how the static morphological view gave way to the genetic, Merz turns directly to Darwin. He presents the hypothesis and the amassed evidence of natural selection, and shows how Darwin turned the attention of biologists toward variation.

From Darwin, Merz proceeds to the vitalists, whom he views almost altogether through their opponents. "In all writings prior to Darwin," he says, "a great deal is made of final causes in nature, of the teleology of living processes. The phenomena of life seemed safely intrenched in the citadel of final causes" (2:407). Before Darwin, some sort of vital force could be mentioned without loss of respectability. Darwin has shown that the marks of design are merely apparent; "there is a natural result in development, but there need not be a purpose . . . in the place of a conscious end or purpose he put the conception of a mere result, a product" (2:412–14). Up to this point, and through the next two chapters, Merz has avoided the word "chance." He has called natural selection "an automatic adjustment."

In the chapter on the statistical view of nature, after paying
tribute to predecessors from Pascal through Clerk Maxwell, and
describing Francis Galton's mathematical studies of genetic varia-
tion—he has clearly not heard of Gregor Mendel—Merz approaches
his destination: "We owe it to Prof. Karl Pearson to have first
grasped clearly and comprehensively the mathematical problem in-
volved, and to have solved it in a manner useful for biological
research" (2:621–22). Pearson has answered the questions raised by
Darwin by an adjustment in the laws of probability. A few pages
further on, Merz reminds the reader that Darwin has "introduced
into the science of nature two novel points of view—the genetic
view and the process of judicial sifting of evidence." And here, two
pages before the end of his chapter on the final view of nature, the
statistical, he continues:

> We may now add that he has indirectly, more than directly,
> furthered quite as much the statistical view of natural phenom-
> ena through which we have learned to find and trace law and
> order in great realms of phenomena and events usually sup-
> posed to be governed by what is termed blind chance. The
> study of this blind chance in theory and practice is one of
> the greatest scientific performances of the nineteenth century.
>
> (2:624)

In short, if Darwin has banished natural law in most of its received
forms, then perhaps order can be found ultimately through the law
of probability, which might explain what seems otherwise to be
random variation. Thus grasping for law, Merz can at last say
almost openly that Darwin replaced law with chance. The "chance"
being discussed allows scientists to distinguish the random as a law;
in a later century than Darwin's a further escape can be formulated:
"Chance is less an objective phenomenon than the way an observing
subject characterizes some event in which it has a stake or interest,
the interpretation of an event, in other words, which occasions loss
or gain for the person."[39] Chance thus becomes merely subjective.
   As late as Merz, though, it was probably also fear of chance that
made him ignore two prominent arguments in Pearson's seminal
work, *The Grammar of Science* (1892), first, that statistics free the
study of life from the category of causation, and second, that the

"outside world is a *construct*" of the human mind, so that natural law exists as a creation of the reasoning mind: Newton did not discover gravity, he created it.[40]

The implications of natural selection, seldom and glancingly confronted, could not be ignored. Herschel called it the law of higgledy-piggledy.[41] The Duke of Argyll, president of the Royal Society of Edinburgh, published in 1866 *The Reign of Law,* which went into a fifth edition by 1868. "Purpose and intention, or ideas of order based on numerical relations," Argyll explains, "are what meet us at every turn, and are more or less readily recognised by our own intelligence as corresponding to conceptions familiar to our own minds."[42] Argyll continued his argument for order, purpose, and intention in a work of 1884, *The Unity of Nature.* During the Darwinian celebrations of 1959 Argyll's objections to the *Origin* were ascribed to religious bigotry, but most of his queries have been revived a century after he raised them.

The worried insistence upon law and order continued. An exception among mathematical scientists was Helmholtz, who said in a lecture of 1869: "Darwin's theory contains an essentially new creative thought. It shows how adaptability of structure in organisms can result from a blind rule of a law of nature without any intervention of intelligence." Helmholtz was inclined to endorse this "new creative thought," even though it came from "descriptive natural science," because it brought order to the greater higgledy-piggledy of "natural affinity," homology, paleontology, and embryology: "Darwin has raised all these isolated questions from the condition of a heap of enigmatical wonders to a great consistent system of development, and established definite ideas in the place of such a fanciful hypothesis as . . . had occurred to Goethe, respecting the facts of the comparative anatomy and the morphology of plants."[43]

One could apply a rule of thumb similar to that by which artists spoke with vehemence against photography in direct ratio to their dependence on illusion. It had become urgent to insist on the stability of natural law. Physicists were not ready to allow biologists a separate domain of accident. Newton's ether was resuscitated as a kind of glue to hold the particles of the world together. Scientists who needed faith were reluctant to lodge that faith in chance. William Benjamin Carpenter, a physiologist in the University of

London, explained in *Nature and Man* (1888) that Darwin offered no challenge to belief in God's power, but simply gave new information about how God had exercised that power.[44] The postulate that Carpenter shared with many other scientists has been neatly stated: "If God was not responsible for designing each species, he had at least created the self-designing forces of nature."[45] Henry Drummond, a Scottish evangelical, drew upon such reputable sources as the sixth edition of Sir William Robert Grove's *The Correlation of Physical Forces* in his own *Natural Law and the Spiritual World* (1883), which reached a sixteenth edition within three years and could count scientists among the approving readers long after Drummond died in 1897. Defending science against theology, the president of Cornell University argued in 1897 that Darwin had made biology as predictive as Newton's calculations had made astronomy.[46] Chance belonged to the kismet of fantasy.

Wallace, the codiscoverer of natural selection, was one among a number of prominent scientists who turned to spiritualism. He had never included the "spiritual existence" of Man in the sequence of biological variants. That he kept belief in spirits separate from his expressed objections to Darwin on descent signals the degree of his distress over deplorable evidence. Sir William Crookes, physicist, chemist, and inventor of scientific instruments, studied both rare earths and common spooks; he went from investigating electrical discharge through rarefied gases to investigating air so rarefied that he found there spirits returned from the dead. Sir Oliver Lodge, physicist, professor, and for twenty years principal of the University of Birmingham, concluding that the universe may be "open to all manner of spiritual influence,"[47] investigated on equal terms electricity and ectoplasm. After serious botanical work in which he found chance so foreign that he ignored Darwin's evidence against inheritance of acquired characteristics, the Reverend Professor George Henslow, M.A., F.L.S., F.G.S., F.R.H.S., published, as Lodge did, photographs of ectoplasm and ghosts, including a photograph said to derive from a scientist described inaccurately—but without total inaccuracy—as "Prof. Hyslop, Ph.D., Principal of the Columbia University, U.S.A."[48] Peter Guthrie Tait, who had published mathematical papers with Kelvin, joined Balfour Stewart as early as 1875 in *The Unseen Universe*. In *Lectures on Some Recent*

*Advances in Physical Science* (1876), Tait opposed both spiritualists and teleologists, but reserved mind, the human mind, as totally mysterious to science. (Conan Doyle, a case of spiritualism, is much less clearly a disciple of science.)

It is understandable that anthropologists and psychologists, trying to establish their disciplines on the mathematical grounds of physics, should argue for the uniformity of natural law.[49] Sir John Lubbock and Edward B. Tylor satisfy that expectation, as does Hugo Münsterberg, the pioneer in experimental and applied psychology at Harvard. With the notable exception of William James, psychologists found functions of the brain a safer study than consciousness. Münsterberg is a telling example, because he resurrected a dualism as sundering as that of Descartes and retained an idealism beyond Hegel's: "Yes, we can say that nature in the sense of the scientist is not found in life at all . . . Nature as a whole then becomes purposive in its relation to us, and we reach thus the values of technical civilization. Every mastery over stubborn nature becomes, then, part of real absolute value."[50] Psychology was to renounce life in order to become an objective science. Perhaps the oddest of all is Freud, who banished the random from the unconscious, which in Freud's account determines infallibly the content and form of dreams.

Lubbock was specifically Darwinian, concerned first to reveal from anthropological evidence the antiquity of man and then to demonstrate human evolution from savagery to European civilization.[51] Tylor, aligned with those who recognize "the unity of nature, the fixity of its laws," and "the definite sequence of cause and effect," set himself, as Lubbock did, against the biblical ethnology that explained non-European races by a theory of degeneration, but Tylor also denied indebtedness to Darwin, Spencer, or other evolutionists who were less than clear on laws of development and on the difference of the human mind "in kind, not merely in degree, from that of other species."[52] Doctrines of evolution fed a racial theory that "savages" embodied vestigial remains of ancestral species; Tylor more healthily paid attention to "survivals" of the "primitive" in folklore and in apparently irrational customs among civilized groups. Racial theories of degeneration, which had arisen from the need to square racial evidence with Genesis, continued among an-

thropologists severed from Jehovah but not from the assumption that Europeans were superior to the natives of other continents.[53] If lesser breeds revealed a law of degeneration, Europe remained as proof of progress in civilization.

Edward Caird, eager to reconcile science and religion, began his Gifford Lectures on *The Evolution of Religion* in 1890 by appeal to natural law: "The work of science is to find law, order, and reason in what seems at first accidental, capricious and meaningless, and the ardousness of that work grows with the complexity and intricacy of the phenomena to be explained."[54] Darwinian uncertainty found its place in a famous autobiographical search for an ever-receding education. After disillusioned attention to the claims of a classical curriculum, religion, politics, diplomacy, art appraisal, and the stock market, Chapter 15 of *The Education of Henry Adams* reports a search through Darwin, and through geological studies supporting Darwin, for a steady, "uniform, unbroken evolution from lower to higher." Adams discovered instead "Evolution that did not evolve; Uniformity that was not uniform; and Selection that did not select." Like Herschel, he found higgledy-piggledy.

Many poets and novelists fled from nature to art. But not all avoided more specific implications of Darwin's work. Nineteenth-century poetry and fiction had their own tradition of responding to the arguments of mechanists and materialists of the Enlightenment in France. Shelley understood by necessity more or less what Jonathan Edwards had declared "Philosophical Necessity" to be. In Edwards's formulation—the will "always follows that last dictate of the understanding"—the "understanding" is the whole bent of the individual:

> The choice of the mind never departs from that which, at that time, and with respect to the direct and immediate objects of that decision of the mind, appears most agreeable and pleasing, all things considered . . . In ordinary language, we say it is necessary, it is impossible. We mean by both that our resistance is overcome . . . The distinction between *nature* and *accident* is false; so is the distinction between nature and choice . . . Necessity is not inconsistent with liberty . . . The will is not free, but the soul is free.[55]

The doctrine or dogma of necessity taught Shelley what George Eliot concluded: we are under the moral necessity of developing good habits and acting on every occasion with awareness that each action has irreversible, universal effects. Eliot's doctrine of consequences, declared most graphically in the metaphors of web and etched glass and the demonstrations of interaction in *Middlemarch,* is stated with sufficient force in *Romola,* Chapter 16: "Our deeds are like children that are born to us; they live and act apart from our own will. Nay, children may be strangled, but deeds never: they have an indestructible life both in and out of our consciousness." She declares the corollary in Chapter 9 of *Silas Marner:*

> Favourable Chance, I fancy, is the god of all men who follow their own devices instead of obeying a law they believe in . . . Let [a man] betray his friend's confidence, and he will adore that same cunning complexity called Chance, which gives him the hope that his friend will never know; let him forsake a decent craft that he may pursue the gentilities of a profession to which nature never called him, and his religion will infallibly be the worship of blessed Chance, which he will believe in as the mighty creator of success. The evil principle deprecated in that religion, is the orderly sequence by which the seed brings forth a crop after its kind.

Eliot the moralist continues the Christian's hatred of kismet. Her narrative begins with one of its springs, the biblically justified drawing of lots that falsely condemned Silas. The story declared by the title to be primary, of the innocent miser and the golden child Eppie, is a simple pastoral that occupies relatively few pages of the novella. The narrative that actuates Eppie's stroll into Silas's hovel—the story of Godfrey Cass, condemned by the author for believing in chance—requires coincidence after coincidence, a fictional plot called by the author in Chapter 14 "the force of destiny." A second spring of the novella, probably not by chance, inverts the force of the entailed estate in *Pride and Prejudice* and *Wuthering Heights:* Godfrey can be blackmailed by his wicked brother Dunstan because their father's estate is unentailed. Old Cass is a Jehovah who encourages the drawing of lots. Coincidence enters because the

author believes in a law of consequences that requires fictional exposure of Godfrey's passive will.

Unlike the Paleyans, Eliot did not find these laws of human conduct in nature. The limits of moral renovation are related to natural disaster by analogy in the conclusion of *The Mill on the Floss*: "Nature repairs her ravages—but not all. The uptorn trees are not rooted again; the parted hills are left scarred; if there is a new growth, the trees are not the same as the old, and the hills underneath their green vesture bear the marks of the past rending. To the eyes that have dwelt on the past, there is no thorough repair." To "eyes that have dwelt on the past," urban ways have ravaged natural behavior. Near the end of *Romola*, mischance and bad weather coincide. Mischance destroys Tito, but a woman of noble soul who has struggled within the constraints on a subjugated wife finds in "the wide landscape" nothing "that might determine her action." Nature had a role in the drama, however, for "the stormy heavens seemed a safeguard against men's devices, compelling them to inaction."

Soon an alternative law of fiction complemented Eliot's law of consequences. Naturalists in fiction accepted as testaments Hippolyte Taine on inexorably determined vice and Zola's essay on clinical method, *Le Roman expérimentale*; naturalists and other novelists as well chose to understand the post-Darwinian world as one of grim chance.

Peter Morton, studying the influence of Darwinian biology on poetry and fiction, says that "chance events may simulate purposiveness, and therefore suggest either helpful design or malevolence." He cogently observes that "the literary utility of a science is at its highest when its central axioms retain sufficient ambiguity to make their exact bearing on the human condition uncertain but interesting."[56] In other words, creative writers do best with scientific theories they do not understand. I find it much harder to agree when Morton follows the sentence on "helpful design or malevolence" by declaring that "Hardy the novelist agrees with the naturalist that to invoke chance is only to admit ignorance of the exact links in the causal chain." Knowledge or ignorance of "exact links" is of no visible significance to the novelist Hardy, nor to Hardy as poet well beyond 1900; Hardy represents neither knowledge nor

links as of any conceivable service to human needs. To the Victorian Hardy, all is blind, infuriating hap, happenstance, chance. Humanity struggles in a universe controlled, if at all, by Darwinian purblind doomsters. Darwin as perceived by Hardy pointed as clearly as Schopenhauer and Hartmann, and more graphically, to human struggle and pain. Paley had been pleased because God wound up the universe and left it well oiled. Hardy professed anger because God withdrew from the universe about 1859. Eliot depicts in Tito Melema, in *Romola,* one who believes the universe and all the lives within it to have no lord but chance. For holding such cynically nihilistic beliefs, Tito is exposed and destroyed by his creator. Hardy's principal characters receive his sympathy with Tito's analysis.

In Hardy's early novel *A Pair of Blue Eyes* (1873), one of the two god-forsaken protagonists, hanging by his fingers over a cliff where his unease is intensified by this fortuitously close attention to fossils of departed species, is saved through chance by a woman whom he and the other wretched fellow will lose through chance. Physicists needed natural law; probability is a natural law; quarks stand for Mortonian "ignorance of the exact links in the causal chain." (Charles Lutwidge Dodgson, mathematician and logician, would agree; quarks are a law.) Hardy needed to compose narratives of fallible, falling, but worthy persons caught in unusual situations and coincidental events, "circumstances," says the Merriam-Webster Collegiate, "remarkable for lack of causal connection." Darwin said to Hardy that life lends realism to such fiction. A reader can feel Hardy's enjoyment in writing "The Darkling Thrush" against Wordsworth and Shelley, in conceiving "the deadest thing alive enough to have the strength to die," in asserting in "The Oxen" willingness to go out in the Christmas cold to watch oxen kneel in prayer—if any one of those damned Christians had faith enough to go with him. "Hardy," it has been cogently said, "only *thought* that the universe was essentially chaotic and senseless, but his imagination spontaneously *felt* that there was drama and some grand suggestion of significance in all those extraordinary happenings and startling scenes which inspired him to write."[57] Still, pheasants and smaller birds die in pain in Hardy's novels, and spiders starve.[58]

In *Tess of the d'Urbervilles*, nature would have lost one opportunity for capital punishment had the letter Tess thrust with moral purpose beneath a door not gone also under a rug inside. The laws of probability were against that fatal incident, but the perverse lawlessness of the universe made it likely. "Nature," Hardy says early in the novel (at the end of Chapter 5), "Nature does not often say 'See!' to her poor creature at a time when seeing can lead to happy doing; or reply 'Here!' to a body's cry of 'Where?' till the hide-and-seek has become an irksome, outworn game." Tess has to contend with a degenerate heredity (what Bernard Shaw was to call a line of downstarts), she has to struggle against an encompassingly fertile environment, she needs to resist what her inadequate mother calls her inner "Nater," and she falls under the black-mass romanticism of her creator, who asks early in the novel, and keeps asking, where Wordsworth got his authority for speaking of "Nature's holy plan." Hardy was writing a tragedy; he tells us that Tess, victim though she was of the Darwinian driving fertility of sex, was of finer stuff than the other dairymaids, who differed very little from cows: Tess was conscious that greater moral effort could have brought a second attempt to confess (Chapter 33), but the universe Hardy describes would have countered with still another ironic accident.

Joseph Conrad's view of society was no bleaker than Thackeray's had been, but his view of nature was as bleak as Hardy's. His first novel, *Almayer's Folly* (1895; begun in 1889) shows the destruction of European character in the unpropped environment of the tropics: no natural religion. Nature in the Lake Country gave Wordsworth's Michael strength; Borneo assured Almayer's decay. Before Darwin, Michael could have hopes of building with stone for his son and his son's son; when Almayer lost his daughter, "he fell on his hands and knees, and, creeping along the sand, erased carefully with his hand all traces of Nina's footsteps"; he "piled up small heaps of sand, leaving behind him a line of miniature graves right down to the water." In *Lord Jim* the officers are faced with a sudden decision to save either themselves or an equally small number out of the eight hundred pilgrims; by mischance, the ship does not sink: the faceless pilgrims survive unluckily as evidence of the officers' malfeasance. Nature had not given the shipping company a way to determine who would be morally fit not to survive.

When Conrad finally got around to writing a novel under the title *Chance* (1914), he had firmly grasped the verities of courage, loyalty, and the Union Jack, and the idea of chance was not much more than a convention of plotting. In the twenty years between, however, Conrad had rejected all hope of moral law in nature and replaced realistic representation increasingly with art. His readers are assured that jungles and typhoons are "inhuman." Art, he wrote in 1897, lies "not in the unveiling of one of those secrets which are called the Laws of Nature." In *Lord Jim* (1899) the crucial speech on cosmic order—"This is Nature—the balance of colossal forces . . . the mighty Kosmos in perfect equilibrium"—and the famous advice "to the destructive element submit yourself" (that is, thrash the deep ocean with your hands and feet) are assigned to the dreaming businessman and collector of butterflies, Stein, who waves his hand sadly and pointlessly toward his lepidoptera as the novel ends. Next, at the beginning of the novella *Typhoon,* Conrad comments on the right ship with the wrong captain at the wrong time: "It was enough, when you thought it over, to give you the idea of an immense, potent, and invisible hand thrust into the ant-heap of the earth, laying hold of shoulders, knocking heads together, and setting the unconscious faces of the multitude towards inconceivable goals and in undreamt-of directions." This sentence may seem at first glance ambiguous in the way of the frightened physicists, but no, the scientists sought to denote the verifiable with a clarity that the writer of symbolic fiction sought to circumvent. Conrad's sentence, if forced to abandon metaphor, says that the least likely possible explanation of life is divine purpose, and the next least likely is natural law.[59]

Conrad had written privately to R. B. Cunningham Graham on 31 January 1898:

> What makes mankind tragic is not that they are the victims of nature, it is that they are conscious of it. To be part of the animal kingdom under the conditions of this earth is very well,—but as soon as you know of your slavery, the pain, the anger, the strife—the tragedy begins. We can't return to nature, since we can't change our place in it. Our refuge is in stupidity, in drunke[n]ness of all kinds, in lies, in beliefs, in murder, thieving, reforming, in negation, in contempt—each

man according to his particular devil. Thre is no morality, no knowledge and no hope: there is only the consciousness of ourselves, which drives us about a world that, whether seen in a convex or a concave mirror, is always but a vain and floating appearance.[60]

In short, the post-Darwinian Conrad interprets human failure in light of the impossibility of a "return to nature." To ease the pain he turns to art, to symbol, as in "Heart of Darkness" (1902). Allow him a full escape into art, and he will treat sympathetically in *The Secret Sharer* a captain who endangers his ship and all the lives aboard for not much more than a nervous whim.

Melville's *Moby-Dick* of 1851 shows by contrast the radical change in attitudes toward nature and natural law that Hardy, Jack London, and Conrad represent. The sea, with its monsters, a constant danger to civilized whalers, is opposed by Melville to the peaceful land. Nothing in *Moby-Dick* is chance; everything is destined. Ahab's madness as well as Starbuck's reason is destiny. Under every challenge from man or nature, Queequeg remains a noble savage, while civilization, from its compulsive activity at sea, destroys the innocent mind of Pip.

In harshness of European winters, nature relented about 1850.[61] Those who applied the hypothesis of relentless selectivity to social relations were undeterred by nature's milder mood. The social changes that had led to an increased population and then to the Malthusian thesis remained.[62] What was christened "Social Darwinism" is Darwinian by implication and Spencerian by descent. It was Herbert Spencer who introduced the term "survival of the fittest," Spencer rather than Darwin who absorbed from Ricardo's bleak view of nature economic principles allied with individualism and laissez-faire, and Spencer who retained from Malthus conviction concerning the limits of social reform. It was the Spencerian cluster of economic opinions that had made Ruskin in *Unto This Last* attempt to restore the validity of natural law in social relations.[63] Spencer held with unremitting sobriety what Butler's *Erewhon* was to express as paradox: bad luck was not in itself sufficient punishment; as evidence of immorality, an unlucky head was a fitting first step from which the industrious could begin their climb to suc-

cess.[64] Samuel Smiles's egregiously successful *Self-Help* was published in the same week as *The Origin of Species,* and from the same publisher. Walter Bagehot treated timidity with Nietzschean ferocity in *Physics and Politics; or, Thoughts on the Application of the Principles of "Natural Selection" and "Inheritance" to Political Society* (1872). Political science recapitulates physical science. Stronger nations overcome. "Savages waste away before modern civilization." It has been pointed out that the resemblance of natural selection to laissez-faire was a subject for opponents of Darwinism, "not often advertised on the Darwinian side."[65]

No writer of fiction in England explicated the lawlessness of survival with the fervor of Jack London. He found habits attributed to wolves basic to human nature in lands where nature used hostile seasons to make clear the rules of survival. His story "The Law of Life" is set in the Yukon: "Nature was not kindly to the flesh. She had no concern for that concrete thing called the individual. Her interest lay in the species, the race . . . To life she set one task, gave one law. To perpetuate was the task of life, its law was death."[66] The maiden would have to be left behind at the first famine: "Such was the law." At the end of the story, wolves that have destroyed a moose close in on old Koskoosh: "What did it matter after all? Was it not the law of life?" In *Martin Eden* (1909), Herbert Spencer provides the truth: "There was no caprice, no change. All was law." Adam Smith, Malthus, Ricardo, J. S. Mill, and Nietzsche confirm the harsh law of endeavor. Martin Eden goes to socialist meetings, but assures his father-in-law: "I am an individualist. I believe the race is to the swift, the battle to the strong. Such is the lesson I have learned from biology, or at least I think I have learned."[67] This Spencerian philosophy earns for Martin success as a bourgeois writer, a life so boring that he drowns himself.

The irony found in *Martin Eden* by Marxist readers is harder to discover in some of the British applications of evolutionary anthropology. The aesthete John Gray combines shock at the collapse of natural law with horror at the origins of social Spencerism as revealed by the anthropologists. Gray's story "The Loves of the Age of Stone," which appeared in the first number of *The Butterfly* (May 1893), depicts a Hobbesian state of nature, with life "solitary, poor, nasty, brutish, and short": first the headman beats a clam-gatherer

to death for desiring the wrong girl, and then the headman's wife beats the girl to death for letting an eel escape, and finally scores her corpse with a great conch for the edification of all the other sullen women. Brutality is slightly less overt, but is part of the fierce irony, in Robert Louis Stevenson's novella *The Ebb-Tide,* which anatomizes Spencerian survival among British social types displaced to a remote island in the Pacific. Grant Allen published "A Ballade of Evolution":

> Prince, in our civilised hive,
> > Now money's the measure of all;
> And the wealthy in coaches can drive,
> > While the needier go to the wall.

The first stanza makes the connection: "For the fittest will always survive." Paradoxically, the same volume includes a tribute to the "Deepest and mightiest of our later seers," Herbert Spencer.[68]

Darwin and Spencer, by removing all likelihood that nature could serve as a model for human conduct, made way for the ascension of art.

Max Beerbohm epitomizes the connection of chance and art in one sentence in a paragraph on gambling in his "Defence of Cosmetics" of 1894: "And just as no one seriously encourages the clergy in its frantic efforts to lay the spirit of chance, that has thus resurged among us, so no longer are many faces set against that other great sign of a more complicated life, the love for cosmetics."

Darwin had put nature out of business as a model for human conduct, but had created even more difficulties than he himself realized—and he knew there were difficulties—in identifying the process of nature as one of slow succession. Hugo de Vries, who argued in 1889 the existence of individual units for each hereditary trait, was to introduce the word "mutation" in 1901 in support of saltation and discontinuity. Gaps in the fossil record have remained so nearly the same gaps Darwin worried over that it no longer seems adequate to say, with an addition of Darwin's to the *Origin,* "The noble science of Geology loses glory from the extreme imperfection of the record" (*Variorum,* p. 756). Niles Eldredge and Stephen Jay Gould as neo-Darwinians offered in 1972 a theory of "punctuated equilibria," accounting for slow change in given species until they

become extinct, then a sudden discontinuity, with an equally sudden emergence of new species.[69] Gould has been inclined subsequently to accept occasional impacts from extraterrestrial bodies as a likely explanation of the punctuations in punctuational change.[70] So many of Argyll's objections have been revived that it seemed appropriate in 1985 to give a book on Darwinism the subtitle "A Theory in Crisis."[71]

Ernst Mayr, a key figure in the synthesis of Darwinian evolution and post-Mendelian genetics, grants that Darwin's explanation is of randomness and uncertainty, and remains dubious, but argues that natural selection is neither chance nor necessity, nor anything between; it is an escape from these. In the first step, pure accident brings about genetic variability; in the second step, those variables that make the organism better able to survive in a changed environment will, by a strict law of cause and effect, have a better chance of survival and procreation. While rejecting interpretations of natural selection as chance, Mayr opposes those who regard mathematics and physics as the lawgivers in science. Biological sciences are not, and need not be, he argues, mathematical. Darwinian evolution is not predictive, and it need not be. Biological science is probabilistic and historical. It deals with "historical narratives"; it provides historical explanations.[72]

A sense of larger uncertainties in the relation of mind to nature informs recent studies. Although "the rationalistic conception of there being just one all-embracing system of truths about the world is not easily dislodged," the possibility of "basic randomness" is widely entertained.[73] Against Plato's belief in reason as the supreme deity superior to the scientists' nature and art, much recent thought has sided rather with Archelaus, who asserted against Plato that "the greatest and most beautiful things are the work of nature and of chance . . . not owing to reason, nor to any god or art, but owing, as we have said, to nature and chance."[74] If "descriptive evolution" is essentially the fossil record, Darwinism becomes "instructional evolution."[75] If we must regard science, "with all its concepts of nature, as the work of man, and man, with all his cognitive capabilities, as a child of nature," then matter "is what enters consciousness in space and time" under the causal laws of physics.[76]

The milestone is T. S. Kuhn's monograph of 1962, *The Structure of Scientific Revolutions,* arguing that an acceptable solution to previously unsolved problems provides a paradigm under which a scientific community will perform "normal science"—"determination of significant fact, matching of facts with theory, and articulation of theory"—until a different paradigm is victorious over the earlier. This formulation requires that we "relinquish the notion, explicit or implicit, that changes of paradigm carry scientists and those who learn from them closer and closer to the truth."[77]

Accepting the hypothesis of paradigms and the distinction between physics and the probabilistic narratives of biology, Misia Landau, and after her Matt Cartmill and other historians of science, have utilized the skeptical methods of deconstructive undecidability. Biology, they greatly exceed Mayr in proposing, depends upon narrative explanations. By argument along this line, visionary romantic scientists imagined the universe as "a vast organism animated by something like a human soul," and evolution satisfied the need of Victorian audiences to be told stories.[78] Evolution is narrative, subject to analysis by narratology.

From these divagations a literary scholar, Gillian Beer, has devised a fine book, *Darwin's Plots.* Although Beer recognizes the randomness of qualities giving the best chance of survival, she finds comfort for Darwin's Victorian readers—"instead of foreknown design, there was inherent purposiveness"—and concludes that Darwinian theory "retains the idea of *natura naturans,* or the Great Mother, in its figuring of Nature." In adept chapters on the place of evolutionary narrative in the novels of George Eliot and others, Beer accepts Freudian analysis as beyond possible alternatives, but seems to imply throughout that Darwin chose sex as the medium of evolution when he could have chosen some other. None of us who follow could better her treatment of Darwin's problems with language, such as his difficulty in avoiding creationist implications and the more general temptation of metaphor: "The quagmire of the metaphoric troubles Darwin, yet he needs it—he needs its tendency to suggest more or other than you meant to say, to make the latent actual, to waken sleeping dogs, and equally, he needs its powers of persuasion through lassitude, through our *inattention.*"[79]

Richard Dawkins, the most valiant answerer to those who ques-

tion natural selection, in *The Blind Watchmaker* accepts Mayr's two-step selection as the initial premise, but goes on to argue statistically that we can calculate improbability more easily than we can imagine it. Regarding the gaps in the geological record as migrational, not evolutionary, he sees no need for Gould's punctuations.[80] Peter Bowler, after dealing with those responsible for "the eclipse of Darwinism" in the 1890s, brushes away Landau, Cartmill, and Beer by concluding that the moral of Darwinian narrative is simply "to accept that we are the accidental products of an undirected, and hence possibly amoral, historical process."[81] When all is said, the most interesting thing about the Landau thesis—other than what Beer made of it—is the way such narratological deconstruction finds the Darwinian theory of chance determined by social and cultural circumstances in Darwin's time. Recent studies do call for an interpretation of *The Origin of Species* as a work of romantic irony.

# DOUBLING
# AND
# DIVISION

I n the course of the nineteenth century, fictional characters having or acquiring a double ceased to need in the process any intervention from a supernatural source. Change in personality might entail, as it had since Ovid's *Metamorphoses,* either corruption or cleansing, but possession of a double no longer necessarily implied possession by the double. More often, later in the century, doubling involved what Freud was to study in his essay on the uncanny, oneself as other. The sense of psychological division, more common as the century advanced, certainly did not arise suddenly out of nothing. Shaftesbury, in *Characteristicks* (1711), had cited the antiquity of opinion that "we have each of us a daemon, genius, angel, or guardian-spirit, to whom we were strictly joined and committed from our earliest dawn of reason, or moment of our birth." Shelley, in poems and prose of the other, had revolved the prism of Narcissism in delving the relations of self to antetype and antitype. Keats, though obsessed with female demons who enthralled male lovers, recognized that enthrallment could occur only to a self divided within. Dickens's Mrs. Gamp creates Mrs. Harris for not altogether venal reasons; his Jarndyce must live a double life to live at all; Jaggers in *Great Expectations* must wash his hands in returning from law to human life; Wemmick, his assistant, shares with Jaggers a false exterior of flint, but isolates himself at home by hoisting a drawbridge. Of the many Dickensian eccentrics who occupy realms of paper flowers or faery, those of divided self yearn for an active role in the religion of progress; others, emblematic of social rather than personal schizophrenia, luxuriate in cradled alienation.[1] The inner

division of characters in Dickens addicted to self-repetition is often a mode of social satire; similarly, Meredith's titular protagonist in *The Egoist,* Sir Willoughby Patterne, looked deeply into Laetitia Dale's eyes, "found the man he sought there, squeezed him passionately, and let her go."

At mid-century, most obviously in Hawthorne among writers read by the English, the supernatural became overtly moral and social.[2] Hawthorne's temptations to send his characters in search of demons would seem to be restrained only by his memory that witches had been hanged in Salem. He chose a method of ambiguity safer for the author than for his characters. Even when tramping alone, however, his characters are emblems for moral dilemmas of the society. His young Goodman Brown, far from finding himself isolated in his encounter with a witches' sabbath, discovers that he joins by this means all the most pious of the community. In "Peter Goldthwaite's Treasure" heaping gold by the bushel, with or without aid from the devil, is equated with business as usual, scraping gold together coin by coin. Realism invaded the realm of romance. William Ernest Henley and Robert Louis Stevenson were to write a play, *Deacon Brodie, or the Double Life,* in which Brodie lives a second life in disguise as a thief in protest against the social environment.

Even in Poe's *William Wilson* the mirrored double is the conscience. Dostoevsky's *The Double* (1846) anticipates his *Notes from Underground* (more exactly, *Notes from a Mousehole*; 1864) in exposing the power of society to warp the consciousness—although, in another view, it illustrates "the shift from exteriorization to internalization, from magic to psychology, from motif to symbol."[3] An indebtedness to fantasy and fairy tales in realistic fiction exploring doubles as if they were merely foils continues throughout the century, as in Charlotte M. Yonge's popular novel of 1864, *The Heir of Redclyffe,* in which interlaced cousins each would choose to be modeled on the characters in Fouqué's *Sintram.*

There could be no clearer example of the progressive internalizaton than *The Bells,* adapted by Leopold Lewis for the Royal Lyceum in 1871 from the French melodrama *Le Juif Polonais.* London audiences were given earlier and clearer clues than audiences in Paris that the audible music and bells and the visible Jew in a sledge were materializations in the theater of Mathias the burgomaster's con-

sciousness. In Act 3 Mathias retires, saying that he never dreams and will sleep well. The audience then sees his dream, in which he is tried for the murder of the Jew by justices who insist that he submit to hypnosis, with the result that he utters (in the dream) a complete confession. When the door of his room is broken in by a man who (in the dream) he was told had killed himself, Mathias cries, "Take the rope from my neck," and falls dead. Henry Irving played the role for twenty-five years as a sensitive, essentially good man shredded by a guilty conscience. In Irving's popular version, there is less psychological division than progressive revelation.

Popularity has chosen more lastingly Stevenson's *Strange Case of Dr. Jekyll and Mr. Hyde* (1886). As a frame for the split of Jekyll into two, Stevenson sets up a contrast to represent four types: The scientific, normal physician, Dr. Hastie Lanyon, is rational, disinterested, amoral, scornful toward any suggestion of the supernatural or transcedent. Dr. Jekyll, less representative of physicians in fiction, is idealistic and hopeful, desirous of ending in humanity the mixture of good and evil. In unwilling evidence of that mixture, he is also hedonistic. If we glance from the Scots to the Irish, Jekyll is a Bernard Shaw with a touch of Wilde. The implied narrator, Utterson, a dry, tolerant lawyer, is concerned to preserve Jekyll's personal reputation, his "name," and—separate from his "name"—his "character," which embodies social conventions that in Utterson's view ought not to be weakened. That Jekyll is less hypocritical than ordinary persons such as Utterson is suggested in a small touch when the police are glad that the man murdered by Hyde is a Member of Parliament, because they are thereby assured of publicity. Stevenson's fourth type, Utterson's distant cousin Richard Enfield, is a complete bon vivant in contrast with the idealistic, romantic Jekyll, who can be no more than half epicure. Yet Enfield is our first witness; it is he who has seen Hyde in indifference trample a child, and he who makes Hyde pay damages for the act.

*Frankenstein* had resorted for scientific explanation to electricity and galvanism. Stevenson's philanthropic physician employs his skill in chemistry to isolate his undesirable traits and thrust them into Hyde. Jekyll's house is so located that Enfield, Utterson, and Lanyon do not guess that Hyde's sordid door affords a rear exit and entrance to Jekyll's house.[4] Early on, when he thinks that Hyde

must be blackmailing Jekyll, Utterson is a sharer, grateful when he thinks of many ill things he has come near doing, acts bad enough to encourage blackmail, but by fate avoided. The Aristotelian plot that precedes Jekyll's explanation contains subtly false leads; two of the characters come to see further into the terror than the reader is then allowed to see. When it is no longer secret that Hyde has been a marauding aspect of Jekyll, the detective plot ends. The story concludes with Jekyll's explanation for Utterson, which tells all— except, of course, the inhumane chemical formula for precipitating evil. The story is one of division, not doubling; Stevenson did not try to create a double, and Jekyll failed in the attempt.[5] For Victorians from mid-century on, self-division can be blamed on nature; doubling belongs to art.

John Addington Symonds pointed out to Stevenson that his tale represents good as restriction, evil as freedom; evil, unconfined, is stronger than good. The point is enforced in G. K. Chesterton's *Robert Louis Stevenson*: "The real stab of the story is not in the discovery that the one man is two men; but in the discovery that the two men are one man. The point of the story is not that a man *can* cut himself off from his conscience, but that he cannot." So great is Stevenson's fame as an optimist oblivious of the Calvinism of his forebears that he is generally thought to understand the point no better than Jekyll did. In a complaint that philosophies of identity tend not to notice that each of us has more than one self to find, Mary Midgley identifies in *Jekyll and Hyde,* specifically in Hyde, the terrifying reminder that evil "is itself a squalid nothing."[6]

Realism was deferring to consciousness, and thus to impression, in ways to encourage the representation of fragmented selves.[7] Of change from earlier ways of representing division and doubling, Joseph Conrad is a more obvious example than Stevenson. Of two nations, two occupations, a single view of courage but a divided view of masculine strength, Conrad found a comfortable alter ego in Marlow as narrator. Of Conrad's two shorter works discussed in all studies of the double, Marlow is the narrator of *Heart of Darkness* but narrates *The Secret Sharer* only insofar as Marlow and Conrad have shared the same experience and consciousness. With shipboard as setting, and narrator as a literate member of the crew, in "Youth" and "Typhoon" it is "we" at sea versus "they" on shore, with we

each going our separate ways ashore, as at the end of the *The Nigger of the Narcissus*. From Conrad's sense of shipboard as microcosm of social interaction, with narrators reminiscing about the youth each once was, his exploration of doubling seldom ignored the narrator.

*Heart of Darkness* (1899) enters a world of artfulness unknown to *Almayer's Folly*. Ian Watt has congregated in a chapter on the contexts of this work the "ideological perspectives" of the Everlasting Nay, God's dissolution into materialism, entropy, survival of the fittest, rampant imperialism, and the anthropologists' equation of primitivism and savages.[8] Such elements of "progress" lie both behind and within *Heart of Darkness*. Throughout the story, there is a steady tide of pity for Africans as collectively oppressed. The details "make you see." But the method is not that of metonymic realism, a bit of life representing a larger parcel; the method is that of symbol requiring inference. The layered meanings of the title invite the reader to act as archaeologist in descent through the symbols, from Marlow as meditating Buddha, in the Thames estuary, past the women who sit in black, knitting outside the shipping office in Brussels for no reason other than that they are Clotho and Lachesis or similar fatedness, and on to the ironically named workers and pilgrims versus criminals and enemy along the unknowable river. Under a fusillade of arrows, Marlow flings one shoe into the river and then, as emblem of his desire to talk with Kurtz, he flings the other as its double.[9] Meanings of "heart of darkness" are measured outward from the hinterland of the Belgian Congo, represented in the story as scarcely explored except by Kurtz. Dark indeed, to Europeans, the ways of cannibals: Conrad, sympathetically, thought that they were so wretchedly paid that they had to eat one another.

From childhood Marlow had yearned to see the space depicted on maps as a "white patch"; he found in actuality the darkness of Europe, blackness in European practice and blackness in the only conscience he discovered. The Belgian empire, careless with its rivets, is all muddle. The exception to muddled inefficiency is Kurtz, idealist and composer of enlightened nonfiction—that is, of proposals for modifying European pratice in Africa toward sympathy and uplift that a publisher would not classify as fiction. In obtaining ivory by supervising such methods as ambush and murder

and indulging in worship from cannibals; in other words, by degenerating into what anthropologists were calling the primitivism of (Kipling's term) "tribes without the law," Kurtz has made himself as efficient as the British imperialists are.[10] Conrad does not make explicit the contrast between the British and the muddling Belgians; if he had wished to, he knew that owner, editor, and readers of *Blackwood's* would not have it; but when Marlow says in the Thames estuary that Roman imperialists once found that place also a heart of darkness, he points toward the ultimate perception that it still is. Marlow is alerting his hearers to the parallel between history being made and the sending of Roman legions "to tackle the darkness that was then the Thames."[11] In a letter to William Blackwood, Conrad defined the subject of the story in progress: "The criminality of inefficiency and pure selfishness when tackling the civilizing work in Africa."[12] Inefficiency of the Belgian sort, then, was to Conrad a crime that exposed the hypocrisy of declared motive.

In 1871 David Livingstone, Scottish missionary turned explorer, returned to Africa to seek the source of the Nile, went among cannibals, and ceased to be heard from. James Gordon Bennett, with an eye to his lucrative New York *Herald,* sent Henry Morton Stanley to find Livingstone. By 1877 Stanley had proved that the headwaters discovered were not of the Nile but of the Congo. In 1890 Stanley published his account of all this, *In Darkest Africa.* With a preface dated October 1890, General William Booth of the Salvation Army published *In Darkest England and the Way Out.* Of the various solutions to poverty in darkest England, Booth most recommended emigration. The sad faces in Ford Madox Brown's *The Last of England* would have been sadder had there been no Australia or Canada or elsewhere for escape from economic oppression. In *The Outpost of Progress* (1896) Conrad showed how childlike minions of progress, perverted by the exotic climate and the job of getting ivory, could slide first into acceptance of slavery and cannibalism and then into acts of murder and suicide. In the comic allegory of *Typhoon* (1902) he would describe clumsy coolies trying to recover spilled coins, when "every fling of the ship would hurl that trampling, yelling mob here and there, from side to side, in whirl of smashed wood, torn clothing, rolling dollars . . . It was a

disaster." Europe was exporting its culture. Conrad's allusions to Stanley and *Darkest Africa* have been well documented, but Booth's *Darkest England* needs to be noted in any discussion of Conrad's ironies. [13]

Marlow's sense of oneness with Kurtz leads him, in violation of his own code, to equivocate twice before his outright lie to Kurtz's "Intended"; instead of Kurtz's actual last words, "The horror! The horror!," Marlow tightens his voice against his conscience and says, "The last word he pronounced was—your name." In a review of Ian Watt's book, Robert S. Baker points out that the Intended is "insistently linked to death, entropy, the jungle, to 'cruel and absurd mysteries,' and to the company," with a corollary: "The Intended is Kurtz's heritage, his idea, the source of the momentum energizing his mistaken mission; in short, his intention." [14] Baker takes the shortest road through the symbols: Kurtz in dying pronounced the intended's name, Horror. [15]

This punning interpretation of "your name" is won at great cost. It is not necessary to go all the way with a biographer's sanity: "Just before he dies Kurtz is vindicated by a full emotional realisation of his experience." [16] Half the distance might be enough. No nihilist, Conrad issues throughout his fiction words of encouragement to those who struggle against entropy and despair. Kurtz may or may not have perceived in dying the horror of personal conduct that greater self-restraint could have made different. Conrad was probably well advised to avoid epiphany and absolution. The conscience to watch is not Kurtz's but Marlow's. Neither Marlow and Kurtz nor Marlow and Conrad are identical twins. In thanking Symons for a favorable account, Conrad protested: "there [are] certain passages in your article which have surprised me. I did not know I had a 'heart of darkness' and 'an unlawful soul.' Mr. Kurtz had—and I have not treated him with easy nonchalance . . . As for the writing of novels, delightful or not, I have always approached my task in the spirit of love for mankind." [17]

The recognition of a double in Kurtz's aspirations and his guilt is Marlow's, and it is reinforced by Marlow's sense that civilization depends upon keeping women, as a cohesive force, ignorant of the sordidness of empire; whatever the cluster of motives, the lie seals his oneness with Kurtz in possession of a heart dark at the core.

Lodging his own Mr. Hyde with Kurtz, he had made a "choice of nightmares." The reader is asked to search her own heart for darkness. If the Intended's name is Horror it is not because she is a rare specimen, or because all women or most effete ladies are like that, but because European "progress" adds shades to the dark heart with which every human animal is born. The rhetorical strategy is to show Marlow that the idealist Kurtz was corrupt in a way to challenge any inclination to isolate the evil of collective empire from the savagery of the individual heart. Civilization is wicked, but nature, which did in Almayer, is not conducive to improvement.[18]

In *The Secret Sharer,* although there are fewer symbols lacking the translucence, as the Norns of Brussels do, of a reality beneath, one can find here a greater triumph of art over life, as well as a tauter tale of adventure, than a reader can extract from *Heart of Darkness.* The titles Conrad considered, "The Secret Self," "The Other Self," "The Secret Sharer," are embedded in the story. A captain embarking on his first command quixotically assumes a watch on deck. In the dark, from a ladder carelessly left hanging over the side, he takes aboard a bare man who has, he soon learns, as chief mate killed an insolent seaman on a ship now anchored at some distance, the *Sephora.* He takes this Leggatt into his cabin, dresses him as a sharer, a double, in his own pajamas; by elaborate ruses, he conceals the sharer's existence from the crew. The double challenge to his courage and his conscience becomes rapidly clear. He and Leggatt came from similar backgrounds; identical maritime training makes them both "Conway boys." The nervous captain sees the case as "there but for the grace of God go I." Where he has ascended by good fortune to a command in which he has not yet been tested, Leggatt is a misunderstood outcast. Our captain's distaste for the captain of the *Sephora,* who gives him the official version of the murder, exceeds his Marlow-like distaste for lying, so that he prevaricates and continues the concealment of Leggatt. In the guise of proving himself worthy, he steers his ship fearfully close to an island and gives Leggatt a fair chance to swim for freedom. The mate moaned in despair, gestured, and "addressed me recklessly": "She will never weather, and you are too close now to stay." The hat given by the captain to Leggatt, floating in the water, provided a mark for avoiding the likelihood, had the hat not been fortuitously

present, of going aground. It might be said that the captain is the savior of Leggatt and Leggatt the savior of the captain.[19]

The story declares Leggatt to be also an archetypal Cain. Leggatt interprets the wife of the captain of the *Sephora,* who wanted him off the ship: "The 'brand of Cain' business, don't you see." He continues in self-pity: "What does the Bible say? 'Driven off the face of the earth.' Very well. I am off the face of the earth now. As I came at night so I shall go." Our captain, at the close, refers to "the saving mark" of the hat moving on the water, and repeats the identification of Leggatt with Cain by observing that his "other self" is now free "to be a fugitive and a vagabond on the earth." Byron's *Cain* shows a clear awareness that God placed the "mark" on Cain to protect him from destruction by any he would encounter in his wanderings; just possibly "the saving mark" of the hat also points toward some god's protective mark on Cain as archetype of Leggatt.

*The Secret Sharer* is a thrilling tale of adventure and, like *Heart of Darkness,* a skillful arrangement of symbolic suggestion. As a representation of life it would raise entirely different questions. A mate who complained of a similar "unforgettable scare" afforded by Conrad himself on his first command—"Ever since then he had nursed in secret a bitter idea of my utter recklessness"—accounts for the assurance with which the mate is disparaged at the end of *The Secret Sharer.*[20] Complete lack of sympathy enabled H. G. Wells to find Conrad here and elsewhere in his fiction: "as a mariner his life was surely a perpetual anxiety about miscalculations, about the hidden structural vices of his ship, about shifting cargo and untrustworthy men; he laid bare with an air of discovery what most adventurers, travellers and sailors habitually suppress."[21]

The captain is Conrad's alter ego; Leggatt his alter alter ego. The captain, who believed that he must first of all win the confidence of the crew, began on the first page of the story to display obvious, *conscious* eccentricity. The course of apparent balminess that began when he assumed the watch of the anchored ship continues through the penultimate sentence of the story. Leggatt has justified his homicide by saying that the ship was in extreme danger, that he alone seemed capable of saving it, and that the seaman violated the code of subordination and responsibility. Our captain, who ac-

cepted all this on trust, could have taken comfort from none of those grounds if he reviewed his own conduct. He justifies his defiance of his crew's collective opinion by reflecting that a commander is not required to explain anything to his subordinates. Their only recourse would be that exercised in *The Caine Mutiny*. Sympathizing with the murderer by instinct only, the captain deliberately thwarts the procedures of legal justice. At the end, on not much more than two whims that happen in his anxiety to coincide, he endangers the ship and all the lives aboard. In the episode drawn upon for the homicide and escape, the chief mate of the *Cutty Sark* felled a recalcitrant black seaman; his escape was aided by his captain and subsequently by the captain of an American ship; he was arrested, tried, and imprisoned in England; and the captain who let him escape killed himself. [22] Conrad's version evades the issues of justice raised by Melville's *Billy Budd, Sailor*. His captain was saved by chance. Perceptively Desmond McCarthy remarked: "I have just been listening to a performance on the Conrad."

The innovative artfulness of Conrad's stories contrasts vividly with the surface and apparent depth of realism in *The Ebb-Tide* by Stevenson. [23] Stevenson's story has nonetheless a Flaubertian economy. The three contrasting characters introduced at the outset, each under alias, have fled the institutions of Western society for exotic seas; each carries a false dream of returning to a "true" identity. The Oxonian, Herrick (alias Hay), serves as virtual register. Henry James also would have chosen Herrick as register, for he is the most sensitive to moral failure. Herrick, like Jekyll and Kurtz, is earthbound by the optimism of belief in capacity for self-control. He shares with Jekyll a streak of hedonism; in every moment of crisis, he has been inattentive. A fatalist in the line from Diderot, Pushkin, and Lermontov, he carries a Virgil for *sortes*. Davis/Brown, a pious Yankee skipper who lost the race of civilized society through drunkenness, dreams lies, is unscrupulous on the plea that he needs "syrup for the kids" (especially a dead one); he is hard but not vile. Huish/Tompkins, once a London clerk, is now only a body that exists for food and drink.

None of the three has had the will to play the cards dealt: Three derelicts of the ebb-tide, genetic losers. First their dreams are laid out for comparison, then their lying letters home. Stevenson leaves

it to the reader to relate their derelictions to the context of commercial fraud perpetrated by a Europe gone to sea. They sail on the *Farallone,* a defective schooner insured for a cargo of champagne— actually water—and expected to carry the evidence, along with the derelict crew, to the bottom. Once literally "on the beach"— sailors' phrase for the condition of derelicts—Herrick finds himself in the Pardoner's Tale: Davis would cheat his mates to death; Huish would bludgeon them. For readers accustomed to Stevenson's kind of tale, a surprise is in store, not in language, which avoids throughout the romantic hyperbole of Conrad, but in plot. The narrative has been moving these three dreamers toward a realist. They wash up on an island occupied by a Crusoe not only ingenious but masterly in the ways of stratified society. Unlike the passively ineffective Herrick, Attwater employs Calvinistic fatalism in Scottish reminiscence of Hogg's Justified Sinner. Whatever he does must be the will of God, or God would not permit it. An organizer of souls and lives, he is a born-again Christian version of Kurtz. That he is totally ruthless is progressively apparent; that he is a hypocrite is not declared in the words of the story. The three born losers see that they must combine to defeat him. Davis would multiply treacheries; the vile Huish dies attempting ambush. Conrad's pessimism sees failure everywhere; Stevenson's "optimism" perceives that a lone realist among a bevy of dreamers can win, and does. Herrick will return to an organized network of dreams; Davis, converted into Christian humility by Attwater, enters a previously unexperienced state of orderly abasement to an efficient entrepreneur. "I," says Attwater, have taken action. "One," he says, must perform the role allotted. When he identifies his most revealing act, it is by verb without pronoun: "Shot." Explanation continues the absence of active voice: the deceased was punished. In contrast with Conrad's ineffective Belgians and Stevenson's three characters beached by the ebb-tide, but much like Henry Morton Stanley, Attwater plays exactly the cards he was dealt. Stevenson would instantly detect a flaw in this comparison: Stanley was given at his Welsh birth the name John Rowlands; fate allotted him the chance for a new identity. Empire was built by men who rode the tide to its crest, not by a Huish, Davis, or Herrick, but by Attwaters.

Stevenson asserted his creed in beginning "A Note on Realism,"

first published in the *Magazine of Art* in 1883: "Style is the invariable mark of any master; and for the student who does not aspire so high as to be numbered with the giants, it is still the one quality in which he may improve himself at will. Passion, wisdom, creative force, the power of mystery or colour, are allotted in the hour of birth, and can be neither learned nor stimulated. But the just and dexterous use of what qualities we have, the proportion of one part to another and to the whole, the elision of the useless, the accentuation of the important, and the preservation of a uniform character from end to end—these, which taken together constitute technical perfection, are to some degree within the reach of industry and intellectual courage." His point could not have been made earlier in the century: The "question of realism, let it then be clearly understood, regards not in the least degree the fundamental truth, but only the technical method, of a work of art."[24] This view enabled him the next year to offer "A Humble Remonstrance" to his friend Henry James:

> No art—to use the daring phrase of Mr. James—can successfully "compete with life"; and the art that does so is condemned to perish *montibus aviis* . . . To "compete with life," whose sun we cannot look upon, whose passions and diseases waste and slay us—to compete with the flavour of wine, the beauty of the dawn, the scorching of fire, the bitterness of death and separation— . . . here are, indeed, labours for a Hercules in a dress coat, armed with a pen and a dictionary to depict the passions . . . No art is true in this sense; none can "compete with life"; not even history, built indeed of indisputable facts, but these facts robbed of their vivacity and sting; so that even when we read of the sack of a city or the fall of an empire, we are surprised, and justly commend the author's talent, if our pulse be quickened.[25]

Along with the truth of style, however, *The Ebb-Tide* reveals passion, wisdom, and creative force perhaps given to Stevenson in the hour of birth but cultivated along with technique.[26]

James, more self-aware than Dickens, similarly utilizes doubling and division for drama as well as for revelation of character. *The*

*Turn of the Screw* has been read as doubling through a divisory hallucination within the governess. It is certainly a *tale* of possession, in which the deceased Quint and Miss Jessel possess the children, Miles and Flora (thus giving two second turns to the screw), and the governess destroys Miles by invading him with the unwelcome morality of contrition.[27] James's doubles seem often the still voice of regret. From *The Beast in the Jungle* through *The Ambassadors* James provides foils to urge protagonists to live more fully, not to build altars to their own deadness. The point is latent in the doubles who exchange past and present in *The Sense of the Past.* James's Brydon in *The Jolly Corner,* in a similar confrontation of present and past, more specifically of deracination in the Old World confronting what has meanwhile gone on in the New World's new world of business, encounters traces of the ghost of what he might have been. The narcissism of Bryden's unnerving experience was to be followed up by the man in James Gould Cozzens's *Castaway,* who found his other in a shut-tight Macy's, shot him, and was found dead there on Monday morning—and with more intense social content in Richard Wright's *The Man Who Lived Underground*: "You've got to shoot his kind. They'd wreck things."[28]

William James's lecture on self-division in *The Varieties of Religious Experience* calls attention to the way autobiographers, from Augustine through the nineteenth century, told of self-division in order to emphasize a method of healing. The lecture, entitled "The Divided Self, and the Process of Its Unification," begins with Annie Besant, timid with servants but bold on a public platform, and ends with Tolstoy and Bunyan; it includes from John Foster's *Essay on Decision of Character* "a case of sudden conversion to avarice," a young man who sprang in an instant from profligacy among worthless associates into a parsimonious accumulation of wealth. Fiction has dealt less and less with successful unification; leaders of taste in the post-Darwinian world regard happy endings as unnatural. It is a further victory of post-Darwinian art that such studies as this one gravitate to a point where possession, doubling, and division occupy a ground in common.

The nineteenth century ended with a notable increase in androgynous confusion of gender.[29] William Sharp wrote as an Englishman and, under the pseudonym Fiona Macleod, as a Scotswoman.[30]

Michael Field as author was made up of Katharine Harris Bradley and her niece, Edith Emma Cooper, who was "Henry," or "Field," to her aunt's "Michael." The pseudonyms Vernon Lee, Violet Fane, and George Paston represented defiance beyond escapes from the derogation of "bluestocking" or the prostration of identity under a label like "Mrs. Humphry Ward." Androgynous bodies copied from the paintings of Burne-Jones and Moreau leaned against the borders of illustrations throughout the 1890s. Imitating works of art, aesthetic males earned the twitting falsely addressed to the corset-free attire of aesthetic women. Scores of aesthetic males adopted the faun as emblem of intellectual rigor and physical release. Greek art and literature had established the centaur as the paradox of bestiality contending with spirit, in one facet, and in another the teaching of arts and skills. Dante's vignette of Chiron's education of Achilles, as an offset to the violence of Nessus, is a major marker on the way from the Greeks to the centaur as sign in Vienna, not of the Sezession, but of training at the Academy. In the nineties the centaur proliferated as an emblem of ambiguous masculinity.

Art pursued division and doubling with sure instinct to the legend of Pygmalion, the sculptor whose prayer was rewarded when Aphrodite brought to life the female form he had created in stone.[31] Such vivification of the artist's desire has been said to epitomize a narcissistic appropriation of the female.[32] Rousseau's interest in the Pygmalion theme certainly seems related to his plan, repeated by such followers as Thomas Day, to educate an ideal wife from earliest possible girlhood. A sentence in Hawthorne's *Peter Goldthwaite's Treasure* associates Pygmalion's aim with the wild imagination that tries to get rich quick. In the formulation by Mario Praz, Pygmalion desires the healthy norm of his ideal, in contrast with Praz's other examples in *La carne, la morte, e il diavolo nella letteratura*, but Pygmalion takes the risk of loving art more than natural generation: a Frankenstein refined into love of his creature. Later than Raphael, Lyly, and Cervantes, the animated statue acquired the name Galatea, on the claim that Pygmalion had set out to represent the nymph of that name loved by the Cyclops. Of the many treatments throughout the nineteenth century of an artist enamored of what he created, most provided tesserae for *The Picture of Dorian Gray*.

An early historical tale by Balzac, *Le chef-d'oeuvre inconnu,* in *L'Artiste* of 1831, made painting the medium available to subsequent Pygmalions. Balzac's theme is romanticism itself. When Poussin learns from the only pupil of Mabuse that the artist is not to copy nature according to rules, but to express nature, he persuades his mistress to serve as the old pupil's model for a final masterpiece. (It is 1612; Mabuse died in the 1530s.) Despite Poussin's protests to the contrary, the mistress Gillette suspects, and is finally convinced, that he is sacrificing love to art. The inhumanity of Poussin's wavering decision appears more strongly because the old pupil hesitates to show the nude on the canvas: after years of overpainting, he has come to love his envisioned beauty as a living woman. Seeking perfection, he has overpainted into nothing; when Poussin speaks openly of the nothingness, the old man burns his canvases and dies.

In 1886 Zola's *L'oeuvre* gives the theme another turn. To win the love of the painter Lantier from women in paintings, Christine poses nude (for a painting informed readers would recognize as Manet's). The success denied to Lantier's picture is awarded instead to his plagiarist, Flagerolles. After a final night with Christine, Lantier hangs himself. Meanwhile, a large Bacchante (an inferior substitute, says Zola, for an actual woman) seems to come alive and collapses onto its unfortunate sculptor. In this emblem, romanticism collapses of its own weight, but Zola's narrator seems to confess that he is no more free of the romanticism of Balzac than Lantier is free of Delacroix.

In Hawthorne's story *The Artist of the Beautiful* a young man trained as a watchmaker attempts to make something uselessly beautiful, but a ruinous touch from love "interposed to steal the cunning from his hand." In *The Prophetic Pictures* a painter of European origin and wizardly skill depicts in the portraits of an affianced pair the sorrow that Destiny will bring; returning in the hour when the husband perceives their fate and stabs his wife, the painter has the "strange thought" that he as artist may be "a chief agent of the coming evil which he had foreshadowed." In *Rappaccini's Daughter* Dr. Rappaccini's experiments in making plants poisonous to insects turns his daughter into a perfumed, poison-breathing femme fatale. Poe inverts the Pygmalion legend in *The Oval Portrait,* a further

source for Wilde: the artist draws from his wife's cheeks the tints for his canvas, and steals her soul; the work perfected, she dies. Of the scores of narratives naming Pygmalion, George MacDonald's *Phantastes* is the most original. In Chapter 5, his protagonist sees a statue of Pygmalion looking at his own creation, revealed by removal of an alabaster sheath to be the marble statue of a reposing woman. A "passionate need of seeing her alive" sends him through complex adventures of subtle suggestion to a simple moral: life requires loving, not being loved.

As with much else, the Pygmalion theme was made more deeply aesthetic for the nineties by Rossetti. His earliest poems include sonnets on paintings. He is possessed with doubles, always in relation to the poetic artist. His representations of the feminine other, from *Hand and Soul* through *The Orchard Pit* (1869) and beyond, are Galatea images seen through an unsatisfied hunger for fulfillment, but without possession by either the one or the other. "No man sees the woman but once, and then no other is near; and no man sees that man again."[33] In *Saint Agnes of Intercession* an artist who paints his beloved is told that he has modeled it on a St. Agnes by one Bucciuolo Angiolieri. In Florence he finds the St. Agnes, sees that it resembles his Mary Arden, learns that the earlier painter was deeply attached to his model, who died early, and recognizes himself in a self-portrait by Bucciuolo. The themes of preemption and return in this curtailed story include the prediction of death explicit in Rossetti's *How They Met Themselves* and the watercolor *Bonifazio's Mistress*.

In his poem *The Portrait* the speaker looks at the picture, now before him, that he made of his lost love:

This is her picture as she was:
  It seems a thing to wonder on,
As though mine image in the glass
  Should tarry when myself am gone.

Another poet might have said, As if your image remained in the mirror after you left. This speaker remembers an occasion reflected in the painting, his purposes in painting it, and how he reminded her, as she sat for the portrait, of the earlier occasion in the woods

when she sang with two echoes, one from the setting, one in his soul. He relived the occasion last night in reverie—re-created now in meditation or in art—wandering among those mystic glades. The poem, like the painting, explores different kinds of reality.[34] Next after the portrait of an artist deepening despair through memory, the chief image is of spiritual drought: "Athirst where other waters sprang." For Rossetti, memory always touches life into death.

The Pygmalion series of Burne-Jones, decorative surfaces attempting the sensuous tactility of sculpture, evokes particularly an awareness that nineteenth-century art is heavy with guilt over the relation of artist to model. In *The Heart Aspires* the sculptor contemplates the implanting of a personal ideal in stone not yet put before the viewer of the painted narrative. *The Hand Refrains* warns the man against greater intimacy while it reminds the artist of the danger of retouching. This second stage includes Browning's and Ruskin's ideals of imperfection. *The Godhead Fires* and *The Soul Attains* lay a joint claim to purity of motive and the liability of divine impulse for anything indecorous in the result. Richard Jenkyns has speculated that the whiteness attributed to Greek sculpture had a special appeal in Victorian aspirations toward purity. Suspicious critics of the Pre-Raphaelites have noted that they tended—though Holman Hunt's effort failed—to accomplish educative marriages with uncultivated and morally dubious models.[35] Shaw's *Pygmalion,* with a preface noting that the victim's name was not properly Galatea, fought Victorian respectability by making her respectable: a method more acceptable to democracy but no more forthright than Burne-Jones's. John Gray, no suitor to respectability, wrote in 1893, in the manner of Corvo's tales from Toto, "Fiorenzo of Maggiolo," telling first of a gold-worker led by the Virgin, in a dream, to a statue so beautiful in its contours that he clothed it, founded a monastery, and brought fame to this simulacrum of Our Lady. The parable turns then to "the very young brother, named Fiorenzo," who in piety decided to reclothe the statue, in so doing "touched yielding flesh," looked upon a figure "radiant and quivering, beautiful beyond thought or desire," and fled, never to be seen again. When the Prior, now Cardinal, returned, he found a shattered idol. "The proud convent itself was

gradually deserted, and . . . only degenerate vines languish above its forgotten foundations."[36] In a line of descent from Rabelais, Boccaccio, and Chaucer the title would be "Simonello of Maggiolo," for it is Simonello who dreamed the vision, found the statue, lived with it in deceit single or double, and built a monastic career upon it; Gray turns the attention to Fiorenzo, an undesigning Pygmalion who flees from the wonder of a feminine body. The frontispiece, by Maurice Greiffenhagen, depicts the young monk gazing upward in awe at the Galatea who gently caresses him. Gray chooses to make the essence of the parable sexual ambiguity.

Oscar Wilde, in the version of *The Picture of Dorian Gray* published in *Lippincott's Monthly Magazine* in July 1890, allowed peeps into homosexual otherness that he narrowed in the lengthened version published as a book in 1891.[37] Ingenuous Dorian learns of his own fragile beauty from Basil Hallward's portrait of him and the brittle words of Lord Henry Wotton. Instantly aware that what Basil and Lord Henry admire is his youth, he prays that its perceived beauty will endure.

Lord Henry serves as bad angel, always immoral in influence, but his essence is inverse hypocrisy, polishing epigrams of sin to which he abandons Dorian but never himself. In speaking immorality he utters Dorian. The opening dialogue stresses the evils of influence. Lord Henry is all mask and art. The earnest, guileless Hallward sees that he has put too much of himself in the painting. A suppressed self has escaped into view, the inverse of Conrad's captain purging his own evil by accepting responsibility for Leggatt's. As Dorian progresses from sins to crimes he not only enacts the desires of his own worst self but is as well the Hyde of both Hallward and Lord Henry. The narcissism of all three aggregates in Dorian. The "picture" is the image Hallward gave Dorian of himself; Lord Henry brings a change in the image ("It is the spectator, and not life," says the preface, "that art really mirrors"); progressive deterioration of a previously unformed soul can be seen only in the picture. Dorian locks it in the schoolroom of his innocence, and it is there that he murders Hallward and there that he blackmails the unfortunate Alan Campbell into destroying the corporal evidence.

Earlier, in the erotic poem *Charmides,* Wilde had told in Keatsian cadences of a beautiful, narcissistic boy, mistaken by others for

Narcissus or Dionysos, who violated in the temple of Athena, so far as one can picture a marble statue violated, the "grand cool flanks, the crescent thighs, the bossy hills of snow." Moreover, the punished but still beautiful corpse of Charmides is wooed by an amorous votary of Diana, with such passionate assault that Venus makes it possible for the young lovers to lie together in Acheron, soon to serve Persephone beside the black throne of "the pale God who in the fields of Enna loosed her zone." Some of this gaminess can be seen just beneath the surface of *Dorian*.

Drawn to the acting of Sibyl Vane, who has been without identity except in her roles, Dorian abandons her when real love for him makes her a bad actor. This cruelty provides the first indication that Dorian's crimes will register, not in his face, but in the portrait. As Dorian is to Lord Henry, the corruptible portrait is to Dorian. All relationships in the book are to show that art is more real than life.

Sibyl is poisoned by life; Dorian declares himself poisoned by a book. The early assumption that the poisonous book with yellow covers was the quarterly published by John Lane, the *Yellow Book*, gave way to another sense of certainty—"it is easy enough to recognise Huysmans's *À rebours*, which had appeared seven years earlier, in 1884."[38] That certainty neglected Wilde's propensity to brazen appropriations. Only large debts to Huysmans, as to many others, remain clear; Wilde had himself planned to write the book that would, in poisoning Dorian, prove in a work of literature that nature subsists on art and therefore can sicken and die of it.[39] The account of this imagined novel in *Dorian Gray* resembles by inversion the reference in *Justified Sinner* to Hogg's letter to *Blackwood's* on the resurrection of a decayed body.

When Dorian stabs the painting in a final effort to destroy his conscience, all the accumulated physical and moral corruption returns from the painting to the man, whose hideous corpse is identifiable by the rings on its fingers. In one view, Dorian takes revenge first on his corrupters and then on a portrait that came alive and acted in malice to destroy him.[40] Like Wilde's first three comedies to follow, this Gothic *Dorian* is sickly with extruded moral: Pater's higher hedonism is admirable, but pursuit of raw pleasure corrupts. As Wilde explained the moral, "All excess, as well as all renunciation, brings its own punishment."[41] In reviewing the

novel, with a reiteration that "true Epicureanism aims at a complete though harmonious development of man's entire organism," Pater went below the forced displays of conventional morality to chastise an aestheticism that deprived the characters of a sense of sin and righteousness. Aside from the morality of plot that contradicts the theme, Wilde stuffed in such incongruous patches as the realism, in Chapter 3 of the expanded novel, of Lord Henry's visit to his uncle, Lord Fermor. In reissues of Wilde's *Poems* by Methuen, "honey" is misprinted as "money" in *Charmides* 2.38 (the inconstant butterfly could "steal the hoarded money from each flower"); the morality of *Dorian* represents a veneer, rather than a misprint, of money over honey.

According to one of the epigrams added as a preface, the book in yellow covers could not have corrupted Dorian, for there "is no such thing as a moral or an immoral book." Nor is it aesthetically proper for a painting to force its subject to retaliate. The appeal of notoriety had made paradoxes and epigrams too central to forgo merely in order to avoid self-contradiction.

Most of Wilde's friends thought him oppressed, if not consumed, by a sense of destiny. If so, he kept his fiction largely free of it. *Lord Arthur Savile's Crime* is the story of a man engaged to be married who is told by a chiromantist that he will commit a murder, chivalrously tries to perform this duty before the wedding, fails in two attempts, throws the chiromantist into the Thames, and enters contentment as husband and father. The tale illustrates Wilde's interest in paradox, transgression, sin, and crime, but shows no Byronic—or other—concern with destiny. *The Canterville Ghost,* published like *Savile's Crime* in the *Court and Society Review* in 1887, is similarly a story less with an idea than about an idea. It gives a new twist to a Jamesian theme—American adults so ingenuous they patronize a wicked Old World ghost, with two American children so judiciously mischievous they torment it. The Americans exorcise the ghost of European aristocracy and reduce British social "tradition" to the merely legendary—as in "traditional ballad."

The significant point of the previous paragraph is not failure of character in Wilde but change in the public. The indifference to destiny is partly but not altogether personal to Wilde. The word "destiny" appeared often, but both the classical and the Christian

meanings had faded. The post-Darwinian world accepted chance in replacement of divine will. Max Beerbohm would write in the first number of the *Yellow Book*: "In fact, we are all gamblers once more, but our gambling is on a finer scale than ever it was. We fly from the card-room to the heath, and from the heath to the City, and from the City to the coast of the Mediterranean . . . no one seriously encourages the clergy in its frantic efforts to lay the spirit of chance."[42]

Not only *Dorian* but almost everything about its author led the period toward self-assessment. Of two satiric jostlings of Wilde in 1894, the one more general in intent, *The Autobiography of a Boy* by G. S. Street, went at *Dorian* (almost) directly only once: "Did Nature keep pace with thought my hair would long ago have been grey." *The Green Carnation,* by Robert Hichens, bases its case against the evil creation of an imitative double not so much on Dorian as on Wilde's evident effect on Lord Alfred Douglas. Subjugated Lord Reggie says what he has learned to say, "Our faces are really masks given us to conceal our minds with," but he goes beyond imitation in adding: "After Dorian's act of cruelty, the picture ought to have grown more sweet, more saintly, more angelic in expression." He explains in a Wildean paradox that exposes one of *Dorian*'s major flaws: "Poor Oscar! He is terribly truthful. He reminds me so much of George Washington."

In *The Happy Hypocrite,* which opens in parody of Regency memoirs parading the misdeeds of rakes, bucks, and dandies, Beerbohm marked "paid" to the century's series of masked doubles: Lord George Hell, an urban rake to whom "the ennobling influences of our English lakes were quite unknown"—who indeed "used to boast that he had not seen a buttercup for twenty years"—is stung by the Merry Dwarf (a Cupid of the stage) into love of Jenny Mere, a pure dancer who could love only a man of saintly face. Disguised by a mask-maker as a saint, transparent only to La Gambogi, his former mistress, Lord George gives Jenny a posy of wildflowers, marries her, disposes of his wealth, and removes Jenny to a woodman's cottage. When La Gambogi exposes him to Jenny by ripping off the mask, his love and the virtue he thought a pretense have made him saintly all through. The parable exposes masks in art and recommends them for the cultivation of good habits, which can

produce unawares good character. Sin, for Stevenson massive and for Wilde and other lost men of the nineties alluring, was to Beerbohm a trivial pursuit.

Yeats, whose earliest play, *The Land of the Heart's Desire,* draws upon Celtic folklore for a romantic plot in which a fair child of the Sidhe steals the spirit of a bride, was to go far beyond Beerbohm in the study and recommendation of masks, for drama, for psychology, and for freedom and strength in art. Examined in the light thrown on doubles, the other, and concrete symbols by Borges and Calvino, all the explorations of the nineteenth century seem a simple prelude to linguistic convolution.

# AESTHETES

Darwin said in his autobiography that scientific pursuits ruined in him the appreciation of poetry. His *Origin* finished the ruin of *natura naturans* as an ethical ideal. The answer to Darwin was a doctrine of two truths, one of science, another, not subject to disproof, of art. Realism, in Tennyson's view "wallowing in the troughs of Zolaism," became insistently an urban art. Attempts to bring the garden into the city made clearer the dependence of urban life upon craft and art. Even Ruskin progressed from what he reports in *Praeterita* as his first sermon, "People, be good," to something like, "Magnates, build well and honor artists who paint well."

As worded in an anonymous translation of 1890, Gautier had said the needful well enough in the preface to *Mademoiselle de Maupin* in 1835: "There is nothing really beautiful but that which is useless; everything useful is ugly, for it is the expression of some want, and man's needs are ignoble and disgusting, like his poor infirm nature. The most useful part of the house is the toilet." Textbooks say that the movement toward art for art's sake begins in lectures of 1818 by Victor Cousin, has an independent beginning in Keats, accelerates in Gautier's preface of 1835, and plummets through the sky in the 1890s. For such an arc Rossetti, Morris, and Burne-Jones provide the zenith, at least in influence.[1] Swinburne, publishing the first critical study of Blake in 1866, declared Blake (who was nearly forty when Keats was born) an exponent of art for its own sake, not a believer in art as handmaid of religion or art as servant of duty, morality, or fact. Beerbohm's caricature of Wilde

lecturing in 1882 bears the informative caption, "The name of Dante Gabriel Rossetti is heard for the first time in America." Yeats begins the movement with Arthur Hallam's review essay on Tennyson's early poems and dates the onset of his own aestheticism from discovery of that essay.[2]

A type of the effete was observed throughout the Victorian era. In Charlotte Yonge's *The Heir of Redclyffe* (1853), at "a toilet-table with a black and gold japanned glass, and curiously shaped boxes to match" in Mrs. Edmonstone's room at Hollywell, the sickly Charles sits "in a gorgeous dressing-gown of a Chinese pattern, all over pagodas." Laurence Oliphant's *Piccadilly* (1870) makes the unnatural a national condition: "We don't keep our hearts in a state of nature in this country a bit more than our bodies—it would not be considered proper."

Pater made a decided advance when he replaced Arnold's advice to know the best that has been thought and said, and make it prevail, with the qualification, "the best as it seems to me," and again when he declared in a passage of 1868, repeated as the conclusion to *Studies in the History of the Renaissance* in 1873 but later rescinded from fear of excessive influence, "While all melts under our feet, we may well grasp at any exquisite passion, or any contribution to knowledge that seems by a lifted horizon to set the spirit free for a moment, or any stirring of the senses, strange dyes, strange colours, and curious odours, or work of the artist's hands, or the face of one's friend."

When W. H. Mallock sounds the alarm in *The New Republic,* in 1877, his parody of aestheticism includes some traits of Rossetti, but his Mr. Rose is Pater in much more than the languor and a tendency to correct the views on culture ("fastidious taste and liberal sympathy") of Mr. Luke (Matthew Arnold). Here is Mr. Rose trying to educate adherents to Ruskin's morality:

> "I know, indeed—and I really do not blame them—several distinguished artists who, resolving to make their whole lives consistently perfect, will, on principle, never admit a newspaper into their houses that is of later date than the times of Addison; and I have good trust that the number of such men is on the increase—men I mean," said Mr. Rose, toying tenderly with an exquisite wine-glass of Salviati's, "who with a steady

and set purpose follow art for the sake of art, beauty for the sake of beauty, love for the sake of love, life for the sake of life."

Carlyle's admonition to do the work that lies nearest was modified by Ruskin, Arnold, Swinburne, Morris, and Pater: not until you have seen Venice, or better France, in Paris especially Baudelaire, and only if it is pleasant to you and results in beauty, *and* only if it has its source and end in a bright internal flame. From noting the simplification introduced by Rossetti into the design of book covers, Pater had anticipated the direction that would follow Rossetti when he wrote to Alexander Macmillan in 1872 of his book then printing on the Renaissance: "For a book on art to be bound quite in the ordinary way is, it seems to me, behind the times; and the difficulty of getting a book bound in cloth so as to be at all artistic, and indeed not quite the other way, is very great."

Negatively, the aesthetic movement was a reaction against perceived insolence in the language of utilitarians, industrial capitalists, and scientific positivists, a rejection of respectability in morals and of democratic leveling, athleticism, imperialism, policy toward Ireland, and illusion as an aim in arts and manufacturing. Nature, turning the weather against agriculture in the late 1870s, weakened the economic power of rural estates; no politician acted to reverse the agricultural decline. Germany and the United States began to compete successfully against British industry. Unionization increased, but there was much sweated labor; women especially were exploited.[3] Ugliness and clumsiness spread like a fan from Liverpool and Manchester. Edward Carpenter, who exchanged a Cambridge degree, fellowship, and Anglican orders for sandalmaking, published in 1889 *Civilization, Its Cause and Cure.* What has been called "violent indecision" within the Church of England encouraged in Pater and later aesthetes a surrender to the beauty of ritual. The splintering of heresies is related to social discomforts in a lively book made graphic by such illustrations as a cartoon by the pioneering Secularist George Jacob Holyoake, "The Seated Member and the Sat Upon."[4] The generation born after 1870 tended to speak of "those Victorians" much as Bloomsbury was to do.

Imperial expansion into Africa may have been less for material

gain, initially, than for strategic superiority over European rivals after the crumbling of Turkey revived fears of Russia. With Victoria proclaimed Empress of India on the first day of 1877, there rose among journalists and writers of fiction a fear that heroism meant hypocrisy. Impressionist painters, like the naturalists, renounced heroic ideals. A. E. Housman found tragedy in the trivialities of every day: washing, drinking, poison, and being hanged were penalties for having been born.

> Oh often have I washed and dressed
> And all's to do again.

George Moore, in his Zolaesque phase, conducted interviews at race tracks and celebrated the fall, not only of heroism, but of imagination as well. Richard LeGallienne, in *The Religion of a Literary Man,* lamented a decadence seeking beauty with no more appeal to wonder than Madame Tussaud's: "It merely addresses the sensual eye and ear the more obviously, and endeavours desperately to limit beauty to form and colour, scornfully ignoring the higher sensibilities of heart and spirit."[5] A casualness that began with Rossetti's *Jenny* was ending in cuisine. To the patriot, loss of backbone was inevitable with the increase in androgyny and the forays of Havelock Ellis and other psychologists into forbidden lands of sex. As early as 1884, in Vernon Lee's *Miss Brown,* the painter-poet Walter Hamlin had "the sense of the dust and smoke, as it were, of the aesthetic factory" (1:8).

The counter-aesthetes, Kipling, Henley, Alfred Austin, William Watson, and Henry Newbolt, depicted and proclaimed patriotic heroism. In "The Three-Decker," a lament for the passing of the three-volume novel, with its morals policed by Mudie's and other circulating libraries, Kipling could gain only partial support from Conrad and Stevenson in linking heroism, restraint ("We never talked obstetrics when the Little Stranger came"), and happy endings:

> I left 'em all in couples akissing on the decks.
> I left the lovers loving and the parents signing cheques.
> In endless English comfort, by country-folk caressed,
> I left the old three-decker at the Islands of the Blest! . . .

That route is barred to steamers: you'll never lift again
Our purple-painted headlands or the lordly keeps of Spain.
They're just beyond your skyline, howe'er so far you cruise
In a ram-you-damn-you liner with a brace of bucking screws.

The poem rejects along with realism the economies and reticences of Henry James.

William Ernest Henley could ask what he would not do for "England, my England"; he could thank gods for an unconquerable soul; he could denounce the New Woman as vile, rank, and bestial; but he celebrated in verse a Japanese print, he frequently employed such French forms as the ballade, he gave to poems musical titles (nocturne, *allegro maestoso*), and shared other traits with the likes of Arthur Symons. Both Henley and Kipling join the naturalists to produce vignettes of the ordinary: "Lord, send a man like Robbie Burns to sing the Son o' Steam!" The periodicals popularly thought decadent, the *Yellow Book, Savoy, Butterfly,* and *Dome,* each engendered a wide variety of superior fiction, poetry, essays, illustrations, and even music.

Everywhere, however, innovation and contraction were at work. Replacing the traditional category of "literature," meaning poetry, fiction, philosophy, biography, history, and indeed any well-written, readable work embodying serious thought, booksellers dropped the heading "Literature" for the narrower category of "Belles-Lettres." Philosophy and history were no longer literature. It was not completely without point that Stanley Weintraub subtitled his selection from the *Yellow Book* "Quintessence of the Nineties." In the *Savoy,* Dieppe and Dublin, France and Ireland, were brought together (a long-recurring dream) against the traditions and conventions of official London. Rejection of plot followed in the wake of Rossetti's rejection of the Academy, as the tale gave way to the short story of mood. Selwyn Image proposed in the first number of the *Savoy* (edited by Symons) that each critic tell "how a man is affected by this or that specimen of the arts at the moment before him"; he drew from Pater's practice the further recommendation that the critic be allowed to avoid a fixed identity and to sign articles variously with actual or fictitious name or initials.

One concern above all united aesthetes, decadents, naturalists,

socialists, *romanciers,* and dramatists: that concern was censorship. Hubert Crackanthorpe, in "Reticence in Literature," asked for a recognition of common ground between idealist and realist against those, "the backbone of our nation; the guardian of our mediocrity; the very foil of our intelligence," who protested with impartiality on moral grounds against "the productions of Scandinavia and Charpentier, Walt Whitman, and the Independent Theatre." Crackanthorpe, like Stevenson, knew why the guardian was wrong: "Art is not invested with the futile function of perpetually striving after imitation or reproduction of Nature; she endeavours to produce, through the adaptation of a restricted number of natural facts, an harmonious and satisfactory whole."[6] Historians of censorship have focused on the theater, but it affected every creative person. Havelock Ellis made the case in an essay on Zola in the first number of the *Savoy.* With censorship in mind, to profess *l'art pour l'art* "is to perform a moral act; it is to criticize life as it has usually and clumsily been lived in the past, and at the same time to offer new modes of seeing and doing, new concepts of the human person and the human condition."[7]

The 1890s enjoyed strong works by Conrad, James, Yeats, Shaw, Hardy, Meredith, Gissing, Moore, Morris, Kipling, Wells, Bennett, Stevenson, Wilde, Beerbohm, Masefield, Du Maurier, Blunt, Barrie, Symonds, Saintsbury, Symons, "Mark Rutherford," and many others.[8] Books by Bernard Muddiman, Le Gallienne, and Osbert Burdett, popular in the 1920s, argued, convincingly as it proved, that a group no larger than the Rhymers' Club, with Whistler, Wilde, and Beardsley setting the norm of falsetto pitch, sunflower yellow, and carnation artificially green, defined the age.[9] Robert Bridges's sobriety in the pursuit of beauty did not count. In this view, Anna Swanwick's *Poets the Interpreters of Their Age* (1892) was a swan song: "Grand indeed has been the function of poetry, as one of the prime factors in promoting human progress, quickening the springs of faith and love, cherishing in the human soul the love of the Good, the Beautiful, and the True; uplifting it to higher and holier aspirations by the creation of ideals transcending our ordinary experience, and keeping alive the sacred fire of enthusiasm, without which the spirit is apt to droop under the deadening influence of custom and routine."[10]

It was not accidental that the learned Swanwick avoided making "the Beautiful" the first or the last of ideals. A useful watershed for study of the movement to make beauty first, central, and final is the opening of Sir Coutts Lindsay's Grosvenor Gallery in 1877. In the 1850s Albert Moore had painted directly from nature, as in the Ruskinian *Study of an Ash Trunk,* exhibited at the Royal Academy in 1858 along with similar works by Alfred William Hunt; it would not happen to Moore again, not after 1877. George Moore said typically: "Realism, that is to say the desire to compete with nature, to be nature, is the disease from which art has suffered most in the last twenty years."[11]

The advance of the aesthete can be followed most relaxingly in the caricatures by George du Maurier in *Punch,* or, since those acidic pages are crumbling, in the ample selections provided by Leonée Ormond in her chapter "The Aesthetic Movement."[12] Du Maurier had begun to satirize Rossetti, Morris, Swinburne, and his former friend Whistler in the 1860s. By 1874 his focus was on "China-mania," the fad for blue-and-white china that spread from Rossetti and Whistler. His wilted but aspiring Jack Sprats of 1878 gave hints for the costumes of *Patience.* All the essential elements had come together by 1880. In one of du Maurier's cartoons of that year, "Intense Bride" in an aesthete's corsetless gown, a Japanese screen with cranes in lieu of peacocks behind her, holds up the titular object, "The Six-Mark Tea-Pot," for the bridegroom to acknowledge as "quite consummate"; in the dialogue beneath, the bride adapts an epigram attributed to Wilde at Oxford: "Oh, Algernon, let us live up to it!" Two of the cartoons give particularly "intense" anticipations of Wilde. In "An Aesthetic Midday Meal" (17 July 1880) the poet Jellaby Postlethwaite sits at a table in a pastrycook's, where he assures the waiter that he requires nothing but water for his lily (his "vegetable love," as *Patience* has it). In "Maudle on the Choice of a Profession," near the end of the series (12 February 1881), Mrs. Cimabue Brown reports that her son wishes to be an artist, like Maudle. Considering "how *consummately* lovely" her son is, Maudle asks: "Why should he *Be* anything? Why not let him remain for ever content to *Exist Beautifully?*" Mrs. J. Comyns Carr, wife of a founder and director of the Grosvenor Gallery, liked to believe, with at least partial justification, that she was the original

for Mrs. Cimabue Brown. But by 1880 aesthetes were fair game without any danger of becoming an endangered species. Other artists and writers in *Punch* drove the subject hard. In successive numbers of January 1877, we get "How really quite too far more than awfully delicious!!!" and a young woman who cannot, despite the P.R.B. and Burne-Jones, "see much beauty in mere bones"; she declares a man mistaken to invite her to dine *on* roses. Wilde was of significance by May 1881, as in the stanzas "More Impressions. By Oscuro Wildegoose."

Meanwhile, two works had raced each other to the stage. F. C. Burnand, the editor of *Punch,* gathered as many aesthetic elements as he could into the characters, plot, and decor of his play *The Colonel,* which opened at the Prince of Wales Theatre in February 1881. The French original had made no reference to aesthetes, but du Maurier's success gave Burnand the intention of proving on stage that the movement consisted of fools and the villains who cheated them.[13] Gilbert and Sullivan's *Patience, or Bunthorne's Bride: An Aesthetic Opera* followed in April, was given new costumes and decor in October as the first opera in the new Savoy Theatre, and had two simultaneous productions in the United States, one in New York and the other on tour. Oscar Wilde, who had brought his reputation as an aesthete to London in 1878, needed the cash offered by Richard D'Oyly Carte for a series of readings or lectures that would show Americans how aesthetes looked and posed, so that audiences could get the full point of *Patience.*[14] Whether or not they heard his lectures, the journalists who gathered around Wilde could report on an oversized embodiment of life imitating art. The chief models for Bunthorne and Grosvenor were Whistler and Swinburne, but Frith made Wilde the central figure in his painting of 1881, *The Private View of the Royal Academy.* Frith describes the picture and its aims:

> Beyond the desire of recording for posterity the aesthetic craze as regards dress, I wished to hit the folly of listening to self-elected critics in matters of taste, whether in dress or art . . . [My work depicts] a well-known apostle of the beautiful, with a herd of eager worshippers surrounding him. He is supposed to be explaining his theories to willing ears, taking some picture on the Academy walls for his text. A group of well-known artists are watching the scene. On the left of the com-

position is a family of pure aesthetes absorbed in affected study of the pictures. Near them stands Anthony Trollope, whose homely figure affords a striking contrast to the eccentric forms near him.

According to Gilbert's Bunthorne, to be aesthetic you must "walk down Piccadilly with a poppy or a lily in your mediaeval hand," as a way of exciting your "languid spleen" with "a sentimental passion of a vegetable fashion"; you must "convince 'em, if you can, that the reign of good Queen Anne was Culture's palmiest day"; you must "long for all one sees" that's Japanese; assuming "stained-glass attitudes" you must utter "idle chatter of a transcendental kind"; you must wish to possess as your very own retainer "a judge of blue-and-white and other kinds of pottery." You would be—certainly not Wilde—

> A pallid and thin young man,
> A haggard and lank young man,
> A greenery-yallery, Grosvenor Gallery,
> Foot in the grave young man!

Those enamored of Bunthorne soon adopt the aesthetic cadence: "Oh, Saphir, are they not quite too all-but?"

Bunthorne specifies, and Gilbert and Burnand agree in attacking, a very wide array of characteristics for any one movement to attain. The explanation lies in the complexity of developments that were heaped together by current satirists and have been left in heaps by historians. In "An Anatomy of Aestheticism," Wendell Harris first names six tendencies—"the medievalizing, the botanical, the ornamental, the omnibeautiful, the demand for art for the artist's sake, and the dreamily melancholic"—and then demonstrates that even when one of the tendencies was shared by more than one group it was shared in differing ways. [15]

Most of Bunthorne's traits and the inclinations he disavows can be readily identified. The walls of the Grosvenor Gallery had become greenery-yallery after Ruskin and others objected to the initial bright crimson. The lily, prominent from Rossetti's earliest painting, had been enlarged in Mallock's recipe for a Pre-Raphaelite poem in *Every Man His Own Poet* (1879): "Take three damozels,

dressed in straight night-gowns . . . Place an aureole about the head of each, and give each a lily in her hand, about half the size of herself." The lily came to suggest Wilde after he carried lilies— more ostentatiously, a large amaryllis—through the streets of London, first to Lillie Langtry, whom he encouraged onto the stage, and then to other actressses. Journals lampooning Wilde's *Poems* in 1881 caricatured him as a sunflower, as did the wrapper of Charles Kendrick's *Ye Soul Agonies: A Life of Oscar Wilde* in New York in 1882. Lily, sunflower, and peacock feather were promotional emblems for *The Colonel.* Sunflower and cornflower, as written up by Grant Allen in the *English Illustrated Magazine,* suggest Rossetti's coarsest model and mistress, Fanny Cornforth. Several of Morris's wallpapers of the 1880s, named after rivers, brought delicacy to such flowers. To avoid what had become commonplace, and to combat nature, Wilde invented the green carnation. Morris and Company had made Burne-Jones the foremost name in stained glass. The "attitudes" had probably descended by way of Lady Hamilton, but Leighton and the other Olympians, decorative Hellenists who exhibited at the Grosvenor, were as popular as bicycles and croquet.

The Olympians were uniform only in financial success; their Hellenism was inevitably somewhat historicist; none was so strictly aesthetic by doctrine as to offend Burnand or Gilbert. One, Alma-Tadema, praising the South Kensington schools for binding art to industry, wrote as a son of the picturesque in 1892:

> If now we accept it as an axiom that Art has to awaken in the spectator a higher sense of the beautiful, we come naturally to the origin of all things, to Nature. What do we see done by Nature? If, for example, a building falls to ruins, or a landslip makes an ungainly gash, Nature at once sets to work to make it beautiful again by hiding and covering with plants and flowers what had become an ugly gap or formless mass. In fact, she is for ever adorning everything with beauty, either by colour, light and shade, or sound; and, therefore, she should teach us to be grateful for all beauty and all good.[16]

Nor was the taste for things Japanese obnoxiously narrow, however aggressively aesthetic some of its proponents. With no great

lag after Commodore Perry opened the ports of Japan in 1854, fans, vases, screens, and other Japanese objects began to appear in paintings by Whistler that openly acknowledge *ukiyo-e* prints as a major source of their design. General knowledge spread from the Japan Court organized by Sir Rutherford Alcock for the International Exhibition of 1862. Morris, the Rossettis, and Whistler were among the numbers who bought Japanese objects from the dealer Murray Marks and from the shop opened by Arthur Liberty in 1875.[17]

The age of Queen Anne, favored by Thackeray and later associated with Austin Dobson of the triolet, rondeau, and villanelle and his favorite illustrator, Hugh Thomson, came into *Patience* from the revival in architecture of red brick, more of Elizabeth than of Anne. The reference by Bunthorne would have been understood as a hit at Bedford Park, a garden suburb developed by John Carr, whose brother, the art critic and director of the Grosvenor, joined him in founding an art school there. J. B. Yeats brought to live there his sons, Jack and W. B., with "artists, actors, writers, revolutionaries, and progressives of every variety." Norman Shaw, the best-known architect involved, established a "Queen Anne" tradition of embedding prominently in the red brick a sunflower of terra cotta.[18] "The Ballad of Bedford Park," in *St. James's Gazette,* 17 December 1881, could have influenced *Patience*:

> Now he who loves aesthetic cheer
> And does not mind the damp
> May come and read Rossetti here
> By a Japanese-y lamp.

E. W. Godwin, the earliest architect at Bedford Park, also built on Tite Street, Chelsea, the "White House" for Whistler (1878), a pair of "Artists' Houses," another that Frank Miles shared with Wilde (1880), and later a house for Wilde and his bride. Godwin's interiors were for that time startlingly simplified, sometimes a stark naked white.[19] Like Philip Webb in the Red House of 1859 for Morris, Godwin strove to free beauty in architecture from revival of period styles.

It is frequently mentioned that Chesterton meant readers of *The Man Who Was Thursday* to understand that "Saffron Park," "faintly

tinged with art . . . though it never in any definable way produced any art," meant Bedford Park; more effectively, R. S. Hichens in *The Green Carnation* describes the return to nature in a garden village where some rusticity is retained, some is restored, and some is fabricated. In the church near Mrs. Windsor's cottage in Surrey "the windows were filled with stained glass, designed by Burne-Jones and executed by Morris, and there was a lovely little organ built by [Henry] Willis."

In derivation from Morris, the Arts and Crafts movement flourished. In "The Critic as Artist," Wilde proclaimed that "All over England there is a Renaissance of the decorative Arts. Ugliness has had its day. Even in the houses of the rich there is taste." He was right. "It was, after all," a later writer has said unkindly, "a consumer movement, with time and money to spare, centered first on the firm [Morris and Company] and then on Liberty's."[20] Such a view is less than fair to the accomplishments of Arthur Heygate Mackmurdo and the Century Guild, which he founded in 1882; to Selwyn Image and Herbert Horne, who laid aesthetic foundations in the *Century Guild Hobby Horse;* to William Lethaby's Art-Workers' Guild, started in 1884; to C. R. Ashbee, who began the Guild and School of Handicraft in 1888; to Walter Crane, the first president of the Arts and Crafts Exhibition Society, no more commercial in aim at its opening in 1888 than the Royal Academy; to Charles Rennie Mackintosh and his Glasgow School of Art, commenced in 1897; to T. J. Cobden-Sanderson, credited with coining the term "Arts and Crafts"; and not generous to Lewis F. Day, prolific designer and author of books on design, or to the potters William De Morgan and Wallace, Walter, and Edwin Martin, perhaps not even to the fourth brother Charles, their office and shop manager.[21]

New magazines, *Decoration, The Artist, The Magazine of Art, The Studio,* gave space to decoration and design. Cosmo Monkhouse's devoted attention to the Arthur Sanderson house on Tyneside, designed and decorated by Scott Morton and filled with blue china, ran in the *Art Journal* throughout 1897. Doulton and Company turned from Gothic to the newer fashions. Fads and pretense flourished, but the hypocrisy of materials attributed by Gloag to "the moral earnestness of the Gothic revival" faded.[22] Such inclusiveness as that of the Metropolitan Museum exhibition and catalogue, *In*

*Pursuit of Beauty,* with "art furniture" enfolded in Gothic weightiness heavily gilded, dissipates the force of simplification that the Arts and Crafts movement continued from Morris.[23]

Organized crafts provided a new outlet for creative women. The thought of young women attending art schools where the models were likely to be nude made the society uneasy, but the clay in guilds of handiwork was acceptably abstract. In keeping with developments in England, the women's college of Tulane in New Orleans, Newcombe, instituted a program for women to design pottery, although a man was retained to work the wheel and the ovens, either in certainty that women lacked the strength or in fear that they might gain it. *News from Nowhere* opposed marital ownership of women, but exposed unconscious assumptions: Every man would build a beautifully decorated workshed and work at it with beautifully decorated tools. Every beautiful woman would make a beautiful broom, and sweep with it. Most of the new guilds attempted to end such distinctions. Walter Crane helped form the Healthy and Artistic Dress Union, which began in its second year, 1894, a periodical, *Aglaia.*[24]

All these elements were detected in the first assessment of the situation, Walter Hamilton's succinct book of 1882, *The Aesthetic Movement,* which had an aesthete's praise for all that was "most consummately intense." Christmas cards, particularly by Albert Ludovici and W. S. Coleman, had already begun to josh each aesthetic aspect. A card for 1881 by Ludovici, in which a young woman in aesthetic dress holds up a teapot, bears the inscription, "May you have a quite too happy time"; soon Ludovici was issuing "Patience" cards for the full range of targets, and before long on such cards nude nymphets held blue china or Japanese fans before Japanese screens or sported some other aesthetic motif.[25] Ridicule of the aesthetes had become a lucrative industry.

Photography obliged one aspect of arts and crafts to proceed more rapidly. It has been estimated that there were 60,000 wood-engravers in London in the 1870s. Over against the 14 firms listed in 1817, there were 128 in 1872.[26] Photographs served in various ways for the production of books, magazines, and newspapers, but most of those ways required wood-engraving between the initial image and the printed page. For a book the engraver could work

slowly, but weeklies required haste. For a full page of the *Illustrated London News* the blocks on which an illustration was traced could be unscrewed and distributed to twenty different engravers. According to M. H. Spielmann in 1895, this method was employed for *Punch* from the 1860s; equally for speed, the assembled blocks were put directly on the printing machines; later, the edition was electrotyped. In "the forty years of wood and stone," 1834–1874, a drawing had to be made of a photograph in order to print it.[27] When Henry Trueman Wood published *Modern Methods of Illustrating Books* in 1887, he knew of no way to transfer a photograph onto the printed page. (As Sir Henry Wood, he was to be president of the Royal Photographic Society, 1894–1896.) In theory, photography made possible the preservation of the artist's original drawing, which previously might have been destroyed in the act of engraving, but W. J. Linton protested that most engravers had copied off-sized drawings onto the block, whereas photography, by reducing the drawing to the exact size required, made the engraver's work more mechanical and assured dullness in the result.[28]

Photography had worried black-and-white artists all along. In one of du Maurier's first contributions to *Punch*, 6 October 1860, figures who are recognizably du Maurier and Whistler have entered a photographer's studio; their friend Thomas Lamont follows with a cigarette in his hand. The photographer, identified in a letter to the artist's mother as "the great Herbert Watkins," says, "No Smoking here, Sir! Please to remember, Gentlemen, that this is not a Common Hartist's Studio!"[29] A new wave of anxiety struck painters as well. George Moore's piece on "The Camera in Art" explained utilization by some artists of "the cheap realism of the Camera" as the fear of catching cold: "no wet feet; no tiresome sojourn in the country"—but (as Lady Eastlake had noted) no chiaroscuro.[30]

As photography became progressively self-sufficient for printed materials, the engravers' occupation was gone. Alfred Hartley, five years out of the Royal College of Art in South Kensington, wrote in 1894:

> We are here specially interested in the aspects of Photography as they appear to the artist, and however much we may be impressed with its many material advantages, it is impossible

to be blind to the disadvantages which have crept in alongside, or to hide from ourselves the fact that Art has suffered at its hands. That Wood-engraving should have been driven to the wall, as is practically the case, through the introduction of "process work," is deplorable; that the art in which Dürer and Bewick excelled, and by means of which they enriched the world, should have to flee in face of the demand for cheapness and speed, is regrettable beyond measure.[31]

As the most exacting student of the processes of illustration puts it, photography "became a good friend to the commercial wood engraver for about three decades, and then it treacherously killed him."[32]

If photography took away engravers' jobs as artisans, the solution, for a few, was to declare themselves artists. The determination of wood-engravers not to be defeated by the photograph helped give rise to the private press movement, to the aesthetic journals that supported it, and to lithography as an altogether fine art. The *English Illustrated Magazine* was founded in 1883, with a stable of wood-engravers, in an effort to sustain an art that had achieved a summit in the 1860s. The *Century Guild Hobby Horse* was the first periodical of a more strictly artistic kind. Every year or so its editors denounced the erroneous belief that art should represent surrounding life. They were cultivating "a region," wrote Mackmurdo, "in which art is farthest removed from attempted portraiture of external nature." In an editorial "On Art and Nature," distinguishing Art from the mere "mechanical reproduction of Nature, Photography"—that "temporary and second-rate mistress"—Selwyn Image declared: "But Art does not wish to be the mirror and facsimile and very counterpart of Nature; she wishes to make her own creations in her own way." Design, he said in a later article, "the inventive arrangement of abstract lines and masses in such a relation to one another, that they form an harmonious whole," is the most interesting element in any art.[33]

Charles Shannon and Charles Ricketts, trained as engravers in the last years of utility as aim, began an occasional art periodical, the *Dial*, in 1889. Their work as illustrators rapidly abandoned the realistic and conventional for distortion and decoration. After they took over the design and illustration of works by Wilde and illus-

trated two transitional volumes distributed by Lane, *Hero and Lean-der* and *Daphnis and Chloe,* Ricketts inaugurated the Vale Press, for which he designed the covers and three fonts of type, cut on the wood the initials and the borders of the first opening (in lieu of title page), and joined Shannon and their disciple Sturge Moore in the illustrations.[34] Lucien and Esther Pissarro did even more delicate work, using at first Ricketts's Vale type, for their Eragny Press. The prototype for the private presses of the 1890s was Morris's Kelmscott Press of 1891–1898, but Ricketts had created aesthetic sensations in 1891–1894 with Wilde's books and the cover and elongated format of John Gray's *Silverpoints.* In 1891 he had designed an art nouveau cover for *Tess of the d'Urbervilles* and imitated in the typography Whistler's asymmetrical layout for *The Gentle Art of Making Enemies* of 1890.[35] Hardy was so taken with this artiness that all his books, previous and to come, were issued with similar typography (and a medallion on the covers) by Ricketts. Theodore DeVinne and other sober students of type complained that Ricketts did arty tricks to make a page surprising rather than legible.

Although few could maintain absolute purity, wood-engravers and other artists committed to anti-industrial handicraft tried to avoid as many aids from machinery as possible. Arguing as Blake had that invention and execution were not separable, they scorned such use as Beardsley's of photomechanical relief blocks (line-block) or other methods related to photo-engraving or "process."[36] It was at least in part reaction against photographic realism that produced ghost tales such as E. G. Swain's *The Man with the Roller,* in which a figure moving across an enlarged photograph of an old vicarage turns out to be a sixteenth-century murderer condemned to roll forever the lawn where he buried his victim. The average photograph was not telling the whole truth. H. G. Wells played similarly with "Certain First Principles" of physics, as in *The Invisible Man* of 1897.

J. H. Buckley has pointed out that even Gissing's *New Grub Street,* sometimes thought a manifesto of English naturalism, with mean streets and dreary lodgings, "concerns itself with the artist, the medium, and the artistic act; it is essentially a novel about novelists and the writing of novels."[37] Gissing packs several meanings into the title of *The Odd Women,* and arranges the chapters so

that their titles will be ironic with reference to some of the characters, a method embryonic in *Middlemarch* and venerable in the novels of Sartre.

Out of the crafts movement came Art Nouveau, the first style in Victorian Britain not imitative of some earlier period.[38] Nearly everything between Biedermeier and modernism has been called Art Nouveau, but it can be identified more narrowly by "the asymmetrically undulating line terminating in a whiplike energy-laden movement."[39] The distinguishing curvilinear forms, smoothing the aberrations from organic plants, proclaimed simultaneously a respect for nature and the aesthetic inadequacy of nature. The Nouveauists, like idealists before them, subjected natural vegetation to correction. C. F. A. Voysey, an architect prominent in the movement, explained in 1893 with wallpaper as an example: "If the form be sufficiently conventionalised the mutilation is not felt; a real bird with his head cut off is an unpleasant sight, so is a rose that has lost half an inch of its petals; but if the bird is a crude symbol and his facsimile occurs complete within ten and a half inches' distance, although one may have lost a portion of its body, it does not violate my feelings."[40]

Although Art Nouveau flamed rapidly across Europe, its sources and earliest manifestations were British. Walter Crane's earliest designs identified and frequently reproduced as illustrations of Art Nouveau added only rhythmic repetition to their sources in Blake. Rossetti, Morris, Burne-Jones, the serpentine movements of the dancer Loie Fuller, Botticelli, Japanese prints, and even Piranesi have been seen as other strong influences.[41] Attention to the last three in Britain did not wait for the 1890s.

Art Nouveau, like most arts, was urban. In London it came to be associated particularly with Liberty's, as in New York with Louis Tiffany. The literature of the aesthetic movement concerned itself with the city, especially with its life after dark. Swinburne, an early promoter of Baudelaire and Whitman in England, had merely populated pastoral landscapes with satyrs and pagan sadists, but James Thomson had published *The City of Dreadful Night* in 1874; by the 1890s urban subjects surpassed the rural, certainly the pastoral, in poetry and painting. Arthur Symons followed Swinburne, but led a host of other poets, in acknowledging debts to Baudelaire.

He declared Verlaine's poetry typically modern, "a perverse, self-scrutinizing, troubled art of sensation and nerves."[42] There is no need to rehearse details. Le Gallienne's *A Ballad of London* says nearly half of what was said:

> From out corruption of their woe
> Springs this bright flower that charms us so,
> Men die and rot deep out of sight
> To keep this jungle-flower bright.

Large numbers of ordinary people moved from London to the sub-urbs in search of normality.[43]

The conversion of nature into rhythmic forms links Art Nouveau to interchanges among the arts common in the period. When nature and life were renounced in favor of form, the arts began to draw blood—sometimes only a vaporous lymph—from one another. All arts aspired to the condition of music on the theory that musical content could not be divorced from form. Often the interchange began, and sometimes it ended, in the title. Borrowing from Paris, Whistler led the way in London. He renamed "The White Girl" of 1862 (now in the National Gallery, Washington) "Symphony in White, No. 1." A satirical piece in *Punch*, 22 September 1877, was called "A Symphony in Blue, or, Pessimism a la Mode." An indirectly confessional "fantasia" by John Addington Symonds, including seven poems beginning "A symphony of blues and white," with the variants "blues and brown," "pink and blue," and so on, was collected in a book with an Art Nouveau cover by Ricketts under the title of the fantasia, *In the Key of Blue*. From Chopin, the title "Nocturne" was appropriated by Whistler and by many poets.

A poem could be called "Chanson sans Paroles" or "Impression" or "Pastel," or named for a color, "Yellow" or "Green" or "Rose and Lavender." The significance of "Impression" was not a more exacting fidelity to the way the eye sees ordinary life, but fleeting, Paterian moments; most poems with "Impression" as whole or part of the title were deliberately monochromatic, yellow or the Whistlerian, crepuscular grey of jaded revelers creeping to their rooms at dawn.

John Gray's *Silverpoints* took from printmaking a title to suggest delicacy in the poems—a fine grey line, providing a fittingly sub-

dued pun on the poet's name; the cover by Ricketts continues the point of delicacy, flame-like leaves over "thin lines of silvery gold, upon a pale green ground."[44] Michael Field's *Sight and Song* of 1892, appealing for authority to Flaubert rather than to Rossetti, aimed in thirty-one poems on thirty-one paintings "to translate into verse what the lines and colours of certain chosen pictures sing in themselves." Pater's general as well as particular influence was tacitly acknowledged in *La Gioconda*:

> Historic, side-long, implicating eyes;
> A smile of velvet's lustre on the cheek;
> Calm lips the smile leads upward; hand that lies
> Glowing and soft, the patience in its rest
> Of cruelty that waits and doth not seek
> For prey; a dusky forehead and a breast
> Where twilight touches ripeness amorously:
> Behind her, crystal rocks, a sea and skies
> Of evanescent blue on cloud and creek;
> Landscape that shines suppressive of its zest
> For those vicissitudes by which men die.

For interfusion of arts, Richard Wagner came first to mind. He was mentioned often for advances in theater, usually with a reference to the synesthesia of *Gesamtkunstwerk*. Lizst's ambition to make music an intellectual art had joined Wagner's. Interfusion of the arts in London of the 1890s was notable largely for its self-consciousness. Erasmus Darwin had been fascinated by experiments toward a "melody of colours," a "luminous music."[45] In Loutherbourg's Eidophusikon color, light, movement, sound, aroma, and (from the splashing of water from a shipwreck) touch had met to produce illusion for the audience. Pater had sought ways to pour diaphanous arts onto the page in chromatic phrasing. Herbert Herkomer, Slade Professor at Oxford 1885–1894, intrigued by the color-organ, produced more than twenty seasons of pictorial-musical plays at Bushey.[46] E. M. Forster was to have Margaret Schlegel complain at length, in *Howards End,* of the absurd confusion of the arts instigated by Wagner: "If Monet's really Debussy, and Debussy's really Monet, neither gentleman is worth his salt— that's my opinion."

Besides aspiring to pure form, the suitors of interfusion hoped to achieve contact with a deeper world than that of the realists, as proposed in Baudelaire's theory of correspondences. By suggestion rather than denotation or rhetoric—to name is to destroy, said Mallarmé—the symbolists sought to convey to a select audience a reality told of in writings on the occult and achieved by the living, if at all, through ritual magic or dreams. In Paris, Joséphin Péledan propagated to painters and poets, and to a select public through exhibitions, the doctrines of Rose + Croix. Symons mentions in *The Symbolist Movement in Literature* the occult in Villiers de l'Isle Adam's *Axël*; he must have known more than he revealed of Mallarmé's Rosicrucian sources. Others adopted from the French symbolists belief "in the image as a radiant truth out of space and time, and in the necessary isolation or estrangement of men who can perceive it."[47]

Yeats was much taken with a production of *Axël* that he saw in Paris in 1894. He hardly needed stimulus toward the occult, but he strenuously sought models that would defy realism on the stage. By 1896 he was certain that poetic drama required "only a symbolic or decorative setting"; in 1899 he asked for simplicity with no distractions, not even Beerbohm Tree's "memorable birds that sing by machinery."[48] As the plays of Maeterlinck were in the process of convincing aesthetes everywhere, *Axël* carried far more argumentative baggage than needed for a symbolic work. Although Ibsen was commended by William Archer as a naturalist, critics joined playwrights in unease over theatrical illusion. Where a drama critic of 1844 called for "the physically real," critics of the 1870s began to lament that daily life was encountered repetitiously on the stage; in 1881 Clement Scott qualified his praise for stage realism: the last act of a play by George Sims was "all too real, too painful, too smeared with the dirt of London life."[49] A decade later, Symons was praising Gordon Craig for opposing illusion with screens that take the audience "beyond reality; he replaces the pattern of the thing itself by the pattern which that thing evokes in his mind, the symbol of the thing." It would seem that much bad painting by symbolists, weak in design, resulted from belief that anything was better than realism and the clumsiest nightmare better than most reality.[50]

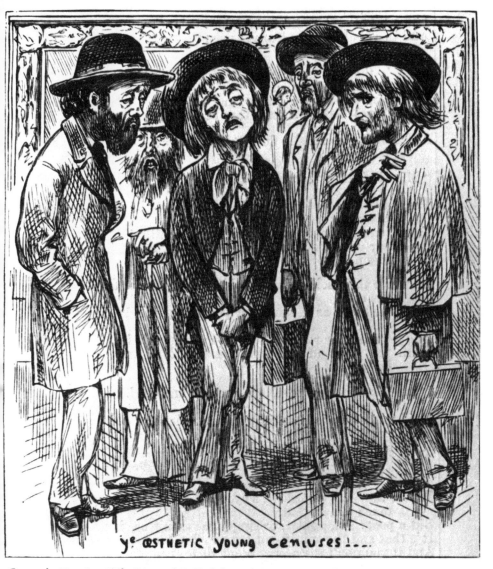

*George du Maurier, "The Rise and Fall of the Jack Sprats: Ye Aesthetic Young Geniuses," 1878. Du Maurier's cartoons established the aesthetic type familiar a few years later from Wilde, Patience,* and many imitators. *In the running text, the "simple-minded young painter" Sprat and his beautiful wife climbed in society until replaced by the arrival of an American sculptor, Pygmalion F. Minnow, with his wife, Galatea.*

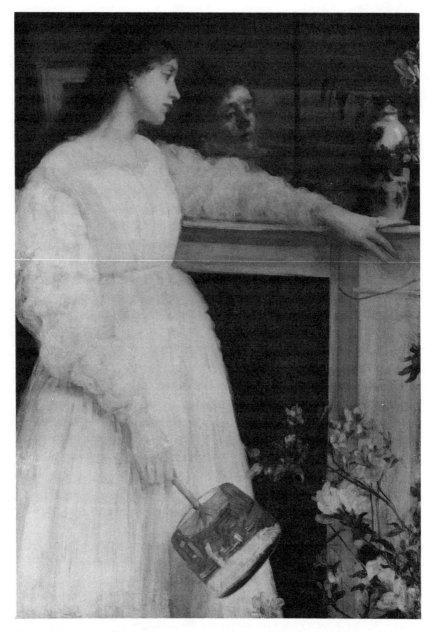

*James Abbott McNeill Whistler,* The Little White Girl: Symphony in White, No. 2, 1864. *In the fan and blue china, an acknowledgment of influence from Japanese prints made even more overtly in* Caprice in Purple and Gold, No. 2: The Golden Screen, *also of 1864, in the Freer Gallery, Washington.*

*Cover of* Parables from Nature, *by Margaret Gatty, 1861–1865. In a typical mid-century manner for gift books, gold-stamped cloth, deeply embossed.*

*Revolutionary design by Dante Gabriel Rossetti for the covers of poems by his sister Christina Rossetti, 1862, 1866, and later.*

*Charles Ricketts, proof for endpapers of Oscar Wilde,* Poems, *1892. An early and highly influential art nouveau design. A similar design, without the doves, was gold-stamped on the front and back covers of the volume.*

The ordering of movement in dance became a frequently evoked emblem of the new approaches to life. Dancers in the music hall became the logogram of the city, as in *The Music-hall* by Theodore Wratislaw:

> The curtain on the grouping dancers falls,
> The heaven of colour has vanished from our eyes;

or the greater melancholy of *The Harlot's House* by Wilde, in which the dancers to a Strauss waltz are marionettes, puppets:

> Like wire-pulled automatons,
> Slim silhouetted skeletons
> Went sliding through the slow quadrille.

Dreaming at sixty of a certain "Ledean body" in earlier years, Yeats would ask, "How can we know the dancer from the dance?" In a "half-dream" of 1896, in *Rosa Alchemica,* a voice cried to him:

> "Into the dance, there is none that can be spared out of the dance; into the dance, into the dance, that the gods may make them bodies out of the substance of our hearts"; and before I could answer, a mysterious wave of passion, that seemed like the soul of the dance moving within our souls, took hold of me and I was swept, neither consenting nor refusing, into the midst.[51]

Symons wrote in *The Dome*:

> The dance is life, animal life, having its own way passionately . . . From the first it has mimed the instincts . . . The dance, then, is art because it is doubly nature; and if nature, as we are told, is sinful, it is doubly sinful . . . Acceptance of the instincts . . . is precisely what gives dancing its pre-eminence among the more than imitative arts.

In *Parsifal* at Bayreuth as in dance, he goes on to say, "there is none of that unintelligent haphazard known as being 'natural.' "[52] Nobody at mid-century could have spoken of "the *more than* imitative arts." Havelock Ellis, who identified the forward dance of the times with Ibsen, Tolstoy, and Huysmans in *The New Spirit* of 1890,

would sanctify formal movement in *The Dance of Life* of 1923. Images of Salome in the 1880s and 1890s sometimes have her dancing not only in seven veils but through the frosts and floods of life.[53]

Roman Catholic ritual seems to have been attractive to aesthetes in England as a concentrated form of the dance of life. Although aestheticism was in certain ways an intellectualization of art, it fled from Protestant rationalization of religion. The impressive number of conversions when near death suggests that the Catholic Church seemed not only ready with beautiful formulas but also especially equipped to meet the need for forgiveness.

Poets and essayists of the time boasted of artificiality as deceit. Masks and makeup were applied, one might say smeared, throughout the lyrics of poets who contributed to *The Yellow Book, The Savoy, The Dome,* and *The Butterfly.* Beerbohm, a dandy who seldom removed his tongue from his cheek, published in *The Yellow Book* "A Defence of Cosmetics," in which he announced the death of the Victorian age, that time gone by when one could "see woman under the direct influence of Nature," with the face "a mere vulgar index of character or emotion." It was not until Gordon Craig founded his magazine on the art of the theater, *The Mask,* in 1908, that Yeats began to use masks in his own plays, but it was out of the aesthetic and the occult of the late 1880s that Yeats derived his doctrine of masks assumed by individuals and nations. Masks, however primitive, are of human artifice. John Gloag's protests against Victorian disguise of buildings and objects of everyday use as other than the material conveniences they actually were do not apply to the masks of the nineties, which were paraded as masks.

The unnatural entered the aesthetic movement through insistence that it was natural. A character in *Mademoiselle de Maupin* had argued that a beautiful body should be cherished because it would be sacrilegious to injure or scorn God's work. Melville is ironic in having Vere, in *Billy Budd,* choose intellect, the head, over nature, the heart, but Flaubert declares the artist a monstrosity, something outside nature, as a way of justifying avoidance of the natural. Symons, in vindication of Verlaine in *The Symbolist Movement,* pursued the implications: "The artist, it cannot be too clearly understood, has no more part in society than a monk in domestic life: he cannot

be judged by its rules, he can be neither praised nor blamed for his acceptance or rejection of its conventions. Social rules are made by normal people for normal people, and the man of genius is fundamentally abnormal." A century later, it could be argued again that decadents reported what was natural: "Decadent artists . . . were Realists, artists whose primary concern was to depict those aspects of human nature, human behaviour or of society that convention suppressed or ignored."[54] Street has the figure representing Wilde in *The Green Carnation* take the tack that the word "unnatural" is used so loosely it is meaningless. A child who hates his mother is unnatural, but then a "man is unnatural if he never falls in love with a woman," and a "boy is unnatural if he prefers looking at pictures to playing cricket": "Branwell Brontë died standing up, and the world has looked upon him as a blasphemer ever since."

What the Victorians called natural conduct Nietzsche called a combination of the natural, meaning the merciless, the greedy, the insatiable, and the murderous, and the pitiful attempt of Christianity to control the natural with groveling humility and pity. The resultant catastrophe could be negated by a dialectical movement beyond good and evil. There is little evidence that London needed or used for its own decadence Nietzsche's arguments that Jesus, God, humanism, history, and all objective certainty were dead and could be buried in one grave. John Davidson and other avowed disciples in England extracted the one point of the *Übermensch:* fulfillment of desire in individual expression.

By the mid 1880s London shared with Paris a sense of *fin de siècle,* what Hardy would call the "Century's corpse outleant." Jean Pierrot has explained the logic by which the aesthetic turned decadent:

> Nature, far from being the attentive and responsive witness conceived by the romantics, is an unfeeling and pitiless mechanism. The best thing for us to do therefore, surrounded by such anguish and sadness, though not without a certain feeling of guilt, is to attempt to escape from that nature, to reject the biological laws of our species as far as is possible, and to hold ourselves aloof from society. Influenced by this conception of life, artists were to shut themselves away inside their inner worlds, straining to perceive the slightest tremor from their secret depths, often terrified by the strange or monstrous feel-

ings that could suddenly erupt into the light of day; and in this anguished quest many were to discover, even before Freud, the realities of the unconscious. They were to seek for escape from the boredom and banality of everyday life through exquisite refinements of sensation.[55]

Arthur O'Shaughnessy, who died in 1881, had anticipated many of the devices and subjects of the decadents: lush detail, eroticism, werewolves, necrophilia, femmes fatales, Cleopatra, "The Daughter of Herodias," severity of form from the Parnassiens. Some of the macabre in O'Shaughnessy came by way of Browning (the lover in "A Troth for Eternity" stabs an adulterous heart as "the only way to keep her mine"), but his poem "To a Young Murderess" could be quoted by Mario Praz as a prime example of romantic agony. A herpetologist by profession, O'Shaughnessy drew on Swinburne, Baudelaire, and Gautier to perceive music-makers as "World-losers and world-forsakers."

Max Nordau, in *Degeneration,* found decadent almost every figure in the arts. In a "Ballade" in memory of Théodore de Banville, Edmund Gosse exempted the Parnassiens:

> One ballade more before we say good-night,
>   O dying Muse, one mournful ballade more!
> Then let the new men fall to their delight,
>   The Impressionist, the Decadent, a score
>   Of other fresh fanatics, who adore
> Quaint demons, and disdain thy golden shrine;
> Ah! faded goddess, thou wert held divine
>   When we were young!

Critics recommending health often found sickness in the realism of Hubert Crackanthorpe, *Wreckage* (1893); Arthur Morrison, *Tales of Mean Streets* (1894); and Ella d'Arcy, *Monochromes* (1895) and *Modern Instances* (1898). Vernon Lee (Violet Paget), noting perhaps the subduing of Swinburne, made a false prophecy in 1884: "It was beginning to be obvious, to every one who was not an aesthete, that the reign of the mysterious evil passions, of the half-antique, half-medieval ladies of saturnine beauty and bloodthirsty voluptuousness, of the demigods and heroes treated like the figures in a piece of

tapestry, must be coming to a close; and that a return to nature must be preparing."[56]

In North America, the architect Ralph Adams Cram chose as a title for his defense of aestheticism in 1893 *The Decadent: Being the Gospel of Inaction.* Jerome Buckley has drawn a line between the high Victorians, who warned of the acceleration of decadence in the society, and the decadents, who chose inaction from indifference to the fate of society.[57] Arthur Symons in 1893 described decadence as excessive attention to style rather than to content, decorative elaboration in style, a morbid subtlety in analysis, a morbid curiosity concerning form, "oversubtilising refinement upon refinement, a spiritual and moral perversity." This particular analysis, among several by Symons, closely follows Gautier's assessment of Baudelaire, quoted by Ellis in *The New Spirit* as particularly applicable to Huysmans. The bible of such decadence was Huysmans's aesthetic novel *À rebours,* a title appropriately translated as *Against Nature.* In Le Gallienne's account, the typical decadent "sips his absinthe (with a charmingly boyish sense of sin) and reads Huysmans."

Beerbohm wrote in 1896 that he had tried in his already-famous essay of 1894 on cosmetics to travesty "paradox and marivaudage, lassitude, love of horror and all unusual things, a love of argot and archaism and the mysteries of style." The aesthetic creed made art independent of matter; decadents chose matter that would test the creed.[58]

Claims that decadence was natural gave way to defiance.[59] Baudelaire had said it: you, hypocrite reader, are like me. Baudelaire and Pater had said that all beauty carried a degree of strangeness; decadents attempted to show that any creature sufficiently strange was beautiful. Putridity, dung, and leprous flowers entered lyric poems stylishly. In the artful *Confessions of a Young Man* (1888), George Moore had told of tying up a guinea pig in order to watch his superb pet python, Jack, starved for two months, strike, "and with what exquisite gourmandise he lubricates and swallows!" Upon meeting Maurice Rollinat in Paris in 1883, Wilde learned that French decadents had surpassed his *Charmides* in the artfulness of necrophilia. Beardsley, in his naughty story of Tannhauser, begun in the *Savoy* as *Under the Hill,* described unnatural conduct in a

delicately unnatural style; the wind, in Chapter 9, was "as fresh and pastoral as a perfect fifth." With pathetic fallacies admired for their fallacy, Dowson could write of "sinister, sad skies." (On the next page of the *Savoy*, Yeats wrote of "the transmutation of life into art".) The strain after evil in art could be unintentionally comic, as in William T. Horton's illustrations of the Bible,[60] or insidiously communicable as in the sick Art Nouveau decorations of Evelyn Waugh's friend Francis Crease. The devout and the hedonist agreed that without sex, no marriage: without sex, no future generations, or without sex, no fun. For the committed decadent, without sex, no—or insufficient—torment. Ellmann's biography of Wilde mentions Sadism only to say that Wilde would have noticed it in *La Faustine* by Edmond de Goncourt, but Praz did not exaggerate its pervasiveness. The adage that art could not be immoral was tested over the hottest flame discoverable.

Misogyny, a great deal of it homosexual mysogyny, accounts only in part for the pervasiveness of the femme fatale. John Gray does not mean to be friendly to women, but he does not reject sado-masochism out of hand:

> And those whose breasts for scapulars are fain
> Nurse under their long robes the cruel thong.

When Pater describes the *Medusa* attributed to Leonardo he assumes Leonardo's homoeroticism, but he also means what he says, "the fascination of corruption penetrates in every touch its exquisitely finished beauty." Despite a few images of diseased, syphilitic femininity, the femmes fatales Lilith, Eve, Delilah, Judith, Jezebel, Herodias, Salome, mermaids, sphinxes, and vampires were for the most part beautifully and fashionably evil in Britain and Western Europe until after 1900.[62] The woman who effectively "caresses with a poisoned hand" must needs be irresistible, whether bejeweled, nude, or as in some of Moreau's images of Salome, both. Hair was a symbol of beauty and all aspects of sex, not solely of tresses for strangling. The two women who made up Michael Field exercised the mode of the femme fatale with as much energy as (the vindictive) Romaine Brooks later. The speaker in Mary Elizabeth Coleridge's little poem "The Witch" is a Christabel whose hearth

has been dark since she lifted over the threshold one whose "voice was the voice that women have/Who plead for their heart's desire." The "Lady of the Hills with crimes untold" who follows the feet of Theodore Watts-Dunton is burrowed from decadence to represent his own departures from Christian faith.

After Burne-Jones and Moreau, the femme fatale often, like other painted women, showed herself in an androgynous body. If Rubens's women bulged with nature, what was now in vogue was a svelte departure from nature, much as Henry James turned his back on the baggy monsters of Thackeray. If the unnatural had a special appeal for the consciously decadent, it should be kept in mind that literature has traditionally shown an interest in adultery rather than in those saints born so saintly they needed no conversion from sin; depiction of dangerous lust is not basically different from the focus on fires, floods, fraud, murder, rape, and disease in the daily entertainment called "news."

The new assertiveness of women undoubtedly gave homoerotic males an easier target. More to be noted than the number of men who supported feminist causes is that satirists who tried to limit their gains and judges ready to sentence them to prison showed a clear comprehension of what the "odd" or surplus women were saying. In 1872 Edward Jenkins, the author of *Lord Bantam: A Satire* (and earlier of *Ginx's Baby*), simply could not conceive of a future for any woman who "once oversteps the bounds of prudery," and found incomprehensible the argument that a large family "tended to the degradation of woman, since they involved on her part the sacrifice of freedom and placed her in a position of which men could take advantage to keep her in subjection." Although Hardy was baffled by his own Sue Bridehead, the "new woman" was understood as a type, if not as an individual, equally in the pages of *Punch* and on stage. A single fact would account for much of the self-consciousness: since 1801 the population of Britain had grown from ten to forty million.

That increase might contribute a little to understanding why the most fatal of women had become Nature. Moreau's *Oedipus and the Sphinx,* more than a female slaughtering centuries of males, is nature at enmity with human intellect. That Nature beguiles and destroys does not have to mean that Nature beguiles in order to

destroy. For decadents, Nature has become the City; urban existence is both the worst way to live and the only way. Le Gallienne is drawn to "Beauty Accurst" even as he seems to denounce it; he is drawn almost as much as Symons to "Circe Paris" and chimera London. The city as a dangerous woman served decadent poets and painters as sailing ships served Conrad, whose Jasper in "Freya of the Seven Seas" feels in his vessel the "swelling outlines of the hills, the curves of a coast, the free sinuosities of a river"; that is, Freya, taken from him forever. In "The Brute" of 1908 Conrad shows that females can have the devil in them, and a manmade ship can be as balky as Nature.

The weariness of *fin-de-siècle* presumably allowed hope for the new century. Demonic attention to form and style, however, *decadence,* said farewell to a civilization, sought and found an analogy with the decline of Greece and the perversities of late Roman luxury. In the dedication of *The Man Who Was Thursday* (1908), cheerful Chesterton announced an end to "Lust that had lost its laughter, fear that had lost its shame," in that decade when "A cloud was on the mind of man, and wailing went the weather," when "aimless gloom" was relieved only by Whistler's white forelock.

The editor of the *Yellow Book* was an American born in St. Petersburg, as if he were trying to outdo James Abbott McNeill Whistler, an American whose parents had moved him to St. Petersburg at the age of nine. Whistler, hard to outdo, had contrived to be the first cynosure, if not quite the omphalos, of the aesthetic movement in London. Robert Buchanan had successfully cowed Rossetti with "The Fleshly School of Poetry" and cowed Swinburne after a further victory in court; Ruskin had embarrassed but not subdued Whistler by declaring of *Nocturne in Black and Gold: The Falling Rocket* that he "never expected to hear a coxcomb ask two hundred guineas for flinging a pot of paint in the public's face," and then in court getting enough aid from Burne-Jones, Frith, and other artists to have the damage to Whistler's reputation assessed by judge and jury at one farthing. Here was Philistine revenge first against the fleshly and then against the fleshless school of painting.[63]

In Paris in the 1850s, studying art, meeting Baudelaire and Murger (of *Scènes de la vie de Bohème*), and perfecting his already

distinctively aesthetic dress, Whistler had strengthened a conviction that art could and should be free of moral concerns. His *Symphony in White No. 2: The Little White Girl* won a tribute from Swinburne:

> White rose in red rose-garden
>  Is not so white.

George Moore detected in this painting "a poetic interest" not elsewhere evident in Whistler's work; in truth, he saw there *The Lady of Shalott*: "She sees in her dream the world like passing shadows thrown on an illuminated cloth."[64]

In the short piece called "The Red Rag" in the *World,* 1878, Whistler began to campaign with words:

> My picture of a "Harmony in Grey and Gold" is an illustration of my meaning—a snow scene with a single black figure and a lighted tavern. I care nothing for the past, present, or future of the black figure, placed there because the black was wanted at that spot . . . Art should be independent of all clap-trap—should stand alone, and appeal to the artistic sense of eye or ear, without confounding this with emotions entirely foreign to it, as devotion, pity, love, patriotism, and the like. All these have no kind of concern with it and that is why I insist on calling my works "arrangements" and "harmonies."

The public had no reason to care that the figure in *Arrangement in Grey and Black* was his mother.[65]

In *The Gentle Art of Making Enemies* Whistler made quotation from his critics a form of satire: "They say very little to the mind." "The work does not feel much." "It is not the Venice of a maiden's fancies." "He is never literary." "Subjects unimportant in themselves." And from his erstwhile disciple and friend, Oscar Wilde: "Popularity is the only insult that has not yet been offered to Mr. Whistler."

Insisting that Wilde and others were stealing attention by plagiarizing his aesthetic doctrines, Whistler put on a show to reiterate his own position in the "Ten O'Clock Lecture" of 1885— London in February, Cambridge in March, Oxford in April: Art is dainty and reticent, "purposing in no way to better others."

> To say to the painter, that Nature is to be taken as she is, is to say to the player, that he may sit on the piano.
>
> That Nature is always right, is an assertion, artistically, as untrue, as it is one whose truth is universally taken for granted. Nature is very rarely right, to such an extent even, that it might almost be said that Nature is usually wrong: that is to say, the condition of things that shall bring about the perfection of harmony worthy a picture is rare, and not common at all.[66]

More vehemently, Whistler protested that the aesthetic posing satirized in *Patience* had become commonplace. His saying that nature was universally regarded as always right was a rhetorical ploy to make his aestheticism sound still revolutionary and repellent. From the midst of the vulgar, he complained, "the Dilettante stalks abroad. The amateur is loosed. The voice of the aesthete is heard in the land, and catastrophe is upon us." The aesthetes acted as if they did not believe nature right, but they made that error in actuality.

In a later perspective, it might seem that Whistler shared the aesthetes' contradiction between rejection of subject and acceptance of subject as irreplaceable. Whistler has even made it into Richard D. Altick's *Paintings from Books: Art and Literature in Britain, 1760–1900*: "One additional link between Scott and the painters of the Pre-Raphaelite–Aesthetic school was James McNeill Whistler's *Arrangement in Yellow and Gray: Effie Deans* (1876)." Whistler's distinction between subject and "subject" is made clear by George Moore:

> It was not until the end of the eighteenth century that the subject really began to make itself felt, and, like the potato blight or phylloxera, it soon became clear that it had come to stay . . . For more than a hundred years painting has been in service. She has acted as a sort of handmaiden to literature, her mission being to make clear to the casual and the unlettered what the lettered had already understood and enjoyed in a more erudite form.[67]

A "subject" was the equivalent of a scene in a play.

Early in the twentieth century Clive Bell, with the doctrine of significant form, and later his more eclectic friend Roger Fry,

seemed to advance beyond Whistler and the yellow nineties in attributing insignificance to subject. Another half-century, and Wilde can be seen to anticipate the end of the line more perceptively than Bell and Fry, although Harold Bloom is unique or near it in acknowledging direct descent. "Life," Wilde tried to assure Degas, "is made not with ideas, but with words."[68]

Wilde's aesthetic doctrines solidified in essays of 1889–1890, as revised for *Intentions* (1891). He had taught the Americans by paradox that art did not need to be useless as ornament had been in 1851. Now he found it possible to invert that paradox by turning only ninety degrees.

In "The Decay of Lying," a Socratic dialogue published in the *Nineteenth Century* of January 1889, Wilde lamented the search by realism for facts, on the grounds that all facts depend upon art for the way we see them. It was from Impressionist paintings, he said, that Londoners discovered "those wonderful brown fogs that come creeping down our streets." He gave anecdotal examples of life imitating art. A tourist who went in search of the land created by Hokusai would discover that "the whole of Japan is a pure invention. There is no such country, there are no such people." Zola was the essence of the decay of creative departure from illusion. The essayist's "final revelation" is that "Lying, the telling of beautiful untrue things, is the proper aim of Art." Dialogue served as mask. The author could deny adherence to any opinion expressed, as when Vivyan says to the innocent Cyril, "My dear fellow, I am prepared to prove anything."

In the essay "Pen, Pencil, and Poison," also published in January 1889, but in the *Fortnightly,* another general forum of opinion, Wilde took up the subject that Thomas De Quincey had called "Murder Considered as One of the Fine Arts." De Quincey's colleague Thomas Griffiths Wainewright first took up painting. "It was not until much later that he sought to find expression by pen or poison."

> He had that curious love of green, which in individuals is always the sign of a subtle artistic temperament, and in nations is said to denote a laxity, if not a decadence of morals. Like Baudelaire he was extremely fond of cats, and with

> Gautier, he was fascinated by that "sweet marble monster" of
> both sexes that we can still see at Florence and in the Louvre.

We are still too close to Wainewright, wrote Wilde, to avoid moral
twinges over his subtle acts of poisoning, but time will effect a cure,
as it has with Nero, Tiberius, and Cesare Borgia. "They have passed
into the sphere of art and science, and neither art nor science knows
anything of moral approval or disapproval."

A longer essay of Wilde's of 1890, "The Critic as Artist," again
cast in the form of a dialogue as a step toward disclaiming didactic
purpose in his own voice, bristles with aphorisms directed against
belief in the morality of art and against the subordination of art to
life:

> Don't let us go to life for our fulfilment or our experience. It is
> a thing narrowed by circumstances, incoherent in its utter-
> ance, and without fine correspondence of form and spirit . . .
>     Action . . . is the last resource of those who know not how
> to dream.
>     . . . the highest Criticism, being the purest form of personal
> impression, is in its way more creative than creation, as it has
> least reference to any standard external to itself, and is, in fact,
> its own reason for existing . . . Certainly, it is never tramelled
> by any shackles of verisimilitude [or] ignoble considerations of
> probability.

Criticism recognizes no position as final.

The straight man in this dialogue, with the disabling name of
Ernest, seems to predict much deconstructive criticism and many
Freudianistic biographies when he summarizes: "you have told me
that all Art is immoral, and all thought dangerous; that criticism is
more creative than creation, and that the highest criticism is that
which reveals in the work of Art what the artist had not put there;
that it is exactly because a man cannot do a thing that he is the
proper judge of it; and that the true critic is unfair, insincere, and
not rational."

Whistler embodied the antiheroism of the aesthetic movement.
Wilde, whose hedonism included pleasure in recklessness, wished
to attract attention as a hero in the attack on heroism. In "The

Critic as Artist" he set against Victorian fertility "beautiful sterile emotions"; he wandered into contradictions in the cause of Hellenism and for the sake of paradox and half-revelation:

> What is termed Sin is an essential element of progress. Without it the world would stagnate, or grow old, or become colourless. By its curiosity Sin increases the experience of the race. Through its intensified assertion of individualism, it saves us from monotony of type . . . It is well for our vanity that we slay the criminal, for if we suffered him to live he might show us what we had gained by his crime.[69]

Wilde was never more ingenuous than when in *The Soul of Man under Socialism* he praised socialism for promoting individualism by making personal charity uninviting. Ellmann's *Eminent Domain* and his biography of Wilde show the essential Wilde emerging in his paradoxical parables, taken by his hearers as impromptu, recommending a new morality and a revolutionary but undefined religion.

Hichens and Street had tried to make personal revelations without provoking suits for libel. Pearl Craigie's *The Gods, Some Mortals and Lord Wickenham* argued that the essential Wilde was not a threat to society but a disease already epidemic:

> Anne had the modern taste for the elaborate and meretricious; for that voluptuousness of environment, which supplies in substance what the enervated men and women of this century vainly strive to extract from their fatigued senses . . . The love for the sham picturesque, for arranging tricks of light and shade and colour, for striking unusual attitudes, inventing discords, combining antagonistic colours, twisting a false knowledge of Nature into a falser presentment of life—all this is not an affectation confined to any small group of idle women, but it is the manner in art, literature, and society of modern London, modern Paris, and modern New York.[70]

Accurate though Craigie's assessment of the general malaise may be—in the title taken from Keats for J. E. Chamberlin's study of the period, *Ripe Was the Drowsy Hour*—Wilde as iconoclast wished to be noted for special mischief.

He achieved this aim in *Salomé*. The beheading of John the

Baptist had been a continuous subject in literature and art through-
out the nineteenth century. Henri Regnault had made his 1870
picture of a peasant holding a basin astoundingly celebrated (it is
now in the Metropolitan Museum) by renaming it *Salomé*. Heine,
Keller, Delacroix, and Puvis de Chavannes may be counted among
major figures whose treatments influenced Wilde's play least;
Flaubert, Mallarmé, Moreau, and Huysmans's descriptions of two
of Moreau's works affected him directly.[71] Flaubert's *Salammbô* as a
destructive female in an overripe setting was a force for Wilde both
directly and through French intermediaries. At the beginning of
the second chapter of Flaubert's novel—Wilde would not forget—
Salammbô watches the lovely moon goddess emerging from the
clouds and prays to the radiant image of Tanit. Wilde was indebted
to the historical research, religious ironies, and disposal of principal
characters and conflicting groups (Romans, Syrians, Samaritans,
Jews) in Flaubert's *Hérodias,* and seems to have drawn upon
Flaubert's method of showing all the action through Herod's eyes.

Herodias, the mother, had been denounced by the prophet as an
incestuous adulteress; authors before Wilde had followed the Gos-
pel, Mark 6, to make her, when Herod offered to gratify any wish if
Salome would dance for him, the wicked instigator of Salome's
request for John's head. In 1868, in the *Fortnightly,* Swinburne
swam against the current by describing Andrea del Sarto's Salome,
"a simple virgin, with the cold charm of girlhood and the mobile
charm of childhood; as indifferent and innocent when she stands
before Herodias and when she receives the severed head of John with
her slender and steady hands; a pure bright animal, knowing noth-
ing of man, and of life nothing but instinct and motion." Wilde's
Salomé, who usually answers Herod's long speeches with three or
four monosyllables, seems childishly ingenuous in contrast with the
evil wills that surround her, but when Herod tells her not to listen
to her mother, she answers: "Je n'écoute pas ma mère. C'est pour
mon propre plaisir que je demande la tête d'Iokanaan dans un bassin
d'argent." Triply offended because John has aroused her from vir-
ginal innocence to lust, has called her in consequence harsh names,
and has refused her the kiss she would have, she is childishly deter-
mined to kiss his mouth. What she wants, she gets. (In the replica
of Strauss's opera, she has been called "a teen-age delinquent under

the influence of a discouraging home life.")[72] The simplicity of language throughout the play is sometimes attributed to the limitations of Wilde's French, but it serves at once the simplicity of Salomé's adolescent petulance and the aesthetic stylization of the whole. Wilde has in effect, with ironic force, transferred to the Herodias story the language of *Un Coeur simple,* Flaubert's tale of a servant so self-effacing her mistress has to do her dreaming. All is stylized; each person in Wilde's play is particularized by spoken reaction to the chief character, the moon. Only Herodias has no metaphor; to her the moon is simply the moon. Beardsley's indulgent illustrations include his discovery and revelation that Wilde distributed his scattered personalities among the personae— Salomé, Herodias, Herod, the moon, and the jester who wrote the play.

Kill that woman, says Herod in the final line; the soldiers carry out his order as the curtain—if there is a curtain—falls. Wilde's sympathy with excluded women seems present here. The interpretation of Jane Marcus in the *Bulletin of the New York Public Library* of 1975 deserves thought: Marcus argues that Wilde's Salomé as the New Woman successfully defies Roman and Christian (and brings death to the jealous Syrian); she is the true Messiah.[73] That Wilde insists on her martyrdom in this cause is no embarrassment to the argument.

Laforgue's Salomé, so ecstatically experimenting with John's head that she falls and is engulfed in the sea, gets a further twist in "A Dance of Death" by Michael Field: this Salomé dances in the frost and is engulfed, but her head—not John's—dances on. By report, Wilde told Maeterlinck of a similar ending, with a silver tray on the ice holding Salomé's severed head, a nimbus dancing around it.[74] Salomé is Wilde's view of nature as passion against the restraints of civilization, as self against others. The case in *Dorian Gray* against Narcissism is superseded; again and again in *Salomé* it is said that one should not look at another too much. When asked in court if he adored boys, Wilde answered that he adored no one but himself.

After well-built but aesthetically false public successes in *Lady Windermere's Fan, A Woman of No Importance,* and *An Ideal Husband,* Wilde invented in *The Importance of Being Earnest* the perfect way to

avoid morality in verbal art. *Earnest* approaches pure form as nearly as words have ever been able to do. Melodrama, comedy, and farce are not so much rewritten in *Earnest* as lightly erased. This is Plautus as filtered through Farquhar and Sheridan, with imaginary doubles serving as aesthetic motif of disguise and deceit. Coursing through the center is the farce of the changeling, in the manner of Gilbert and Sullivan. The relation of guardian and ward, frequently copied from Beaumarchais, is reversed: Jack as absurdly young guardian and appropriate suitor frustrated like the Jack of *The Rivals* by acceptance only in disguise. Construction is tight; the seemingly frivolous mention early on of Miss Prism's three-volume novel is a preparation for Act 3. All is chilled artifice. There are a few atrocious puns—a dentist "produces a false impression"—but no warm, damp spots. The dialogue comes near enough to real life problems to alert earnest members of the audience, but always escapes in good taste.

Critics and playgoers who had disparaged Wilde for plagiary now recognized in almost every line some play or type of play not quite present. The opening with Algernon and the servant Lane exploits no confidences for background, but unfolds merely to set the tone. Victorian hypocrisy dissolves under Algernon's flippant remark that servants should set a moral example for the upper classes—uplift for such idle rich as you see congregating on the stage. The audience can try in vain to deplore the materialism of hedonists as Algernon eats all the cucumber sandwiches intended for the always unforgiving Lady Bracknell. The capsizing of familiar plots and adages allows the foreground to be a pattern of repetition with variation and progression; the opening scene anticipates Jack's remark to Algernon: "My dear fellow, the truth isn't quite the sort of thing one tells to a nice, sweet, refined girl." Each of Wilde's comedies had had at least one character whose epigrams turned respectability upside down; he had learned the value of having this role shared by one self-conscious dandy and one dowager or matron who seemed honestly to think her paradoxes truths that preserved the privileges of her class. The heartless Lady Bracknell expresses artificial values that fulfill every convention of a concerned mother.

Jack's remark on shielding the innocent from the truth represents a typical moment in *Earnest*: a character has been cornered and

would be ruined if only bare truth and earnestness were available for reply. In scene after scene crises evaporate as paradoxical epigrams prove the unimportance of being earnest. In *Dorian Gray* and other earlier works persons who had characterized themselves in epigram contributed little to plot or situation; in *Earnest* each situation requires an epigram that will turn anticlimax into climactic surprise. In Act 2 the overly protected Cecily sends the servant to open the door to the nonexistent wicked Ernest Worthing, impersonated, as the audience will soon discover, by Algernon: "I have never met any really wicked person before. I feel rather frightened. I am so afraid he will look just like everyone else." When Algernon enters, "He does."

What's in a name? Everything. Or not quite everything, for pleasure also matters. The two "Ernests" are neither Ernest nor earnest; to be earnest even in attempts to satisfy desire would reduce pleasure.

Among the scores of artists and writers who fled to Paris when Wilde was sentenced—partly, as some thought, for being some sort of creative person acceptable in aesthetic circles—many would have understood the title of the great comedy still playing, but now without Wilde's name on the marquee, as "The Importance of Being a Boy Loved by a Pederast."[75] The desire to live without inhibitions had brought disaster, but Wilde's last, great comedy endures by avoiding the inhibitions and ambivalences that had kept the Dorians and women with fans and of no importance from being the convincing individuals that the stylized speakers of *The Importance of Being Earnest* all are.

Henry James thought he wanted in his fiction only the appearance of morality, but in avoiding the appearance of the amoral he avoided also amorality. His nervousness over aesthetic tendencies had been evident from his first novel, *Roderick Hudson,* begun in 1874. Rowland Mallet, although a lotus-eater, "an awkward mixture of strong moral impulse and restless aesthetic curiosity," collects current art both from sure taste and from the desire to support genuine talent. Roderick, the young sculptor who needs both support and guidance until his reckless, fatal fall in the Alps in the last chapter, is self-indulgent and self-defeating. He turns living Galateas into statues, but is undone by pursuing beauty instead of

art. Early on, he betrays his talent by a secret engagement; he betrays his fiancée through moral vacuity. His author is not one to notice that Roderick is exposed, with evident condemnation, for choosing life rather than art.

In *The Tragic Muse* (1889) full approval is withheld from characters who choose art over politics and over marriage to a diplomat. Aware of an internal conflict between economy of form from Flaubert and earnest assessments of life from Eliot, James gave a glancing blow to his own art in *The Aspern Papers*. His narrator lays claim as literary journalist to a right similar to that exercised in this *nouvelle,* which began from an anecdote about the needy Claire Clairmont. James began each work from a "germ" drawn not just from life, but from lives; he was unwilling to go with the aesthetes in freeing art from its time-honored parasitical relation to life.

In *The Spoils of Poynton,* called in 1895 "The House Beautiful" and in 1896, in the *Atlantic,* "The Old Things," James concentrated years of meditation on beauty conserved for beauty's sake. Mrs. Gereth and her late husband have chosen with infinite care each treasure collected at Poynton from centuries of fine decorative art. The arranged objects mean more to her, possess more of perceived life and bestowed individuality, than any creature of nature could. The plot of the novel unfolds from her fear that her more casual son Owen will let Poynton pass by marriage into the hands of Mona Brigstock. To Mrs. Gereth, Mona is not tasteless in the sense of having poor taste; she is beneath taste. Mona's blue eyes are the only beads she wears. Her voice, to the woman of refinement, is "like the squeeze of a doll's stomach." Owen is malleable, "pointlessly active and pleasantly dull." Poynton can be saved by achieving a marriage of Owen with Fleda Vetch, James's register, "in whose intenser consciousness we shall profitably seek a reflexion of the little drama." Fleda is "intelligent, not distinctively able." She has no dowry; her father collects old match boxes. She agrees readily with Mrs. Gereth that she would give Poynton attention and care beyond Mona's capacity to imagine.

A moment comes when Owen would marry Fleda, move with her into their entirely appropriate country house, Ricks, and leave his mother without worry among the objects at Poynton. Mrs. Gereth's perfection of taste lacks humanity. Pure taste and tastelessness have

met head on with no consideration for others. Fleda, sensitive in the deep sense of sensitivity to the needs and emotions of persons unlike herself, has scruples. An eager player in the game of preserving for Mrs. Gereth the treasures as perfectly arranged at Poynton, she must by her own rules gain nothing for herself. Since to lack humanity is to lack morality, Mrs. Gereth steals from Poynton most of the best loved objects to assuage the pain of banishment to Ricks. In consequence of Fleda's scrupulosity, Mona gets Owen and Poynton; greedy and stubborn, she threatens to break off the marriage unless Owen insists on recovering the spoils from their spiritual owner. To readers less scrupulous than either James or Fleda, who is a poignant case of Jamesian renunciation, Fleda can seem a case rather of self-regarding conscience bringing flagrantly destructive consequences.

After hesitation and delay, Fleda decides to accept Owen's offer of a symbolic piece to be chosen at Poynton by her. On the platform of the Poynton station, with her eyes and throat full of smoke from a mile away, she is convinced by the porter that she should take the next train back to London. Poynton and its possessions have been burning all night; you may well call lost, says the porter, what "ain't really saved." Neither the story nor James's extensive notes accuse either Mrs. Gereth or God; the porter thinks it must have been a clumsy servant that "the old lady" would never have employed. The conflagration in *Jane Eyre* makes future happiness possible; despite a conviction that his Fleda was heroic, James chose to write a story about the fate of a place and its things.

Perfection of taste was not enough. It lacked moral fiber. James came to think of the model for Poynton as the Wallace Collection in Hertford House. Ricks was habitable and "sweet"; Poynton was a museum. To pursue objects with a collector's fervor is to suffer a dehumanizing disease. An author not intent on avoiding melodrama might have burned Mrs. Gereth in the midst of her things. Oscar Wilde was about to be consumed as if in a morally oriented novel. Modernism would be founded in the ashes of the movement reverently incinerated in *The Spoils of Poynton*.

# NOTES

## 1. Nature and Art

1. Ernest Robert Curtius, *European Literature and the Latin Middle Ages*, tr. Willard R. Trask (New York: Pantheon, 1953), pp. 183–202. W. R. Johnson finds in the centrality of Virgil's *Ecloques* to the European tradition of pastoral an explanation of the eclipse of Theocritus: "In Virgil's pastoral world the ordinary becomes the extraordinary, the real becomes the symbolically surreal, the dramatic becomes the lyrical, and danger and disorder become the principles of artistic order . . . In Theocritus, art exists to mirror life; in Virgil, life (or a dim, painful memory of it) exists to serve art." *The Idea of Lyric* (University of California Press, 1982), pp. 162, 169–70.

2. On the context in theory, a good place to begin is Madeleine Doran, *Endeavors of Art* (University of Wisconsin Press, 1954).

3. Jean H. Hagstrum, *The Sister Arts: The Tradition of Literary Pictorialism and English Poetry from Dryden to Gray* (University of Chicago Press, 1958, pp. 82–88. The honesty of literary claims to nature in the sixteenth and seventeenth centuries has been questioned by the "new literary historians," e.g., James Turner, *The Politics of Landscape: Rural Scenery and Society in English Poetry, 1630–1660* (Harvard University Press, 1979).

4. *The Poems of George Chapman*, ed. Phyllis Brooks Bartlett (New York: Modern Language Association, 1941), p. 393.

5. (4th edn., London: Cadell and Davies, 1799), p. 12.

6. As reported by Coleridge's nephew H. N. Coleridge, 25 April 1830, in *Table Talk*, ed. Woodring (Princeton University Press), 1:111. For a representative distinction by Coleridge between active, energetic nature, as in human intelligence *(natura naturans, forma formans)*, and passive, material nature *(natura naturata)*, see *The Friend*, ed. Barbara Rooke, 1:467n, in *The Collected Works of Samuel Taylor Coleridge*, ed. Kathleen Coburn and Bart Winer (Princeton University Press).

7. Friedrich von Schiller, *Naive and Sentimental Poetry and On the Sublime: Two Essays*, tr. Julius A. Elias (New York: Ungar, 1966), p. 103.

8. It has been suggested that Constable's long note to "A Sea-beach: Brighton" in *English Landscape Scenery* (Plate 2 in 1830; Plate 9 in Wilton, 1979) was propaganda for the friend who laid out the Brighton gardens, but the note proceeds from observing that the heavy surf first catches the eye to proclaiming that an unimportant fishing town has rapidly become "one of the largest, most splendid, and gayest places in the kingdom," with much further in this social vein. *John Constable's Discourses*, ed. R. B. Beckett (Ipswich: Suffolk Records Society, 1970), pp. 19–21, 21n.

9. MS B, lines 85–86, *Home at Grasmere*, ed. Beth Darlington (Cornell University Press, 1977), p. 42. After a list of virtuous advantages natural to human society, Wordsworth puts Schiller's principle as a question (line 631): "Or must we seek these things where man is not?" Post-structural superiority easily finds a way through Schiller's principle: "Man goes out into the world seeking to recover the lost unity of mind and nature, but he stops by the first stream or pool of water he comes to, satisfied that he has found an image of himself." Joseph G. Kronick, *American Poetics of History from Emerson to the Moderns* (Louisiana State University Press, 1984). p. 63.

10. René Descartes, *Meditations on First Philosophy* (1641), tr. Donald A. Cress (Cambridge, Mass.: Hackett, 1980), p. 94. For a brief, useful account of natural religion, see Wilhelm Windelband, *A History of Philosophy*, tr. James H. Tufts (New York: Macmillan, 1905). pp. 487–93.

11. "Nature Worship: Its Falseness," *Miscellanies from the Collected Writings of Edward Irving* ("Third Thousand," London and New York: Strahan, 1866). p. 23. Cf. "Theology of Nature" (specifically against the theological arguments of William Paley). pp. 11–18; "Analogy between Natural and Spiritual Processes," pp. 18–23. John Wesley asks if it is only the tiger, wolf, shark, or eagle "that tears the flesh, sucks the blood, and crushes the bones of its helpless fellow-creatures," and answers, "Nay, the harmless fly, the laborious ant, the painted butterfly" are crushed without mercy by "the innocent songsters of the grove." Passage quoted from *Works* (New York, 1826), 6:256–57, in J. Hillis Miller, *The Disappearance of God* (Harvard University Press, 1963), p. 164n.

12. John Drinkwater, *A Book for Bookmen . . .* (London: Dulau, 1926), p. 137.

13. The entry on Paley (1743–1805) by Leslie Stephen in *DNB* is as entertaining as any entry in *Burke's Peerage*.

14. 1.2.7, p. 2; 1.4.9, p. 3; 1.33.3, p. 17. During growth from infancy, Love's "active mind o'er nature's works would range" (1.18.3, p. 10). Canto 2, even more allegorical, names God's created Nature less frequently; instead, Love must overcome such "sublime" difficulties as "horrid grandeur" and "horrid gloom" (2.34.3, p. 44; 2.38.1, p. 46).

15. Morse Peckham, *Romanticism and Ideology* (Greenwood, Fl.: Penkevill, 1985), p. 221.

16. A remark quoted in Julius Charles Hare, *The Mission of the Comforter* (2nd edn., Cambridge, 1850), p. 410.

17. G. Gregory, *The Economy of Nature Explained and Illustrated on the Principles of Modern Philosophy* (3rd edn., 3 vols., London: J. Johnson, 1804), 1:ix.

18. Quoted in Michael Denton, *Evolution: A Theory in Crisis* (London: Burnett, 1985), p. 20.

19. Matthew Young, *An Analysis of the Principles of Natural Philosophy* (Dublin: University Press, 1800), p. 1.

20. A. F. M. Willich, *Lectures on Diet and Regimen* . . . (4th edn., London: Longman, 1809).

21. Charles Robert Maturin, *Melmouth the Wanderer* (Edinburgh, 1820, ch. 3; University of Nebraska Press, 1961, p. 23).

22. George Edward Woodberry, *The Torch: Eight Lectures on Race Power in Literature delivered before the Lowell Institute for Boston, MCMIII* (New York: McClure, Phillips, 1905), p. 22. Richard Payne Knight found the origins of Natura in phallic worship, but we shall not find Victorian poets or prophets following that trail.

23. *The Letters of John Keats*, ed. Hyder E. Rollins (2 vols., Harvard University Press, 1958), 1:213, 218, 232.

24. John Keble, *Lectures on Poetry, 1832–1841*, tr. Edward Kershaw Francis (2 vols., Oxford: Clarendon, 1912), 1:23; 2:260, 272, 480–81; cf. 1:53, 58–59. On a topic pertinent to this discussion, see G. B. Tennyson, "The Sacramental Imagination," in *Nature and the Victorian Imagination*, ed. U. C. Knoepflmacher and G. B. Tennyson (University of California Press, 1977), pp. 370–90.

25. Tr. Michael Snideman, in *Nineteenth-Century Theories of Art*, ed. Joshua C. Taylor (University of California Press, 1987), pp. 262–63. On the grounds that romanticism and realism lack a single, absolute, uniform style ("there is no such thing as romantic art"), and that romanticism is emotional, "intensity of experience rather than art," the romantics are cast into hell by a teleological last judgment in Wylie Sypher, *Rococo to Cubism in Art and Literature* (New York: Random House, 1960), pp. 64, 70, 74.

26. Arthur O. Lovejoy made romantic temporalization a law of history in lectures of 1933, published as *The Great Chain of Being: A Study in the History of an Idea* (Harvard University Press, 1947), supplemented by his *Essays in the History of Ideas* (Johns Hopkins Press, 1948).

27. A longer historical context is provided in Edwin Arthur Burtt, *The Metaphysical Foundations of Modern Physical Science* (New York: Harcourt, Brace, 1925; rev. edn., London: Routledge and Kegan Paul, 1949), ch. 1.

28. Stephen Hales, *Vegetable Staticks: Or, an Account of Some Statistical Experiments on the Sap in Vegetables: Being an Essay towards a Natural History of Vegetation* (London, 1727), p. [1].

29. Joseph Warren Beach, in *The Concept of Nature in Nineteenth-Century Poetry* (New York: Macmillan, 1936), concluded that the romantics, inheriting the triad of nature, man, and God, had replaced God with nature, had come to worship nature. M. H. Abrams, in *Natural Supernaturalism: Tradition and Revolu-*

*tion in Romantic Literature* (New York: Norton, 1971), finds a replacement or elimination of God by man (mind, ego).

30. *Kant's Cosmogony* . . . ed. and tr. W[illiam] Hastie, D.D., with Introduction, Appendices by Thomas Wright of Durham. (Glasgow: James Macklehose and Sons, Publishers to the University, 1900). pp. 152, 145, 144, 149.

31. Keith [Vivian] Thomas, *Man and the Natural World, 1500–1800* (London: Allen Lane, 1983). p. 53. A telling example (p. 38): Cotton Mather determined to differ from the dog by thinking noble, holy thoughts when he made water against a wall. It is possible that the increase in the number of paintings of wild animals, and of domestic animals unaccompanied by owners, signals a decline in the sense of divinely appointed human superiority, although Thomas's theory and evidence of a greater sensitivity to animals are questioned by Howard Erskine-Hill in the *Times Literary Supplement*, 29 May 1983, p. 511.

32. Pp. 180–87. The S.P.C.A. was founded in 1824. If the antislavery movement was a manipulated diversion from local conditions, as some historians argue, then Thomas is willing to grant that the concurrent moral concern for animals other than pets may have been similarly manipulated (p. 187).

33. In July 1850 the painter-to-be Burne-Jones described for his father the pleasures afforded by the British Museum: "The Zoological gallery gratified me, the Mammalian saloon delighted me, the Lycian, Nimroud, Phigalian, Elgin, Egyptian, Etruscan, and above all the Fossil rooms put me into ecstacies." Georgiana Burne-Jones, *Memorials of Edward Burne-Jones* (2 vols., London: Macmillan 1904), 1:46. An engraving in William Thornbury and Edward Walford, *Old and New London* (London, 1830), 4:492 displays giraffes prominently on the first landing of the Montagu House entrance of the museum.

34. David Elliston Allen, *The Naturalist in Britain: A Social History* (London: Allen Lane, 1976), p. 35.

35. William Coleman, *Biology in the Nineteenth Century: Problems of Form, Function, and Transformation* (New York: Wiley, 1971), pp. 1–9.

36. Ralph Waldo Emerson, *Essays and Lectures*, ed. Joel Porte (Library of America, 1983), p. 8.

37. Hermann von Helmholtz, *Popular Lectures on Scientific Subjects*, tr. E. Atkinson (2 vols., London: Longmans, 1893), 1:24.

38. Epistles 1.10.24–25, "Naturam expelles furca, tamen usque recurret, et mala perrumpet furtim fastidia victrix," tr. H. Rushton Fairclough in the Loeb Classical Library.

39. Gregory, *Economy of Nature*, 3:522.

40. Woodring, "Three Poets on Waterloo," *Wordsworth Circle* (1987), 18:54–57.

41. Frederick B. Artz, *From the Renaissance to Romanticism: Trends in Style in Art, Literature, and Music, 1300–1830* (University of Chicago Press, 1962), p. 224.

42. Karl Kroeber proposes that Wordsworth, "in good romantic fashion" in all his poetry, goes as far as he can toward identifying nature and nurture." *British Romantic Art* (University of California Press, 1986), p. 83.

43. On other keen examples from Austen's novels, see Martin Price, "The Picturesque Moment," in *From Sensibility to Romanticism: Essays Presented to Frederick A. Pottle*, ed. Frederick W. Hilles and Harold Bloom (New York: Oxford, 1965), pp. 265–68.

44. As in James K. Chandler, *Wordsworth's Second Nature: A Study of the Poetry and Politics* (University of Chicago Press 1984). In Wordsworth's Intimations Ode, says Chandler (p. 80), the " 'more habitual sway' is the power of second nature, the strength of what remains behind when the particular repetitions of life's seasons have passed."

45. George Gordon, Lord Byron, *Letters and Journals*, ed. Leslie A. Marchand (Harvard University Press), 5 (1976), 74–75.

46. C. R. Leslie, *A Hand-Book for Young Painters* (London: Murray, 1855), p. 254; here corrected from *The Antiquary*, ch. 20.

47. Paul Oskar Kristeller, "The Modern System of the Arts: A Study in the History of Aesthetics," *Journal of the History of Ideas* (1951), 12:496–527; (1952), 13:17–46. On the social context see M. H. Abrams, "Art-as-Such: The Sociology of Modern Aesthetics," *Bulletin of the American Academy of Arts and Sciences* (March 1985), 38:8–33.

48. Selection in Bernard Denvir, ed., *The Early Nineteenth Century: Art, Design, and Society, 1789–1852* (London: Longman, 1984), p. 90.

49. Charles Robert Leslie, *Autobiographical Recollections*, ed. Tom Taylor (Boston: Ticknor, 1860), p. 182. He advised in 1830, "divest yourself of every other intention than that of giving *true pictures of nature*" (p. 290).

50. *The Letters of Robert Burns*, ed. J. De Lancey Ferguson (2 vols., Oxford: Clarendon, 1931), 1:51, 2:68–69.

51. *The Temple of Nature; or, the Origin of Society: A Poem, with Philosophical Notes* (1803), 1.47.

52. Eugène Delacroix, *Journal*, tr. Lucy Norton, ed. Hubert Wellington (New York: Phaidon, 1951), p. 117. Cf. 21 Sept. 1854: "The world was not made for man. Man is the master of nature and is mastered by it. He is the only living creature who not only resists, but overcomes the laws of nature and extends his authority by energy and force of will. But to say that the universe was made for man is a very different matter. All man's constructions are as transitory as himself; time overthrows his buildings and blocks his canals, it reduces his knowledge to nothing and obliterates the very names of his nations" (p. 256).

53. Letter of Robert Gilmor of Baltimore quoted by Oswaldo Rodriguez Roque in *American Paradise: The World of the Hudson River School*, ed. John K. Howat (New York: Metropolitan Museum of Art, 1987), p. 24. The insistence on visible strokes as natural goes beyond the contrast of nature and manner in Constable's letter of 29 May 1802 to John Dunthorne: "still Nature is the fountain's head, the source from whence all originality must spring—and should an artist continue his practice without referring to nature he must soon form a *manner*, & be reduced to the same deplorable situation as the French painter mentioned by Sir J. Reynolds, who told him that he had long ceased to look at nature for she only put him out." Constable, *Correspondence*, 2:31, quoted in Ann

Bermingham, *Landscape and Ideology: The English Rustic Tradition, 1740–1860* (University of California Press, 1986), p. 117.

54. A[ugustus] Welby Pugin, *The True Principles of Pointed or Christian Architecture* . . . (London: Bohn, 1853). p. 49. In *Specimens of Gothic Architecture* . . . (London: Taylor, Pugin, and Britton, 1821), he had denounced "Egyptianised, Grecianised, Romanised, Gothicised, Castleised, Abbeyised, buildings" (p. v.).

55. Richard Redgrave and Matthew Digby Wyatt, cited in Linda Nochlin, *Realism* (New York: Penguin, 1971). p. 231; cf. 222.

56. William Makepeace Thackeray, "Caricatures and Lithography in France," *Paris Sketch Book*, in *Works* (26 vols., New York: Scribners, 1911), 12:213.

57. Pugin, *True Principles*, p. 47.

58. Mark Girouard, *The Victorian Country House* (rev. edn., Yale University Press, 1979), pp. 46–59.

59. On the importance of the distinction, see Robert Sokolowski, "Natural and Artificial Intelligence," *Daedalus* (1988), 117:45–48.

## 2. Sublime, Picturesque, Beautiful

1. We still have nothing on this subject superior to Walter Jackson Bate, *From Classic to Romantic: Premises of Taste in Eighteenth-Century England* (Harvard University Press, 1946).

2. William Gilpin, *Five Essays on Picturesque Beauty* (3rd edn., London, 1808), pp. 26, 78, 160.

3. Ann Bermingham has been able to show that Gainsborough was praised by contemporaries and immediate followers, including Constable, for close observation of nature, but a passage she quotes from Gainsborough's first biographer reveals the common bias toward the fanciful and the general: "Friendship there was between him and dame NATURE, for I may justly say, Nature sat to *Mr. G.* in all her attractive attitudes of beauty, and . . . all came forth equally chaste from his inimitable and fantastic pencil." *Landscape and Ideology*, pp. 57–63; cf. 29–42.

4. *The Diary of Joseph Farington*, ed. Kenneth Garlick, Angus Macintyre, Kathyrn Cave (Yale University Press, 1978–), 13 (1984), 4488.

5. Anthony Ashley Cooper, 3rd Earl of Shaftesbury, "The Moralists," *Characterisks* (3 vols., London, 1749), 2.233.

6. Hazard Adams, *Philosophy of the Literary Symbolic* (University Presses of Florida, 1983). p. 19.

7. Studies taking the German *Naturphilosophen* as representative of nineteenth-century romantics characteristically neglect the respect of the English for empirical search. For an example of the argument by historians of science that romanticism is an aberration from the early eighteenth century overcome in the twentieth, see Hans Eichner, "The Rise of Modern Science and the Genesis of Romanticism," *PMLA* (January 1982), 97:8–30. There is a succinct refutation in N. Katherine Hayles, *The Cosmic Web* (Cornell University Press, 1984), pp. 17–19.

8. See Woodring, "Nature, Art, Reason, and Imagination in *Childe Harold*," in *Romantic and Victorian: Studies in Memory of William H. Marshall*, ed. W. P. Elledge and R. L. Hoffman (Fairleigh Dickinson University Press, 1971), pp. 147–57.

9. Alan Grob, *The Philosophic Mind: A Study of Wordsworth's Poetry and Thought, 1797–1805* (Ohio State University Press, 1973), p. 179. "Wordsworth's antagonism to science at this time arose then not because he feared the encroachment of science upon the poet's imaginative freedom but because of an intense preoccupation with ethical issues that had led him to distrust as inimical to man's welfare any occupation that tempted man to deal with the world around him in a manner wholly divorced from moral consequence" (p. 182).

10. William Lisle Bowles, *Invariable Principles of Poetry* (1819), quoted in George Gordon, Lord Byron, *Works: Letters and Journals*, ed. R. E. Prothero (6 vols., London: Murray, 1898–1905), 5:532.

11. See Albert Boime, *The Academy and French Painting in the Nineteenth Century* (London: Phaidon, 1971), pp. 136–40.

12. Samuel H. Monk, *The Sublime: A Study of Critical Theories in Eighteenth-Century England* (New York: MLA, 1933); Walter John Hipple, Jr., *The Beautiful, The Sublime, and The Picturesque in Eighteenth-Century British Aesthetic Theory* (Southern Illinois Univeristy Press, 1957); W. P. Albrecht, *The Sublime Pleasures of Tragedy: A Study of Critical Theory from Dennis to Keats* (University Press of Kansas, 1975); David B. Morris. *The Religious Sublime: Christian Poetry and Critical Tradition in Eighteenth-Century England* (University Press of Kentucky, 1972); article by Rosario Assunto on the sublime in the McGraw-Hill *Encyclopedia of World Art*, 14:268–76.

13. Edward Gibbon, *Miscellaneous Works* (2nd edn., 5 vols., London: Murray, 1814), 5:263. The doctrine and implications of the treatise are analyzed by Paul H. Fry in "Longinus at Colonus: The Grounding of Sublimity," *The Reach of Criticism: Method and Perception in Literary Theory* (Yale University Press, 1983), pp. 47–86. Fry points out (p. 61) that the subsequent emphasis on "mist and obscurity" was a departure from Longinus, who sought "clarity and illumination."

14. (3rd edn., 2 vols., London: Kettilby, 1697), 1:94–95. On Burnet, see particularly Marjorie Hope Nicolson, *Mountain Gloom and Mountain Glory: The Development of the Aesthetics of the Infinite* (Cornell University Press, 1959). Thomas Gray is often cited as the first Englishman to record an aesthetic response to the Alps. For a lingering awe at the horrid, devoid of the sublime, see the example of George, Lord Lyttelton, "Account of a Journey into Wales: in Two Letters to Mr. Bower," *Works*, ed. George Edward Ayscough (2nd edn., London: Dodsley, 1775), pp. 713–26, esp. 717–20. Rain kept Lyttelton off Snowdon.

15. (Turner's notes, "Route to Rome"), Cecilia Powell, *Turner in the South: Rome, Naples, Florence* (Yale University Press for the Paul Mellon Centre, 1987), p. 65.

16. John Brown, "Description of Keswick in Cumberland," *London Chronicle*

(24–26 April 1966), 19:393. See Jonathan Wordsworth, Michael C. Jaye, and Robert Woof, *William Wordsworth and the Age of English Romanticism* (Rutgers University Press and The Wordsworth Trust, 1987), p. 225, Catalogue No. 212. What Brown described as "the perpetual change of prospect" would soon be called a perpetually changing prospect.

17. Alexander von Humboldt, *Cosmos*, tr. E. C. Otté (4 vols., London: Bohn, 1849–1852), 1:4–5.

18. Thomas Gray, *Correspondence*, ed. Paget Toynbee and Leonard Whibley (3 vols., Oxford: Clarendon, 1935), 1:129. (Letter to Richard West, 16 November 1739.)

19. For example, James B. Twitchell, *Romantic Horizons: Aspects of the Sublime in English Poetry and Painting, 1770–1850* (University of Missouri Press, 1983), pp. 28–32. A counter-movement along the lower road of demonic possession has near its center Paul H. Fry, in *The Reach of Criticism: Method and Perception in Literary Theory* (Yale University Press, 1983), pp. 47–86, and "The Possession of the Sublime," *Studies in Romanticism* (1987), 26:187–207.

20. On earlier identification of Hebrew sublimity, in apparent independence from Longinus, see Debora Shuger, "Morris Croll, Flacius Illyricus, and the Origin of Anti-Ciceronianism," *Rhetorica* (1985), 3:269–84.

21. François René de Chateaubriand, *Génie du Christianisme, ou beautés de la religion chrétienne* (Paris: Gallimard, 1978), pp. 761–86; as paraphrased, p. 775.

22. Thomas Whately, *Observations on Modern Gardening* (London and Dublin, 1770), selection in *The Genius of the Place: The English Landscape Garden 1620–1820*, ed. John Dixon Hunt and Peter Willis (London: Elek; New York: Harper, 1975), pp. 307, 305.

23. At or near the beginning, Neil Hertz, "The Notion of Blockage in the Literature of the Sublime," in *Psychoanalysis and the Question of the Text*, ed. Geoffrey H. Hartman (Johns Hopkins University Press, 1978). The sublime offers special opportunities for vacating an author's intentions, as in Thomas Weiskel, *The Romantic Sublime: Studies in the Structure and Psychology of Transcedence* (Johns Hopkins University Press, 1976); David Quint, "Representation and Ideology in *The Triumph of Life*," *SEL: Studies in English Literature* (1978), 18:639–57; Ronald Paulson, *Representations of Revolution (1789–1820)* (Yale University Press, 1983), esp. p. 220; Frances Ferguson, "Shelley's *Mont Blanc*: What the Mountain Said," in *Romanticism and Language*, ed. Arden Reed (Cornell University Press, 1984); Neil Hertz, *The End of the Line: Essays on Psychoanalysis and the Sublime* (Columbia University Press, 1985). And see Richard Kuhns, "The Beautiful and the Sublime," *New Literary History* (1982), 13:287–306; and the forum on the sublime in *Studies in Romanticism* (Summer 1987), 26:187–301. Theories of the sublime are put in a larger context, from the aesthetics of taste in the eighteenth century to the Marxist ideology of the Frankfurt school, by Gary Shapiro, "From the Sublime to the Political: Some Historical Notes," *New Literary History* (1985), 16:213–35.

24. Sonnet 13 in *Posthumous Poems* (1850) and in *Works*, ed. Derwent Cole-

ridge (2 vols., London: Moxon, 1851). Cf. Byron, *Childe Harold* 3.62: "All that expands the spirit, yet appals."

25. C. W., "The Sublime," in *The Penquin Encyclopedia of Horror and the Supernatural*, ed. Jack Sullivan (New York: Viking, 1986).

26. George Gordon, Lord Byron, *Letters and Journals*, ed. Leslie A. Marchand (12 vols., Harvard University Press), 5 (1976):166.

27. Andrew Wilton, *Turner and the Sublime* (University of Chicago Press, 1981).

28. It is easy to argue persuasively that Martin's illustrations of the Bible and Milton "expressed, in a disguised way, emotions aroused in him by the contemporary industrial scene." Francis D. Klingender, *Art and the Industrial Revolution*, ed. Arthur Elton (London: Evelyn, Adams and Mackay, 1968), p. 90.

29. *Lectures 1808–1819 on Literature*, ed. R. A. Foakes, 2:427, in *The Collected Works of Samuel Taylor Coleridge.*

30. Tennyson Notebook 7 in the Harvard College Library, quoted in Dorothy Mermin, *The Audience in the Poem: Five Victorian Poets* (Rutgers University Press, 1983), p. 17.

31. John Wilmerding, ed., *American Light: The Luminist Movement* (New York: Harper and Row, 1981); Earl A. Powell, "The American View: Landscape Paintings and Drawings," in *An American Perspective* . . . ed. John Wilmerding et al. (University Press of New England, 1981), pp. 15–38. With the luminists, cf. the German painter Franz Steinfeld, "Hallstatter See," Tafel 14 in *Deutsche Malerei im 19. Jahrhundert* (Nuremberg Museum, 1977).

32. Dugald Stewart, *Philosophical Essays* (Edinburgh: Creese; London: Cadell, 1810), pp. 391–92. Even Erasmus Darwin distinguished the "Gracefully great" from the "terribly sublime." *Epistle from Erasmus D—n, M.D. to Thomas Beddoes, M.D.* (London, 1794), p. 4. Thomas Whately said in a chapter on rocks: "That which inspires ideas of greatness, as distinguished from those of terror, has less wildness in it than any; there is a composure of dignity." *Observations on Modern Gardening, Illustrated by Descriptions* (London: Payne, 1770), p. 99. Recommending the erection of ruins in gardens, Whately noted that reflection on the times thereby suggested evoked "sensations of regret, of veneration, or of compassion": "It is true that such effects properly belong to real ruins; but they are produced in a certain degree by those which are fictitious; the impressions are not so strong, but they are exactly similar" (p. 132). Next in this context he discussed Tintern Abbey.

33. Woodring, "The New Sublimity in *Tintern Abbey*," in *The Evidence of the Imagination* . . . , ed. Donald H. Reiman et al. (New York University Press, 1978), pp. 86–100. Of those who have questioned aspects of this interpretation, I would quarrel only with critics who ignore the absences explicitly pointed to in the poem and substitute the presence as if palpable of what is metaphorical for evident purposes or the "absence as presence" of what in the text is neither present nor absent. For one example, see David B. Pirie, *Wordsworth: The Poetry of Grandeur and of Tenderness* (London: Methuen, 1982), pp. 271–72.

I have discovered, as some embarrassment to my argument, that Wordsworth's approval of the little lines of sportive wood, "hardly hedge-rows," had been nearly anticipated by a writer on the picturesque, Uvedale Price, chastising Lancelot Brown's creation of artificial "belts," in Price's Letter to H. Repton, Esq. of 1795: "Observe the difference of those accidental screens to many of the old parks, where thickets of thorns and hollies, groups, and single trees are continued quite to the wall, or the pales." Sir Thomas Dick Lauder, ed., *Sir Uvedale Price on the Picturesque: With an Essay on the Origin of Taste, and Much Original Matter* (Edinburgh: Caldwell; London: Orr, 1842), p. 447. In taste, Wordsworth shared much with writers on the picturesque; what he objected to in 1798 was the rule-giving of a "mimic art."

For some general agreements on the sublime of subdued continuity, see Donald Wesling, *Wordsworth and the Adequacy of Landscape* (New York: Barnes and Noble, 1970), pp. 26, 51; George Levine, "High and Low: Ruskin and the Novelists," in *Nature and the Victorian Imagination*, ed. U. C. Knoepflmacher and G. B. Tennyson (University of California Press, 1977), p. 140; James A. Heffernan, *The Re-creation of Landscape* (University Press of New England, 1984), p. 78 ("two kinds of sublimity: the one dark and brooding, the other bright and exultant"); Christopher Salvesen, "Aspects of the Romantic Sublime," *Charles Lamb Bulletin* (1985), 50:51.

34. *The Notebooks of Samuel Taylor Coleridge*, ed. Kathleen Coburn (New York: Pantheon Books for Bollingen Foundation), 2(1961):2012.

35. For issues more general, see Elinor S. Shaffer, "Coleridge's Revolution in the Standard of Taste," *Journal of Aesthetics and Art Criticism* (1969), 28:213–23; Raimonda Modiano, "Coleridge and the Sublime: A Response to Thomas Weiskel's *The Romantic Sublime*," *Wordsworth Circle* (1978), 9:110–20.

36. "Some Thoughts on Art Addressed to the Uninitiated," *Art Journal* (1849), 11:70. In the paragraph quoted, she is discussing sculpture. Jameson was probably aware that an autocrat had recently declared the picturesque not necessarily either small or large. Uvedale Price, ed. Lauder, p. 96.

37. (London, 1803), note to 2:230, p. 102.

38. From Elizabeth Wheeler Manwaring, *Italian Landscape in Eighteenth Century England: A Study Chiefly of the Influence of Claude Lorrain and Salvator Rosa on English Taste, 1700–1800* (New York: Oxford for Wellesley College, 1925), subsequent studies "chiefly" descend. One of the most astute is Martin Price, "The Picturesque Moment," in *From Sensibility to Romanticism*, ed. Hilles and Bloom, pp. 259–92. Most to be recommended for delight is David Watkin, *The English Vision: The Picturesque in Architecture, Landscape and Garden Design* (London and New York: Harper, 1982). Watkin cites Carroll Meeks, *The Rail-Road Station, an Architectural History* (London, 1957), pp. 3–8, as showing that the picturesque, with "variety, movement, irregularity, intricacy and roughness" is the baroque defined by Heinrich Wölfflin.

39. Leslie, *Hand-Book*, p. 155.

40. Carl Paul Barbier, *William Gilpin: His Drawings, Teaching, and Theory of*

*the Picturesque* (Oxford: Clarendon, 1963), pp. 104, 112, 113. Barbier argues that Gilpin progressed from the objective reason of topography to creative imagination "free to convey the 'spirit' of lake and mountain scenery" (p. 139); most of what Gilpin and Barbier call "imagination" I call "general nature," but Barbier is able to quote a manuscript that makes Gilpin sound like Blake: "It is the imagination, that sees"; imagination, aided by experience, "sees through the eye" (p. 141).

41. Maynard Mack, *The Garden and the City: Retirement and Politics in the Later Poetry of Pope* (University of Toronto Press, 1969); Jeffrey B. Spencer, *Heroic Nature: Ideal Landscape in English Poetry from Marvell to Thomson* (Northwestern University Press, 1973), pp. 191–251; Morris R. Brownell, *Alexander Pope and the Arts of Georgian England* (Oxford: Clarendon, 1978); Peter Martin, *"Pursuing Innocent Pleasures": The Gardening World of Alexander Pope* (Hamden, Conn.: Shoe String Press, 1984); John Dixon Hunt, *Garden and Grove: The Italian Renaissance Garden in the English Imagination, 1600–1750* (Princeton Univerity Press, 1986). pp. 194–216.

42. James Thomson distinguished a vista, as a view between rows of trees, from a prospect, an extended view from a height, and both from a general "view" in which a "landscape" was open for observation. Ralph Cohen, *The Unfolding of the "Seasons"* (Johns Hopkins Press, 1970), p. 172n.

43. Louis Hawes, *Presences of Nature: British Landscape 1780–1830* (Yale Center for British Art, 1982), pp. 35–48.

44. Price, ed. Lauder, 1842, pp. 69, 191, 460.

45. The phrase belongs to Lauder (p. 89), but the point is implicit throughout Price's writings.

46. Richard Payne Knight, *An Analytical Inquiry into the Principles of Taste* (London: Payne and White, 1805), pp. 194, 229, 142, 151, 10, 361, 344, 337, 247, 425.

47. *The Temple of Nature*, Additional Notes, p. 87.

48. Oil painting in the Yale Center for British Art, color plate in Michael Rosenthal, *British Landscape Painting* (Cornell University Press, 1982), p. 55. Rosenthal dates the work "1740's (?)" on the assumption that the painter could not have been in such untutored difficulties at a later date.

49. Reproduced in Hawes, *Presences of Nature*, Plate 108, facing p. 133.

50. Anthony Ashley Cooper, 3rd Earl of Shaftesbury, *The Moralists, a Philosophical Rhapsody* (London, 1709), p. 255.

51. In a note to 4.160, Darwin ascribed the pleasure from "a fine landscape" to "excitement of the retina" and association with "some agreeable sentiments or tastes" (p. 143).

52. Edward James Willson, "Remarks on Gothic Architecture, and Modern Imitations," in August Charles Pugin, *Specimens of Gothic Architecture* (London, 1821–1823), 2:xviii–xix.

53. *Man and the Natural World*, pp. 261–64.

54. That travel literature was the principal agent in changing the British sense

of landscape is the one point of agreement between Barbara Maria Stafford, *Voyage into Substance: Art, Science, and the Illustrated Travel Account, 1760–1840* (MIT Press, 1986, and Charles Rosen's vigorous review of the work in the *New York Review of Books*, 6 Nov. 1986, pp. 55–60.

55. Humboldt, *Cosmos*, 2:448.

56. Thomas, pp. 180–87, 223, 243–52.

57. In 1782 J. H. Pott, in *An Essay on Landscape Painting*, declaring the superiority of English clouds to Italian skies, noted that every foreigner was "immediately and powerfully struck" by "English park and forest." Quoted in John Gage, *A Decade of English Naturalism, 1810–1820* (University of East Anglia and Norwich Castle Museum, 1969), p. 2. This patriotic aspect of the English sublime is demonstrated with telling examples by Jayme Blackley Hannay, "Jane Austen and the Picturesque Movement: The Revision of English Landscape" (Ph.D. dissertation, Columbia University, 1982).

58. P. 230. Lauder, whose large objection to Price is that he seems to attribute to objects qualities they can only have by association, as explained convincingly by Alison, also cautions against letting ideas of the picturesque banish from the gardens and grounds smooth walks and roads (pp. 75, 467).

59. Henry T. Tuckerman, in *Book of the Artists* (New York: Putnam, 1867), called the sublimity of American scenes "eminently national." On pride in the wilderness, see Henry Nash Smith, *Virgin Land* (New York: Random House, 1950); Hans Huth, *Nature and the American: Three Centuries of Changing Attitudes* (University of California Press, 1957); R. W. B. Lewis, *The American Adam* (University of Chicago Press, 1958); James T. Flexner, *That Wilder Image: The Painting of America's Native School from Thomas Cole to Winslow Homer* (Boston: Little, Brown, 1962); Perry Miller, *Errand into the Wilderness* (New York: Harper and Row, 1964); Leo Marx, *The Machine in the Garden* (New York: Oxford University Press, 1964); Roderick Nash, *Wilderness and the American Mind* (Yale University Press, 1967); Barbara Novak, *American Painting in the Nineteenth Century* (New York: Praeger, 1969) and *Nature and Culture: American Landscape and Painting, 1826–1875* (New York: Oxford University Press, 1980). Novak, who makes extensive use of Tuckerman, points out that American landscapists seem to have come to terms with the train, the "machine in the garden."

60. Review of the 2nd edn. of Archibald Alison on taste, in the *Edinburgh Review* of May 1811, revised for the *Encyclopaedia Britannica*; quoted here from *Jeffrey's Criticism: A Selection,* ed. Peter F. Morgan (Edinburg: Scottish Academic Press, 1983), pp. 165–66. A different version of the passage is given in Lauder's edition of Price, pp. 9–10.

61. Selections in Denvir, *Early Nineteenth Century*, pp. 36–37.

62. *The Landscape* (1794), pp. 30–31.

63. *The Journal of Thomas Moore*, ed. Wilfred S. Dowden (University of Deleware Press), 1 (1983): 33.

64. *The Prelude* (1850), 12:111, 154.

65. Wordsworth's objection is sharpened still further if one accepts Berming-

ham's identification of "picturesque objects" as "the aesthetic counterparts to the increasingly bureaucratic system of rural poor relief." *Landscape and Ideology*, p. 69. Cf. p. 75: "the picturesque represented an attempt to wipe out the fact of enclosure and to minimize its consequences."

66. Mud is cleared away in Joan Baum, "On the Importance of Mathematics to Wordsworth," *Modern Language Quarterly* (1985), 46:390–406.

67. *The Prelude* (1850), 6:526–28.

68. Charles Baudelaire, review of the Exposition Universelle of 1855, *Art in Paris*, ed. Jonathan Mayne (London: Phaidon, 1965), p. 124.

69. For overviews, see *English Romantic Hellenism*, ed. Timothy Webb (Manchester University Press, 1982); Frank M. Turner, *The Greek Heritage in Victorian Britain* (Yale University Press, 1981).

70. In 1819, from Tivoli, Thomas Lawrence wrote that only Turner could capture the "union of the highly and varied picturesque, the beautiful, grand, and sublime, in scenery and effect" of what a painter could see in Italy. D. E. Williams, *The Life and Correspondence of Sir Thomas Lawrence* (2 vols., London, 1831), 2:160, quoted here from Cecilia Powell, *Turner in the South: Rome, Naples, Florence* (Yale University Press for the Paul Mellon Centre, 1987) pp. 19, 74.

71. Percy Bysshe Shelley, *Letters*, ed. Frederick L. Jones (2 vols., Oxford: Clarendon, 1964), 2:80–81; on Phidias and Praxiteles, 2:88–89.

72. Of Zeus and "die Stille": "In solcher Stille bildet uns der grosse Dichter den Vater der Götter, welcher allein durch das Winken seiner Augenbrauen und durch das Schütteln seine Haare den Himmel bewegte"; "in wiederholter Betrachtung wird der Geist und das Auge ruhiger und geht von Ganzen auf das Einzelne." Johann Joachim Winckelmann, *Geschichte der Kunst der Altertums* (Vienna: Phaidon, 1934), bk. 4:2, 5; pp. 165, 273.

73. In *Drawings by John Flaxman in the Huntington Collection*, ed. Robert R. Wark (San Marino: Huntington Library, 1970).

74. Keats, *Letters*, 1:232.

75. John Claudius Loudon, *Encyclopaedia of Cottage, Farm and Villa Architecture* (rev. edn., London: Longman, 1846), p. 766.

76. Kroeber, *British Romantic Art*, pp. 152–70, 193–96.

77. Including "man's alienation from the life of nature," as recognized in pastoral elegy by many, e.g. Jay Macpherson, *The Spirit of Solitude* (Yale University Press, 1982), pp. 10–16.

## 3. Imagination and Irony

1. Richard Hurd, *Letters on Chivalry and Romance*, ed. Edith J. Morley (London: Frowde [Oxford], 1911), p. 138.

2. *The Diary of Joseph Farington*, ed. Kenneth Garlick, Angus Mcintyre, and Kathryn Cave (Yale University Press), 13 (1984), 4564 (23 July 1814). Later in the year, Benjamin West complained to Farington of the training that made "imitators of those works which were admired without looking beyond them" (13:4600). With Quintilian's praise of imitation predominant, the first charge

that one artist had plagiarized another (his teacher) had come in 1614, according to Richard E. Spear, "Plagiary or Reinterpretation," *Art News* (1983), 82:121–23.

3. *Logic*, ed. J. R. de J. Jackson, pp. 75–76, in *The Collected Works of Samuel Taylor Coleridge*.

4. *The Notebooks of Samuel Taylor Coleridge*, ed. Kathleen Coburn (New York: Pantheon Books for Bollingen Foundation) 2 (1961):2546.

5. Maurice Z. Shroder, *Icarus: The Image of the Artist in French Romanticism* (Harvard University Press, 1961), pp. 2–11. In John Keble's third lecture on poetry, declaring that the poet or painter close to nature gives us the object, not the artist, he seemed about to defend an objective realism, but no, the "conception," which requires feeling, is superior to the execution; the "poetry" in painting, architecture, sculpture, and music gives "faithful and felicitous expression to the deepest secrets of the human spirit." Keble, *Lectures on Poetry*, 1:41, 43, 48.

6. Quoted in Walter Thornbury, *The Life of J. M. W. Turner* (rev. edn., London, 1877), p. 148. With the same usage and with no reference to verse, Thornbury himself says: "Girtin, in short, was a great artist; but he was not a great poet" (p. 64).

7. *Collected Correspondence of J. M. W. Turner*, ed. John Gage (Oxford: Clarendon, 1980). pp. 50–51.

8. John Guille Millais, *The Life and Letters of Sir John Everett Millais* (2nd edn., 2 vols., London: Methuen, 1900), 1:56. The context is denunciation of critics who suggested influence on Millais from Ruskin and Rossetti.

9. Robert K. Merton, "Scientific Fraud and the Fight to be First," *Times Literary Supplement*, 2 Nov. 1984, p. 1265.

10. This is the argument of Thomas McFarland's *Originality and Imagination* (Johns Hopkins University Press, 1985).

11. J. R. Watson, *Picturesque Landscape and English Romantic Poetry* (London: Hutchinson, 1970), p. 194.

12. Bryan Jay Wolf, *Romantic Re-Vision: Culture and Consciousness in Nineteenth-Century American Painting* (Chicago University Press, 1982), pp. 107–73. Arguments that belief in imagination is more evident in the eighteenth than in the nineteenth century are absorbed from Morse Peckham and James Engell by L. J. Swingle, *The Obstinate Questionings of English Romanticism* (Louisiana State University Press, 1987), p. 15 and passim.

13. Albert Boime, *The Academy and French Painting in the Nineteenth Century* (London: Phaidon, 1971), pp. 166–84.

14. Hugh Honour, *Romanticism* (New York: Harpers, 1979), pp. 245–75.

15. Peter L. Thorslev, Jr., *Romantic Contraries* (Yale University Press, 1984), p. 99.

16. In the Metropolitan Museum, New York. Antoine-Jean Gros had captured a similar look over the shoulder in *Le Général Bonaparte à Arcole* (1796, exhibited in 1801, now at Versailles), but the spontaneity exudes determination and power.

17. *Lectures 1808–1819 on Literature*, ed. R. A. Foakes, 1:35, in *The Collected Works of Samuel Taylor Coleridge*.

18. Ibid., 1:310; cf. 2:147–48.

19. Robertson Davies, *The Mirror of Nature* (University of Toronto Press, 1983), p. 6.

20. These issues are carefully examined in John P. McGowan, *Representation and Revelation: Victorian Realism from Carlyle to Yeats* (University of Missouri Press, 1986), pp. 2–22.

21. Translated from an edition of 1864 in *Nineteenth-Century Theories of Art*, ed. Joshua C. Taylor (University of California, 1987), p. 177.

22. Kepler "perceived the exact resemblance of this organ [the eye] to the *dark chamber*, the rays entering the pupil being collected by the crystalline lens, and the other humours of the eye, into *foci*, which paint on the *retina* the inverted images of external objects." John Playfair's account for the *Enclyclopaedia Britannica*, facsimile reprint in *Dissertations on the Progress of Knowledge* (New York: Arno, 1975), pp. 117–18. On the crucial idea of painting an image on the retina, see David C. Lindberg, *Theories of Vision from Al-Kindi to Kepler* (University of Chicago Press, 1976).

23. *The Friend*, ed. Barbara Rooke, 1:486 in *The Collected Works of Samuel Taylor Coleridge*. Similar praise of Kepler appears in Coleridge's *Philosophical Lectures*, ed. Kathleen Coburn (New York: Philosophical Library, 1949), p. 336.

24. *Specimens of the Table Talk of the late Samuel Taylor Coleridge*, ed. H. N. Coleridge (2 vols., London: Murray, 1835), 2:266. For "at once" read "in rapid sequence," but Coleridge understood the distinction that E. H. Gombrich has made clear for our time: in a *trompe-l'oeil* painting of two drunkards that can be seen also as skull and crossbones, or the rabbit that is also duck, or the distorted human skull that can be seen from the left in Holbein's *French Ambassadors*, the mind can know the alternatives simultaneously, but the eye cannot see both at once.

25. *Lay Sermons*, ed. R. J. White, p. 30, in *The Collected Works of Samuel Taylor Coleridge*. Coleridge's capitalizations are here omitted.

26. David Simpson, *Irony and Authority in Romantic Poetry* (London: Macmillan, 1979), pp. 76–77.

27. Robert Melville, *Samuel Palmer (1805–1881)* (London: Faber, 1956), p. 4.

28. Jonathan Wordsworth, *The Music of Humanity: A Critical Study of Wordsworth's "Ruined Cottage"* (New York: Harper and Row, 1969), pp. 107–09, 124–26.

29. "Michael" is examined and acutely related to Constable's *Salisbury Cathedral, from the Meadows* in Kroeber, *British Romantic Art*, pp. 49–58, 238n12.

30. Jay Appleton, *The Experience of Landscape* (London: Wiley, 1975), passim.

31. Stoddard Martin, *Wagner to "The Waste Land"* (Totowa, N.J.: Barnes and Noble, 1982), p. 123.

32. Jack Lindsay, *J. M. W. Turner: His Life and Work* (London: Cory, 1966),

p. 121. For the purpose of locating the source of Turner's vortexes in James Thomson's *Liberty*, with its "revolving, wheeling, circling movements," Lindsay makes more than is warranted of Thomson's rejection of Carthage in a brief passage, 5:381–87.

33. Andrew Wilson, *Turner and the Sublime* (University of Chicago Press, 1980), p. 72. Cf. "the first appearance in oil of Turner's extraordinary formal invention, the swirling vortex of light and color," Lynn R. Matteson, "The Poetics and Politics of Alpine Passage: Turner's *Snow-storm: Hannibal and His Army Crossing the Alps*," *Art Bulletin* (1980), 62:385. The proposal of Charles Stuckey that the vortex is a visual pun on the name Turner is amplified by Ronald Paulson, *Literary Landscape: Turner and Constable* (Yale University Press, 1982), pp. 98–103.

34. Martin Hardie and others on Turner's innovations as watercolorist are summarized in W. F. Axton, "Victorian Landscape Painting: A Change in Outlook," in *Nature and the Victorian Imagination*, ed. Knoepflmacher and Tennyson, p. 296.

35. Some of these developments in watercolor, oil, and engraving are summarized by John Gage in *J. M. W. Turner: 'A Wonderful Range of Mind'* (Yale University Press for the Paul Mellon Centre, 1987), p. 81.

36. Details concerning this and other aspects of the painting and Turner's attitudes toward it appear in Woodring, "Road Builders: Turner, Coleridge, Wordsworth, and Constable," manuscript.

37. *The Sunset Ship: The Poems of J. M. W. Turner*, ed. Jack Lindsay (Lowestoft: Scorpion, 1966), p. 81.

38. Kroeber, in *British Romantic Art*, finds the issue insignificant: "Commentators have disagreed as to whether we see Carthaginians robbing natives or mountaineers preying on army stragglers. No matter—Turner's historical vision focuses on little, nameless, unremembered acts of violence and fear" (p. 150). Kroeber aptly quotes Carlyle to the effect that "the nameless boor who first hammered out for himself an iron spade" was a greater innovator than the general "who first led armies over the Alps" (p. 144).

39. 7.38, *The History of Rome*, by Titus Livius, tr. George Baker (6 vols., London: Strahan, 1797), 2:147.

40. Reproduced in Mordechai Omer, *Turner and the Poets: Engravings and Watercolours from His Later Period* (Greater London Council, 1975), figs. 1, 2, 3, and in Adele M. Holcomb, "Turner and Rogers' *Italy* Revisited," *Studies in Romanticism* (1988), 27:89 (on the Hannibal and its relation to *Napoleon in the St. Bernard Pass*, 27:85–86).

41. Wilton, *Turner and the Sublime*, p. 74.

42. Did the straight horizon that silhouettes Hannibal and the elephant provide the model for the ruled-line horizon on the left side of a *Hampstead Heath* by Constable in the Yale University Art Gallery? It is reproduced, with an observation that the line with silhouetted figures is "a striking note, however unusual for Constable," in Hawes, *Presences of Nature*, p. 65.

43. *The Prose Works of William Wordsworth*, ed. W. J. B. Owen and J. W.

Smyser (3 vols., Oxford: Clarendon, 1974), 2:80. On Hannibal see also 1:336, 2:320. On 21 May 1807 Wordsworth reminded Lady Beaumont that Coleridge had said to her that the writer, "in proportion as he is great or original, must himself create the taste by which he is to be relished; he must teach the art by which he is to be seen." *Letters: Middle Years*, ed. Ernest de Selincourt, rev. Mary Moorman (Oxford: Clarendon), 1 (1969):150. Whether Coleridge employed the simile of Hannibal's roadbuilding or whether he used language so clearly applicable to painting is not clear. On 16 April 1808 Farington heard Sir George Beaumont quote Coleridge to the effect that "all men who write in a new & superior stile must *create a people* capable of fully relishing their beauties." What Farington heard, Turner may we have heard, but I do not insist that he did. Sir George stood high among those who complained frequently to Farington of Turner's "endeavouring to make painting in oil to appear like water colours," leaving his foregrounds unfinished and harmfully misleading taste. Farington, *Diary*, ed. James Greig, 7 (1927), 118; cf. 5:71, 204–206; 6:279.) Farington seems generally to have kept clear of Turner, but he did talk with him, as on 17 August 1810 (6:105; cf. 5:170).

44. 3:82. The idea of introducing "a new element," which Wordsworth's reader might not allow, belonged to Coleridge's repeated definitions of imagination. This essay is the most openly bookish of Wordsworth's critical statements, but the caution with regard to idealism is characteristic.

45. Woodring, "On Looking into Keats's Voyagers," *Keats-Shelley Journal* (1965), 14:16–17.

46. On Motherwell, see David Rosand, "Voyages of Discovery," *Times Literary Supplement*, 25 January 1985, p. 93.

47. Tr. in the Loeb Classics by H. Rushton Fairclough, who appends a note: "*i.e.* Virgil himself is the path-finder. In this metaphorical way he claims originality."

48. Peckham, *Romanticism and Ideology*, p. 28. "And when to 'imagination' is added 'creative,' " says the ever-innovative author, "we have a phrase of inexhaustible flatulence."

49. *The Prelude* (1850), 6:562–616.

50. *Inquiring Spirit: A New Presentation of Coleridge from His Published and Unpublished Writings*, ed. Kathleen Coburn (corr. edn., Hyperion, Conn.: Hyperion, 1980), pp. 143–44.

51. *The Friend*, ed. Barbara Rooke, 1:55, in *The Collected Works of Samuel Taylor Coleridge*.

52. *John Constable's Discourses*, ed. R. B. Beckett, in the Suffolk Records Society series, 14 (1970):10; also in Andrew Shirley, *The Rainbow: A Portrait of John Constable* (London: Joseph, 1949), pp. 163–64.

53. Turner, *Correspondence*, p. 136.

54. Noted by John Gage; see particularly Powell, *Turner in the South*, pp. 145–56.

55. In a recent detailed study of the work, some of the oddities have been attributed to Turner's purposes in showing the extraordinary range of Raphael

and presenting himself as a competitor in range: Robert E. McVaugh, "Turner and Rome, Raphael and the Fornarina," *Studies in Romanticism* (1987), 26:365–98.

56. Paulson, *Literary Landscape*, p. 95. Paulson and Lawrence Gowing have company in preferring Turner's color and light to his puns, glosses, and "clumsy additions" (ibid., p. 98). "The main interest lies after all in his great achievement as a painter, and not in the doggerel which he liked to append to his pictures, however self-revealing it may be, and however useful in clarifying the story or anecdote behind them. For what the eye finds in these pictures, first and foremost, is sheer delight; and however persuasive the 'fallacies of hope' may be, the painter holds the key to the one reality which gives them their appeal—colour and light." Jean-Jacques Mayoux, *English Painting from Hogarth to the Pre-Raphaelites*, tr. James Emmons (New York: St. Martin's, 1975), p. 209.

57. Fragment 69 of *Ideen* (1800): "Ironie ist klares Bewusstsein der ewigen Agilität, des unendlich vollen Chaos."

58. Besides several studies by L. A. Willoughby, there are valuable surveys by Raymond Immerwahr, "The Subjectivity or Objectivity of Friedrich Schlegel's Poetic Irony," *Germanic Review* (1951), 26:173–91; Hans Eichner, *Friedrich Schlegel* (New York: Twayne, 1970), pp. 44–83, esp. 69–74; Ernst Behler, *Klassische Ironie, Romantische Ironie, Tragische Ironie* (Darmstadt: Wissenschaftliche Buchsgesellschaft, 1972), esp. pp. 65–84. Eichner and Behler agree on the importance of Fichtean dialectic for Schlegel's theory, which was indisputably a product of his progressive modification of Schiller's views on naive and sentimental, ancient and modern. Recent standards of lucidity in the study of romantic irony have been set by Anne K. Mellor, *English Romantic Irony* (Harvard University Press, 1980); David Simpson, *Irony and Authority in Romantic Poetry* (Totowa, N.J.: Rowman, 1979); Lilian R. Furst, *Fictions of Romantic Irony* (Harvard University Press, 1984); Jocelyne Kolb, "Die Puppenspiele meines Humors: Heine and Romantic Irony," *Studies in Romanticism* (1987), 26:399–419.

59. Mark Kipperman, going beyond Harold Bloom, finds Fichtean subjectivity and alienation, "I" as ever-thwarted process, in quest narratives by the English romantics: "I exist only so far as the world I create does, and the world exists only so far as I permit it to." "Fichetean Irony and Some Principles of Romantic Quest," *Studies in Romanticism* (1984), 23:227.

60. The engraver of the painting, John Burnet, has Wilkie explain these details in Burnet's autobiographical novel, *The Progress of a Painter* (1854), quoted in *Sir David Wilkie of Scotland (1785–1841)* (Raleigh: North Carolina Museum of Art, 1987), p. 116 (on the collie, cf. p. 6).

61. Turner read Poussin's paintings in the way, although without the learning, of E. H. Gombrich, "The Subject of Poussin's *Orion*, "*Burlington Magazine* (1944), 84:37–41.

## 4. The Supernatural

1. *Nature* (1869), 1:9–11.

2. Raimonda Modiano, *Coleridge and the Concept of Nature* (Florida State Uni-

versity Press, 1985), pp. 3, 206, quoting *The Collected Letters of Samuel Taylor Coleridge*, ed. Earl Leslie Griggs (6 vols., Oxford: Clarendon, 1956–1971), 5:496–97.

3. Coleridge to the abolitionist Thomas Clarkson, 13 October 1806, in *Collected Letters*, 2:1196. The metaphors show how mistaken it would be in a chapter on the supernatural to succumb to the temptation of equating romantic imagination with the moon in opposition to the sun as rational understanding.

4. C. R. Leslie, *Memoirs of the Life of John Constable, Composed Chiefly of His Letters* (London: Phaidon, 1951), p. 282. Leslie adds in a note his own view: "Why do 'the Gods of Homer continue to this day the gods of poetry', but because they are endued with human passions? And for the same reason do the weird sisters, the Oberon, Titania, Puck, Ariel, and Caliban interest us."

5. The thesis of Tzvetan Todorov, specifically that the observing character in a work to be designated as fantastic hesitates when natural law seems to be violated, has been generalized by readers of *The Fantastic: A Structural Approach to a Literary Genre*, tr. Richard Howard (Case Western Reserve University Press, 1973; rpt. Cornell University Press, 1975). into a thesis that the fantastic leaves the reader unable to decide between natural and supernatural explanations. In derivation, fun has been had by the uncannily inaccurate Rosemary Jackson, *Fantasy: The Literature of Subversion* (London: Methuen, 1981); and by Linda Bayer-Berenbaum, *The Gothic Imagination: Expansion in Gothic Literature and Art* (Associated University Presses: Farleigh Dickinson, 1982); James B. Twitchell, *The Living Dead: A Study of the Vampire in Romantic Literature* (Duke University Press, 1981) and *Dreadful Pleasures: An Anatomy of Modern Horror* (New York: Oxford University Press, 1985); Clayton Koelb, *The Incredulous Reader: Literature and the Function of Disbelief* (Cornell University Press, 1984), on "lethic" and "alethetic apistic" modes; the rivalry and scapegoat theories of René Girard adapted to romantic violence against the self in Tobin Siebers, *The Romantic Fantastic* (Cornell University Press, 1984); William Patrick Day, *In the Circles of Fear and Desire: A Study of Gothic Fantasy* (University of Chicago Press, 1985), on "anxiety and terror over the experience of the family"; Eve Kosofsky Sedgwick, "Toward the Gothic: Terrorism and Homosexual Panic," ch. 5 in *Between Men: English Literature and Male Homosocial Desire* (Columbia University Press, 1985); books by Jack Zipes on the fairy tale; and see *Penguin Encyclopedia of Horror and the Supernatural*, ed. Jack Sullivan (New York: Viking, 1986). The structural approaches of Todorov and Northrop Frye are dissected and left half alive by Christine Brooke-Rose, *A Rhetoric of the Unreal: Studies in Narrative and Structure, Especially of the Fantastic* (Cambridge University Press, 1981). Meanwhile, comprehensive study of the Gothic, as by Montague Summers, has been continued variously by Devendra P. Varma and by Thomas Meade Harwell, *The English Gothic Novel* (4 vols., Salzburg: Universität Salzburg, 1986).

6. [Andrew Baxter] *An Enquiry into the Nature of the Human Soul; wherein the Immateriality of the Soul is evinced from the Principles of Reason and Philosophy* (3rd edn., 2 vols., London: Millar, 1745). 2:66.

7. Facsimile of 2nd U.S. edn. (1834), in *Significant Contributions to the History*

*of Psychology, 1750–1920*, ed. Daniel N. Robinson, ser. A. vol. 10 (Washington, D.C.: University Publications of American, 1977), p. 49.

8. S. T. Coleridge, *Philosophical Lectures*, ed. Kathleen Coburn (New York: Philosophical Library, 1949), pp. 104–105, 304–305. One of Coleridge's authorities, John Ferriar, *An Essay towards a Theory of Apparitions* (London: Cadell, 1813), explained most spectral effects as lingering visual images accompanying irregularities of the nervous system. For the topic, see Woodring, "Vision without Touch: Coleridge on Apparitions," in *The Cast of Consciousness: Concepts of the Mind in British and American Romanticism*, ed. Beverly Taylor and Robert Bain (Westport, Conn.: Greenwood, 1987), pp. 77–85.

9. Patricia Meyer Spacks, *The Insistence of Horror: Aspects of the Supernatural in Eighteenth-Century Poetry* (Harvard University Press, 1962), p. 200.

10. "Terrorist Novel Writing," *The Spirit of the Public Journals in 1797* (2nd edn., London, 1799), p. 224.

11. See particularly G. Malcolm Laws, Jr., *The British Literary Ballad* (Southern Illinois University Press, 1972), pp. 33–35.

12. As in *Christabel*, temptation to escape nature comes more often through an intermediary than from direct encounter with the Devil. An already possessed intermediary is assumed by Jay Macpherson, *The Spirit of Solitude* (Yale University Press, 1982), p. 246: "Alchemist and Avenger . . . each has given himself over to an inexorable law of cause and effect . . . refusing to take warning from the prophetic example of the prior fall of the other signatory or secret-bequeather, who clearly has entered on a course that binds him to victimize others." Macpherson discovers this pattern in Shelley's *Alastor*, "the quest of both the Poet and the narrator, pursuing Nature in order to penetrate her inmost shrine or wrest her secret from her" (p. 184).

13. *Notebooks*, 2:1876.

14. The "witchcraft by daylight" and the specificity of the Lakes, in Part 2, both treasured by the poet as a challenge to Gothic horrors, were regarded at the other end of the century as drifting in a direction to "vulgarize his shadowland" and to let in "the dull and earthy imp, Topography." William Watson, "Coleridge's Supernaturalism," *Excursions in Criticism* (London: Mathews and Lane, 1893), p. 103. Preference for twilight and dark has prevented critics from taking seriously Coleridge's assertions that Christabel is a St. Theresa required to travel to a sacrifice (not to a martyrdom, if the summaries leading to a happy ending are valid). For an abortive attempt to make the poem illustrate the Christian principle that only the spiritually defective can be bewitched, see Woodring, "Christabel of Cumberland," *A Review of English Literature* (1966), 7:43–52.

15. Coleridge's natural supernatural unfinished poem, "The Three Graves," bears the subtitle "a Fragment of a Sexton's Tale."

16. (2 vols., London: Strahan, 1777), 1:185–86.

17. Walter Pater, *Essays from the Guardian* (London: Macmillan, 1910), pp. 100–101.

18. The opposition of natural and unnatural is fully examined by Eve Leoff, *A Study of John Keats's Isabella* (Salzburg: Universität Salzburg, 1972).

19. Stanley Cavell, "In Quest of the Ordinary: Texts of Recovery," in *Romanticism and Contemporary Criticism*, ed. Morris Eaves and Michael Fischer (Cornell University Press, 1986), pp. 183–239.

20. "The Metempsychosis," *Blackwood's Edinburgh Magazine* (1826), 19:511–29. Maturin's Bertram—"High-hearted man, sublime even in thy guilt"—may be a sharpening source for Manfred, but Maturin's leader of ruffian robbers is more Byronic than Schilleresque, as in this apostrophe to Imogine: "Thou fairest flower— / Why didst thou fling thyself across my path, / My tiger spring must crush thee in its way, / But cannot pause to pity thee." *Bertram*, 3.3; 4.2 (2nd edn., London, 1816, pp. 35, 56).

21. "Strong and original," says the account of Hogg in the *DNB*, "the work never became popular." Gide read a copy of the edition that marked its resurrection after a full century in the grave.

22. "A Scots Mummy. To Sir Christopher North," signed "James Hogg *Altrieve Lake. Aug.* 1, 1823," *Blackwood's Edinburgh Magazine* (1823), 14:188–90. Hogg's preferred title for the novelette was "The Private Memoirs and Confessions of Fanatic: with a Detail of Curious Traditionary Facts, and Other Evidence, by the Editor (J. H.)." *The Tales of James Hogg, the Ettrick Shepherd* (2 vols., London: Hamilton; Glasgow: Morison, 1884), 1:308–409.

23. See S. T. Coleridge, *Lectures 1808–1819 on Literature*, ed. R. A. Foakes, 1:352 and nn, in *The Collected Works*.

24. The quoted phrase is from Robert M. Adams, Introduction to James Hogg, *The Private Memoirs and Confessions of a Justified Sinner* (New York: Norton, 1970), p. xii.

25. The two works share language, as in Wringhim's description "My mother was a burning and a shining light," and subtle thrusts, as in Wringhim's next paragraph, which recalls Jesus in the temple—"I acquired so much skill that I astonished my teachers, and made them gaze at one another." Before any mention of a cloven hoof, Drummond's double "walked as if he had been flat-soled, and his legs made of steel, without any joints in his feet or ankles" (ibid., p. 73). Cloven-hoofed and flat-souled.

26. *Blackwood's* (1827), 21:549.

27. *Blackwood's* (1830), 28:943–50.

28. *De rerum natura*, 5.878–900.

29. *Ars poetica*, 1.1–13.

30. The Horatian tradition of the grotesque in art is applied indirectly to *Frankenstein* by Ronald Paulson, *Representations of Revolution (1789–1820)* (Yale University Press, 1983), pp. 242–44. His observation regarding Blake, Rowlandson, and Gillray is applicable also to *Frankenstein*: "the term *grotesque* carried both connotations of deviations from nature (the monstrous) and of a breakthrough into a higher art" (p. 171; on Horace, p. 170).

31. Mary Wollstonecraft Shelley, *Frankenstein or The Modern Prometheus (The 1818 Text)*. ed. James Rieger (Indianapolis: Bobbs-Merrill, 1974), p. 228.

32. Gillian Beer, *Darwin's Plots* (London: Routledge, 1983), pp. 110–11, 278*n*10. For three readings after Moers, see Sandra Gilbert and Susan Grubar,

*The Madwoman in the Attic* (Yale University Press, 1979), pp. 213–47; Mary Poovey, *The Proper Lady and the Woman Writer* . . . (University of Chicago Press, 1984), pp. 123–33; William Veeder, *Mary Shelley and Frankenstein: The Fate of Androgyny* (University of Chicago Press, 1986). According to Margaret Homans, *Bearing the Word: Language and Female Experience in Nineteenth-Century Women's Writing* (University of Chicago Press, 1986), pp. 100–19, making the monster means killing Elizabeth, the substitute mother, as the route to murdering motherhood.

33. "Possessing Nature: The Female in *Frankenstein*," in *Romanticism and Feminism*, ed. Anne K. Mellor (Indiana University Press, 1988), pp. 220–32; Mellor, *Mary Shelley: Her Life, Her Fiction, Her Monsters* (New York: Methuen, 1988), pp. 70–88. Mellor's book gives the fullest, most varied, and most balanced account of *Frankenstein* available, pp. 38–140. To supplement note 32 above, see Mellor, p. 231n3.

34. For most of these interpretations, see *The Endurance of Frankenstein*, ed. George Levine and U. C. Kneopflmacher (University of California Press, 1979); Christopher Small, *Mary Shelley's Frankenstein* (University of Pittsburgh Press, 1973), first published as *Ariel Like a Harpy* (London, 1972); *Penguin Encyclopedia of Horror* (cross-referenced under various headings); Karl Miller, *Doubles* (Oxford University Press, 1985). In an independent reading, Irving Massey finds Frankenstein seeking a body in a creature that proves to be equally bodiless: *The Gaping Pig: Literature and Metamorphosis* (University of California Press, 1976), pp. 124–37. As well as *Manfred* or the other dramatic works treated, *Frankenstein* would have illustrated the thesis of loss of Paradise by criminal rebellion against the father's blood in Erika Gottlieb, *Lost Angels of a Ruined Paradise: Themes of Cosmic Strife in Romantic Tragedy* (Victoria, B.C.: Sono Nis, 1981).

35. Arnold Kettle, *An Introduction to the English Novel* (2 vols., London: Hutchinson, 1951–1953), 1:139–55.

36. Criticism today tends to hold, in scorn of biological law taken seriously by Victorians, that it makes no difference in fiction whether children raised together are blood kin. Fictional children live dangerously.

37. On this longing for the supernatural there is a general agreement among the essays in *Etudes Brontëennes*, ed. J. Blondel and J. P. Petit (Paris: Ophrys, 1970).

38. Barbara Gates, "Suicide and *Wuthering Heights*," *Victorian Newsletter* (1976), 50:16–17.

39. "A Fresh Approach to *Wuthering Heights*," in F. R. and Q. D. Leavis, *Lectures in America* (New York: Pantheon, 1969), pp. 85–138; portions are reprinted in *Wuthering Heights: An Authoritative Text with Essays in Criticism*, ed. William M. Sale, Jr. (rev. edn., New York: Norton, 1972), pp. 306–21.

40. One critic, with a fine perception of the structure, goes too far in describing the "patterned repetitions" as eclipsing the "individual characters," thus performing "an ingenious exercise in creating family ties and resemblances," so tightly woven that the pattern "tends somewhat to dilute Heathcliff's origi-

nality." Leo Bersani, *A Future for Astyanax: Character and Desire in Literature* (Boston: Little, Brown, 1976), pp. 197–217, 221–223, 225. Bersani, despite qualifiers—"tends somewhat"—uses phrases such as "compete for our attention," as most of us in the trade do, as if *Wuthering Heights* had been written for critics.

## 5. Realism

1. Charles Lamb, *Specimens of the English Dramatic Poets*, ed. Israel Gollancz (2 vols., London, 1893; New York: Johnson Reprint, 1970), 1:189.

2. *Three Essays* (3rd edn., 1808), p. 160, quoted in Carl Paul Barbier, *William Gilpin: His Drawings, Teaching, and Theory of the Picturesque* (Oxford: Clarendon, 1963), p. 106.

3. Coleridge, *Table Talk*, ed. Woodring, 1:194.

4. Michael Rosenthal, *British Landscape Painting* (Cornell University Press; Oxford: Phaidon, 1982), pp. 80–112.

5. Morland is dismissed as an animal painter of dissolute habits, who incidentally had an influence on "simple pictures of our own picturesque land," in Richard and Samuel Redgrave, *A Century of British Painters*, ed. Ruthven Todd (London: Phaidon, 1947), pp. 137–44.

6. *The Life of George Morland* (London, 1807), p. 184, quoted in John Barrell, *The Dark Side of the Landscape: The Rural Poor in English Painting, 1730–1840* (Cambridge University Press, 1980). p. 104. Barrell, who changed my views of Morland, observes that the painter, and then his engravers even more obviously, brought boors within the acceptability of the picturesque by suggesting shabbiness, not in their neat clothing, but in the buildings behind and above them (p. 108). Even so, in Barrell's view, rustics in the landscapes of Constable and his contemporaries represent "the increasing insistence on an image of actuality in art, and a consequent unwillingness to continue to represent the poor through the idealising stereotypes of Pastoral (p. 140)."

7. John Thomas Smith, *Remarks on Rural Scenery* (London, 1797), p. 9; for a fuller quotation, see Paulson, *Literary Landscape*, p. 115.

8. Arthur S. Marks, "Wilkie and the Reproductive Print," in *Sir David Wilkie of Scotland (1785–1841)* (Raleigh: North Carolina Museum of Art, 1987), p. 80. I have borrowed the specification of saucepans from Wilkie's envious friend Haydon, but pans, pots, bowls, and watering cans are as prevalent in Wilkie's works as curs.

9. Richard and Samuel Redgrave, *Century*, p. 185; *The Works of John Ruskin*, ed. E. T. Cook and Alexander Wedderburn (39 vols., London: Allen, 1903–1912), 5:105.

10. [John Gage], *A Decade of English Naturalism, 1810–1820* (Norwich: University of East Anglia, 1969). The exhibition moved to the Victoria and Albert Museum in early 1970. See also "Landscapes with Laborers," Hawes, *Presences of Nature*, pp. 77–83.

11. *A Memoir of Thomas Bewick, written by Himself,* ed. Jane Bewick (New York: Macveagh, 1925), 208.

12. Iain Bain, *Thomas Bewick: An Illustrated Record of His Life and Work-* (Montclair, N.J.: Schram, 1981); *The Watercolours and Drawings of Thomas Bewick and His Workshop Apprentices,* ed. Iain Bain (2 vols., MIT Press, 1982); Montague Weekley, *Thomas Bewick* (London: Oxford University Press, 1953); Charles Rosen and Henri Zerner, *Romanticism and Realism: The Mythology of Nineteenth-Century Art* (New York: Viking, 1984), pp. 1–5, 72–96.

13. *Memoir,* p. 135; cf. p. 222. For Bewick, Selwyn Image notes in the introduction to the 1925 edition, nature and countryfolk flourish together (pp. xiii-xiv).

14. Wordworth, "Essay, Supplementary," *Prose Works,* 3:63.

15. C. R. Leslie, *Memoirs of the Life of John Constable, Composed Chiefly of His Letters,* ed. Jonathan Mayne (London: Phaidon, 1951), *pp.* 17, 86, 106.

16. Quoted in Alan S. Downer, *The Eminent Tragedian: William Charles Macready* (Harvard University Press, 1966), p. 73, in a discussion of Macready's "natural standard," pp. 71–80. A variety of devices for illusions of depth, movement, and weather are depicted in Richard Southern, *The Victorian Theatre: A Pictorial Survey* (Newton Abbot: David and Charles, 1970).

17. The grievous error of E. T. A. Hoffmann that the more intense the emotion the more appropriately fluid the musical line and the more fittingly prolonged the harmonic ambiguity, leading to Liszt's theory of the tone-poet who reproduces impressions and adventures of the soul, related to the blunder of romantic poets in believing that the relaxation of syntax through associational ideas and images brings poetry toward music—these disastrous mistakes motivate James Anderson Winn's attack in *Unexpected Eloquence: A History of the Relations between Poetry and Music* (Yale University Press, 1981), pp. 194–286. An esteemed colleague of mine finds opera in unceasing decline after Gluck.

18. I learned about the mechanical conditions of ballet in the early nineteenth century, and much more about dance, from Carol Kyros Walker.

19. William Butler Yeats, "The Play, the Player and the Scene" (1904), in Liam Miller, *The Noble Drama of W. B. Yeats* (Dublin: Dolmen, 1977), p. 115.

20. I have quoted the passages from an edition of 1908 illustrated largely by photographs of Florence as it was from about 1870 to 1905. Reproduction of a painting by G. Bezzuoli testifies to the entry of Charles VIII into Florence, but photographs of Santa Maria and other scenes of the novel assure the reader that Savonarola preached among stones that survive although stalls in the Mercato Vecchio might differ from those there when the fictional Tessa gave a cup of milk to the fictional Tito. The reader is asked to believe that Savonarola existed in the setting described and that Tito does or could exist in form now current, with a "large cup of fragrant milk" binding the then to the now.

21. Thomas Vargish, *The Providential Aesthetic in Victorian Fiction* (University Press of Virginia, 1985).

22. Illustration in *Victorian Artists and the City*, ed. Ira Bruce Nadel and F. S. Schwarzbach (Elmsford, N.Y.: Pergamon, 1980). p. 103.

23. George W[alter] Thornbury, *Art and Nature at Home and Abroad* (2 vols., London: Hurst, 1856), 1:9, 2:74.

24. Robert L. Patten, " 'A Surprising Transformation': Dickens and the Hearth," in *Nature and the Victorian Imagination*, ed. U. C. Knoepflmacher and G. B. Tennyson (University of California Press, 1977), pp. 153–70.

25. Philip Fisher, *Hard Facts: Setting and Form in the American Novel* (New York: Oxford University Press, 1985), p. 182.

26. Linda Nochlin, *Realism* (New York: Penguin, 1975). p. 13.

27. Bersani, *Future for Astyanax*, p. 60–61.

28. Humphry House, "Man and Nature: Some Artists' Views," in *Ideas and Beliefs of the Victorians*, ed. Harmon Grisewood (London: BBC, 1949), p. 225.

29. Richard Carlisle, *Every Woman's Book* (1826); Charles Knowlton, *Fruits of Philosophy* (1832); discussed in Jill K. Conway, *The Female Experience in Eighteenth- and Nineteenth-Century America: A Guide to the History of American Women* (New York: Garland, 1982).

30. Selection in *French Utopias: An Anthology of Ideal Societies*, ed. Frank E. and Fritzie P. Manuel (New York: Free Press, 1966), p. 256. The utilitarian English would have replaced the word "scientists" with "engineers." In *A New View of Society*, Robert Owen urged those who had learned "the advantages of substantial, well-contrived, and well-executed machinery" to keep workers also in "a high state of repair": "It would also prove true economy to keep this vital machine neat and clean; to treat it with kindness, that its mental movements might not experience too much irritating friction" (Everyman's edn. pp. 8–9).

31. See Alasdair Clayre, ed., *Nature and Industrialization* (Oxford University Press for Open University Press, 1977), pp. 117–19; Steven Marcus, *Engels, Manchester, and the Working Class* (New York: Random House, 1974), pp. 60–66; cf. Leonard Lutwack, *The Role of Place in Literature* (Syracuse University Press, 1984), p. 11. Among many similar expressions of horror, Humphrey Jennings quotes James Nasmyth: "The Black Country is anything but picturesque. The earth seems to have been turned inside out. Its entrails are strewn about; nearly the entire surface of the ground is covered with cinder-heaps and mounds of scoriae." *Pandaemonium: The Coming of the Machine as Seen by Contemporary Observers* (London: Deutsch, 1985), p. 172.

32. Ann Bermingham, *Landscape and Ideology*, pp. 185–90. Courbet's painting of a stonebreaker (1850) had introduced a subject found as repellant as his realistic manner.

33. Klingender, *Art and the Industrial Revolution* (1968), p. 176.

34. Christopher Hobhouse, *1851 and the Crystal Palace* (London: Murray, 1937); C. H. Gibbs-Smith, *The Great Exhibition of 1851* (London: H.M. Stationery Office, 1950); Patrick Beaver, *1831–1836: A Portrait of Victorian Enterprise* (London: Evelyn, 1970); Eric de Maré, *London 1851: The Year of the Great*

*Exhibition* (London: Folio Society, 1972); Kenneth Luckhurst, *The Story of Exhibitions* (London: Studio, 1951), pp. 83–116; Carl Dawson, *Victorian Noon: English Literature in 1850* (Johns Hopkins University Press, 1979); George W. Stocking, Jr., *Victorian Anthropology* (New York: Free Press, 1987), pp. 1–6 and passim. Of what Beaver (p. 57) called "the greedy attempt to substitute the machine for the craftsman," Yvonne ffrench, in *The Great Exhibition: 1851* (London: Harvill, 1950), p. 230, called "the bastardisation of taste without parallel in the whole recorded history of aesthetics." Paxton's materials and methods were anticipated by J. C. Loudon: John Gloag, *Victorian Taste* (London: Black, 1962), p. 41.

35. Walt Whitman, "A Backward Glance o'er Travel'd Roads," *Complete Poetry and Collected Prose*, ed. Justin Kaplan (Library of America, 1982), pp. 659, 662, 664.

36. Peter M. Sacks, *The English Elegy* (Johns Hopkins University Press, 1985), p. 350n6.

37. Ralph Waldo Emerson, "Art," *Essays and Lectures*, ed. Joel Porte (Library of America, 1983), pp. 437, 436.

38. Letter of 1843, quoted in Neil Harris, *The Artist in American Society: The Formative Years, 1790–1860* (New York: Braziller, 1966), p. 174.

39. Chris Brooks, *Signs for the Times: Symbolic Realism in the Mid-Victorian World* (London: Allen and Unwin, 1984); W. David Shaw, *The Lucid Veil: Poetic Truth in the Victorian Age* (University of Wisconsin Press, 1987); Marshall Brown, "The Logic of Realism: A Hegelian Approach," *PMLA* (1981), 96:224–41. A movement from industrial realism toward a "politics of culture" that replaced realism "not by calling attention to the sign's nonreferentiality, but by emphasizing its being *as representation*" is traced by Catherine Gallagher, *The Industrial Reformation of English Fiction* (University of Chicago Press, 1985). Emphasis upon representation, upon style that rejects illusion, is attributed to the declared Realists Courbet and Flaubert, as "proof that what was represented had been left untouched, uncontaminated by art," in Charles Rosen and Henri Zerner, *Romanticism and Realism: The Mythology of Nineteenth-Century Art* (New York: Viking, 1984), pp. 155–60.

40. Robert L. Patten argues in a paper that ought to be published soon that in *Hard Times* only fantasies, none of the "facts," turn out to be true.

41. See especially Joseph A. Kestner, *Protest and Reform: The British Social Narrative by Women, 1827–1867* (University of Wisconsin Press, 1985); Louis F. Cazamian, *Le roman social en Angleterre (1830–1850)* . . . (rev. edn., 2 vols., Paris: Didier, 1934). Gallagher, in *Industrial Reformation of English Fiction*, accepts the argument of Raymond Williams, *The Long Revolution*, that recalcitrant social problems were translated in the fiction into private conflicts that could be solved.

42. Rosen and Zerner, *Romanticism and Realism*, pp. 155–60. This insistence on the truth of art as unreal is a corollary of their argument against Albert Boime's approval of Thomas Couture on the ground that academic *fini* is "shame-

ful work" that "rubs out the traces of the real work" and "hides the fact that the picture is a real object made out of paint." (p. 222).

43. Harriet Beecher Stowe, *Three Novels*, ed. Kathryn Kish Sklar (Library of America, 1982), p. 294. Stowe's stance toward the reader is noted by Zahava Karl McKeon, *Novels and Arguments: Inventing Rhetorical Criticism* (University of Chicago Press, 1982), pp. 17, 243n35.

44. L. V. Fildes, *Lukes Fildes, R.A.: A Victorian Painter* (London: Joseph, 1968), pp. 24–33.

45. "In periodical and other fiction, in social and industrial reports, and in the illustrated journals, pictures in black and white, on wood or steel, already provided a grimmer, more reportorial account of modern life than was thought appropriate in color." Meisel, *Representations*, p. 396.

46. "Pictures and Stories," *Connoisseur* (1957), 139:146.

47. Sacheverell Sitwell, *Narrative Pictures: A Survey of English Genre and Its Painters* (London: Batsford, 1936); Graham Reynolds, *Painters of the Victorian Scene* (London: Batsford, 1953); Raymond Lister, *Victorian Narrative Paintings* (New York: Potter, 1966).

48. Boime, *Academy and French Painting*, p. 136.

49. Arts Council of Great Britain, *Great Victorian Pictures: Their Paths to Fame* (London, 1978), p. 33.

50. F. M. Redgrave, *Richard Redgrave, C.B., R.A.: A Memoir, from His Diary* (London: Cassell, 1891), pp. 358–64.

51. *Manual of Design Compiled from the Writings and Addresses of Richard Redgrave, R.A., Surveyor of Her Majesty's Pictures, Late Inspector-General for Art, Science and Art Department*, ed. Gilbert R. Redgrave (London: Chapman and Hall, for the Committee of Council on Education, [1876]), pp. 18–19, 34, 58.

52. Ibid., pp. 365–87.

53. Ibid., p. 58.

54. For an astute argument against the primacy of photography for realism, see Svetlana Alpers, *The Art of Describing: Dutch Art in the Seventeenth Century* (University of Chicago Press, 1983), esp. pp. 243–44, confirmed by Marjorie Munsterberg, "The World Viewed: Works of Nineteenth-Century Realism," *Studies in Visual Communication* (1982), 8:55–69. I have not found convincing the specific anticipations of photography in Peter Galassi, *Before Photography: Painting and the Invention of Photography* (New York: Museum of Modern Art, 1981), although it is clear that high viewpoints, cropped edges, and other aspects of nineteenth-century painting that have been specified as proof of photographic origin may have other sources. In trenchant paragraphs, Joshua Taylor noted the role of photography in ending the assumption that the most realistic rendering of an object required "a tight outline description" of its form. *Nineteenth-Century Theories of Art*, p. 412.

55. Leslie Parris, *Landscape in Britain c. 1750–1850* (London: Tate Gallery, 1973), pp. 124–25; Beaumont Newhall, *The History of Photography from 1839 to*

*the Present Day* (New York: Museum of Modern Art, 1964), pp. 11–12; Naomi Rosenblum, *A World History of Photography* (New York: Abbeville, 1984), pp. 15–16, 192–94. A stern writer in 1844 welcomed new mechanical methods as reducing the sentiment and increasing the accuracy of representations. "Illustrated Books," *Quarterly Review* (1844), 74:167–96.

56. Facsimile, ed. Beaumont Newhall (New York: DeCapo, 1969), p. 1.

57. [Elizabeth Rigby, Lady Eastlake], "Photography," *Quarterly Review* (1857), 101:442–68, quotation from p. 444. Writers on the subject who quote from histories such as Helmut and Alison Gernsheim, *The History of Photography, from the Earliest Use of the Camera Obscura in the Eleventh Century up to 1914* (Oxford University Press, 1955, with a changed subtitle in revisions of 1969 and 1983), are often more indebted than they know to Lady Eastlake's facts and observations.

58. *A Victorian Canvas: The Memoirs of W. P. Frith, R.A.*, ed. Neville Wallis (from 3 vols. of 1887–1888; London: Bles, 1957), pp. 92–97. Photograph and painting of *Derby Day* are reproduced by Wallis, facing p. 96. Frith and Charles Landseer are cited often in discussions of photographic realism, e.g. by Jerome Hamilton Buckley, *The Victorian Temper: A Study in Literary Culture* (Harvard University Press, 1951), pp. 131, 136–38, and (in a valuable chapter on uses of photography) by Jeremy Maas, *Victorian Painters* (New York: Putnam, 1969), pp. 189–208.

59. Charles Baudelaire, "The Salon of 1859," *Art in Paris, 1845–1862: Salons and Other Exhibitions*, ed. Jonathan Mayne (Oxford: Phaidon, 1965), pp. 149–58.

60. Cited in David Cecil, *Visionary and Dreamer: Two Poetic Painters, Samuel Palmer and Edward Burne-Jones* (London: Academy, 1969), p. 93.

61. Theodore Ziolkowski, *Disenchanted Images: A Literary Iconology* (Princeton University Press, 1977), p. 119, drawing upon Max J. Friedländer, *Landscape—Portrait—Still-Life: Their Origin and Development*, tr. R. F. C. Hull (New York: Schocken, 1963), pp. 261–62. Neil Harris's discussion of "technical precision," cited in Ziolkowski's footnote, is unrelated to photography. For the equally frequent argument of direct correlation, see, e.g., Elizabeth Anne McCauley, *Likenesses: Portrait Photography in Europe, 1850–1870* (University of New Mexico Press, 1980), p. 213 and passim. Although granting that the camera was seen by the 1860s as dangerous rival to artists, Aaron Scharf insists that photography grew out of "the growing preoccupation of artists with truth representation" and from the pride of the whole society in mechanical achievements. *Art and Photography* (London: Allen Lane, 1968, rev. 1974, rpt. Penguin, 1979), p. 13 and passim.

62. Alan Thomas, *Time in a Frame: Photography and the Nineteenth-Century Mind* (New York: Schocken, 1977), p. 143.

63. Ruskin, *Works*, 33:347; quoted fittingly in Diana L. Johnson, *Fantastic Illustration and Design in Britain, 1850–1930* (Providence: Rhode Island School of Design, 1979), p. 9.

64. Jacques Barzun, *Romanticism and the Modern Ego* (Boston: Little, Brown, 1943), pp. 143–44.

65. Matthew Paul Lalumia, *Realism and Politics in Victorian Art of the Crimean War* (Ann Arbor: UMI Research Press, 1984), pp. xxi, 115–27.

66. Rosen and Zerner, *Romanticism and Realism*, p. 101.

67. It has been argued that a photograph cannot, as a painting might, perform as representation; in this argument, it is not the photograph that represents Tennyson as "a dirty monk"; Julia Cameron performed the act of representation before she took the photograph. In this sense, a photograph is by its essence more "realistic" than a painting as material object. Roger Scruton, "Photography and Representation," *Critical Inquiry* (1981), 7:577–603.

68. H. P. Robinson, *The Elements of a Pictorial Photograph* (Bradford: Lund, 1896; facsimile, New York: Arno, 1971), pp. 17, 20, 31, 32, 65–72.

69. Peter Turner and Richard Wood, *P. H. Emerson, Photographer of Norfolk* (Boston: Godine, 1974); Nancy Newhall, *P. H. Emerson: The Fight for Photography as a Fine Art* (New York: Aperture, 1975). Emerson's claim to be scientific was based particularly on the optics of Hermann von Helmholtz.

70. "The photograph has been accepted as showing that impossible desideratum of the historian—*wie es eigentlich gewesen*—how it actually was." William M. Ivins, Jr., *Prints and Visual Communication* (MIT Press, 1968, from Routledge and Kegan Paul, 1953), p. 94.

71. Theodore Wratislaw, "The Photographic Salon at the Dudley Gallery," *Studio* (1893), 3:69.

## 6. Pre-Raphaelites

1. W. O. Raymond, *The Infinite Moment, and Other Studies in Robert Browning* (University of Toronto Press, 1950).

2. Those as familiar as Browning was with Italian art would see the vein, with one connotation of blue removed, as on "Magdalene's breast."

3. The discussion in Richard D. Altick, *Paintings from Books: Art and Literature in Britain, 1760–1900* (Ohio State University Press, 1985), pp. 459–61, needs to be supplemented with A. I. Grieve, *The Art of Rossetti No. 3: The Watercolours and Drawings of 1850–1855* (Norwich: Real World, 1978), pp. 47–51.

4. E. D. H. Johnson, *The Alien Vision of Victorian Poetry* (Princeton University Press, 1952).

5. Hallam Tennyson, *Alfred Lord Tennyson: A Memoir* (2 vols., London: Macmillan, 1897), 1:117.

6. Jerome Hamilton Buckley, *The Turning Key: Autobiography and the Subjective Impulse since 1800* (Harvard University Press, 1984), p. 13.

7. This is essentially the argument of Pauline Fletcher, *Gardens and Grim Ravines; The Language of Landscape in Victorian Poetry* (Princeton University Press, 1983), pp. 18–71.

8. On particularity there is no finer optic than Carol T. Christ, *The Finer*

*Optic: The Aesthetic of Particularity in Victorian Poetry* (Yale University Press, 1975). For particularity with a tincture of deconstruction, see John P. McGowan, *Representation and Revelation: Victorian Realism from Carlyle to Yeats* (University of Missouri Press, 1986).

9. *The Journals and Papers of Gerard Manley Hopkins*, ed. Humphry House and Graham Storey (London: Oxford University Press, 1959), pp. 104–106. The essay (pp. 86–114) argues more generally that (a) the sense of beauty arises in a comparison of parts and (b) the numerically symmetrical in nature is always observable as (picturesquely) asymmetrical. In "On the Signs of Health and Decay in the Arts," the contrasting terms are "chromatic" and "intervallary" (p. 76).

10. Algernon Charles Swinburne, *William Blake: A Critical Essay* (2nd edn., London: Hotten, 1868), pp. 90–91. After granting Hugo as an exception, but not Shelley or Dante, he adds a footnote that concedes nothing: "Accidentally of course a poet's work may tend towards some moral or actual result; that is beside the question" (p. 93n).

11. Swinburne, *Essays and Studies* (5th edn., London: Chatto, 1901), p. 375. Gautier's rebellion against moral art began in the preface to *Albertus* (1830).

12. Swinburne, "Notes on Designs of the Old Masters at Florence," in *Strangeness and Beauty: An Anthology of Aesthetic Criticism*, ed. Eric Warner and Graham Hough (2 vols., Cambridge University Press, 1983), 1:241–43.

13. David G. Riede, *Swinburne: A Study of Romantic Mythmaking* (University Press of Virginia, 1978).

14. Jerome J, McGann, *Swinburne: An Experiment in Criticism* (University of Chicago Press, 1972), pp. 24–48. This book, as Cecil Lang says, "is an experience."

15. Swinburne, *Ave atque Vale: In Memory of Charles Baudelaire*, line 25.

16. *The Swinburne Letters,* ed. Cecil Y. Lang (6 vols., Yale University Press, 1959–1962), 2:85.

17. Kerry McSweeney, *Tennyson and Swinburne as Romantic Naturalists* (University of Toronto Press, 1981), esp. p. 188.

18. William Morris, *Collected Letters*, ed. Norman Kelvin (Princeton University Press, 1984–    ), 2 (1987): 119.

19. "The Industrial Revolution made the romantic love affair with earth untenable"—the opening of a paragraph on naturalism in Leonard Lutwack, *The Role of Place in Literature* (Syracuse University Press, 1984). p. 11.

20. W. F. Axton, "Victorian Landscape Painting," in Knoepflmacher and Tennyson (1977), p. 300.

21. W. Holman Hunt, *Pre-Raphaelitism and the Pre-Raphaelite Brotherhood* (2 vols., London: Macmillan, 1905), 1:xv. Cf. 46, 49, 50, 86, 133, 135–47. The other members of the short-lived Brotherhood were F. G. Stephens, James Collinson, Thomas Woolner, and William Michael Rossetti.

22. The incautious metaphor comes from Hunt, 1:116. Rossetti left Ford Madox Brown to study with Hunt, who had to explain at length why Rossetti's

continued praise of Brown was ill-founded: "I am obliged . . . to repeat that the first principle of Pre-Raphaelitism was to eschew all that was conventional in contemporary art, and that this compelled me to scrutinise every artist's productions critically. Impressed as I felt by his work as the product of individual genius, I found nothing indicative of a child-like reversion from existing schools to Nature herself" (1:125).

23. Wordsworth, *Prose Works*, 3:77.

24. "It was, at first, as if the Brotherhood looked at the world without eyelids; for them, a livelier emerald twinkled in the grass, a purer sapphire melted into the sea." Robin Ironside and John Gere, *Pre-Raphaelite Painters* (London: Phaidon, 1948), p. 13; on hallucination, see Rosen and Zerner, *Romanticism and Realism*, p. 151n.

25. A "loss of pictorial unity" marring works by Millais, Arthur Hughes, and other Pre-Raphaelites is attributable to reliance upon disparate photographs according to Scharf, *Art and Photography*, pp. 110–11.

26. "Royal Academy," *Athenaeum*, 1 June 1850, p. 590, quoted in Hunt, *Pre-Raphaelitism*, 1:205n. The German Nazarenes, though "repressive," avoided the "visible deformity" practiced by the English in such scenes as Millais's carpenter's shop, contrived with "a circumstantial art-language from which we recoil with loathing and disgust" (p. 591).

27. "The Drama," *Blackwood's* (February 1856), 79:218–19.

28. Perhaps there was a deeper reason, not understood by Stephens: "The *fini* of the Pre-Raphaelites was an essential part of their program to restore to the artist the imagined dignity of the medieval craftsman, to re-create a lost pre-capitalist world." Rosen and Zerner, *Romanticism and Realism*, p. 226.

29. Philip Henry Gosse, *The Romance of Natural History* (2 vols., London: Nisbet, 1860–1861), 1:190. Gosse's probable influence on the Pre-Raphaelites is noted by Herbert L. Sussman, *Fact into Figure: Typology in Carlyle, Ruskin, and the Pre-Raphaelite Brotherhood* (Ohio State University Press, 1979).

30. *Dante Gabriel Rossetti: His Family Letters*, ed. W. M. Rossetti (2 vols., London: Ellis, 1895), 1:190.

31. Thornbury, *Art and Nature*, 1:323. On the accusation of "monkish follies," see Allen Staley, *The Pre-Raphaelite Landscape* (Oxford: Clarendon, 1973), p. 15.

32. Leslie, *Memoirs of Constable*, p. 9.

33. Hunt, 1:106. Wylie Sypher misfires in the direction of a special contemporaneity when he finds Rossetti's Mary Virgin "clearly a London type" in *Rococo to Cubism in Art and Literature* (New York: Random House, 1960), p. 212. Before Rossetti, the Virgin had been of Siena, Florence, Bruges, and Paris. The Virgin's father as a modern gardener reaching above a cross as trellis, with a haloed dove nearby (in the *Girlhood*), is more to the point.

34. Ruskin, *Academic Notes*, in *Works*, 14:20.

35. Richard L. Stein, *The Ritual of Interpretation: The Fine Arts as Literature in Ruskin, Rossetti, and Pater* (Harvard University Press, 1975); George P. Landow,

*William Holman Hunt and Typological Symbolism* (Yale University Press, 1979), *Victorian Types, Victorian Shadows: Biblical Typology in Victorian Literature, Art and Thought* (New York: Methuen, 1980), and *Images of Crisis: Literary Iconology, 1750 to the Present* (Boston: Routledge, 1982); Sussman, *Fact into Figure;* G. B. Tennyson, *Victorian Devotional Poetry: The Tractarian Mode* (Harvard University Press, 1981).

36. Sussman, p. 3; cf. G. B. Tennyson, p. 56: "Tractarian Analogy means quite simply that the entire universe is a symbol of its creator."

37. Meisel, "Half Sick of Shadows," in Knoepflmacher and Tennyson (1977), p. 313.

38. Linda S. Ferber and William H. Gerdts, *The New Path: Ruskin and the American Pre-Raphaelites* (Brooklyn Museum, 1985), p. 31; cf. pp. 34, 53–54.

39. C. R. Leslie, *A Hand-Book for Young Painters* (London: Murray, 1855), pp. 34–37.

40. *The Diary of W. M. Rossetti,* ed. Odette Bornand (Oxford: Clarendon, 1977), p. 8, 22.

41. Ruskin, *The Art of England,* in *Works,* 33:287–88.

42. Constable, *Memoirs,* pp. 141, 142.

43. Leslie, *Hand-Book,* p. 273. The printed text reads, "now remembered by nobody, or rather a writer of verse."

44. Hunt, 2:405.

45. "Old Lamps for New Ones," *Household Words* (1850), 1:265–66.

46. Thornbury, *British Artists,* p. 231.

47. *"Ecce Ancilla Domini" (The Annunciation),* 1849–1850, no. 44 in Virginia Surtees, *The Paintings and Drawings of Dante Gabriel Rossetti (1828–1882): A Catalogue Raisonné* (2 vols., Oxford: Clarendon, 1971).

48. Hunt, 1:355. The work is discussed as a model of "symbolic realism" in Brooks, *Signs for the Times,* pp. 138–41.

49. George Hersey quoted in *Dante Gabriel Rossetti and the Double Work of Art,* ed. Maryan Wynn Ainsworth (Yale University, 1976), p. 46; Ruskin, *Works,* 12:334; Meisel, *Realizations,* p. 367; Hunt, *Pre-Raphaelitism,* 1:355, 2:428–31. Susan Ball Bandelin, responsible for the quotation from Hersey, and noting that Rossetti alters his sonnet, "Mary Magdalene at the Door of Simon the Pharisee," in order to represent the conscience as fully awake, says (in Ainsworth, p. 47): "There is thus a shift of accent from the *awakening* to the *awakened* conscience, which once again is a reversal of Hunt." If anything in Meisel's account needs adjustment, it is that he is insufficiently insistent on the change Hunt effected. For valuable comments on the painting, including a quotation from the *Athenaeum* on the original "painful-looking face," see Mary Bennett's introduction to *William Holman Hunt: An Exhibition Arranged by the Walker Art Gallery* (Liverpool: Walker Art Gallery, 1969), pp. 35–37.

50. Jean Gambart, who commissioned the work, said to Linnell, " I wanted a nice religious bicture, and he bainted me a great goat!" Alfred T. Story, *The Life of John Linnell* (2 vols., London: Bentley, 1892), 2:43.

51. Rosenthal, *British Landscape Painting,* pp. 108–12.

52. On two paintings entitled *The Stonebreaker*, one by John Brett and one by Henry Wallis, both exhibited at the Royal Academy in 1858 and both related to the notorious Courbet work of 1850, see Bermingham, *Landscape and Ideology*, pp. 185–90. Roadbuilding, no longer emblem of imagination, now signified poverty, overwork, and punishment.

53. The fullest discussions, with a bibliography of previous treatments, appear in *Ladies of Shalott, A Victorian Masterpiece and Its Contexts: An Exhibition by the Department of Art, Brown University* (1985).

54. On the final version as a "visual protest" see Lisa Norris, "Hunt and Aestheticism," in Brown University, *Ladies of Shalott*, pp. 73, 80.

55. F. G. Stephens, *Dante Gabriel Rossetti* (London: Seeley, 1894), p. 25.

56. On Pre-Raphaelite compression, Allen Staley, *The Pre-Raphaelite Landscape* (Oxford: Clarendon, 1973), esp. 26, 82.

57. A. I. Grieve has noted that Rossetti's earliest designs employ curtains behind the foreground figures to avoid problems of perspective. *The Art of Dante Gabriel Rossetti: The Pre-Raphaelite Period, 1848–50* (Hingham, Norfolk: Real World, 1973), pp. 4–5, 14.

58. Asa Briggs, *The Age of Improvement* (London: Longmans, 1959), esp. pp. 1–37, 222–25, 435–43.

59. Stephens, *Rossetti*, pp. 37–38.

60. Ibid., p. 39.

61. Quoted in Virginia Surtees, *The Paintings and Drawings of Dante Gabriel Rossetti (1828–1882): A Catalogue Raisonné* (2 vols., Oxford: Clarendon, 1971), 1:28.

62. Linda Nochlin, "Lost and *Found*: Once More the Fallen Woman," *Art Bulletin* (1978), 60:139–53, reprinted in *Feminism and Art History: Questioning the Litany*, ed. Norma Broude and Mary D. Garrard (New York: Harper, 1982), pp. 220–45. Nochlin is also valuable on the visual sources of *Found*. Rossetti said he painted for a livelihood, for to be an artist was "just the same thing as to be a whore, as far as dependence on the whims and fancies of individuals is concerned"; his "true mistress" was poetry. Rossetti, *Letters*, ed. Oswald Doughty and J. R. Wahl (4 vols., Oxford University Press, 1965–1967), 2:749–50, 3:1175, 1348.

63. A. I. Grieve, *The Art of Dante Gabriel Rossetti: 1. Found. 2. The Pre-Raphaelite Modern-Life Subject* (Norwich: Real World, 1976), pp. 1–20.

64. See Woodring, *Victorian Samplers: William and Mary Howitt* (University of Kansas Press, 1952). Even Grieve makes nothing of the drover's ownership of the cart and the "baa-ing calf." If the drover is an emblem of nature, nature becomes less immaculate upon contact with the city. Grieve (pp. 13, 20) cites articles by Dickens in *Household Words* against the cruelties, crowding, and insanitary conditions of Smithfield market, and cites (pp. 25, 27–38) contemporary associations of prostitution with the inability of country girls to make a living in the city by any other occupation. Rossetti himself seems inconstantly aware that males created the world responsible for the shame of the woman in *Found*.

65. Carol A. Bock, "D. G. Rossetti's *Found* and *The Blessed Damozel* as

Explorations in Victorian Psychosexuality," *Journal of Pre-Raphaelite Studies* (1981), 1:86.

66. It was William Graham, who commissioned the better-known version of the painting (now in the Fogg Museum of Harvard University), who asked for the predella of the lover gazing upward, but the addition is consonant with changes in the poem. That Rossetti failed in his usual attempt to explicate a picture with a sonnet or other poem, but succeeded in explicating with a picture the Blessed Damozel poem is argued by Barbara Gates in "Framing Sonnets—Whistler's Quip and Rossetti's Artistry," *Journal of Pre-Raphaelite Studies* (1985), 5:27–30.

67. *A Pre-Raphaelite Friendship: The Correspondence of William Holman Hunt and John Lucas Tupper*, ed. James H. Coombs et al. (Ann Arbor: UMI Research Press, 1986), pp. 101–105.

68. Morris, *Collected Letters*, 2:229.

69. G. K. Chesterton, *The Victorian Age in Literature* (London: Williams and Norgate, 1913), p. 197.

70. Paul Thompson, *The Work of William Morris* (London: Heinemann, 1967); Ray Watkinson, *William Morris as Designer* (London: Studio Vista, 1967), and *Pre-Raphaelite Art and Design* (Greenwich, Conn.: New York Graphic, 1970); Fiona Clark, *William Morris Wallpapers and Chintzes* (London: Academy, 1974). Influences from Morris on design and politics are brought somewhat messily together in *William Morris Today* (London: Institute of Contemporary Arts, 1984).

71. Ruskin, *Works*, 10:326, and see Ellen E. Frank in Knoepflmacher and Tennyson, p. 74.

72. *Collected Letters*, 2: 120–21, 426, 578, 620–21.

73. Jeffrey L. Spear, *Dreams of an English Eden: Ruskin and His Tradition in Social Criticism* (Columbia Univeristy Press, 1984), p. 201–39.

74. J. Bruce Glasier, *William Morris and the Early Days of the Socialist Movement* . . . (London: Longmans, 1921); May Morris, *William Morris, Artist, Writer, Socialist* (2 vols., Oxford: Blackwell, 1936); E[dward] P. Thompson, *Morris: Romantic to Revolutionary* (2nd edn., London: Merlin, 1977). Morris read Marx in French, but he read attentively.

75. Thomas Jefferson, *Writings*, ed. Merrill D. Peterson (Library of America, 1984), p. 1259.

76. Richard Jefferies, *After London; or, Wild England* (London: Cassell, 1886), p. 313. See Morris, *Collected Letters*, 2:426–27 and editor's note.

77. H. G. Wells, *Experiment in Autobiography* (New York: Macmillan, 1934), pp. 192, 193.

78. Ibid., p. 202.

79. William Morris, *Collected Works*, ed. May Morris (24 vols., London: Longmans, 1910–15), 23:104–105, 22:5.

80. Walter Crane, *William Morris to Whistler: Papers and Addresses on Art and Craft and the Commonweal* (London: Bell, 1911), pp. 4, 5. (Crane's italics omitted.)

81. Henry Cole, *Fifty Years of Public Work of Sir Henry Cole, K.C.B. Accounted for in His Deeds Speeches and Writings*, ed. Alan S. and Henrietta Cole (2 vols., London: Bell, 1884), 2:287.

82. Charles L. Eastlake, *A History of the Gothic Revival*, ed. J. Mordaunt Crook (Leicester University Press, 1970), pp. 145–280; Clark, *Gothic Revival*, pp. 122–49; Graham Hough, *The Last Romantics* (London: Duckworth, 1949), pp. 84–95. On parallel developments in Germany, see Hans Lehmbruch and Nancy Halverson Schless, "Furniture and Fittings," in *Late Nineteenth-Century Art*, ed. Hans Jürgen Hansen, tr. Marcus Bullock (Newton Abbot: David and Charles, 1973), pp.99–100.

83. Carole Silver, *The Romance of William Morris* (Ohio University Press, 1982). In the immediate drama, Guenevere can say anything to prolong the proceedings until Lancelot arrives for rescue.

84. Stephens, *Rossetti*, p. 41.

85. *The Collected Letters of William Morris*, ed. Norman Kelvin (Princeton University Press), 2 (1987): 38, 41.

86. Fletcher, *Gardens and Grim Ravines*, pp. 164–90.

87. Giles Barber, "Rossetti, Ricketts, and Some English Publishers' Bindings of the Nineties," *The Library* (1970), 5th s., 25:314–330; James G. Nelson, *The Early Nineties: A View from the Bodley Head* (Harvard University Press, 1971), esp. pp. 18–55, 73–74; H. Halliday Sparling, *The Kelmscott Press and William Morris, Master-Craftsman* (London: Macmillan, 1924); *William Morris and the Art of the Book*, ed. Paul Needham (New York: Pierpont Morgan Library, 1976).

88. Christopher Wood, *Olympian Dreamers: Victorian Classical Painters, 1860–1914* (London: Constable, 1983), p. 191; cf. p. 182, also Francis Spalding, *Magnificent Dreams: Burne-Jones and the Late Victorians* (Oxford: Phaidon, 1978). At the expense of Whistler, Ruskin in *Fors Clavigera* for July 1877, Letter 79, praised Burne-Jones's work as " 'classic' in its kind."

89. Georgiana Burne-Jones, *Memorials of Edward Burne-Jones* (2 vols., London: Macmillan, 1904), 2:261.

90. Joseph Kestner, "Burne-Jones and Nineteenth-Century Fear of Women," *Biography* (1984), 7:95–122, and "The Force of the Past: The Perseus Legend and the Mythology of 'Rescue' in Nineteenth-Century British Art," *Victorians Institute Journal* (1987), 15:55–70; *Mythology and Misogyny: The Social Discourse of Nineteenth-Century British Classical-Subject Painting* (University of Wisconsin Press, 1989), pp. 65–107.

91. Penelope Fitzgerald, *Edward Burne-Jones: A Biography* (London: Joseph, 1975) p, 182.

92. D. S. MacColl, *Nineteenth-Century Art* (Glasgow: Maclehose, 1902), p. 142; Ironside and Gere, *Pre-Raphaelites*, p. 19.

93. Fitzgerald, 112–35, 142–43, 150–51.

94. *Burne-Jones: All Colour Paperback*, ed. May Johnson (New York: Rizzoli, 1979), Plate 37.

## 7. *Darwin*

1. Isaac Newton, *The Mathematical Principles of Natural Philosophy*, tr. Andrew Motte (3 vols., London: Symonds), 2:160.

2. John Frederick William Herschel, *A Preliminary Discourse on the Study of Natural Philosophy* (London, 1830; facsimile reprint with introduction by Michael Partridge, New York: Johnson, 1966), pp. 18, 42.

3. Lorenz Oken, *Elements of Physiophilosophy*, tr. Alfred Tulk (London: Ray Society, 1847), pp. 121, 204, 372–73, 494, 655, 662.

4. Edward Stuart Russell, *Form and Function: A Contribution to the History of Animal Morphology* (London: Murray, 1916), pp. 89–101 (on Richard Owen, pp. 102–12; on Baer, pp. 113–32 and passim); Philip F. Rehbock, *The Philosophical Naturalists: Themes in Early Nineteenth-Century British Biology* (University of Wisconsin Press, 1983), pp. 15–30 (on Robert Knox, Edward Forbes, and Owen, pp. 16–114); Stephen Jay Gould, "The Rule of Five," *Natural History*, October 1984, pp. 14–23.

5. Professor [Richard] Owen, *Report on the Archetype and Homologies of the Vertebrate Skeleton* (London: Taylor, 1847); *Hard Times,* ch. 3.

6. In England, the most notable contributions were the combination of Neptunian and Plutonian geologies by Granville Penn, *A Comparative Estimate of the Mineral and Mosaical Geologies* (London: Ogle, 1822), and the equally sublime and Mosaic William Buckland (Professor of Mineralogy and Geology in the University of Oxford), *Reliquiae Diluvianae . . .* (London: Murray, 1823).

7. Byron's Napoleonic interest in Cuvier's destroyed worlds was noted by Franicis C. Haber, *The Age of the World: Moses to Darwin* (Johns Hopkins Press, 1959), pp. 206–209.

8. William Whewell, *History of the Inductive Sciences, from the Earliest to the Present Time* (3 vols., London: Cass, 1967 reprinted from the 3rd edn. of 1857), 3:400, 401. The reprint forms vols. 2–4 of *The Historical and Philosophical Works of William Whewell* (10 vols.).

9. Whewell, 3:377, 387, 389–90.

10. Charles Coulston Gillispie, *Genesis and Geology: A Study in the Relations of Scientific Thought, Natural Theology, and Social Opinion in Great Britain, 1790–1850* (Harvard University Press, 1951), pp. 111, 124, 280nn37–38. This most detached of many surveys of evolutionary theories before Darwin is well followed by Sir Gavin de Beer, *Charles Darwin: Evolution by Natural Selection* (London: Nelson, 1963).

11. For reasons of his own, Stephen Jay Gould has argued that the catastrophists were motivated by scientific evidence, not by religious considerations. "Toward the Vindication of Punctuational Change," in *Catastrophes and Earth History: The New Uniformitarianism*, ed. W. A. Berggren and John A. Van Couvering (Princeton University Press, 1984), pp. 9–34.

12. "Natural History of Creation, *Edinburgh Review* (1845), 82:3.

13. Chauncey C. Loomis, "The Arctic Sublime," in Knoepflmacher and Tennyson, pp. 95–112.

14. John Stuart Mill, "Nature," *Three Essays on Religion* (London: Longmans, 1874), pp. 3, 28–29. Arnold's and Mill's disillusionment with benign nature has been attributed to a common influence from Goethe by S. Bailey Shurbutt, "Matthew Arnold and John Stuart Mill: In Harmony with Nature," *Essays in Literature* (1988), 15:35–43.

15. Nathaniel Hawthorne, *Tales and Sketches*, ed. Roy Harvey Pearce (Library of America, 1982), p. 766.

16. Erasmus Darwin, *The Temple of Nature* (1803), Additional Notes, p. 38.

17. Loren Eiseley, *Darwin's Century: Evolution and the Men Who Discovered It* (Garden City, N.Y.: Doubleday [Anchor], 1961), pp. 125–32; Ernst Mayr, *The Growth of Biological Thought: Diversity, Evolution, and Inheritance* (Harvard University Press, 1982). pp. 499–500. The essential passage from Matthew, *On Timber and Aboriculture* (1831), is reprinted in H. L. McKinney, ed., *Lamarck to Darwin: Contributions to Evolutionary Biology 1809–1859* (Lawrence, Kan.: Colorado, 1971), pp. 29–40.

18. With reference to Monboddo and others who thought animals had language, belief in human progress has been seen as an encouragement to acceptance of simian ancestry: "The growing belief in the social evolution of mankind thus encouraged the view that men were only beasts who had managed to better themselves." Keith Thomas, *Man and the Natural World*, p. 132.

19. Mayr, *Growth of Biological Thought*, pp. 299–393, 499–500.

20. *Edinburgh Review* (1860), 11:487–532, annotated version in David Hull, *Darwin and His Critics: The Reception of Darwin's Theory of Evolution by the Scientific Community* (Harvard University Press, 1973), pp. 172–215.

21. Darwin, *Journal of Researches into the Natural History and Geology of the Countries Visited during the Voyage of H.M.S. Beagle* (New York: Collier, 1901), pp. 205–06.

22. Humboldt, *Cosmos,* 1:18.

23. Leslie Stephen's interpretation has been summarized: "Darwin introduced the idea that *chance* begot order. Fortuitous events, not planned or rational but fortuitious, resulted in a physical law: the process of natural selection . . . broke the principle of internal determinism so that the links in the Chain of Being fell apart." Noel Annan, *Leslie Stephen: The Godless Victorian* (rev. edn., New York: Random House, 1984), pp. 200–201.

24. By accidental variations, Darwin meant "not that they have not determinate cause, but that they bear no relation to the organism's conditions of life; they are not adaptations." Dov Ospovat, *The Development of Darwin's Theory . . . 1838–1859* (Cambridge Univeristy Press, 1981), p. 69. Ernst Mayr describes natural selection as a two-step escape from the antithesis of chance or necessity: "During the first step, the production of variation, . . . every event is largely governed by chance. During the second step, selection *sensu stricto* (beginning with the fertilized egg through ontogeny, to successful reproduction of the adult), everything is largely controlled by the quality of the genotype and phenotype, even though with a very strong probabilistic component." "The Triumph of Evolutionary

Synthesis," *Times Literary Supplement,* 2 November 1984, p. 1262. Leon R. Kass identifiies the teleology assumed without explanation by Darwin as the "desire or tendency of living things to stay alive and their endeavor to increase their numbers." *Toward a More Natural Science: Biology and Human Affairs* (New York: Free Press, 1985), p. 261.

25. "This is an utilitarian age . . . The farmer and grazier are as much interested as the naturalist in all facts concerning the origin of life and of specific forms, whether by direct creation, or by secondary laws as claimed by the followers of Lamarck or Darwin." So opened the *American Naturalist: A Popular Illustrated Magazine of Natural History* (March 1867), vol. 1, no. 1, pp. 2–3.

26. Bernard Campbell, *Human Evolution: An Introduction to Man's Adaptations* (3rd edn., New York: Aldine, 1985), p. 3.

27. Hull, *Darwin and His Critics*, pp. 53, 62, 65, 66.

28. *The Origin of Species by Charles Darwin: A Variorum Text,* ed. Morse Peckham (University of Pennsylvania Press, 1959), pp. 757, 759. Darwin expressed to J. D. Hooker regret that he had "truckled to public opinion." *More Letters* (London, 1903), 1:321, quoted in Hull, p. 53.

29. Francis Darwin, *The Life and Letters of Charles Darwin* (2 vols., New York: Appleton, 1900), 1:279. Darwin referred there to a passage in his *Variation of Animals and Plants under Domestication*: "no shadow of reason can be assigned for the belief" that variations in nature, "man included," were "intentionally and specially guided."

30. Ernst Mayr, *The Growth of Biological Thought: Diversity, Evolution, and Inheritance* (Harvard University Press, 1982), pp. 57, 117, 519–20. Despite the scientific need to save as much law as practicable, Mayr describes the Darwinian system, in sum, as "probabilistic with a strong stochastic element" (p. 520).

31. Thomas Henry Huxley, "The Genealogy of Animals [1869]," in *Collected Essays* (9 vols., London: Macmillan, 1896–1902), 2:109–10.

32. Huxley, *Methods and Results* (1893), p. 65. Huxley had probably been shaken into this view by the prediction of Jevons that "the Reign of Law will prove to be an unverified hypothesis, the Uniformity of Nature an ambiguous expression, the certainty of our scientific inferences to a great extent a delusion." William Stanley Jevons, *The Principles of Science: A Treatise on Logic and Scientific Method* (2 vols., London: Macmillan, 1874), 1:ix. Hegel had provided Humboldt with a phenomenological step toward contingency: "Science is the labour of mind applied to nature, but the external world has no real existence for us beyond the image reflected within ourselves through the medium of the senses." *Cosmos,* 1:59.

33. John Tyndall, "Miracles and Special Providences," *Fortnightly Review* (1867), n.s. 1:659–60, quoted in Edwin Mallard Everett, *The Party of Humanity* (University of North Carolina Press, 1939), pp. 126–27.

34. Reprinted in *Science and Religion in the Nineteenth Century,* ed. Tess Cosslett (Cambridge University Press, 1984), pp. 176–77.

35. R. Howard Collins, *An Epitome of the Synthetic Philosophy,* with a preface by Herbert Spencer (London: Williams, 1889), p. 109.

36. "Since Butler's time, a new complexion has been put upon biological philosophy by the profound speculations of Bergson. But it is not impossible that the future development of biological thought will follow some such lines as those which he tentatively laid down." Russell, *Form and Function*, p. 341.

37. Cosslett, p. 180. Botanists who assert belief in natural selection still casually imply purposiveness, as of a flower "brightly coloured and sweet smelling, mainly to attract pollinating agents such as insects": G. W. Lennox and S. A. Seddon, *Flowers of the Caribbean* ([London:] Macmillan Caribbean, 1978), p. vi.

38. Herschel, *Preliminary Discourse on Natural Philosophy* (1830), pp. 360–61.

39. William Beatty Warner, *Chance and the Text of Experience: Freud, Nietzsche, and Shakespeare's "Hamlet"* (Cornell University Press, 1986), p. 20.

40. Karl Pearson, *The Grammar of Science* (London: Scott, 1892), pp. 99, 104. The similar position of J. H. Poynting is noted by David B. Wilson, "Concepts of Physical Nature: John Herschel to Karl Pearson," in Knoepflmacher and Tennyson, pp. 213–14.

41. Francis Darwin, *Life of Darwin*, 2:37. In *Physical Geography of the Globe* (1861), Herschel wrote with sober acidity: "We can no more accept the principle of arbitrary and casual variation of natural selection as a sufficient condition, *per se*, of the past and present organic world, than we can receive the Laputan method of composing books (pushed *à outrance*) as a sufficient account of Shakespeare and the Principia." Quoted in Hull, *Darwin and His Critics*, p. 61. Karl von Baer, in 1873, expanded the parallel with Laputan chance; Hull, p. 419.

42. George Douglas Campbell, 8th duke of Argyll, *The Reign of Law* (5th edn., London: Strahan, 1868), p. 49. There is an astute examination of Argyll in Neal C. Gillespie, "The Duke of Argyll, Evolutionary Anthropology, and the Art of Scientific Controversy," *Isis* (1977), 68:40–54.

43. Helmholtz, "On the Aim and Progress of Physical Science," tr. W. Flight, *Popular Lectures on Scientific Subjects*, 1:338, 340.

44. Roger Smith, "The Human Significance of Biology: Carpenter, Darwin, and the vera causa," in Knoepflmacher and Tennyson, pp. 216–30.

45. Peter J. Bowler, *Theories of Human Evolution: A Century of Debate, 1844–1944* (Johns Hopkins University Press, 1986), p. 1. Bowler has studied the persistence of Lamarckian purpose in two books. *The Eclipse of Darwinism: Anti-Darwin Evolution Theories in the Decades around 1900* (Johns Hopkins University Press, 1983) and *Evolution: The History of an Idea* (University of California Press, 1984). His *Evolution* includes a good account of Galton, Pearson, and other biometricians, pp. 240–42. The Lamarckian impulse, and that of the later Teilhard de Chardin, continues in such pieces as Arthur Fabel, "The Dynamics of the Self-Organizing Universe," *Cross Currents* (1987), pp. 168–77.

46. Andrew Dickson White, *A History of the Warfare of Science with Theology in Christendom* (2 vols., New York: Appleton, 1897), 1:66–68, 407. The autobiography, periodical essays, and science fiction of H. G. Wells reveal a long struggle to maintain belief in absolute causation as central to all science, against the kind of indeterminateness his contemporaries attributed to Max Planck.

47. Sir Oliver Lodge, *Science and Immortality* (New York: Moffat, 1909), p. 21. The idea of nature should not be limited to "that region of which we now believe that we have any direct scientific knowledge"; for one reason, science "has not yet witnessed the origin of the smallest trace of life from dead matter" (pp. 10, 17).

48. G. Henslow, *The Proofs of the Truths of Spiritualism* (2nd edn., rev., London: Kegan Paul, 1919), p. 4. The frontispiece is labeled, "A typical Spirit photograph. Two ladies sitting; one almost entirely obscured by spirit-cloud. None of the five faces recognised."

49. The centrality of Darwin to evolutionary anthropology is challenged, on the grounds that the inadequacy of static utilitarianism in the first third of the century called for evolutionary political and social thought, by J. W. Burrow, *Evolution and Society* (Cambridge University Press, 1966), pp. 1–100, 114, 181. It has been argued throughout the present study that no theory of stasis could flourish or survive in the nineteenth century. The justification for utilitarianism was that is accomplished practical change.

50. Hugo Münsterberg, *Science and Idealism* (Boston: Houghton, Mifflin, 1906), pp. 12–14, 61.

51. George W. Stocking, Jr., *Victorian Anthropology* (New York: Free Press, 1987), pp. 150–56.

52. Edward B. Tylor, *Primitive Culture* (3rd U.S. from 2nd London edn., 2 vols., New York: Holt, 1883), 1:2–3; Tylor, *Anthropology* (New York: Appleton, 1888), p. 38, 331–32; Sir John Lubbock, *The Origin of Civilisation and the Primitive Condition of Man . . .* (4th edn., New York: Appleton, 1882), p. 480; Leslie A. White, introduction to Tylor's *Anthropology* (University of Michigan Press, 1960), p. iii.

53. Nancy Stepan, "Biological Degeneration: Races and Proper Places," in *Degeneration: The Dark Side of Progress*, ed. J. Edward Chamberlin and Sander L. Gilman (Columbia University Press, 1985), pp. 97–120.

54. Edward Caird, *The Evolution of Religion* (2 vols., Glasgow: Maclehose, 1893), 1:1.

55. Jonathan Edwards, *A Careful & Strict Enquiry into . . . Freedom of Will* (London: J. Johnson, 1790), pp. 16, 19, 23, 32, 223.

56. Peter Morton, *The Vital Science: Biology and the Literary Imagination, 1860–1900* (London: Allen and Unwin, 1984), pp. 207, 50.

57. A. K. Thorlby, "Literature," in *The New Cambridge Modern History,* vol. 11, ed. F. H. Hinsley (Cambridge University Press, 1962), 123.

58. K. D. M. Snell, *Annals of the Labouring Poor: Social Change and Agrarian England, 1660–1900* (Cambridge University Press, 1985), pp. 374–410., argues that Hardy so thoroughly confused his interest in upward mobility with agricultural laborers, of which he knew little, that he assigned to Tess work that few women were doing in the 1860s and almost none in the 1880s.

59. The significance of an Author's Note added to *The Secret Agent* in 1820, to the effect that anarchism is just another aspect of the general absurdity of life, is

discussed by Roger Tennant, *Joseph Conrad* (New York: Atheneum, 1981), p. 171. Tennant picks up (p. 170), as important in this connection, the observation of Norman Sherry *(Conrad's Western World*, p. 138) that Conrad was indebted in *Gaspar Ruiz* to *The Voyage of the Beagle.*

60. *The Collected Letters of Joseph Conrad*, ed. Frederick R. Karl and Laurence Davies (2 vols., Cambridge University Press, 1986), 2:30.

61. H. H. Lamb, *Climate History and the Modern World* (London: Methuen, 1983), pp. 47–48.

62. Alan Macfarlane, *Marriage and Love in England: Modes of Reproduction 1300–1840* (Oxford: Blackwell, 1986), pp. 20–29, 322–44.

63. To Adam Smith, nature "was part of a divinely ordained, if mechanical, harmony . . . Malthus conceived of nature as hostile and niggardly, and David Ricardo, the greatest of the classical economists, saw it as blind, indifferent, and in a sense irrational. These various conceptions were united by the belief that nature is all-powerful and that man, being its subject, must live according to its laws." Lloyd J. Hubenka, ed., Ruskin, *Unto This Last* (University of Nebraska Press, 1967), pp. XXVIII. Hubenka sees Ruskin's use of biblical revelation to support ideals of justice as "a rhetorical tactic" (p. XXXV).

64. It was Spencer's writing in general that defended survival of the fittest. There is no reference to competition in his skeletal account of evolution by redistribution, integration, and process from homogeneity to heterogeneity in Collins, *Epitome of the Synthetic Philosophy*, pp. VIII–XI. Some Darwinian morphologists toward the end of the century gave natural selection a worse name by positing competition for survival among parts of a single organism.

65. Alvar Ellegård, *Darwin and the General Reader: The Reception of Darwin's Theory of Evolution in the British Periodical Press, 1859–1872* (Göteborg: Gothenburg Studies in English, no. 8, 1958), p. 334.

66. Jack London, *Children of the Frost* (New York: Macmillan, 1902), pp. 40–41.

67. Jack London, *Martin Eden* (New York: Macmillan, 1910), pp. 108, 259.

68. Grant Allen, *The Lower Slopes* (London: Mathews and Lane, 1894, pp. 9–10, 45–47.

69. Eldredge and Gould, "Punctuated Equilibria: an Alternative to Phyletic Gradualism," in *Models in Paleobiology*, ed. T. J. M. Schopf and J. M. Thomas (San Francisco: Freeman, 1972), pp. 82–115.

70. Stephen Jay Gould, "Toward a Vindication of Punctuational Change," in *Catastrophes and Earth History: The New Uniformitarianism*, ed. W. A. Berggren and John A. Van Couvering (Princeton University Press, 1984), pp. 9–34; "The Godfather of Disaster," *Natural History* (1987), 96:20–29.

71. Michael Denton, *Evolution: A Theory in Crisis* (London: Burnett, 1985).

72. Ernest Mayr, *The Growth of Biological Thought: Diversity, Evolution, and Inheritance* (Harvard University Press, 1982), pp. 35–78, 117, 131–32, 520–23. The current situation for Darwinists is similarly assessed in Ervin Laszlo, *Evolution: The Grand Synthesis* (Boston: Shambala, 1987).

73. R. S. Woolhouse, review of Patrick Suppes, *Probabilistic Metaphysics,* in *Times Literary Supplement,* 28 December 1984, p. 1509.

74. Plato, *Laws* 10.889, tr. R. G. Bury, Loeb Classical Library (1926), 2:310–15.

75. Huston Smith, "Two Evolutions," in *On Nature,* ed. Leroy S. Rouner (University of Notre Dame Press, 1984), pp. 42–59.

76. Carl Friedrich Weizsäcker, *Die Einheit der Natur* (1971), tr. Francis J. Zucker as *The Unity of Nature* (New York: Farrar Straus Giroux, 1980), pp. 6, 252; cf, 233, 259.

77. Thomas S. Kuhn, *The Structure of Scientific Revolutions* (2nd edn., University of Chicago Press, 1970), pp. 10, 23, 34, 170, 176.

78. Matt Cartmill, "Four Legs Good, Two Legs Bad: Man's Place (If Any) in Nature," *Natural History* (1983), 192:64–79. In 1968 A. Dwight Culler observed that *Alice in Wonderland,* like the *Origin,* "subjects the rigidities of an ethical, social, and religious world to the fresh natural vision of a child and to the destructive analysis of formal chance," and related Darwin similarly to Pater, but he also offered a predictive generalization: "I do not think that ultimately the Darwinian technique is susceptible of very profound or satisfying literary exploitation." "The Darwinian Revolution and Literary Form," in *The Art of Victorian Prose,* ed. George Levine and William Madden (New York: Oxford University Press, 1968), pp. 224–46.

79. Gillian Beer, *Darwin's Plots: Evolutionary Narrative in Darwin, George Eliot and Nineteenth-Century Fiction* (London: Routledge and Kegan Paul, 1983), pp. 117, 16, 9, 51–57, 102.

80. Richard Dawkins, *The Blind Watchmaker* (London: Longman, 1986), esp. pp. 45, 160, 223–52, 272, 296.

81. Peter J. Bowler, *Theories of Human Evolution* (Johns Hopkins University Press, 1986), p. 14.

## 8. Doubling and Division

1. On divisions of self from nature see John Pappas, "Victorian Literature of the Divided Mind" (Ph.D. diss., Columbia University, 1968).

2. "Hawthorne's tales rob the fantastic of its force and empower the ethical." Tobin Siebers, *The Romantic Fantastic* (Cornell University Press, 1984). p. 157; cf. Michael J. Colacurcio, *The Province of Piety: Moral History in Hawthorne's Early Tales* (Harvard University Press, 1984).

3. Theodore Ziolkowski, *Disenchanted Images: A Literary Iconology* (Princeton University Press, 1977), p. 180. On Dostoevsky's "subversive double as a reflex of social self-consciousness," see Robert Alter, "Playing Host to the *Doppelgänger,*" *Times Literary Supplement,* 24 October 1986, p. 1190.

4. Filmmakers have more than once carelessly placed the house on a corner of the block.

5. "At no time does Hyde achieve independent existence, the objective real-

ity, of the true second self." C. F. Keppler, *The Literature of the Second Self* (University of Arizona Press, 1972), p. 9. Robert Rogers agrees, but notes that Utterson's joke, "If he be Mr. Hyde, I shall be Mr. Seek," points to Utterson's role as "pursuer double." *The Double in Literature* (Wayne State University Press, 1970). pp. 93–94.

6. Mary Midgley, "Viewpoint: Selves and Shadows," *Times Literary Supplement*, 30 July 1982, p. 821. Vanity, she says, is the key to Jekyll as it is "to Wringhim's enslavement" in *Justified Sinner*.

7. So, among others, Chris Brooks, *Signs of the Times* (1984); Christine Brooke-Rose, *A Rhetoric of the Unreal* (1981), Michael H. Levenson, *A Genealogy of Modernism: A Study of English Literary Doctrine, 1908–1922* (Cambridge University Press, 1984) pp. 1–22.

8. Ian Watt, *Conrad in the Nineteenth Century* (University of California Press, 1979), pp. 151–68.

9. Noted by Miller, *Doubles* (1985), p. 262. Marlow later learns that Kurtz instigated the attack.

10. Marlow summarized Kurtz's activities in a sentence omitted from the final version: "More of what? More blood, more heads on stakes, more adoration, rapine, murder." *Heart of Darkness*, Norton Critical Edition, ed. Robert Kimbrough (rev. edn., New York: Norton, 1988) p. 72n.

11. Norman Sherry, *Conrad's Western World* (Cambridge University Press, 1971), p. 119. Sherry, p. 120, quotes a speech of 1892 in which Stanley quoted Pitt proposing in 1792 that the British opportunity to civilize Africans echoed the Roman accomplishment of civilizing what the British were then, "as debased in our morals, as savage in our manners, as degraded in our understandings as these unhappy Africans are at present."

12. *The Collected Letters of Joseph Conrad*, ed. Frederick R. Karl and Laurence Davies (Cambridge University Press, 1986–     ), 2:139–40.

13. Sherry, *Conrad's Western World*, esp. pp. 14, 54–55, 119–31, 339–50; Zdzislaw Najder, *Joseph Conrad: A Chronicle*, tr. Halina Carroll-Najder (Rutgers University Press, 1983), pp. 117, 135–42; Watt, *Conrad in the Nineteenth Century*, pp. 138–46. In 1898 a French attempt to reach the Nile was foiled by the British conquest of the Sudan; the United States freed Cuba from Spain and annexed the Philippines.

14. Robert S. Baker, "Joseph Conrad," *Contemporary Literature* (1981) 22:123, revised in *Heart of Darkness*, ed. Kimbrough, p. 342.

15. Ibid., p. 343. Watt, pp. 244–45, offers excuses for Conrad's misogyny.

16. Jocelyn Baines, *Joseph Conrad: A Critical Biography* (London: Weidenfeld, 1960), p. 229. With equal sanity but with relaxed logic, Baines argues that it is morally right, in Conrad's view, for Marlow to make a concession to evil. Conrad did write to Cunninghame Graham on 8 February 1899, in French, that crime is a necessary condition of organized existence, that society is essentially criminal (*Collected Letters*, 2:161). The assumption that this letter is pertinent does not

require belief that Conrad would approve without comment Marlow's violation of his own moral code. Nor does the French, "l'existence organisée," necessarily give freedom by default to the moral individual within organized society.

17. Arthur Symons, *Notes on Joseph Conrad, with Some Unpublished Letters* (London: Myers, 1926), p. 15. Noting the protest, but observing also that Conrad grants the eclipse of the author once the work is out, Lionel Trilling implies that Conrad released a personal antitype in letting Marlow accord to Kurtz "an admiration and loyalty which amount to homage, and not, it would seem, in spite of his deeds but because of them." *Sincerity and Authenticity* (Harvard University Press, 1972), pp. 106–10.

18. In the traditional terms of literary study, lovers dream of a *locus amoenus*, but nature does not provide it. William W. Bonney, *Thorns and Arabesques: Contexts for Conrad's Fiction* (Johns Hopkins University Press, 1980), pp. 89–96. On Marlow, pp. 153–57, 201–202.

19. C. F. Keppler, *The Literature of the Second Self* (University of Arizona Press, 1972), pp. 112–15.

20. Norman Sherry. *Conrad's Eastern World* (Cambridge University Press, 1966), pp. 261–69; Najder, *Joseph Conrad,* pp. 107, 353–54. The "unforgettable scare" is from the account by Conrad, *The Mirror of the Sea* (London: Dent, 1946), pp. 18–19.

21. H. G. Wells, *Experiment in Autobiography* (New York: Macmillan, 1934), p. 526.

22. Baines, *Joseph Conrad,* pp. 356–57; Sherry, *Conrad's Eastern World,* pp. 255–62. Sherry concludes that the captain killed himself *because* he had helped the mate. With light from the parallels, we may be sure, alas, that the seaman Leggatt killed was black. In the psychoanalytic reading by Robert Rogers, the realistic and the symbolic are found admirably balanced by Conrad through ambiguity in each. *The Double in Literature,* pp. 42–44.

23. Magazine version 1893; book 1894. The work was planned with Lloyd Osbourne, but carried out by Stevenson.

24. Robert Louis Stevenson, *Essays and Criticisms* (Boston: Small, 1907), pp. 212, 216.

25. *Henry James and Robert Louis Stevenson: A Record of Friendship and Criticism,* ed. Janet Adam Smith (London: Hart-Davis, 1948), pp. 89–90.

26. It must be knowledge that Stevenson began the book in collaboration with Lloyd Osbourne that accounts for neglect of this splendid work even during the recent period of reappraisal.

27. Christine Brooke-Rose, *A Rhetoric of the Unreal: Studies in Narrative and Structure, Especially of the Fantastic* (Cambridge University Press, 1981) pp. 128–229, the fullest examination of the structure of *The Turn of the Screw,* ignores the debates that have gone on since Edmund Wilson first impugned the governess.

28. Available, e.g., in *Literature of the Western World,* ed. Brian Wilkie and James Hurt (2 vols., New York: Macmillan, 1984), 2:2121–59.

29. Androgyny is located between Marsyas and Pierrot as aesthetic image in

J. E. Chamberlin, *Ripe Was the Drowsy Hour: The Age of Oscar Wilde* (New York: Seabury, 1977), pp. 171–79. On masked identities and doubling see Miller, *Doubles*, pp. 209–11.

30. The implications are vigorously explored by Flavia Alaya, *William Sharp—"Fiona Macleod"—1855–1905* (Harvard University Press, 1970).

31. Hermann Schlüter, *Das Pygmalion-Symbol bei Rousseau, Hamann, Schiller* (Zürich: Juris, 1968); Heinrich Dörrie, *Pygmalion: Ein Impuls Ovids und seine Wirkungen bis in die Gegenwart* (Düsseldorf: Rheinisch-Westfälsche Akademie der Wissenschaften, 1971); Annegret Dinter, *Der Pygmalion-Stoff in der Europäischen Literatur* (Heidelberg: Winter, 1979).

32. Mary Jacobus, *Reading Woman: Essays in Feminist Criticism* (Columbia University Press, 1986), p. 95. Kestner, in *Mythology and Misogyny,* relates Victorian treatments of the Pygmalion myth to masculine rescue of fallen women and to Apollonian solar myths defining women as helpless and generally inferior.

33. "The Orchard Pit," *Works*, ed. William Michael Rossetti (London: Ellis, 1911), p. 608. Cf. *The House of Life*, 15:112: "O born with me somewhere that men forget," the four "Willowwood" sonnets, and "Sudden Light," *Works,* pp. 79, 91–92, 200.

34. Stein, *The Ritual of Interpretation*, p. 147. On the double in Rossetti in general, see *Dante Gabriel Rossetti and the Double Work of Art*, ed. Maryan Wynn Ainsworth (Yale University, 1976), esp. Susan P. Casteras, pp. 9–11; David G. Riede, *Dante Gabriel Rossetti and the Limits of Victorian Vision* (Cornell University Press, 1983), passim. I was led toward admiration for Rossetti by William and Mary Howitt; my next guides were Carl Peterson and Robert N. Keane.

35. Richard Jenkyns, *The Victorians and Ancient Greece* (Harvard University Press, 1980), pp. 138–50; George P. Landow in *The Aesthetics of Fantasy Literature and Art*, ed. Roger C. Schlobin (University of Notre Dame Press, 1982), p. 136.

36. *Butterfly* (1893), 1:69–78.

37. On the role of *Dorian Gray* in creating a new reality in subversion of "normative standards for male behavior," see Ed Cohen, "Writing Gone Wilde: Homoerotic Desire in the Closet of Representation," *PMLA* (1987), 102:801–13.

38. Graham Hough, *The Last Romantics* (London: Duckworth, 1949), p. 195.

39. "The book in *Dorian Gray* is one of the many books I have never written, but it is partly suggested by Huysmans's *A Rebours* . . . It is a fantastic variation on Huysmans's over-realistic study of the artistic temperament in our inartistic age." *The Letters of Oscar Wilde*, ed. Rupert Hart-Davis (New York: Harcourt, 1962), p. 313; and see David Bonnell Green in *Etudes Anglaises* 18:13–18, cited in *The Picture of Dorian Gray,* ed. Isobel Murray (Oxford University Press, 1974), pp. 243–44.

40. C. F. Keppler, *The Literature of the Second Self* (University of Arizona Press, 1972), p. 81.

41. Wilde, *Letters*, p. 259.

42. Beerbohm, "Cosmetics," often reprinted under its later title, "A Defence of Cosmetics."

## 9. Aesthetes

1. General contours have not changed greatly since two seminal books published in Paris by Honoré Champion in 1931: Louise Rosenblatt, *L'idée de l'art pour l'art dans la littérature anglaise pendant la période victorienne*; Albert J. Farmer, *Le mouvement esthétique et "décadent" en Angleterre (1873–1900)* (both Paris: Champion, 1931).

2. William Butler Yeats, "Art and Ideas," 1914; included in *The Cutting of an Agate* and in *Essays* (London: Macmillan, 1924), pp. 431–34.

3. Carlton J. H. Hayes, *A Generation of Materialism, 1871–1900* (rev. edn., New York: Harper, 1963); Herman Ausubel, *In Hard Times: Reformers among the Late Victorians* (Columbia University Press, 1960); Booth, *In Darkest England and the Way Out* (1890); R. C. K. Ensor, *England 1870–1914* (Oxford: Clarendon, 1936); *The New Cambridge Modern History . . . 1870–1898*, ed. F. H. Hinsley (Cambridge University Press, 1962), 11:1–100, 383–410.

4. Warren Sylvester Smith, *The London Heretics, 1870–1914* (London: Constable, 1967).

5. Richard Le Gallienne, *The Religion of a Literary Man* (London: Mathews and Lane, 1893), p. 89. George Santayana tried to replace such misconceptions as Le Gallienne's: "A naturalistic conception of things is a great work of imagination,—greater, I think, than any dramatic or moral mythology . . . Naturalism is a philosophy of observation, and of an imagination that extends the observable; all the sights and sounds of nature enter into it, and lend it their directness, pungency, and coercive stress. At the same time, naturalism is an intellectual philosophy; it divines substance behind appearance, continuity behind change, law behind fortune." *Three Philosophical Poets* (Harvard University Press, 1927), pp. 21. 35.

6. *Yellow Book*, July 1984, reprinted in *The Yellow Book: A Selection*, ed. Norman Denny (London: Bodley Head, 1950), pp. 94–104; *The Yellow Book, Quintessence of the Nineties*, ed. Stanley Weintraub (Garden City, N.Y.: Doubleday, 1964), pp. 364–73. Arthur Waugh's attack on "literary frankness," to which Crackanthorpe responds, is given in Weintraub, pp. 347–63.

7. W. R. Johnson, *The Idea of Lyric* (University of California Press, 1982), p. 112.

8. For a much fuller list, see Holbrook Jackson, *The Eighteen Nineties: A Review of Art and Ideas at the Close of the Nineteenth Century* (London: Richards, 1913).

9. Bernard Muddiman, *The Men of the Nineties* (London: Danielson, 1920); Osbert Burdett, *The Beardsley Period: An Essay in Perspective* (London: Lane, 1925); Richard Le Gallienne, *The Romantic Nineties* (New York and London: Putnam's, 1926).

10. Anna Swanwick (1813–1899), *Poets the Interpreters of Their Age* (London:

Bell, 1982), p. 3. Swanwick, translator of Aeschylus and of Goethe's *Faust*, president of Queen's College, was omitted from *Who's Who* as late as 1909; *Who Was Who, 1897–1916*, identifies her as a "lady of independent means."

11. George Moore, *Modern Painting*, p. 116–17.

12. Leonée Ormond, *George du Maurier* (London: Routledge, 1969), pp. 243–307.

13. Sir Francis C. Burnand, *Records and Reminiscences, Personal and General* (2nd edn., 2 vols., London: Methuen, 1904), 2:151–66.

14. The genesis of Wilde's tour in a telegram from D'Oyly Carte has been often mentioned and often denied as improbable; it is documented in Richard Ellmann, *Oscar Wilde* (New York: Knopf, 1988), pp. 151–57.

15. Wendell V. Harris, "An Anatomy of Aestheticism," in *Victorian Literature and Society: Essays Presented to Richard D. Altick*, ed. James R. Kincaid and Albert J. Kuhn (Ohio State University Press, 1984), pp. 331–47.

16. L[awrence] Alma-Tadema (knighted, 1899), "Art in Its Relation to Industry," *Magazine of Art* (November 1892), 16:8. "Alma-Tadema [unlike Leighton and Watts] had no cast of the Parthenon frieze set into his studio wall; he preferred to collect photographs of Pompeii." Christopher Wood, *Olympian Dreamers: Victorian Classical Painters, 1760–1914* (London: Constable, 1983), p. 28.

17. Siegfried Wichmann, *Japonisme: The Japanese Influence on Western Art in the Nineteenth and Twentieth Centuries*, tr. Mary Whittall et al. (London: Harmony, 1981; New York: Park Lane, 1985, from the German of 1980); The Fine Art Society Ltd., *The Aesthetic Movement and the Cult of Japan* (London, 1972). Of a dozen helpful books contemporary with the aesthetic movement, three have been especially serviceable: Sir Rutherford Alcock, *Art and Industries of Japan* (London: Virtue, 1878); Thomas W. Cutler, *A Grammar of Japanese Ornament and Design* (London: Batsford, 1879–1880); C. J. Holmes, *Hokusai* (London: Unicorn, 1898). For a near-perfect epitome of this and all related developments, see Elizabeth Aslin, *The Aesthetic Movement: Prelude to Art Nouveau* (New York: Praeger, 1969; Excalibur, 1981).

18. Walter L. Creese, *The Search for Environment: The Garden City, Before and After* (Yale University Press, 1966), pp. 60–62, 87–107; Aslin, *Aesthetic Movement*, pp. 49–60; Mark Girouard, *Sweetness and Light: The "Queen Anne" Movement, 1860–1900* (Oxford: Clarendon, 1977), pp. 160–76.

19. Aslin, pp. 49–50, 84, and passim; W. B. Yeats, *Memoirs*, ed. Denis Donoghue (London: Macmillan, 1972), p. 21; Mark Girouard, *The Victorian Country House* (rev. edn., Yale University Press, 1979), pp. 76, 329–35, 453 (Beauvale n. 4.)

20. Fitzgerald, *Edward Burne-Jones*, p. 167.

21. Gillian Naylor, *The Arts and Crafts Movement: A Study of Its Sources, Ideals and Influence on Design Theory* (London: Studio Vista, 1971); Isabel Anscombe and Charlotte Gere, *Arts and Crafts in Britain and America* (London: Academy, 1978); Robin Spencer, *The Aesthetic Movement: Theory and Practice* (London: Studio Vista, 1972); and a trail-blazer, Nikolaus Pevsner, *Pioneers of Modern Design: From William Morris to Walter Gropius* (New York: Museum of Modern Art, 1949).

22. John Gloag, *Victorian Taste: Some Social Aspects of Architectural and Industrial Design from 1820–1900* (London: Black, 1962), p. xv.

23. Doreen Bolger Burke et al., *In Pursuit of Beauty: Americans and the Aesthetic Movement* (New York: Metropolitan Museum of Art, 1986).

24. Even when a suspicion of homosexuality hovers around the guilds, as in Peter Stansky, *William Morris, C. R. Ashbee and the Arts and Crafts* (London: Nine Elms, 1984), pp. 3–10, their service to the women's movement stands.

25. Gleeson White, "Christmas Cards and Their Chief Designers," *Studio* (1984), 4:supplement, 3–56. Alice Havers did more serious Olympian and aesthetic imitations.

26. Eric de Maré, *The Victorian Woodblock Illustrators* (London: Fraser, 1980), p. 7. Currently, this is the most compact and best-illustrated single volume on the subject.

27. I take the quoted phrase and the dates from C. T. Courtney Lewis, *The Story of Picture Printing in England during the Nineteenth Century; or, Forty Years of Wood and Stone* (London: Sampson Low [1926]).

28. W. J. Linton, *Some Practical Hints on Wood-Engraving for the Instruction of Reviewers and the Public* (Boston: Lee and Shepherd, 1879), pp. 35, 44–55, 70–81.

29. *The Young George du Maurier*, ed. Daphne du Maurier (London: Davies, 1951), p. 14; Ormond, *George du Maurier*, pp. 109–10.

30. George Moore, *Modern Painting*, pp. 182–89.

31. Alfred Hartley, "Some Views on Photography. By a Painter," *Studio* (1984), 4:60. Ricketts, a wood-engraver, painter, modeler, and connoisseur who disliked the realism of the Impressionists, noted in his diary in 1901 that William Rothenstein, William Nicholson, and Augustus John were all moving away from Watts and Burne-Jones with "a strong realistic tendency" that betokened the future, but added: "At any rate, none of these men show the slightest traces of photography and its curse." *Self-Portrait: Taken from the Letters and Journals of Charles Ricketts, R.A.*, ed. T. Sturge Moore and Cecil Lewis (London: Davies, 1939). pp. 66–67.

32. Geoffrey Wakeman, *Victorian Book Illustration: The Technical Revolution* (London: David and Charles, 1973), p. 50.

33. *Hobby Horse*, 1:5, 48; 2:13–16, 3:16–18, 117–18.

34. Stephen Calloway, *Charles Ricketts, Subtle and Fantastic Decorator* (London: Thames and Hudson, 1979); Joseph Darracott, *The World of Charles Ricketts* (New York: Methuen, 1980); Colin Franklin, *The Private Presses* (London: Studio Vista, 1969), pp. 81–93 and passim; John Russell Taylor, *The Art Nouveau Book in Britain* (2nd edn., New York: Taplinger, 1980), pp. 71–92 and passim; James G. Nelson, *The Early Nineties: A View from the Bodley Head* (Harvard University Press, 1971), passim; Dennis Farr, *English Art, 1870–1940* (Oxford: Clarendon, 1978), pp. 68–69.

35. Osbert Burdett, who (in envy on Beardsley's behalf) disliked Whistler and his style as a lecturer and writer, understood the format: "In Whistler's book even typography becomes a decoration. The prose lines wander and waver across

the printed page like the lines of a composition, and the words on the cover and title-page are so spaced as to make them, apart from their meaning, a decoration." *Beardsley Period*, p. 76.

36. On the full range of processes, Woodburytype, collotype, photogravure, etc., see Wakeman, *Victorian Book Illustration*; David Bland, *The Illustration of Books* (3rd edn., London: Faber, 1962), pp. 141–70; Harry G. Aldis, *The Printed Book* (2nd edn., Cambridge University Press, 1941); or any edition of Helmut and Alison Gernsheim, *The History of Photography*.

37. Jerome Hamilton Buckley, "A World of Literature: Gissing's *New Grub Street*," in *The Worlds of Victorian Fiction*, ed. Buckley (Harvard University Press, 1975), pp. 223, 232.

38. Nikolaus Pevsner, "Art and Architecture," *The New Cambridge Modern History*, 11:174.

39. S. Tschudi Madsen, *Art Nouveau*, tr. R. I. Christopherson (London: Weidenfeld, 1967), p. 15.

40. *Studio* (1893), 1:233–34, quoted by Ellen E. Frank, "The Domestication of Nature: Five Houses in the Lake District," in Knoepflmacher and Tennyson, *Nature and the Victorian Imagination*, pp. 91–92.

41. Sypher, *Rococo to Cubism*, pp. 224–54; Robert Schmutzler, *Art Nouveau*, tr. Edouard Roditi (New York: Abrams, 1964), pp. 8, 35–124; Maurice Rheims, *The Flowering of Art Nouveau*, tr. Patrick Evans (New York: Abrams, 1966), p. 129; Hans H. Hofstätter, *Art Nouveau: Prints, Illustrations and Posters* (Baden-Baden: Holle, 1968; tr. New York: Greenwich House, 1984), pp. 59–72.

42. Review of Henley's *London Voluntaries* in the *Fortnightly Review*, August 1892, included in *Studies in Two Literatures* and in Warner and Hough, *Strangeness and Beauty*, 2:233.

43. Mingay, *The Victorian Countryside*, 1:9. From London of this period only Gissing's *The Nether World* and Wells's *The Time Machine* are considered in Wendy Lesser, *The Life Below the Ground: A Study of the Subterranean in Literature and History* (Boston: Faber, 1987).

44. J. W. Gleeson White, "The Artistic Decoration of Cloth Book-Covers," *Studio* (1894), 4:18.

45. *The Temple of Nature* (1803), add. nn., pp. 87–90.

46. John Stokes, *Resistible Theatres: Enterprise and Experiment in the Late Nineteenth Century* (London: Elek, 1972), pp. 69–110, following a discussion of the aesthetic theater of E. W. Godwin, pp. 31–68. For a different but pertinent perspective, see Martin Stoddard, *Wagner to the "Waste Land": A Study of the Relationship of Wagner to English Literature* (Totowa, N.J.: Barnes and Noble, 1982).

47. Frank Kermode, *Romantic Image* (London: Routledge, 1957), p. 2.

48. Quoted in Liam Miller, *The Noble Drama of W. B. Yeats* (Dublin: Dolmen, 1977), pp. 25, 34. Later Yeats said that he had Ricketts in mind all along as the appropriate decorator.

49. Michael R. Booth, ed., *English Plays of the Nineteenth Century* (5 vols., Oxford: Clarendon, 1969–1976), 2:6, 7, 12.

50. Philippe Jullian, *Dreamers of Decadence: Symbolist Painters of the 1890s*, tr. Robert Baldick (New York: Praeger, 1971), and *The Symbolists*, tr. Mary Anne Stevens (Oxford: Phaidon, 1973); *French Symbolist Painters: Moreau, Puvis de Chavannes, Redon and Their Followers* (London: Arts Council of Great Britain, 1972); Alastair Mackintosh, *Symbolism and Art Nouveau* (London: Thames and Hudson, 1975); John Christian, *Symbolists and Decadents* (London: B. C. Cooper, 1977); Maly and Dietfried Gerhardus, *Symbolism and Art Nouveau: Sense of Impending Crisis, Refinement of Sensibility, and Life Reborn in Beauty*, tr. Alan Bailey (London: Phaidon, 1979), Diana L. Johnson, *Fantastic Illustration and Design in Britain, 1850–1930* (Rhode Island School of Design, 1979); Edward Lucie-Smith, *Symbolist Art* (London: Thames and Hudson, 1972).

51. *Savoy* (1896), 1:69.

52. Arthur Symons, "Ballet, Pantomime, and Poetic Drama," *The Dome* (1898), n.s. 1:65, 66, 69.

53. Besides the examples given later in this chapter, see Kermode, *Romantic Image*, pp. 68–70, 72–77.

54. Simon Wilson, *Beardsley* (rev. edn., Oxford: Phaidon, 1983), p. 8.

55. Jean Pierrot, *The Decadent Imagination, 1880–1900*, tr. Derek Coltman (University of Chicago Press, 1981), p. 10.

56. *Miss Brown*, vol. 2, ch. 3.

57. Jerome Hamilton Buckley, *The Triumph of Time: A Study of the Victorian Concepts of Time, History, Progress, and Decadence* (Harvard University Press, 1966), pp. 66–93. Cram's argument of inaction justifies the inclusion of perplexities and postponements as aesthetic decadence in Suzanne Nalbantian, *Seeds of Decadence* . . . (New York: St. Martin's, 1983), esp. pp. 42–43.

58. Cf. Albert Cassagne, *La théorie de l'art pour l'art en France chez les derniers romantiques et les premiers réalistes* (Paris: Hachette, 1906), p. 449. John R. Reed, in *Decadent Style* (Ohio University Press, 1985), defines decadence as a style "particularly suitable for themes of decay, degeneration, and collapse," but identifiable by dissolution ending in reconstruction, by "atomization and reintegration," from artists and writers who yearned to convert fascination with detail into stylized wholes.

59. Barbara Charlesworth, *Dark Passages: The Decadent Consciousness in Victorian Literature* (University of Wisconsin Press, 1965); John A. Lester, Jr., *Journey through Despair, 1800–1914: Transformations in British Literary Culture* (Princeton University Press, 1968)—especially valuable on the compulsive resort to nature by Henry Salt, Edward Carpenter, W. H. Hudson, and Edward Thomas.

60. *Savoy* (1896), 1:71–74.

61. John Gray, "Femmes Damnées," in *Silverpoints* (London: Lane, 1893), p. 35.

62. Patrick Bade, *Femme Fatale: Images of Evil and Fascinating Women* (London: Ashe, 1979); Beatrice Phillpotts, *Mermaids* (London: Ashe, 1980); Bram Dijkstra, *Idols of Perversity: Fantasies of Feminine Evil in Fin-de-siècle Culture* (London: Oxford University Press, 1988).

63. I retain the Victorian sense of "Philistine"; Arnold could not anticipate archaeological efforts to prove the ancient Philistines a highly artistic people.

64. Moore, *Modern Painting*, p. 20.

65. Whistler, *The Gentle Art of Making Enemies* (London: Heinemann, 1890), pp. 126–28.

66. Ibid., p. 143.

67. George Moore, *Modern Painting*, pp. 51–52.

68. *Oscar Wilde: Interviews and Recollections*, ed. E. H. Mikhail (2 vols., London: Macmillan, 1979), fully indexed, greatly extends the standard collection of published reactions, *Oscar Wilde: The Critical Heritage*, ed. Karl Beckson (New York: Barnes and Noble, 1970). Degas gave Wilde in return a Whistler-like objection to aesthetes: "Il y a quelque chose plus terrible encore que le bourgeois—c'est l'homme qui nous singe." Ellmann, *Oscar Wilde* p. 219n.

69. Oscar Wilde, *Intentions and the Soul of Man*, vol. 8 in the first collected edition (14 vols., London: Methuen, 1908), pp. 41, 48, 56, 68, 94, 133, 143, 223, 134.

70. John Oliver Hobbes [Pearl Craigiel], *The Gods, Some Mortals and Lord Wickenham* (London: Henry, 1895), pp. 136–37, 254–55.

71. Richard Ellmann's first survey of the subject, "Overtures to Salome" of 1968, reprinted in *Oscar Wilde: Modern Critical Views*, ed. Harold Bloom (New York: Chelsea House, 1985), pp. 77–90, is thickened with new details in his *Oscar Wilde* (1988), pp. 339–45, 371–76. Wilde reviewed in 1888 a version (one of two) by the American Joseph Converse Heywood, who made more graphic than Heine had done Salome's act of kissing the bodiless head.

72. *Opera News*, 17 February 1962.

73. Among other provocative approaches: Françoise Meltzer, *Salome and the Dance of Writing: Portraits of Mimesis in Writing* (University of Chicago Press, 1987), pp. 19–27; C. S. Nassar, *Into the Demon Universe: A Literary Exploration of Oscar Wilde* (Yale University Press, 1974), pp. 80–109; Peckham, *Romanticism and Ideology*, pp. 152–53; Peter Conrad, *Romantic Opera and Literary Form* (University of California Press, 1977), pp. 159–60; Helen Grace Zagona, *The Legend of Salomé, and the Principle of Art for Art's Sake* (Paris: Minard, 1960); Robert O. Delevoy, *Symbolists and Symbolism* (New York: Rizzoli, 1978), pp. 40–43; Jean Pierrot, *The Decadent Imagination: 1880–1900* (University of Chicago Press, 1982), pp. 198–99; Janine Chasseguet-Smirgel, *Creativity and Perversion*, (New York: Norton, 1984), pp. 95–98.

74. Ellmann, *Oscar Wilde*, pp. 344–45. Ellmann takes each varying report on Wilde's conversation as evidence that he kept changing his mind about the play he was writing.

75. Timothy d'Arch Smith, *Love in Earnest: Some Notes on the Lives and Writings of English "Uranian" Poets from 1889 to 1930* (London: Routledge, 1970); Rupert Croft-Cooke, *Feasting with Panthers: A New Consideration of Some Late Victorian Writers* (New York: Holt, 1968); *Sexual Heretics: Male Homosexuality in English Literature from 1850 to 1900* (New York: Coward-McCann, 1971), p. 43.